T0419585

WOMAN TRIUMPHANT

THE STORY OF HER STRUGGLES FOR FREEDOM, EDUCATION AND POLITICAL RIGHTS

WOMEN'S ISSUES

Additional books and e-books in this series can be found
on Nova's website under the Series tab.

WOMAN TRIUMPHANT

THE STORY OF HER STRUGGLES FOR FREEDOM, EDUCATION AND POLITICAL RIGHTS

RUDOLPH CRONAU

snova
New York

NOTICE TO THE READER

Library of Congress Cataloging-in-Publication Data

ISBN: 978-1-53617-158-7

Published by Nova Science Publishers, Inc. † New York

CONTENTS

PREFACE[*]

Are you aware of the fact that you are living in the most important period of human history? Not for the reason that a World's War has been fought and a "League of Nations" formed, but because all civilized nations are beginning to acknowledge that women, who form the greater part of the human race, are entitled to the same rights and recognition as have heretofore been enjoyed by men only. The entry of woman into industry, the professions, literature, science and art in modern times, her participation in social and political life, mark the beginning of an era of a significance, equal, if not greater, than when by the discovery of America a New World was added to the old.

Although it is a fact that man owes innumerable benefits to woman's care, devotion, and mental initiative, it is also true that through egoism and self-conceit he has never appreciated woman's work and achievements at their full value. On the contrary: while she was giving all and asking little, while she shared with man all hardships and perils, she was for thousands of years without any rights, not even as regards her own person and property. From ancient times up to the present day she has been an object of rape and barter, and quite often, for sexual purposes, held in the most horrible slavery. During the Middle Ages innumerable women were persecuted for witchcraft, subjected to the most cruel tortures, dragged to the scaffold to be beheaded, or burnt alive at the stake.

Woman's status to-day is the result of her own energy, efforts and ability. She overcame the prejudice and stubborn opposition of bigoted priests, pedantic scholars and reactionary statesmen, who were unable to see that the advance and emancipation of woman is synonymous with the progress and liberation of the greater part of the entire human race. To short sighted people such as these Tennyson directed his lines:

"The Woman's Cause is Man's! They rise or sink together, dwarf'd or godlike, bond or free; if she be small, slight-natured, miserable, how shall men grow!"

[*] This is an edited, augmented and reformatted version of "Woman Triumphant: The Story of Her Struggles for Freedom, Education and Political Rights" by Rudolph Cronau, originally published in 1919. The views, opinions, and nomenclature expressed in this book are those of the authors and do not reflect the views of Nova Science Publishers, Inc.

The book submitted here gives an account of woman's evolution, of her enduring and trying struggles for liberty, education, and recognition. While this account will make every woman proud of the achievements of her sex, man, by reading it, will become aware that it is his solemn duty not only to protect woman from injustice, brutality and exploitation, but to give her all possible assistance in her endeavors to attain that position in which she will be man's ideal consort and friend.

Rudolph Cronau.

PART I. WOMEN DURING THE REMOTE PAST

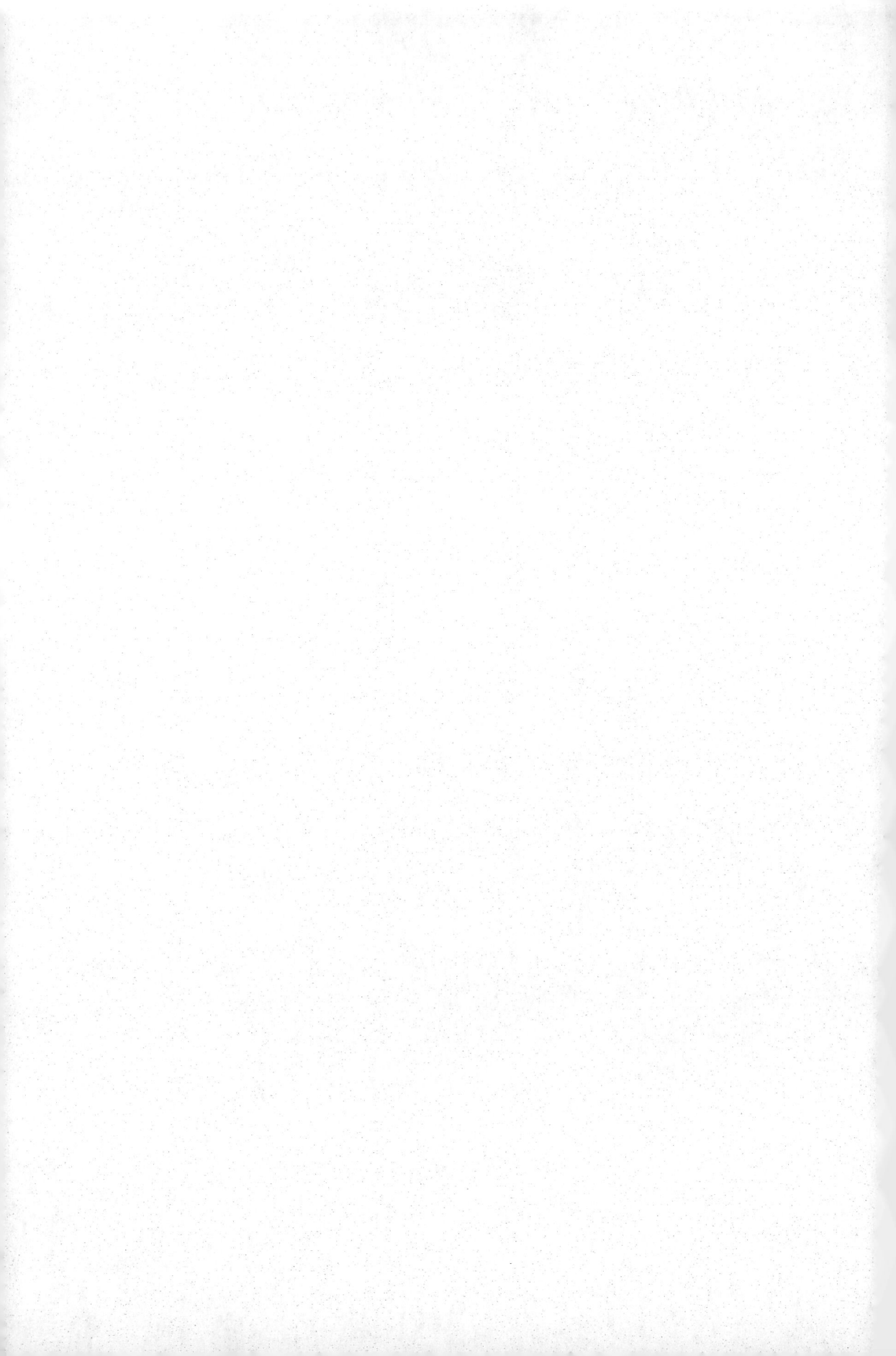

Chapter 1

PRIMEVAL MAN, HIS ORIGIN AND SEVERE STRUGGLE FOR EXISTENCE

Figure 1. Aboriginal Huts at the Amazon River.

While we were young and credulous, black-robed theologians impressed upon our minds their theory of creation, according to which the first man was moulded by the divine author of all things in his own image and placed in an enchanting paradise. Here he enjoyed with his mate, whom the same deity formed from one of man's ribs, a state of innocence, bliss and happiness, since want, sickness, and death were as yet unknown, and all animals lived together in peace and harmony.

In later years, after we had become inquisitive, we found that this story of creation is merely one of innumerable similar 8myths, invented by aboriginal people when they began to ponder over their origin. We also became acquainted with the theory of evolution, as taught by Lamarck, Darwin, Haeckel, Huxley, Tylor, Lubbock, Osborn, and other eminent anthropologists. And by investigating and comparing fossil facts and living forms we became convinced that man was not specially created, but gradually evolved from far lower animal forms. Furthermore, we recognized that primitive man never enjoyed paradisical peace and happiness, but was constantly compelled to a far more desperate struggle for existence than any human beings had to carry on during later periods.

To realize the innumerable hardships and terrors of this battle is almost beyond the power of imagination. Try to place yourself in the situation of such naked and unarmed beings. Day in and out they were persecuted by wild beasts, which in size as well as in strength and ferocity far surpassed those of to-day.

There were the terrible sabre-toothed tigers, whose enormous fangs hung like daggers from their upper jaws. There were fierce lions and bears, in comparison to which the present species would appear dwarfed. The plains and forests were infested with bloodthirsty hyenas and wolves, that hunted in packs and allowed no creature to escape which they were able to cut off from its retreat. Ugly snakes, quick as lightning, lurked in the underbrush and trees. The lakes and rivers were alive with hideous alligators, that made every attempt to get a drink a hazardous task. Even the skies were full of danger, as sharp-eyed eagles and vultures circled about, ready to swoop on any living thing that might expose itself to view. Awe-inspiring were also the immense mammoths, elephants and rhinoceros, which with heavy tread broke through the dense forests.

In contrast to these powerful beasts man was not protected at all. Indeed, his means of defense were so poor, that his survival strikes us almost as an inconceivable wonder. Neither was he armed with strong teeth, sharp claws, horns or poisonous stings. His body had no covering but a very thin and vulnerable skin. To escape his many pursuers, he was compelled to hide in almost inaccessible places, among the branches of high trees, or in the crags and on top of towering cliffs.

The never-ending struggle increased, when his kin multiplied and began to split into various bands, tribes and races. With this separation quarrels arose over the limits of the hunting grounds. Men began to fight and kill their neighbors. Even worse, they slaughtered the captives and devoured their flesh during cannibal feasts.

Figure 2. An Ape-Man.

In physical appearance primeval men were far from resembling those ideal figures of Adam and Eve, pictured by mediæval artists who strove to give an idea of the glories of our lost Paradise. While these products of imagination can claim no greater authenticity than the illustrations to other fairy tales, we nevertheless owe to the diligent works of able scientists restorations of the figures of primeval men. These deserve full credit, as they are based on skeletons and bones, found in caves, which some hundred thousand years ago were inhabited by human-like beings. From such remains it appears that our predecessors were near relatives to the so-called man-apes, the orang outang, chimpanzee, gibbon, and gorilla. Ages passed before these ape-men, in the slow course of evolution, developed into man, distinctly human, though still on a far lower level than any savage people of to-day.

The ape-man probably knew no other shelter than nests of twigs and leaves, similar to those constructed by the orang outang and the gorilla. But with the gradual development of man's brain and intelligence he improved these nests to tree-huts like those still used by certain aborigines of New Guinea, India, and Central Africa. To these huts they retreated at night, to be safe from wild beasts, and also at sudden attacks by superior enemies.

Figure 3. Tree Huts in New Guinea.

The cliff dwellings, abounding among the steep cañons of Colorado, New Mexico and Arizona were similar retreats. Here we find thousands of stone houses, many hidden at such places and so high above the rivers that they can hardly be detected from below. In the cañon of the Rio Mancos several cliff dwellings are 800 feet above the river. To locate them from below a telescope is needed. How it was possible for human beings to get to some of these places, is a mystery still unsolved.

Other dwellings stand on almost unscalable boulders, or they are placed within the fissures and shallow caverns of perpendicular walls. They can be reached only by descending from the upper rim of the cañon by means of long ropes, or by climbing upwards from below by using hands as well as feet. If one succeeds in getting to these places, one finds them always provided with store rooms for food and water. Constant danger of hostile assaults must have compelled people to live in such difficult retreats, which could be prepared only at enormous expenditure of time and labor.

Another form of refuge were the lake-dwellings, which were erected far out in the lakes on platforms resting on heavy posts. Traces of such structures have been found in many parts of the world. They are still used by some of the aborigines of New Guinea and India, and also by the Goajiro Indians of Northern Venezuela. Indeed, Venezuela owes its name to the fact, that the Spanish discoverers of these lake-dwellings were reminded of Venice, the queen city of the Adriatic.

Figure 4. Cliff Dwellings in the Canon of Rio San Juan, New Mexico.

When in time such aboriginal tribes increased, so that their number spelled warning to their neighbors, they created more comfortable camps on the shores. Or they moved into caves, such as abound in all countries where limestone is prevailing.

Nomadic peoples like the Indians of North America and some tribes of Siberia prepare tents of dressed skins, which are sewed together and stretched over a framework of poles. Many aborigines of Southern Africa and Australia are satisfied with bush shelters. Or they construct lodges of willows, which they cover with bark or mud, to afford protection against rain and the fierce rays of the sun.

Figure 5. Lake Dwellings in New Guinea.

Figure 6. Women of Kambala. Central Africa, Crushing Grain.

People, living in cold regions like the Eskimo, seek shelter from the biting winter storms by digging pits five or six feet deep. These holes they cover with dome-shaped roofs of whale-ribs and turf. Where these materials are not at hand the Eskimos rely on hemispherical houses, built of regular blocks of snow laid in spiral courses. The entrance is gained by a long passage-way that shuts off cold as well as penetrating winds.

Having thus summarized the principal kinds of primitive dwellings, we shall now briefly consider the activity of aboriginal peoples.

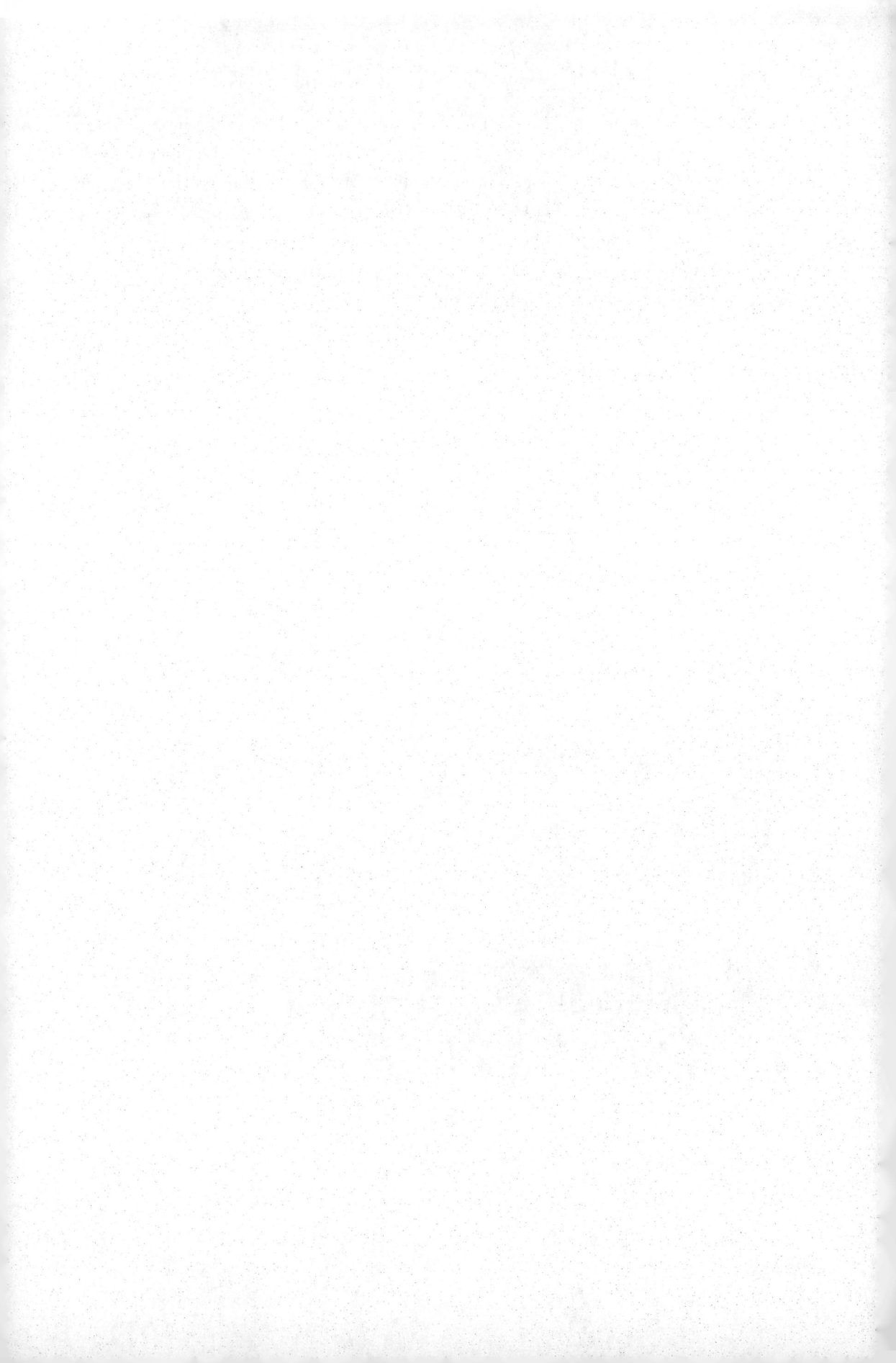

Chapter 2

THE DIVISION OF LABOR AND RESPONSIBILITIES BETWEEN THE SEXES

Explorers and scientists, who have lived among aboriginal tribes in order to study their manners and customs, have always found, that each sex has its own sphere of duty and work. To the stronger man fell the obligation of protecting his family, which consisted of his wife or wives and their offspring. It was also his share to support them with the products of the chase, and to provide suitable material for the building of the lodge. "These activities," so states J .N. B. Hewitt in the 'Handbook of American Indians' (Vol. II, 969), "required health, strength and skill. The warrior was usually absent from the fireside on the chase, on the warpath, or on the fishing-trip, days, weeks or months, during which he often traveled many miles and was subjected to the hardships and perils of hunting and fighting, and to the inclemency of the weather, often without adequate shelter or food."

To the lot of women fell the care of the children, the labor required in the home and in all that directly affected it.

The essential principle governing this division of labor and responsibility between the two sexes lies much deeper than in an apparent tyranny of the man. The ubiquity of danger from human foes as well as from wild beasts, the suddenness of their assaults when least expected, compelled aboriginal men to keep their weapons always at hand. During the day they hardly lay them aside, even for a minute, and at night they are always within reach. This fact explains, why the women and children transport all the loads, while the men carry nothing but their weapons when aborigines move from one place to another.

This division of functions consequently led men to confine their ingenuity and activity chiefly to the improvement and skillful handling of their arms, to the invention of snares for the game and to methods of fighting animal and human foes. It led also to the inclination to regard hunting and warfare as the only occupations worthy of men, and to relegate all domestic work to the women, since such labor would be degrading to the warrior.

But the despised work of the weaker sex has proven of far greater value to the progress of the human race than all heroic acts ever accomplished by fighting men. To woman's ingenuity we owe our comfortable homes. Women kept the warming hearth-fire burning, prepared the meals, watched faithfully over the children and made the clothes that gave protection against rain and cold. To women's inventive sense we owe also our most important industries: agriculture, weaving, pottery, tannery, basketry, dyeing, brewing, and many other peaceful arts.—

It has been said that human culture began with man's knowledge and control of fire, that mysterious, ever consuming, ever brightly flaming element, which was regarded by all aborigines as a thing of life, by some even as an animal. It must have all the more forcibly impressed men's imagination, inasmuch as it not alone promoted man's comfort, but even made life endurable, especially in cold climates.

Figure 7. Life among Prehistoric Cave-Dwellers.

Figure 8. Woman of Loango, Tilling the Soil.

It is certain that the practical knowledge of fire was obtained not at one given spot only but in many different parts of the world and in a variety of ways. In time men discovered also various methods of producing sparks, generally by rubbing two sticks of wood or by knocking two flints together. But as these methods were slow and laborious, it became the custom for each band to maintain a constant fire for the use of all families in order to avoid the troublesome necessity of obtaining it by friction. Generally this constant fire was kept in the centre of the village, to be in reach for everybody. The duty to keep it always burning fell naturally to the women, as they remained always in the village, and especially to those women not burdened with the cares of maternity. As fire

later on was regarded as a present of the good spirits or gods to men, these central fires were held sacred, and so the fire worship grew by degrees into a religious cult of great sanctity and importance.

While searching for edible roots and berries, women became aware of the usefulness of many plants. And soon they made attempts to cultivate them in closer proximity to their lodges.

Having cleaned a suitable spot women made with their primitive digging sticks the holes, into which they sunk the 18seeds, from which the plants were expected to develop. Experience, the mother of all wisdom, taught women that these plants needed constant attention. So the ground was kept free from weeds and properly watered. From time to time it was loosened with hoes, which in the beginning were made of bones, shells or stones, and later on of metal.

Such was the origin of our vegetable gardens, orchards, and grain fields. The continuous care, devoted to these plantations, greatly improved the quality of useful plants. Poor and tasteless varieties developed in time into those rich and palatable species, without which our present human race could scarcely exist for a single day. I need only name wheat, corn, barley, rye, peas, lentils, beans, rice, tapioca, potatoes, yams, turnips, bread-fruit, pears, apples, plums, cherries, bananas, dates, figs, nuts, oranges, coffee, cacao, tea, cotton and hemp, to convince the reader of the immense value of women's activity in agriculture.

As simple as were the tools for the cultivation of the soil, just as simple were the implements for the extraction of flour from the grain. Recent archæological research has disclosed the fact that many thousand years before Christ Egyptian women ground corn between two stones in just the same manner as the women of the Apache and Pueblo Indians and many other aboriginal tribes are doing to this day.

Other aboriginal women crushed the seeds in mortars of wood or stone. In several parts of Asia women succeeded in inventing hand-mills, which proved much more effective.

The necessity of storing provisions for the winter and hard times led to the invention of receptacles in which grain, nuts and dried berries might be kept and be safe from destruction by rain and animals. While pondering over the best methods of accomplishing this, women observed that certain insects and birds moulded their nests from wet clay, and that such nests, after hardening, were rain-proof. By this observation women became induced to use the same material for all kinds of nest-like vessels, in which provisions could be stored successfully. By accident such vessels came in contact with fire. Then it was found that by such baking the hardness of the vessels increased considerably. And so the preliminaries were discovered for the art of pottery, in which many aborigines became masters.

Similar observations led to the art of weaving. The nets, spread out everywhere by spiders for the capture of insects, gave women the first hint to make similar fabrics for

the capture of birds and fishes. The spider's thread was imitated by long hair and the fibres of certain plants. These were twisted together in a manner similar to that used by the weaver-birds in constructing their airy nests.

For many thousand years weaving was done exclusively by hand. But in time all kinds of apparatus were invented. And so weaving developed into an art that among many aboriginal tribes was improved to the highest degree. At the same time these female weavers created a genuine native art. So for instance the garters, belts, sashes and blankets of the Navajo and Pueblo Indians are, for their splendid quality as well as for their tasteful designs and colors, highly appreciated by all connoisseurs. The same is true in regard to the ponchos of the Mexicans and Peruvians, and the magnificent shawls and carpets, made by the women of Cashmere, Afghanistan, Persia and other countries of the Orient.

Figure 9. A Toltec Woman Spinning Cotton.

Basketry, including matting and bagging, belongs also to the primitive textile arts in which many native women excelled. By using choice materials, or by adding resinous substances, some aboriginal women are able to make baskets water-tight for holding or carrying water for cooking. From crude beginnings basketry developed into an industry,

which 20in many countries grew to great importance, as for instance in Morocco, where the markets are always supplied with large quantities of bags and baskets of beautiful design and workmanship.

Aboriginal women also attended to the dressing and tanning of skins of those animals which the men brought home from their hunting expeditions. In the domestic economy of many tribes skins were and are the most valued and useful property, especially in all regions having a severe climate. Every kind of skin, large enough to be stripped from the carcass of beast, bird or fish, is used here in some way.

A painting by George Catlin, the well-known artist, who during the first part of the last century travelled among the various Indian tribes of North America, illustrates the methods by which the skins of buffalo and deer are staked out upon the ground or between poles. We see the women engaged in scraping off the flesh and fat, a process which is followed by several others until the skin is fit to be used for tent covers, beddings, shields, saddles, lassoes, boats, clothes, mocassins, and thousands of other things.

Most skillful tanners and dressmakers are likewise the women of the Eskimo tribes. They make excellent suits from the skins and even the entrails of whales, walrus, seals and other animals.

To the keen sense of women we also owe undoubtedly most of our domestic implements. From the bones of fish and other animals they made needles and pins; from the horns splendid spoons and combs. Gourds, pumpkins and cocoanuts were turned into water bottles. Women also devised the comfortable hammocks. About the cribs, cradles and swings, invented in endless variety by aboriginal mothers for the protection and comfort of their darlings, volumes might be written. And by innumerable pictures and photographs it could be proven that the great care, bestowed nowadays upon our babies, is not the outcome of our advanced culture, but originated many thousand years ago among aboriginal women.

The same is true in regard to the dolls and play-things with which women seek to amuse those little ones, dearest to their hearts. What motherly affection, ever present and everlasting, has done for the welfare and progress of mankind, no one can conceive, nor describe, nor illustrate.

As brief as these remarks about aboriginal woman's activity are, they indicate, however, sufficiently her share in the founding and evolution of human culture. To appreciate this even more, we must not forget that the life of those women was one of constant care, misery and danger. The blissful happiness of aboriginal existence, of which we read sometimes in novels, written by poetical dreamers, was never enjoyed by these women. How full of hardships their share was in reality, we find by investigating their place in the social life of their tribes.

Figure 10. Woman of Northern Africa Tending To Her Baby.

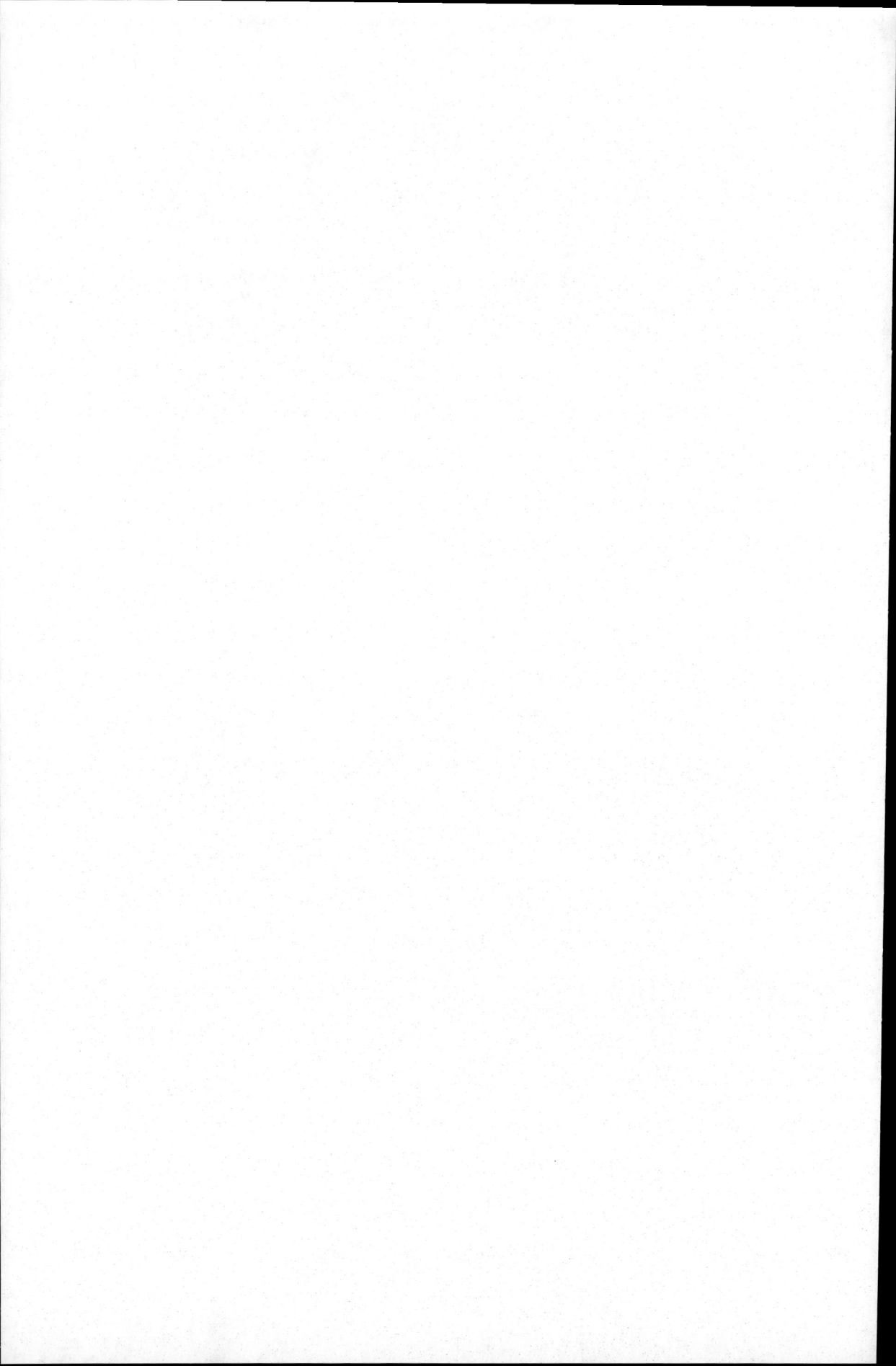

Chapter 3

WOMEN AS OBJECTS OF RAPE, BARTER AND RELIGIOUS SACRIFICE

Matrimony is, like all other human institutions, the result of evolution. In the dim past, after the ape-man had evolved to true man, it was not known at all. Most probably all the females were the common property of the males, the strongest of whom took hold of several women, leaving the rest to their inferior chums.

With the evolution of property rights these mates as well as their offspring came to be regarded as the absolute property of the husband and father, who could dispose of them at his pleasure by barter or otherwise. So it was among primitive men a hundred thousand years ago and so it is customary among aboriginal peoples to-day. At the death of the husband his rights generally go to the oldest son or to the person who becomes the head of the family.

Accordingly as girls are not masters of their own bodies, so the barter for women is customary among all aboriginal tribes. If a man sees a girl to his liking he bargains with the head of her family about the price. Among pastoral tribes it is generally paid in cattle; among hunters in skins or other objects of value.

Among the Zulu Kaffres the price for good-looking girls ranges from five to thirty cows. In Uganda it is three or four oxen; among the Samoyedes and Ostiaks of Siberia a number of reindeer; among the Sioux Indians two to twenty horses; among the Bedouins a number of camels; in Samoa pigs or canoes; among the Tatars sheep and several pounds of butter; among the Bongo twenty pounds of iron and twenty spear-heads; among other tribes a certain quantity of gold dust, beads, shells, and so on in endless variety. As soon as the price is paid the girl, without being asked her consent, is obliged to follow her new master.

As among aborigines women have no will of their own, they cannot object if their husbands exchange, trade or loan them to other men. So it is customary among many

tribes that if persons of importance come visiting, the daughters or the wives of the host are assigned to comfort them over night.

If among the inhabitants of the Fiji Islands men became tired of their "better halves," they killed and boiled them and arranged cannibal feasts in which all neighbors participated.

Aboriginal women also must gracefully assent to their husbands' taking several wives. Their number depends on the man's means. While poor men satisfy themselves with one wife, chiefs generally buy numbers. The despots of Dahomey in West Africa, for instance, filled their houses with hundreds of women, who were obliged not only to amuse these kings during their lifetime, but also to follow them in death. When such an autocrat was assembled to his ancestors, his body was deposited in a large cave. But in order that he should not travel alone through eternity, his wives as well as all the members of his court were led into the cave and provided with food for several days, whereupon the entrance of the cave was closed and the occupants were left to their fate.

If among the aborigines a man is too poor to buy a wife, he generally tries to steal one. But as he must not do so within his own clan, as he would trespass upon the property rights of his fellow-men, nothing remains but to kidnap a girl of some neighboring tribe. So he lurks around the villages till some day a girl, while gathering berries or edible roots, unfortunately happens to come too near his hiding place. In this case the manner of his proposal is sudden, but effective. A blow with his war club makes the damsel unconscious, whereupon he drags her to some secure place. Here he keeps her till she has recovered her senses and is able to follow him to his lodge.

George Gray, who has written about the natives of Australia, states that the life of young and attractive women among those tribes is a continuous chain of capture by different men, terrible wounds and long wanderings to unknown bands. In addition, such unfortunate females must suffer very often extremely bad treatment by other women, to whom they are brought as prisoners by their capturers.

But women have been kidnapped not merely for sexual reasons, but also for their ability to work. Herewith we open the darkest chapter in woman's history: Slavery, a word which has not lost its terrible meaning for women up to the present day.

Slavery has been practiced in all parts of the world in some form. But Africa was the continent where it prevailed from time immemorial to the greatest extent and assumed the most cruel forms. Phœnicians, Greeks, Romans, Arabs, Turks, Spaniards, Portuguese, Italians, Frenchmen, Dutchmen, Englishmen and Americans sailed to its coasts, to capture men as well as women and children, to sell and use them for slaves.

It is impossible for human imagination to conceive the horrors and misery, caused here by heartless pirates for thousands of years.

Figure 11. Carrying Off a Woman in Australia.

Imagine a peaceful village, approached stealthily in the night by cruel enemies, who surround it and then set fire to the huts. As the inhabitants rush out in terror, those who resist capture are killed, and those who have escaped the blessing of immediate death are fettered and marched off. Imagine long columns of such unfortunate and often severely wounded men, women and children chained together and driven by ruthless brutes through pathless jungles and arid deserts, to far away markets. No matter how hot the sun burns down, they must move on. Woe to those who break down! They are left where they have dropped, to perish of hunger and thirst, or to be torn by wild beasts. Or, as a warning

to the others, they are butchered in cold blood by their drivers. For those who reach their destination, where they are traded like cattle, an existence is waiting that will have fewer moments of joy than there are oases in an endless desert.

For time immemorial women also fell prey to religious superstition. To keep evil demons in good humor, or to thank some imaginary gods for victories and other blessings, human beings have been sacrificed by thousands. The "Dark Continent" again holds the record in this respect. And again the autocrats of Dahomey were those who, in religious frenzy, spilled the blood of hundreds and thousands of men as well as of women.

Figure 12. A Bride of the Nile. After a painting by W. Gentz.

From their country the so-called Vodoo-service, the worship of the "Great Snake," has been brought by slaves to the West Indies, where it was handed down from generation to generation. It still prevails in Hayti, "the black man's republic." Here it is, that the Vodoo priests and their devout followers meet in silent forests, to pay homage to their ugly god by sacrificing women as well as children.

Herodotus and other historians of classic times relate that every year in Egypt, when the Nile began to rise, to which that country owes its abundance, the priests persuaded a beautiful girl to become the bride of the river-god. Adorned with jewels and flowers, and greeted by all the people, this virgin was led to the flat roof of a temple overlooking the mighty river. After prayers and invocations had been made, she was tossed into the swirling floods, which swiftly carried her away.

Among the early Latin peoples similar sacrifices seem to have been customary, as is indicated by the fact that in Rome on the 15th of May in every year the Vestal virgins, in presence of all the priests, municipal authorities and the people threw twenty-four life-size dolls, the so-called Argeer, into the Tiber.

To calm the rage of the god of fire and earthquake, the priests of ancient Japan also hurled beautiful virgins into the flaming crater of Fuji Yama.

Humanity needed thousands of years to shake off such monstrous illusions and customs, because nothing is so difficult as to eliminate ideas and customs that are rooted in religious superstition, and, through being handed down from generation to generation, become surrounded with a halo of sacredness and solemnity.

To such institutions belonged also, what by some students of human culture has been characterized as "hierarchical or sacred prostitution." As is generally known, there exist among almost all aboriginal tribes crafty charlatans, who pretend to have influence over those supernatural powers, which are believed to be the distributors of all blessings as well as of all evils. These so-called sorcerers, healers, conjurors, magicians, medicine-men, or shamans, the predecessors of the priests, usurped among many tribes the privilege of deflouring all virgins before their entrance into marriage. With the gradual evolution of priesthood this practice was made a rite, which among various nations of antiquity developed into the most voluptuous orgies known in history.

PART II. WOMEN DURING THE AGES OF ANTIQUITY

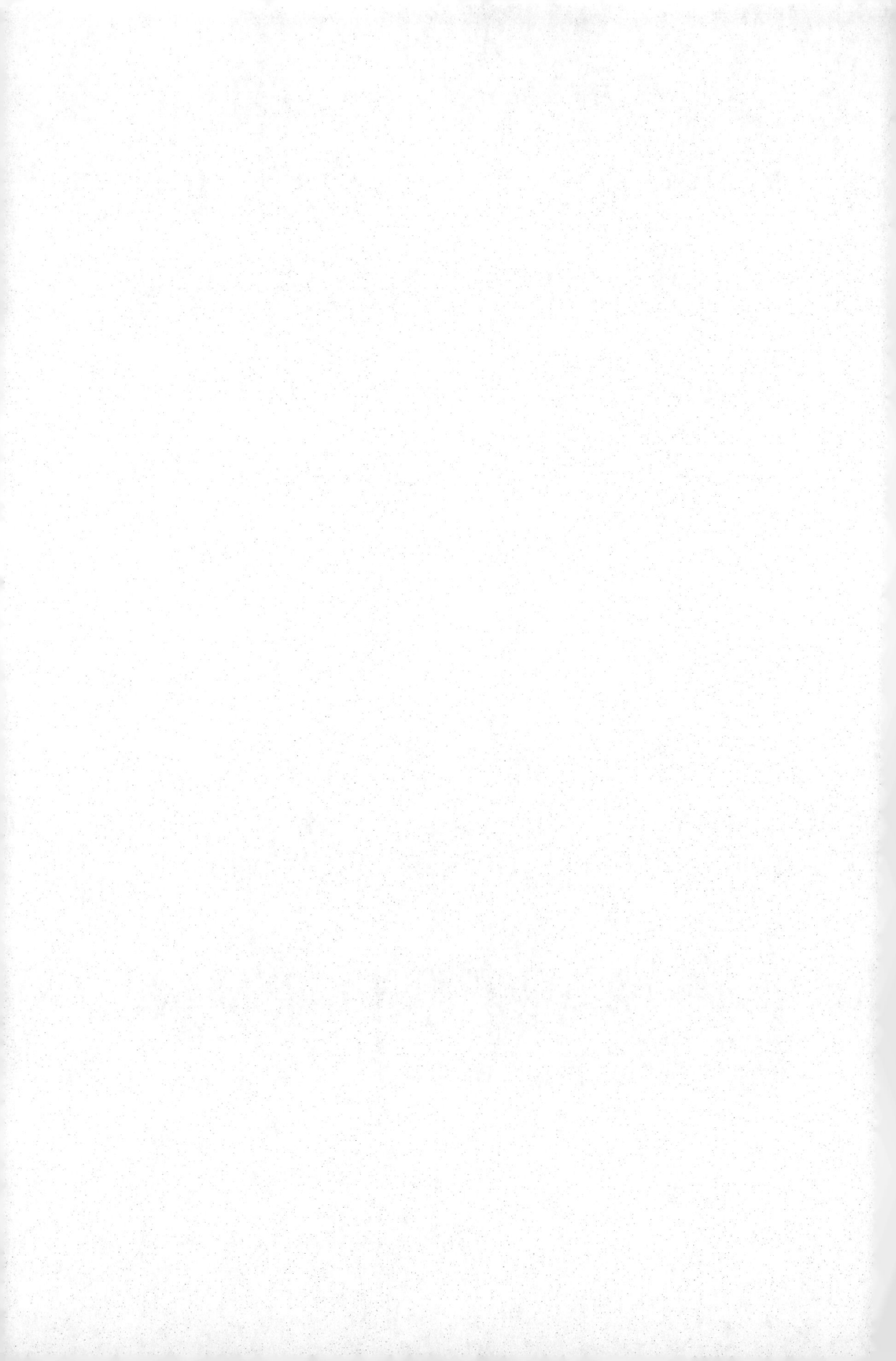

Chapter 4

WOMEN IN BABYLONIA

Figure 13. A Nobleman and His Wife in Babylon.

As the cultivated nations of Antiquity sprang from inferior tribes, it is only natural that in their social life many of the habits and customs of prehistorical times survived. Nowhere was this fact more evident than in the status of women. Everywhere we find a strange mixture of the rude conceptions of the dim past and promising prospects for a brighter future. In many places women were still regarded as inferior creatures, subjected

to the will of men and with no rights whatever over their own persons. We also note that polygamy, barter, rape, slavery and hierarchical prostitution still flourish in all kinds of forms and disguises. But at the same time we are surprised to see that among certain nations the members of the fair sex enjoy already the same respect and almost a similar amount of rights and liberty, as our women possess to-day.

Modern archæologists are inclined to recognize those formerly fertile lands between the Persian Gulf and Asia Minor, and watered by the Euphrates and Tigris Rivers, as the "Cradle of Civilization," or the place, where in misty ages, before history began, the so-called Sumerians, a Semitic people, first attempted to form themselves into organized communities. According to the traditions of the Hebrews here was the original home of the human race, the "Garden of Eden," and here was, as is told in Genesis XI, "that men said one to another: 'Go to, let us build a city and a tower whose top may reach unto heaven; and let us make us a name, lest we be scattered abroad upon the face of the whole earth.'"

This city was called Babylon, and the country *Babylonia*. Wonderful stories and legends are connected with these two names, but still more astounding are the revelations unearthed by the pick and shovel of modern explorers. By their diligent work it has been discovered that the people, living in this region somewhere about 4,000 to 6,000 years B. C. were already a highly organized and civilized race, skilled in various trades and professions, and living in towns of considerable size and importance. The inhabitants of these cities were by no means awkward in the fine arts. Most important of all, they had already evolved a very complete and highly developed system of writing, which in itself must have taken many centuries to reach the stage at which it was found by the explorers.

As may be read in the elaborate works of Maspero, Hilprecht and other explorers, they discovered in the ruins of the principal cities of Babylonia several ancient libraries and archives containing thousands of tablets of clay, stone and bronze, covered with inscriptions of religious, astrological and magical texts, epics, chronicles and syllabaries. There are also contracts; records of debts; leases of lands, houses and slaves; deeds of transfer of all kinds of property; mortgages; documents granting power of attorney; tablets dealing with bankruptcy and inheritance; in fact, almost every imaginable kind of deed or contract is found among them.

The most precious relic is the famous Code of Hammurabi, King of Babylonia. This collection of laws, engraved on stone 2,250 years B. C. and now preserved in the Louvre, is so elaborate and systematic that it can hardly have been the first one. Back of it there must have been a long period of usage and custom. But it is the first great collection of laws that has come down to us. In 282 sections it regulates almost every conceivable incident and relationship of life. Not only are the great crimes dealt with and penalized, but life is regulated down to its most minute details. There are laws on marriage, breach of promise, divorce, desertion, concubinage, rights of women, purchase-money of brides, guardianship of the widow and orphan, adoption of children, etc. Through these laws we

gain full information about the position of women in ancient Babylonia. Three classes of women are recognized: wives, concubines, and slaves. From other sources we know that all women of the higher class were cloistered in the harem and never appeared by the side of husbands or brothers in public. The harem system, at least for Western Asia and Europe, most probably originated in Babylonia.

The National Geographic Magazine of February, 1916, gives the text of a love letter, written several thousand years ago and sent by a young man to his sweetheart. It reads as follows:

"To Bibea, thus says Gimil Marduk: may the Gods Shamash and Marduk permit thee to live forever for my sake. I write to inquire concerning thy health. Tell me how thou art. I went to Babylon, but did not see thee. I was greatly disappointed. Tell me the reason for thy leaving, that I may be happy. Do come in the month Marchesvan. Keep well always for my sake."

In the same place we find the following example of a marriage contract:

"Nabu-nadin-akhi, son of Bel-akbe-iddin, grandson of Ardi-Nergal, spoke thus to Shum-ukina, son of Mushallimu: 'Give me thy Ina-Esagila-banat, the virgin, to wife to Uballitsu-Gula, my son.' Shum-ukina hearkened unto him and gave Ina-Esagila-banat, his virgin daughter, to Uballitsu-Gula, his son. One mina of silver, three female slaves, Latubashinnu, Inasilli-esabat and Taslimu, besides house furniture, with Ina-Esagila-banat, his daughter, as a marriage-portion he gave to Nabu-nadin-akhi. Nanâ-Gishirst, the slave of Shum-ukina, in lien of two-thirds of a mina of silver, her full price Shum-ukina gave to Nabu-Nadin-akhi out of the one mina of silver for her marriage-portion. One-third of a mina, the balance of the one mina, Shum-ukina will give Nabu-nadin-akhi, and her marriage-portion is paid. Each took a writing (or contract)."

This document, written on a tablet of clay, is signed by six witnesses and the scribe.

As Professor Clay explains "it has been the custom with most peoples in a large part of the ancient as well as the modern Orient to base a betrothal upon an agreement of the man or his parents to pay a sum of money to the girl's father." In Babylonia this "bride-money," together with the gift of the father and other gifts, formed the marriage-portion which was given to the bride. There were prudential reasons for this practice. It gave the woman protection against ill-treatment and infidelity on the part of the husband, as well as against divorce; for if she returned to her father's house she took with her the marriage portion unless she was the offending party. If she died childless, the marriage-portion was divided among them.

In case the girl's father rejected the suitor after the contract had been made, he was required to return double the amount of the bride price. The betrothals took place usually when the parties were young, and as a rule the engagements were made by the parents. A

marriage contract was necessary to make a marriage legal. In some cases peculiar conditions were made, such as the bride's being required to wait upon the mother-in-law, or even upon another wife. If it was stipulated that the man should not take a second wife, the woman could secure a divorce in case her husband broke the agreement.

Concubinage was indulged in, especially when the wife was childless and she had not given her husband a slave maid that he might have children. The law fully determined the status of the concubine and protected her rights.

At the husband's death the wife received her marriage-portion and what was deeded to her during the husband's life. If he had not given her a portion of the estate during his life, she received a son's share and was permitted to retain her home, but she could marry again. A widow with young children could only marry with the consent of the judge. An inventory of the former husband's property was made and it was intrusted to the couple for the dead party's children.

If a man divorced a woman, which he could do by saying to her "Thou art not my wife!" she received her marriage-portion and went back to her father's home. In case there was no dowry, she received one mina of silver, if the man belonged to the gentry; but only one-third of a mina if he was a commoner.

Figure 14. The Marriage Market at Babylon. After a painting by Edwin Long.

For infidelity the woman could divorce her husband and take the marriage-portion with her. In case of a woman's infidelity, the husband could degrade her as a slave; he even could have her drowned or put to death with the sword. In case of disease, the man could take a second wife, but was compelled to maintain his invalid wife in his home. If she preferred to return to her father's house, she could take the marriage-portion with her.

From several of these engraved tablets it appears, that a woman received the same pay for the same work when she took a man's place.

To Herodotus, the so-called "Father of History," we are indebted for some highly interesting notes about the "marriage market of ancient Babylon." Its site, uncovered in 1913 by the German Oriental Society, was in close neighborhood of the palaces of Nebuchadnezzar and Belshazzar and occupied a rectangle of 100 by 150 feet. Open to the air on all four sides, it was most probably shielded from the sun by rich awnings devised to shelter the daughters of Babylon and bring out their charms.

The marble block upon which they stood while being bid for was in the center of the spectators and richly carved with cherubs, who worshiped and protected the "Tree of Life." Several inscriptions leave no doubt, that this was the actual market of which Herodotus gave the following description:

"Once a year the maidens of age to marry in Babylon were collected at the market, while the men stood around them in a circle. Then a herald called up the damsels one by one and offered them for sale. He began with the most beautiful. When she was sold for no small sum he offered for sale the one who came next to her in beauty. All of them were to be sold as wives. The richest of the Babylonians who wished to wed bid against each other for the loveliest maidens, while the humbler wife seekers, who were indifferent about beauty, took the more homely damsels with marriage-portions. For the custom was that when the herald had gone through the whole number of the fair ones he should then call up the ugliest—a cripple if there chanced to be one—and offer her to the men, asking who would agree to take her with the smallest marriage-portion. And the man who offered to take the smallest sum had her assigned to him. The marriage-portions were furnished by the money paid for the beautiful girls, and thus the fairer maidens portioned out the uglier. No one was allowed to give his daughter to the man of his choice, nor might any one carry away the damsel he had purchased without finding bail really and truly to make her his wife. If, however, it was found that they did not agree the money might be paid back. All who liked might come, even from distant villages, and bid for the women."

Herodotus as well as the Roman Curtius Rufus have written also about the so-called "hierarchical or sacred prostitution," as it was connected with the service of Mylitta or Belit, the Babylonian goddess of the producing agencies.[1] Her temple was surrounded by

[1] About this subject Rev. T. M. Lindsay, Professor of Divinity and Church History, Free Church College, Glasgow, writes in the Encyclopædia Britannica in an essay about Christianity: "All paganism is at bottom a worship of Nature in some form or other, and in all pagan religions the deepest and most awe-inspiring attribute of nature was its power of reproduction. The mystery of birth and becoming was the deepest mystery of Nature; it lay at the root of all thoughtful paganism and appeared in various forms, some of a more innocent, others of a most debasing type. To ancient pagan thinkers, as well as to modern men of science the key to the hidden secret of the origin and preservation of the universe lay in the mystery of sex. Two energies or agents, one an active and generative, the other a feminine, passive, or susceptible one, were everywhere thought to combine for creative purpose, and heaven and earth, sun and moon, day and night, were believed to co-operate to the production of being. Upon some such basis as this rested almost all the polytheistic worship of the old civilization, and to it

a grove, which, like the temple, became the scene of most voluptuous orgies, about which Jeremiah too has given indications in his letter directed to Baruch. (Baruch VI. 42, 43.)

According to these statements every woman was compelled to visit the temple of Mylitta at least once during her life and give herself over to any stranger, who would throw some money on her lap and with the words: "I appeal to Mylitta!" indicate his desire to possess her. Such an appeal could not be rejected, no matter how small the sum was, as this money was to be offered on the altar of the goddess and thus became sacred.

may be traced back, stage by stage, the separation of divinity into male and female gods, the deification of distinct powers of nature, and the idealization of man's own faculties, desires, and lusts, where every power of his understanding was embodied as an object of adoration, and every impulse of his will became an incarnation of deity. But in each and every form of polytheism we find the slime-track of the deification of sex; there is not a single one of the ancient religions which has not consecrated by some ceremonial rite even the grossest forms of sensual indulgence, while many of them actually elevated prostitution into a solemn service of religion."

Chapter 5

WOMAN'S STATUS AMONG THE HEBREWS

Figure 15. Hebrew Women during the Time of Antiquity.

The early *Hebrews* or *Israelites*, being of the same Semitic stock as the Babylonians, but preferring a pastoral life, observed similar habits in their relations to women. Matrimony to them was not a necessity based on mutual love and respect, but a divine order, binding especially the man. While it was his obligation to maintain the human race, especially the Jewish stock, woman was merely the medium to reach this end by her beauty and charm and by giving birth to children.

For the conclusion of a marriage the mutual consent of the two contrahents was necessary. But generally the marriage was arranged by the fathers or some other relations, who likewise settled the question as to how much would be the dowry of the son as well as of the daughter. That sometimes even a faithful servant was charged with the negotiation of these delicate questions, is told in Genesis XXIV, where it is said that Abraham, in order to secure for his son Isaac a wife of his kindred, commissioned his eldest servant to make a journey to his former home in Mesopotamia. While resting at a well, he met Rebekah, the beautiful daughter of Bethuel, a son of Nahor, Abraham's brother. When Rebekah consented to become Isaac's wife, Abraham's servant brought forth many jewels of silver and gold and raiment, and gave them to Rebekah. Having given also to her brother and to her mother many precious things, he started for the return journey, taking Rebekah and her maid servants with him.

The story of Jacob and Rachel, as told in Genesis XXIX, proves, that among the early Hebrews the barter for women was customary, but that the wooer might obtain the girl of his longing likewise by serving her father for a certain length of time. As the early Hebrew had an aversion to mingling with the inhabitants of Canaan, Isaac, Jacob's father, sent him to Mesopotamia, the former habitat of the Hebrews, to select a wife among the daughters of Laban, his mother's brother.

Meeting Rachel, Laban's youngest daughter, he became so deeply impressed by her charm, and so eager to gain her, that he offered Laban to serve him for Rachel for seven years. Having fulfilled his contract, Jacob was, however, beguiled by Laban, who at the wedding-night substituted his eldest daughter Leah for Rachel. When in the morning Jacob became aware of the deception, Laban claimed that it was not customary, in his country, to give away a younger daughter before the firstborn. And so he succeeded in persuading Jacob to serve him for Rachel another term of seven years.

While monogamy was the rule among the Hebrews, polygamy was permitted, especially if the first wife was barren. As this was the case with Sarah, the wife of Abraham, she gave her husband Hagar, an Egyptian maid-servant, with whom Abraham begat a son, Ishmael. Of Leah and Rachel, the two wives of Jacob, we may read in Genesis XXX, that they, not having born children to Jacob, likewise introduced to him their maids Bilhah and Zilpah, each of which bore Jacob two sons.—It is certain that some of the patriarchs had a great number of wives, and that not all of these held the same rank, some being inferior to the principal wife. The right of concubinage was practically unlimited. Abraham kept a number of concubines, as appears in Genesis

XXV, 6, where it is said that he, when dividing his property, gave gifts to the sons of his concubines. Of Solomon the first book of Kings XI, 3, states, that he had 700 wives and 300 concubines.

In the Mosaic law concubinage and divorce was a privilege of the husband only. A wife accused of adultery was compelled to undergo the horrible ordeal of the bitter water, as described in Numbers V. If found guilty, she might be stoned to death.

To continue the male issue of the family was the paramount mission of the wife. That the birth of a male baby was regarded as an event of far greater importance than that of a female, appears from Leviticus XII, where it is said, that a woman, giving birth to a son, was regarded unclean for only seven days and must not touch hallowed things nor come into the sanctuary for a period of thirty-three days. But if unfortunately she became the mother of a girl, she was considered unclean for fourteen days and had to abstain from religious service for sixty-six days. Only after she had made atonement for the sin of motherhood by offering a lamb or a pair of pigeons, was she forgiven.

The prejudice against woman is also confirmed by the fact, that, according to Exodus XXIII, 17, all male Jews were required to appear before the Lord three times in the year, and that they had to repair to Jerusalem once a year, with all their belongings. But the women were not privileged to accompany their husbands.

Figure 16. Hindoo Women from Cashmere.

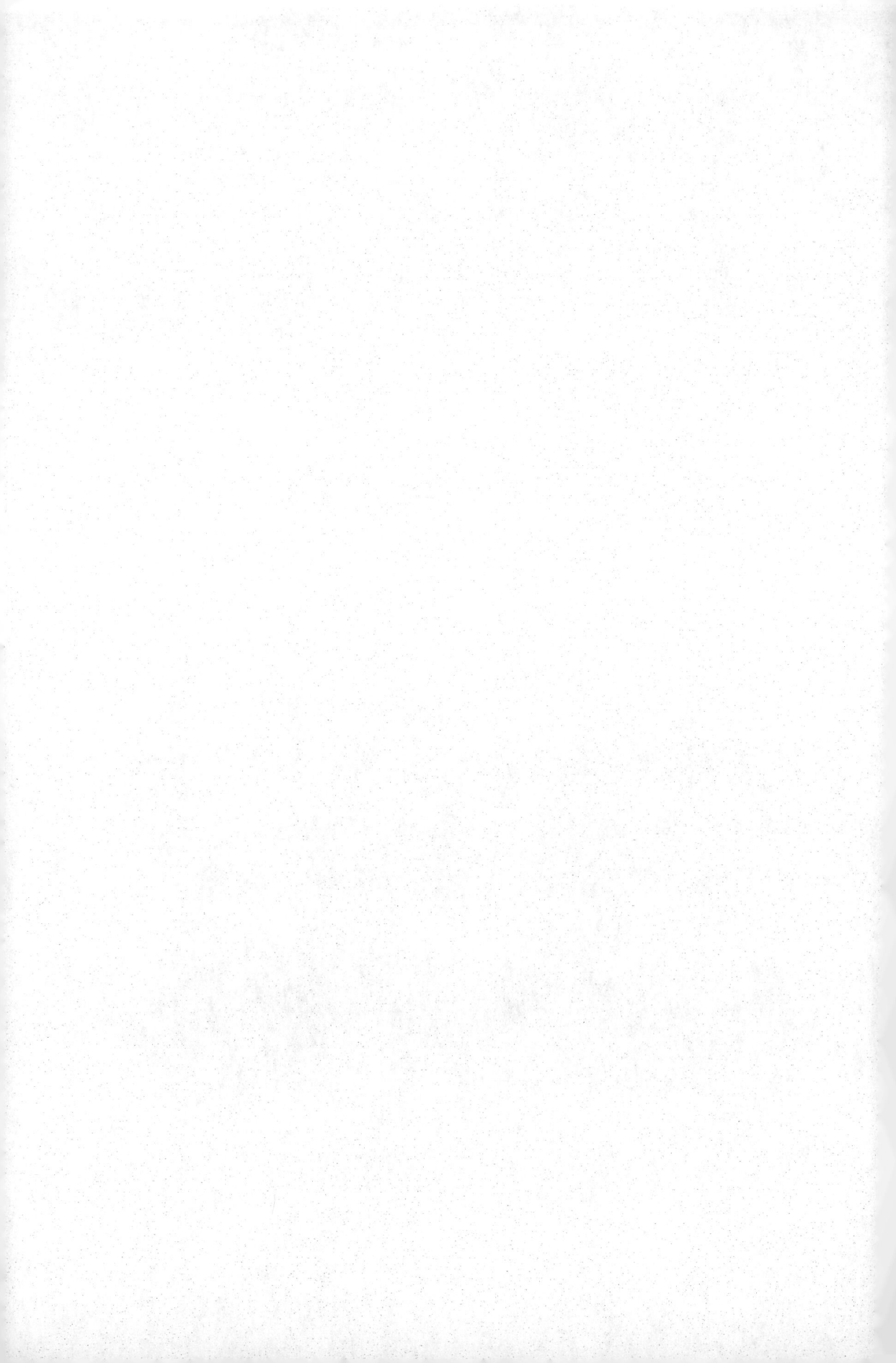

WOMAN'S STATUS AMONG THE PARSEE AND HINDOO

To investigate woman's position among the other ancient nations of Asia is also of interest.

The Parsee or Parsis, belonging to the great Aryan or Indo-Germanic race, occupied two thousand years before Christ that part of Central Asia known at present as Iran or Persia. Whether this country was the original home of that race, is unknown. Some modern scientists are inclined to seek it in more northern parts of Asia or even of Europe, as the sacred songs of the Parsee contain indications, that the Aryans originally came from countries with a temperate or frigid zone. When for instance the Vedic singers in hot India prayed for long life, they asked for "a hundred winters."

In their treatment of women these Aryans or Parsee have been much more noble than any other Asiatic race. They believed in marriage for higher purposes than the mere begetting of children. The principal incentive to conclude a marriage was the desire to contribute to the great renovation hereafter, which, according to the sacred book of the Parsee, the Zend-Avesta, is promised to humanity. This renovation cannot be carried out in the individual self, but must be gradually worked out through a continuous line of sons, grandsons, and great-grandsons. The motive of marriage was therefore sacred. It was a religious purpose they had in view, when the male and female individuals contributed by marital union their assistance, first, in the propagation of the human race; second, in spreading the Zoroastrian faith; and third, in giving stability to the religious kingdom of God by contributing to the victory of the good cause, which victory will be complete about the time of resurrection. The objects of the marriage bond were, therefore, purely religious, tending to the success of light, piety or virtue in this world. For this reason the Avesta declares that married men are far above those who remain single; that those who have a settled home are far above those who have none; and that

those who have children are of far greater value to humanity than those who have no offspring.

While daughters were believed to be less useful than sons for the continuation of the father's race, they were, however, not disliked, but also objects of love and tenderness. Marriages were not the result of any barter or capture, but of pure selection on the part of the two individuals. If they were still of minor age, the marriage was subject to the confirmation of the parents or guardians.

Infanticide was strictly prohibited. There were also laws against the destruction of the fruit of adultery. Such illegitimate offspring had to be fed and brought up at the expense of the male sinner until they became seven years of age.

Like the valleys of the Euphrates and Tigris rivers, and like the highlands of Central Asia, or Ariyana, so the mountains, plains and forests of India were inhabited long before the dawn of history by masses of men of various races and split into many hundreds of tribes. Of these races descendants exist in almost the same conditions as their ancestors did many thousand years ago. In Southern India the Kader are still living in primitive tree-huts. Assam and Bhutan are regions abounding with villages which are the exact counterparts of the prehistorical lake-dwellings of Switzerland.

These vast regions of India were at some unknown time invaded by tribes of Aryan or Indo-Germanic race. While among the aborigines of India women were subjected to all the hardships and bad treatment of primeval times, the women of the Aryans enjoyed, as stated above, a far higher position. Like their husbands they were the "rulers of the house," had the entire management of household affairs, and were allowed to appear freely in public. Husband and wife also drew near to the gods together in prayer. That the education of the females was not neglected is proven by the fact, that some of the most beautiful Vedas or national hymns and lyric poems were composed by ladies and queens.—

With the decline of the Aryan race and culture in India, caused most probably by the hot, enervating climate of the country, the position of women also underwent a change for the worse. Especially the growing despotism of the Brahmanic priests gradually robbed women of all their former rights and liberty. In time they became completely subject to the authority of man. Mothers owed obedience to their own sons, and daughters were absolutely dependent upon the will of their fathers. The system of conventional precepts, known as "Manu's Code of Laws," clearly defined the relative position and the duties of the several castes and sexes, and determined the penalties to be inflicted on any transgressors of the limits assigned to each of them. But these laws are conceived with no human or sentimental scruples on the part of their authors. On the contrary, the offenses, committed by Brahmans against other castes, are treated with remarkable clemency, whilst the punishments inflicted for trespasses on the rights of the Brahmans and higher classes are the more severe and inhuman the lower the offender stands in the social scale.

Against the female sex Manu's laws are full of hostile expressions: "Women are able to lead astray in this world, not only the fools, but even learned men, and to make them slaves of lust and anger."—

"The cause of all dishonor is woman; the cause of hostility is woman; the cause of our worldly existence is woman; therefore we must turn away from woman."—"Girls and wives must never do anything of their own will, not even in their own homes."— "Women are by their nature inclined to seduce men; therefore no man shall sit even with his own relative in lonely places."—"The wife must be devoted to her husband during her whole life as well as after his death. Even if he is not without blame, even if he is unfaithful and without a good character, she must nevertheless respect him like a god. She must do nothing that might displease him, neither during his life nor after his death."—"Day and night must women be held in a state of dependence."—

As the subjection of women was made a cardinal principle of the Brahman priests, they did not shrink from misinterpreting the text of the Vedas accordingly. So the sentence: "You wife, ascend into the realm of life! Come to us! Do your duty toward your husband!" was explained to mean that a widow must not marry again but ought to follow her husband also in death. This led to the voluntary burning of the widows with the corpse of the husband, a practice which assumed great dimensions and was observed till the middle of the 19th Century. Mrs. Postans, an English lady, who during the first part of the last century resided many years in Cutch, one of the northern provinces of India, gave the following account of such a ceremony: "News of the widow's intentions having spread, a great concourse of people of both sexes, the women clad in their gala costumes, assembled round the pyre. In a short time after their arrival the fated victim appeared, accompanied by the Brahmins, her relatives, and the body of the deceased. The spectators showered chaplets of mogree on her head, and greeted her appearance with laudatory exclamations at her constancy and virtue. The women especially pressed forward to touch her garments—an act which is considered meritorious, and highly desirable for absolution and protection from the "evil eye.""

"The widow was a remarkably handsome woman, apparently about thirty, and most superbly attired. Her manner was marked by great apathy to all around her, and by a complete indifference to the preparations which for the first time met her eye. Physical pangs evidently excited no fears in her; her singular creed, the customs of her country, and her sense of confused duty excluded from her mind the natural emotions of personal dread, and never did martyr to a true cause go to the stake with more constancy and firmness, than did this delicate and gentle woman prepare to become the victim of a deliberate sacrifice to the demoniacal tenets of her heathen creed."

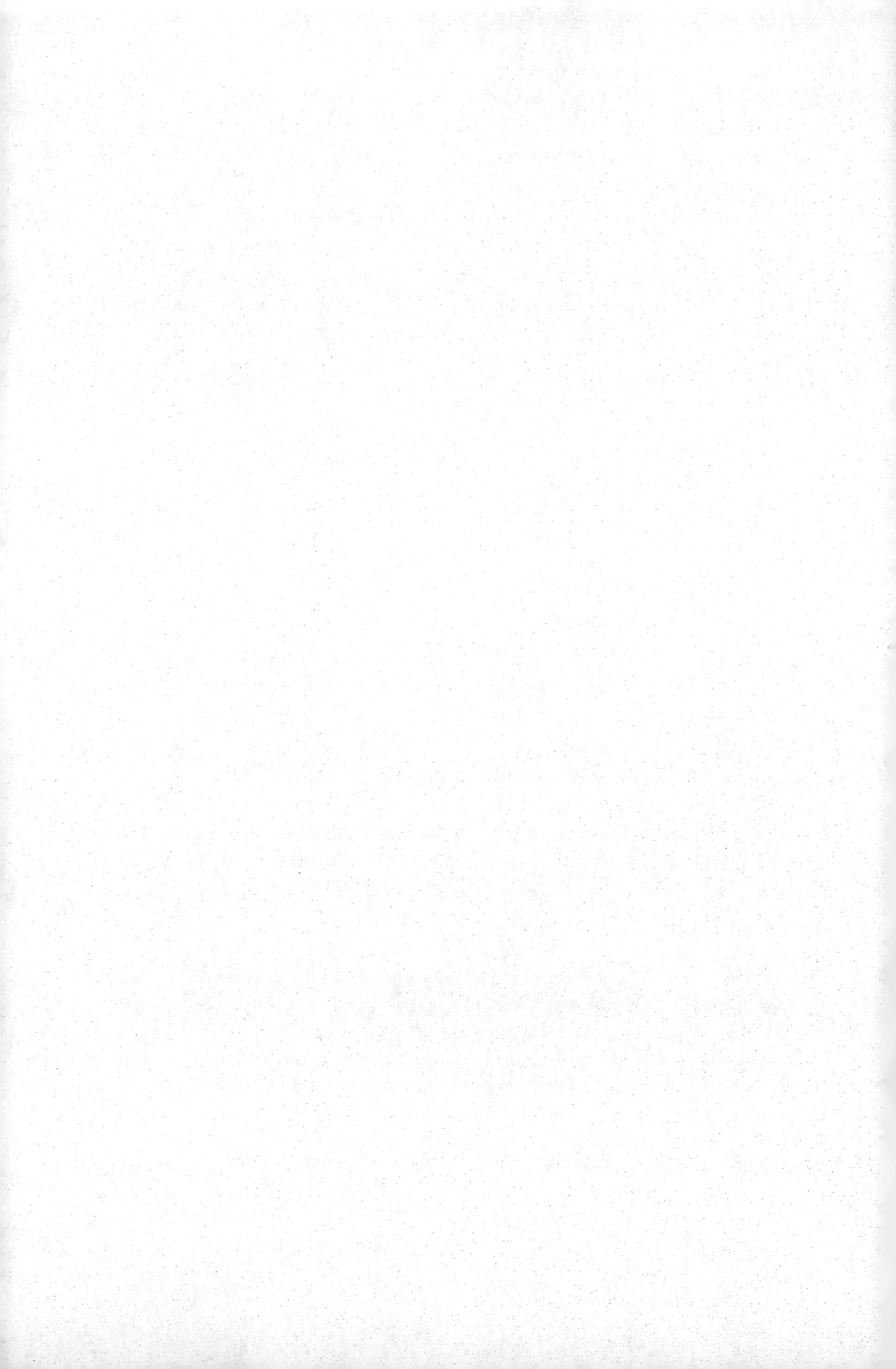

WOMAN IN CHINA AND JAPAN

Figure 17. A Ladies' Parlor in China.

While the fate of women in India was shaped by Manu's Code of Laws, in *China* it was decided by the orders of Confucius, the famous sage, born in the year 550 B. C. and in popular histories of his life praised in the lines:

"Confucius! Confucius! How great was Confucius!
Before him there was no Confucius,
Since him there has been no other.
Confucius! Confucius! How great was Confucius!"

In the rules, which this savant gave to his followers, he demanded full subordination of woman to man; also, that the two sexes should have nothing in common and live separated in two different parts of the house. The husband must not mingle in the internal affairs of the home, while the wife must not concern herself in any outside matter. Also women should have no right to make decisions but in everything be guided by the orders of their husbands.

Women have likewise no proper position before the law and cannot be witnesses in any court. The father may sell his daughter, and the husband may sell his wife. Concubines are permitted and often are housed under the same roof with the wife. Daughters are not welcomed, but treated with contempt.

To get rid of a superabundance of infant girls which were regarded as a burden and as unwelcome eaters, the Chinese in former times resorted to exposure and infanticide to such an appalling extent that these cruelties became a national calamity and disgrace. Generally the female babies were drowned. In the provinces of Fukian and Kiangsi infanticide was so common, that, according to Douglas, at public canals stones could be seen bearing the inscription: "Infants must not be drowned here!"—

To lessen these abuses one of the emperors of the Sung-dynasty decreed that all persons, willing to adopt exposed children, should be compensated by the government. But this well-meant decree brought evil results, as many people, who adopted such foundlings, raised them for the purpose of making them their own concubines, or to sell them to the keepers of brothels, of which every Chinese city had an abundance. Placed in these brothels when six or seven years old, the unfortunate girls were compelled to serve the older inmates for several years. Later on they assisted in entertaining visitors with song and music. But having reached the age of twelve or thirteen, they were regarded as sufficiently developed to bring profit in the lines of their actual designation.

The final fate of such unfortunate beings was in most cases miserable beyond description. Having been exploited to the utmost by their heartless owners, they were, when withered and no longer desirable, thrown into the streets, to perish in some filthy corner.

Figure 18. An Entertainment among the Geishas of Japan.

Women of the lower classes too had a hard life. In addition to such unfavorable conditions there existed among the aristocrats a strict adherence to ancient manners and customs. Accordingly the life of the whole nation became rigid and ossified. Foreigners, who came in close contact with Chinese aristocrats, speak of their women with greater pity than of the females of the poor, describing them as dull and boring creatures, with no higher interests than dress and gossip.

As in Japan the rules of Confucius were likewise in force, the position of woman in "the Land of the Rising Sun" likewise was an inferior one. Obedience was her lifelong duty. As a girl she owed obedience to her father, as a wife to her husband, and as a widow to her oldest son. And in the "Onna Deigaku," the classic manual for the education of women, she was advised to be constantly aware of the bar between the two sexes.

Chapter 8

WOMAN AMONG THE EGYPTIANS

Figure 19. An Egyptian Queen and Her Attendants.

Of the many nations that occupy the shores of the Mediterranean Sea, the *Egyptians* are the oldest. To them one of the foremost scholars, George Ebers, paid the following compliment:

> "If it is true that the culture of a nation may be judged by the more or less favorable position, held by its women, then the culture of ancient Egypt surpassed that of all other nations of Antiquity."

Indeed, when we study the innumerable inscriptions, paintings and sculptures of Egyptian tombs, and investigate the many well preserved papyrus rolls, we find this praise fully justified. Not only did the Egyptians generally confine themselves to one wife, but they also extended to her more and greater privileges, than she had in any other country. Woman was honored as the source of life, as the mother of all being. Therefore contracts, carefully set up, protected her in her rights and secured her the title Neb-t-em pa, "the mistress of the house." As such she had, if the authority of Diodorus can be credited, absolute control over all domestic affairs and no objection was made to her commands whatsoever they might be. It is also significant, that where biographical notes appear, on tombs, statues and sarcophagi, the name of the deceased mother is frequently given, while the name of the father is not mentioned. So it reads for instance: "Ani, born by Ptah-sit," "Seti, brought to life by Ata." The spirit of true affection and real family life likewise found expression in many poetical names given by sorrowful widowers to their departed wives. There is an inscription, in which a husband praises his lost mate as "the palm of loveliness and charm"; another one extols his spouse as "a faithful lady of the house, who was devoted to her husband in true fondness."

That the highly developed, culture of the Egyptians was based on strong ethical principles, also appears from the text of the so-called "Papyrus Prisse," perhaps the oldest book of morals ever written. Its author, Prince Ptah-hotep, who lived about 3350 B. C., gives hints and advice in regard to social intercourse and manners, to be observed among people of refinement. Hear what he says about the treatment of women:

> "If you are wise, you will take proper care of your house and love your wife in all honor. Nourish, clothe and adorn her, as this is the joy of her limbs. Provide her with pleasing odors; make her glad and happy as long as you live, because she is a gift that shall be worthy of its owner. Don't be a tyrant. By friendly conduct you will attain much more than by rough force. Then her breath will be merry and her eyes bright. Gladly she will live in your house and will work in it with affection and to her heart's content."

Children were regarded as the gifts of the gods, and brought up in good manners and obedience.

In company with their husbands Egyptian women took part in all kinds of social and public festivals. At social affairs the master and mistress of the house presided, sitting

close together, while the guests, men and women, frequently mingled, strangers as well as members of the same family. Agreeable conversation was considered the principal charm of polite society, and according to Herodotus it was customary at such gatherings, to bring into the hall a wooden image of Osiris, the Lord of Life and Death, to remind the guests not only of the transitoriness of all earthly things and human pleasures, but also of the duty, to meet all others during the short span of this earthly life with kindness and love.

Figure 20. A Ladies' Party in Ancient Egypt.

That ladies' parties are not an innovation of our times but date back thousands of years before Christ, we learn from many finely executed carvings and frescoes which represent feasts. In long rows we see the fair ones sitting together, in finest attire, with hair carefully dressed and adorned with lotus flowers. Waited upon by handmaids and female slaves, they chat and enjoy the delicious sweets, cakes and fruits, with which the tables are loaded. As the hours passed, fresh bouquets were brought to them, and the guests are shown in the act of burying their noses in the delicate petals, with an air of luxury which even the conventionalities of the draughtsman cannot hide. Wine was also partaken of, and that the ladies were not restricted in its use, is evident from the fact, that the painters have sometimes sacrificed their gallantry to a love of caricature. "We see some ladies call the servants to support them as they sit; others with difficulty prevent themselves from falling on those behind them; a basin is brought too late by a reluctant

servant, and the faded flower, which is ready to drop from heated hands, is intended to be characteristic of their own sensations."[1]

In Egypt women were permitted to practice as physicians. They were likewise admitted into the service of the temple. In most solemn processions they advanced towards the altar with the priests, bearing the sacred sistrum, an instrument emitting jingling sounds when shaken by the dancer. Queens and princesses frequently accompanied the monarchs while they offered their prayers and sacrifices to the deity, holding one or two ceremonial instruments in their hands.

The constitution of Egypt also provided that, when at the death of a king no male successor was at hand, the royal authority and supreme direction of affairs might be entrusted without reserve to one of the princesses, who in such case ascended the throne. History records several Egyptian queens, among them Cleopatra VI, who became famous through her relations to Cæsar and Anthony.

[1] Wilkinson, Manners and Customs of the Ancient Egyptians, Vol. II, p. 166.

Chapter 9

WOMAN AMONG THE GREEKS

Figure 21. In The Time of Sappho and Aspasia.

The great regard extended to women by the Egyptians could not fail to influence to some extent those nations, with whom they came in contact, especially the *Greeks* and the *Romans*.

Ancient Greece, or to be more correct, Hellas, was occupied by the *Hellenes,* belonging to the Aryan or Indo-Germanic race, who had immigrated from Central Asia in prehistoric times. A pastoral rather than an agricultural people, they were divided into several branches, of which the Dorians, Ionians, Aeolians, and Pelasgians were the most prominent.

51No people has ever recognized the charm of women with greater enthusiasm than the Greeks. To them the fair sex was the embodiment of cheerful life, of the joy of being. To this conception we owe many of the most excellent works of art, among them several unsurpassed statues of Venus, the goddess of beauty and love.

In the treatment of their women the various branches of the Hellenes were not alike. But all took deep interest in the harmonious development of the body, of beauty and art. Gymnastic games and prize-fights were the favorite entertainments, especially among the Dorians, one branch of whom, the Spartans, became famous for their strict methods in rearing and educating boys as well as girls.

To secure to the state a race of strong and healthy citizens, the Spartans allowed no sickly infant to live, and girls were required to take part in all gymnastic exercises of the young men. Women were even admitted to co-operate in all public affairs. As great attention was given also to their education, the women of Sparta gained in time such great influence over their men, that the other Hellenes jokingly spoke of "Sparta's female government," a remark, which was promptly answered with the reply, that the women of Sparta were also the only ones, who gave birth to real men.

That the Hellenic women were treated with great dignity during the so-called "heroic age," and that they enjoyed far greater liberty than in later periods, is evident from the poems of Homer. In the Iliad Achilles says: "Every true and sensible man will treat his wife respectfully and take proper care of her." And in another place Homer declares that "besides beauty good judgment, intellect and skill in all female works are the merits, by which a wife will become a respected consort to her husband."

In the "Odyssey" Homer gives in Penelope a very attractive example of female faithfulness and dignity. He also makes Odysseus say to Nausikaa: "There is nothing so elevating and beautiful, as when husband and wife live in harmony in their home, to the annoyance of their adversaries, to the rejoicing of their friends, and to their own honor!"

Among the many deities, worshiped by the Greeks, one of the most attractive figures was Hestia, the goddess of the home or hearth fire. As explained in a former chapter, the constant fire, kept by aboriginal bands in the centre of their villages, became in time a sacred symbol of home and family life, and by degrees grew into a religious cult of great sanctity and importance. As women in ancient Hellas too were the guardians of this tribal fire, so its deity was believed to be a goddess, Hestia, whose name means "home—or hearth-fire." As the tribal fire was always kept burning so the fire in the Pytaneion, the temples of Hestia, was to remain alive. If by any mischance it became extinguished, only sacred fire made by friction, or got directly from the Sun, might be used to rekindle it.

The Pytaneion was always in the center of the villages and cities. Around its fire the magistrates met, and received foreign guests. From this fire, representing the life of the city, was taken the fire wherewith that on the hearth of new colonies was kindled.

In later times, however, the high conceptions the Greeks had of womanhood underwent considerable change, and the close intimacy between husband and wife, which had hitherto distinguished married life, vanished. When with the extension of navigation and commerce the Greeks came into closer touch with the luxurious life of Asiatic nations, they adopted many of their manners and thoughts. Suspicion and jealousy, conspicuous traits in the character of southern races, now made themselves felt. Besides misogynists like Hipponax, Antiphanes, Eubulos and others began to poison the minds of the people with degrading, insulting remarks about women and matrimony. As did for instance Hipponax by saying: "There are only two pleasant days in married life, the first, when you take your bride in your home, and the second, when you bury her."—

And Eubulos is responsible for the sentence: "Deuce may take him, who marries a second time! I shall not scold him, that he took his first wife, as he did not know what was in store for him. But later on he knows that this evil is woman."—

Euripides is responsible for the most degrading comment. He wrote the following lines:

"Dire is the violence of ocean waves,
And dire the blast of rivers and hot fires,
And dire is want, and dire are countless things,
But nothing is so dire and dread as woman.
No painting could express her dreadfulness,
No words describe it. If a god made woman
And fashioned her, he was for man the artist
Of woes unnumbered, and his deadly foe!"

The undermining effect of such remarks was increased by numerous comedies in which married life was turned to ridicule, and husbands were depicted as despicable slaves to women. So bye and bye the high position, formerly held by the female sex, sank to a much lower level. Their liberty was greatly curtailed, and daughters as well as wifes were confined to the strict seclusion of the "Gynäkonitis" or women's quarters at the back of the house. Here they spent their time 53with spinning, weaving, sewing and other female work, not seeing or hearing much of the outside world. For this reason they were often nicknamed "the locked up," or "those reared in the shadow." As they rarely got out into the fresh air, they relied greatly on rouge and cosmetics, to hide their faded complexion. The only interruption in this monotonous life were the festivals of the various deities, during which they joined the solemn processions and carried the ceremonial implements and vessels on their heads.

As the education of the girls was greatly neglected, and as they generally married very early, they had no influence whatever on the male members of the family. They even didn't appear at table with men, even with their husbands' guests in their own homes. But the principal cause for the decline of woman's, position and of family life in Hellas was the rise and growing prevalence of the "heteræ" or courtesans, many of whom became famous for their fascinating beauty and accomplishments. Clever in graceful dances, well educated in song, music and in the art of entertaining, these women, many of whom were natives of foreign countries, in time became constant guests of the symposiums of prominent citizens. Far outshining the housewives and their daughters in gracefulness and wit, they soon won a domineering influence over the all too susceptible men, many of whom became lost to their own neglected families.

The most striking illustration of this is offered by the life of the famous Athenian statesman Pericles, who fell victim to the charms of Aspasia, a courtesan born in Miletus, Asia Minor. Her extraordinary beauty and still more remarkable mental gifts had gained her a wide reputation, which increased after her association with Pericles. Having divorced his wife, with whom he had been unhappy, Pericles attached himself to Aspasia as closely as was possible under the Athenian law, according to which marriage with a "barbarian" or foreigner was illegal and impossible. And after the death of his two sons by his lawful wife he secured the passage of a law, by which the children of irregular marriages might be rendered legitimate. His son by Aspasia was thus allowed to assume his father's name.

Aspasia enjoyed a high reputation as a teacher of rhetoric. It is said that she instructed Pericles in this art, and that even Socrates admitted to have learned very much from her. The house of Aspasia became the center of the most brilliant intellectual society. Men who were in the advance guard of Hellenic thought, Socrates and his friends included, gathered here.

Another noted courtesan was Phryne, who by her radiant beauty acquired so much wealth that she could offer to rebuild the walls of Thebes, which had been destroyed by Alexander (335 B. C.), on condition that the restored walls bear the inscription, "Destroyed by Alexander, restored by Phryne, the hetære." When the festival of Poseidon was held at Eleusis, she laid aside her garments, let down her hair and stepped into the sea in the sight of the people, thus suggesting to Apelles his great painting of "Aphrodite rising from the sea." The famous sculptor Praxiteles too used her as a model for his statue "the Cnidian Aphrodite," which Pliny declared to be the most beautiful statue in the world.

Figure 22. A Dancing Lesson in the Temple Of Dionysos. After a painting by H. Schneider.

Anteia, Isostasion, Korinna, Phonion, Klepsydra, Thalatta, Danae, Mania, Nicarete, Herpyllis, Lamia, Lasthenia, Theis, Bachis and Theodota are the names of other courtesans, who became widely known for their relations with prominent men of Hellas and acquired enormous wealth.

Sappho, the famous poetess, whom Plato dignified with the epithets of "the tenth Muse," "the flower of the Graces," and "a miracle," most probably belonged likewise to this class. It is said that she established in Mytilene a literary association of women of tastes and pursuits similar to her own, and that these women devoted themselves to every species of refined and elegant pleasure, sensual and intellectual. Music and poetry, and the art of love, were taught by Sappho and her older companions to the younger members of the sisterhood.

Hierarchical prostitution prevailed in Hellas. It was connected with the service of Aphrodite, the Greek counterpart of the Babylonian Mylitta. Strabo states, that in her temple of Corinth more than one thousand courtesans were devoted to the service of this goddess. The amount of money, earned by these girls and flowing into the priest's treasury, was so enormous that Solon, the great statesman and law maker, envying the temples for such rich income, founded the Dikterion, a brothel of great style, the income of which went into the treasury of the state.

Enticed by the luxurious and easy life of such courtesans, thousands of young girls chose the same profession and entered the schools, which were established by many courtesans for the special purpose of giving instruction in all the arts of seduction.

As the legislators, bribed by heavy tributes, were most liberal in giving concessions to these institutions as well as to prostitutes and keepers of brothels, public life became in time thoroughly demoralized. In fact these conditions were greatly responsible for the final decay and downfall of the whole Hellenic nation.

Chapter 10

WOMAN AMONG THE ROMANS

Among the various nations who in early times occupied the Italian peninsula, the Latins, Sabines and Etruscans were the most prominent. That among them barter and the forceful abduction of women was customary, is indicated by the well-known story of the "Rape of the Sabine Women" by the original settlers of Rome.

As the legend runs Romulus and his band of adventurers, having no women with them, and too poor to buy some from their neighbors, decided in the fourth month after the foundation of Rome to get wives by resorting to a stratagem. Accordingly they invited their Sabine neighbors to partake with their wives and daughters in the celebration of a festival. Suspecting nothing, the Sabines came and greatly enjoyed the entertainments provided for them. But in the middle of the feast the Romans, far outnumbering the unarmed Sabines, rushed upon their maiden guests and carried them off by force. To avenge themselves, the Sabines went to war, in which both parties suffered severely. But the fierce struggle was brought to an end, when the kidnapped girls flung themselves between the combatants, imploring their fathers and brothers to become reconciled, as they would like to stay with their Roman husbands. Their urgent appeals brought not alone peace, but resulted even in the confederation of the Sabines and Romans.

It is impossible to say whether this legend rests on actual facts, but it indicates that the forceful abduction of women was customary in ancient Italy. Undoubtedly it took many centuries before this drastic means of securing wives gave way to more peaceful methods. But to remind people of the intervention by which the women had ended the bloodshed between Romans and Sabines, the Romans celebrated a festival on the first of March of each year, called "Matronalia." It could only be participated in by women, who went with girdles loose, and on the occasion received presents from husbands, lovers, and friends.

Laws were also instituted for the protection of women. Woe to those who dared to hurt their feelings by disorderly acts or insolent language. They were brought before the blood-judge, who dealt very severely with such evil-doers.

Figure 23. The Vestal Virgins. After the painting by H. le Roux.

Like the Greeks the Romans venerated a divine guardian of family life. Her name was Vesta, "the domestic hearth-fire." The hearth, around which the members of the family assembled in the evening, was the place consecrated to her. Numa Pompilius is said to be the one who erected the first temple to this goddess in Rome. Round in shape, its center contained an altar with a fire that was never allowed to be extinguished. To keep this sacred flame always burning and to offer daily sacrifices and prayers for the welfare of the state, two virgins of the noblest families were chosen by the Pontifex maximus or High-Priest. Afterwards the number of these "Vestal Virgins" was increased to four, and later to six. Their garments were of spotless white, with a veil and a fillet round the hair. Strict observance of the vow of chastity during the thirty years of their term of service was one of their chief obligations.

The privileges extended to these virgins were very remarkable. Free from any paternal control, except that of the Pontifex maximus, they could dispose by will of their own property. When appearing in a public procession they were preceded by a number of lictors, who carried with them the symbols of their judicial office, the fasces, a bundle of sticks, out of which an axe projected as a sign of sovereign power. Should it happen that in the street they met a criminal on his way to execution, they had the prerogative of pardoning him. In theatres, in the arena, and at other places of amusement the best seats were reserved for them. They also lived in great splendor; their home, the Atrium Vestæ,

was not only very large, but of the best material and magnificently decorated. Like the emperors they shared the privilege of intramural burial.

With all this esteem, the Vestal Virgin was severely punished if found guilty of neglecting her duty or violating her vow of chastity. The latter crime caused the whole city to mourn. While innumerable sacrifices and prayers were offered up to appease the offended goddess, preparations were made to punish the priestess as well as her seducer horribly. The man was scourged to death on the public market; the unfortunate priestess was placed in a subterranean chamber on the criminals' field. After she had been provided with a bed, a lighted lamp, and some bread and water, the vault was closed, the earth thrown over it, and the priestess left to die.

While the "Vestal Virgins" enjoyed many privileges, the Roman women during the first time of the republic were completely dependent. A daughter, if unmarried, remained under the guardianship of her father during his life, and after his death, she came into the control of her agnates, that is, those of her kinsmen by blood or adoption who would have been under the power of the common ancestor had he lived. If married she and her property passed into the power of her husband. Whatever she acquired by her industry or otherwise while the marriage lasted fell to her husband as a matter 59of course. Marriage was a religious ceremony, conducted by the high priests in the presence of ten witnesses. Its effect was to dissociate the wife entirely from her father's house and to make her a member of her husband's, provided he himself had grown to manhood and started a household of his own. If this was not the case, his wife and their children, as they were born, fell likewise into the power of the "pater familias," the father-in-law of the wife, and the latter was entitled to exercise over his daughter-in-law and grandchildren the same rights as he had over his sons and unmarried daughters.

Of the wife of the "pater-familias" the Romans spoke as the "mater-familias," the "housemother," or as the Domina, "the mistress of the house," and she was treated as her husband's equal. But in spite of the fact that her position in the family was one of dignity, she could not make a will or contract, nor could she be a witness or fill any civil or public office.

So the life of a Roman woman was one of perpetual servitude. For centuries she had no control over her own person, no choice in marriage, no right to her own property, and no recourse against cruelty. Any man could beat his wife, sell her, or give her to some one else, when he was tired of her. He could even put her to death, acting as accuser, judge, jury, and executioner.

The dependent position of the women changed considerably, when the Romans came in touch with the Greeks and other nations. Marriage was made easier. It became even possible, without the sanction of priests or civil authorities, to conclude an agreement to which men and women might live together on probation. If such union was kept up without interruption for one year, then it was considered a regular marriage with all its consequences. If, however, the two persons concerned wished to reserve for themselves

the right of separation later on, it was only necessary that the wife should stay in the house of her parents for three nights before the end of the year.

There was also perfect freedom in divorce, as it was regarded improper to force persons to continue in the bonds of matrimony when conjugal affection no longer existed.

In later times women secured full right to dispose over their own property. Either they might manage it personally or have it administered by a "Procurator."

The Greek conception that the presence of women lends charm and luster to festivals, was adopted by the Romans. As they were convinced that no entertainment was worth while without the presence of the ladies, festivals were developed to even a far greater extent than was the case in Greece.

This step for the better was due to the greater intelligence of the Roman women. Recognizing that the vast influence exerted by many courtesans over the prominent men of Hellas was not due solely to the beauty and grace of these women, but also to their refinement and knowledge of literature, music and art, the Roman ladies, to attach their husbands to their homes, eagerly endeavored to acquire similar merits. And so they devoted themselves to the culture of everything that makes life interesting and beautiful. We know the names of many Roman women, who in this way became real companions of their husbands. Hear, for instance, what Pliny, the famous naturalist, wrote about Kalpurnia, his wife, in one of his letters. Having praised her keen intellect, moderation and affection, he continues: "In addition to these virtues comes her deep interest in literature. My own books she not only possesses them, but reads them over and over again, until she knows them by heart. If I have to give a lecture, she sits close by behind a curtain, listening eagerly to the appreciation shown to me." In similar terms Plutarch speaks of the wives of Pompejus and Kato; Tacitus of the wife of Agricola, of Cornelia, the mother of the Graches, of Aurelia and Atia, the mothers of Cæsar and Augustus.

While such cultured women retained a strong sense of duty towards their home and family, the influence of Hellas, however, made itself felt also in other ways. Its universal corruption and immorality had made it easy for Rome to subjugate the whole country. But during the occupation of the country the Romans became acquainted with the luxurious life and lascivious debaucheries in which the rich Greeks indulged in full disregard of the dreadful distress of the lower classes. Many Roman officers, consuls and prefects, morally unfit to resist the allurements of such loose life, fell victims to all sorts of vices and crimes. And when, after several years, they returned to Italy, they generally took with them, besides enormous quantities of stolen valuables, numbers of courtesans and slaves.

With the expansion of the empire these evils increased accordingly. And so Rome became finally permeated with foreign elements, manners and vices.

Even religious life became demoralized. Not only the voluptuous worship of Aphrodite or Venus was transplanted to Roman cities, but also the obscene service of Astarte, the Phœnician goddess of the begetting agencies. The orgies, committed in the

ostentatious temples of these deities, formed indeed a striking contrast against the chaste worship of Vesta.

By all these conditions the life of the Roman women became deeply affected. The works of contemporary writers abound with complaints about the growing emancipation of the female sex, the neglect of their duties, and the ever increasing love of amusement. Comparing the women of his time with those of former days, Kolumella remarks:

"Now, our women are sunk so deeply in luxury and laziness, that they are not even pleased to superintend the spinning and weaving. Disdaining home-made goods, they always seek in their perverted mania to extort from their husbands more elaborate ones, for which often great sums and even fortunes must be paid. No wonder that they regard housekeeping as a burden and that they do not care to stay at their country seats even for a few days. Because the ways of the former Roman and Sabine housewives are considered old-fashioned, it is necessary to engage a housekeeper, who takes charge of the duties of the mistress."

Young girls liked to stroll through the shady colonnades of the temples and through the groves, that surrounded them. Here they met their beaus, who in the art of flirt were just as cunning as are the Lotharios of to-day. The ladies of the aristocrats or patricians enjoyed to be carried about in sedan-chairs, as in these comfortable means of transportation they had full chance to show themselves to the public richly dressed and in graceful positions. As these sedan-chairs were always provided with costly canopies and curtains, and shouldered by fine-looking Syrian slaves, clad in red and gold, such a sight could not fail to attract general attention and to become the talk of the town.

That this mode of shopping and paying calls became a real fashion may be concluded from a remark of Seneca, who grumbles that those husbands, who forbid their wives to be carried about and exhibit themselves in such manner are considered as unpolished and contemptible boors.

As appears from the works of Juvenal, Sueton, Plutarch, Martial and others the growing passion for emancipation, notoriety and excitement, combined with the rage for gossip was responsible for the production of many unwomanly characters. We hear the complaint that scores of women boldly intrude into the meetings of men and often compete with them, in their drinking bouts. These authors also condemn that such females eagerly mix with officers and soldiers, to discuss with them the details and events of the war, while others try to spy out all domestic secrets, only to blab them out again in the street.

Ovid too expresses his disappointment about the changes going on in the life of the fair sex.

"Disdaining matronly seclusion, our ladies patronize circus, theatre and arena, eager to see and to be seen. Like an army of ants or like a swarm of bees they hurry in elaborate

attires to the beloved plays, often in such crowds that I am utterly unable to guess their numbers."

This inordinate greediness for enjoyments grew in time into a real intoxication of the senses. Nothing indicates this more than the concentration of all thoughts, of the patricians as well as of the plebejans, of the men as well as of the women, of the free as well as of the slaves on the questions which party would win in the public games, how many hundred gladiators would fight each other, or how many thousands of wild beasts would be set loose in the arena.

When we read that such public shows sometimes lasted for weeks and months, and that all regions of the known world were ransacked in order to secure some new and more cruel feature, that would set people wild with excitement, it will be clear that the susceptible mind of women must have suffered most. And indeed with the increasing degeneration of social life the female sex became more and more demoralized. As among the foreign slaves as well as among the freed and enfranchised were many fine-looking and accomplished persons, unfaithfulness and adultery increased. Especially among the ladies of the upper classes the "nicely curled procurator," who managed the property of such women, served only too often as a "Cicisbeo," in which role he figures in many satires and comedies. Men and women met in the public bath houses as well as in watering-places like Bajae, an ill-reputed resort, where libertinism and dissipation flourished, and from which it was said, that no virgin, who went there, ever returned as a virgin.

Bajae and Rome were also the places where the mysterious rites of the Bachanalia found the greatest number of devotees. Originally a festival in honor of Dionysos, the Greek god of spring and wine, it degenerated into wild orgies after its introduction to Rome. This is what Livy writes about it:

> "The mysterious rites were at first imparted to a few, but were afterwards communicated to great numbers, both men and women. To their religious performances were added the pleasures of wine and feasting, to allure a greater number of proselytes. When wine, lascivious discourse, night, and the mingling of the sexes had extinguished every sentiment of modesty, then debaucheries of every kind were practiced, as every person found at hand that sort of enjoyment to which he was disposed by the passion most prevalent in his nature. Nor were they confined to one species of vice, the promiscuous intercourse of freeborn men and women. From this storehouse of villainy proceeded false witnesses, counterfeit seals, false evidences, and pretended discoveries. In the same place, too, were perpetrated secret murders and other unmentionable infamies. To consider nothing unlawful was the grand maxim of their religion."

It was in Bajae where Marcellus, the son-in-law of Emperor Augustus, was poisoned by intriguing Livia; and here Agrippina, the mother of Nero, was clubbed to death after

an attempt by her son to shipwreck and drown her during a cruise in a magnificent gondola had failed.

Figure 24. Street Life in Rome. After a painting by L. Boulanger.

In time adultery, poisoning and murder prevailed among the Roman society to such an extent, that men became afraid to enter matrimony, and addicted themselves to illicit intercourse.

This period of moral degeneration was, however, distinguished by a most wonderful rise of literature, science and art. At no time before so many beautiful temples, basilicas, theatres, arenas, public buildings, palaces and country-seats were erected. And all these buildings were adorned with an abundance of mosaics, mural paintings and works of sculpture. There were also numbers of brilliant writers, poets, dramatists, orators, law-makers and men who made themselves famous as naturalists or philosophers.

Of the philosophers the so-called Stoics, among them Seneca, Lucan, Epictetus and Musonius Rufus formed a school, which exerted a wide and active influence upon the world at the busiest and most important time in ancient history. This school was remarkable for its anticipation of modern ethical conceptions, for the lofty morality of its exhortations to forgive injuries and overcome evil with good. It also preached the obligation to universal benevolence on the principle that all men are brethren. Regarding virtue as the sole end, to be gained mainly by habit and training, the Stoics furthermore succeeded in reforming matrimonial life as well as the conceptions about women. In

these efforts they were aided later on by an ethical movement of still greater power, namely Christianity.

Chapter 11

WOMAN'S POSITION AMONG
THE GERMANIC NATIONS

Figure 25. Valkyries, the Fair Maidens of the Battlefields.

Before we consider woman's position in Christianity, we must take a glance at her status among another important branch of the Aryan race, the *Germans*.

As is familiar to every student of history, the Germans are indebted to an alien, the Roman Tacitus, for the best account of the character and manners of their ancestors. In his famous book "Germania" he describes them as a pure and unmixed race and gives many valuable particulars about their family life. He says:

"Matrimony is the most respected of their institutions. They are almost the only barbarians who are content with one wife. Very few among them are exceptions to this rule and then they do so not for sensuality but for political considerations. The young men marry late, and their vigor is unimpaired. Nor are the maidens hurried into marriage. Well-matched and in full health they wed, and their offspring reproduce the strength of their parents. The wife does not bring a dowry to the man, but the husband to his bride. These presents are not trinkets to please female vanity or to serve for adornment, but on the contrary, they consist of cattle, a bridled horse, and a shield with sword and spear. While the wife is welcomed with such gifts, she too presents her husband with a piece of armor. All these things are held sacred as a mysterious symbol of matrimony. Lest the wife should think that she is shut out from heroic 66aspirations and from the perils of war, she is reminded by the ceremony which inaugurates marriage that now she is her husband's partner in his toil as well as in all danger, and destined to share with him in peace and in war alike. This is the meaning of the yoked oxen, the bridled horse and the weapons. And she must live and die with the feeling that the weapons she has received, have to be handed down untarnished and undepreciated to her sons, from whom they are to pass to her daughters-in-law, and again to the grandchildren.

"So the wife lives under the protection of clean manners, uncorrupted by the allurements of voluptuous comedies or licentious festivals. Clandestine communication by letters is absolutely unknown. Adultery among this numerous people is exceedingly rare. Its punishment is left to the husband and quickly executed. In the presence of her relatives the guilty woman is kicked out of the house, naked and with her hair cut. And thus she is whipped through the whole village. Loss of chastity finds no excuse. Neither beauty nor youth nor wealth wins the culprit a husband, because no one indulges in vice or pardons seduction. Blessed the country where only virgins enter matrimony and where their vow to the husband is binding and final for all time. As they are born only once so are they married but once and they devote themselves to their husband as well as to the duties of matrimony. To limit the number of children or to kill one of them is regarded as a sacrilege. Thus good habits accomplish more here than good laws in other countries."

Tacitus as well as other Roman writers state likewise that the women frequently accompanied the men in times of war and encouraged them in battle by their cheers and actions.

"They always stay near them, so that the warriors may hear the voices of their wives and the wailing of their children. Women's approval and praise is to the men of the highest value. To their mothers and wives they come with their wounds for relief, and the women do not hesitate to count the gashes, and dress the wounds. The women also encourage the men while they are fighting, and provide them with food and water. We have been told that wavering battle lines were made to stand fast by women, who with bare breasts mingled with the warriors and admonished them by their cries to new resistance."—

Figure 26. A Betrothal among the Ancient Germans. After a painting by F. Leeke.

Many of the names given to members of the fair sex, indicate the men's great respect for women, and show that they were considered as able consorts even in battle. The names Daghilt, Sneburga, Swanhilt and Sunnihilt remind us of the purity of the daylight, the white of the snow and the swan, and the gold of the sunshine. And the qualities of strength, agility and skill in everything connected with war and victory we find in names like Hildegund, "the protectoress of the home"; Hadewig, "the mistress of battle"; Gertrud, "the thrower of the spear"; Gudrun, "the expert in war"; Thusinhilde or Thusnelda, "the giant fighter"; Sieglind, "the shield of victory"; Brunhild, "she who is strong like a bear," and in many other names.

The many noble female personages who figure in German mythology also testify to the high conception the Germans had of womanhood. There was Frigg, the spouse of Odin, and the ideal personification of a German housewife. There was Freya, the goddess of spring, beauty and love; Gerda, the bright consort of Fro, the sun god; Sigune, the faithful; not to forget the Valkyries, those beautiful maidens who hovered over the field of battle, wakened the dead heroes with a kiss and carried them on their swift cloud horses to Valhalla, where they were welcomed and feasted by the gods and enjoyed all kinds of martial games.

The Germans saw in women also something that was sacred and prophetic. It was this belief that lent importance to Veleda, Alruna, and other prophetesses, who were looked up to as oracles, and played a conspicuous part during the time of the Roman invasion.

THE HEROIC WOMEN OF THE BRITONS AND THE NORSEMEN

The same noble spirit that distinguished the German women, was likewise found among the females of Britain and Scandinavia. Tacitus in his "Annals" XIV gives an account of Boadicea, queen of the Iceni, a tribe that occupied the eastern coasts of Britain. To defend the independence of her country against the Romans, this queen succeeded in uniting some of the British tribes and drove the invaders from several fortified places. When Suetonius, on hearing of the revolt, hastened up with a strong army, he found himself opposed by large numbers of the aborigines, men as well as women. Among the fighters were many priestesses or Druids, who, clothed in black, with streaming hair and brandished torches, fought like furies. When they saw themselves far outnumbered and realized that all was lost, these women preferred death to slavery and perished among the flames, which destroyed their stronghold.

When the Roman legions met the main body of the Britons, they beheld Boadicea admonishing her warriors, to conquer or die in battle. In the fearful contest 70,000 Romans and 80,000 Britons were slain. But when the combat resulted in the complete defeat of the latter, Boadicea poisoned herself to avoid falling into the hands of the victor.

The Edda and many other sagas of the Scandinavians contain likewise accounts about heroic women such as they were in those days of the past: strong in body as in mind, and equal to any emergency. Brave alike in heart and in character, independent, open and frank, they were loyal to their husbands and their duty when fitly matched. Fearlessly they joined in the daring expeditions of their sea-kings, who packed their "dragon-ships" to full capacity with warriors and made raids on all the coasts of Europe, even on the countries that border the Mediterranean Sea.

From several interesting relics of old Icelandic literature we also know that as early as in 986 A. D. Norse women went with Eric the Red to Greenland. Here they helped in establishing a settlement, Brattahlid. And when in 1007 Thorfin Karlsefne sailed from this place to Vinland, some newly discovered country in the far Southwest, he too was accompanied by several women, among them his wife Gudrid. Some time after her arrival she gave birth to a son, Snorre, the first child of white parentage born on American soil.

Another of these fearless women, Froejdisa, took active part in a hot skirmish with the aborigines of Vinland. When the Norsemen were about to yield to the overwhelming numbers of these "Skraelings," it was she who encouraged the men to stubborn resistance. Several years later, in 1012, this same resolute woman, in company with two men, fitted out an expedition of her own to Vinland. After an absence of one year she returned to Brattahlid with a large cargo of valuable lumber, furs, and other goods, but also suspected of having killed her partners as well as their men with her own hands.

Chapter 12

WOMAN AMONG THE EARLY CHRISTIANS

Figure 27. Christians of the Third Century.

Just at the time, when the capitals of Hellas and Rome were reservoirs for all the streams of wickedness and infamy, there originated in Palestine a religious sect destined to exercise an enormous influence upon the moral and political life of the world. Its adherents called themselves *Christians*, "the Annointed," and followed the doctrines of Jesus, who, according to the Jewish historian Josephus, was condemned for his teachings by Pilate, the Roman governor of Judæa, and crucified.

As Jesus left no records or gospels written by himself, we do not know his personal views about woman, home, marriage, and maternity. We must rely on the accounts which were written by his followers many years after his death, and now are called the New Testament. After the death of Jesus some of his followers drifted from Palestine to Syria, Greece and Rome, where for their pure and austere morals they attracted the attention of numerous persons who stood aghast in views of the vices that surrounded them.

For the spread of a new religion such as Christianity, the Roman world was wonderfully ripe. As it had been the politics of Rome not to interfere with the religions of the peoples subdued by her armies, there had been added to the already overcrowded pantheon of Rome many of the principal deities of the conquered nations. But there existed also a longing for some religion, which would have more individuality and personal power in it then were supplied by the thoughts of a supreme spiritual fate, or by the mere materialistic conception of the genius of Rome. There was a decided thirst for information about sacred things. Men discussed the claims of the various conflicting religions philosophically, and amid all the gross materialism of the time there were longings for some deeper, truer religion than any they had known.

This longing was satisfied by the simple but sublime conceptions of God held by the Christians, and also by the noble purity of their life. These Christians had no settled form of doctrine, no settled rule of discipline, no body of magistrates. They were merely an association of believers in a common faith, with common sentiments, feelings, emotions and convictions. To women this new religion was particularly appealing, as it preached many important reforms. First of all, it granted to woman the full right of disposing of herself. By making her consent necessary for marriage, woman remained no longer a piece of property, which might be sold or disposed of at will by the father, brother, husband or other relatives. She also was not compelled any more to accommodate, with her own body, some visiting strangers. There was no hierarchical prostitution, either, but matrimony was elevated to a sacred ceremony, of which the benediction of a priest formed a necessary part. Chastity was regarded a supreme law, which governed the whole family life.

The majority of these Christians consisted of poor illiterate people, who tried to lead a clean and honest life. Their simple manners and frugal habits contrasted strongly with the luxury of those Greek and Roman patricians among whom they dwelt. They regarded such extravagance with contempt, and the unlimited emancipation and licentiousness of the rich women filled them with horror.

Accordingly they applied to themselves strict rules which would protect them against any temptation. For this reason their women never adorned themselves with jewelry or gaudy dresses of dyed cloth, silk, and embroideries; they never wore false or colored hair. If married, they took care of the house, attended to the children, and were devoted to their husbands, whom they respected as the head of the family. The only occasion for their going out was when they went to church, or to visit some poor or sick neighbor.

Depending on one another, husband and wife endeavored to form that union recommended by the scriptures as the goal of married life.

Such happy nuptial ties inspired Tertullian, a Carthaginian, who came in contact with Christians in Rome, to the following lines: "Whence are we to find language adequate to describe the happiness of that marriage which the church cements and the oblation confirms, and the benediction signs and seals, which angels report and the Father holds as ratified? Together they pray, together prostrate themselves, together they perform their fasts, mutually teaching, mutually exhorting, mutually sustaining."

Commemorations of conjugal happiness, and commendations of such female virtues as modesty, chastity, prudence and diligence, we also frequently find in many sepulchral inscriptions of the Catacombs, those famous subterranean cemeteries excavated by the early Christians of Rome for the express and sole purpose of burying their dead. There are inscriptions as for instance: "Our well deserving father and mother, who lived together (for 20, 30, 50 or even 60 years) without any complaint or quarrel, without taking or giving offense."

During the first centuries of Christianity women took a prominent part in all affairs of the church and they were allowed to be active wherever there was a chance to spread the Gospel. In particular, they taught the children, took charge of the orphans, and acted as door-keepers in the assembly rooms, directing the worshipers to their places, and seeing that all behaved quietly and reverently.

The new sect, which in every respect contrasted so strongly with Roman customs and conceptions, could not fail to attract the attention and inquisitiveness of the people as well as of the Government. But also suspicion and hostility were aroused. As the Christians met secretly in private houses, people suspected that they were conspirators banded together for criminal purposes, that they occasionally slaughtered infants, poured their blood into a cup, and that passing this cup around they all drank of it. Their insistance in only one God, that of the despised Jews, and their aim to discredit and overthrow all other creeds of the world in order to fuse all mankind in their own faith, were decried as contempt of those deities, under which Rome had become great and prosperous. Naturally, their enmity against these deities was regarded as enmity against the State, which stood under the protection of these deities. Accused of being apostates and revolutionists, the Christians soon enough became the objects of much bitter persecution; such as has been described by Sienkiewicz in his famous book "Quo Vadis."

During these persecutions the Christian women shared with their husbands, children and brothers all the horrible cruelties Roman ingenuity could invent. In the arena they were thrown before lions, tigers, bears and other savage beasts. They were crucified, or besmeared with pitch and publicly burned. Worst of all, many of those women who regarded chastity as their highest virtue, were handed over to the keepers of brothels and made victims to the voluptuous passions of the lowest class of people.

But in time the pure and noble ideals which inspired the hearts of those first Christians, began to appeal to the masses of the people. The scriptures of the great apologists Tertullian, Justin, Origenes and others were read and studied with growing interest. And when later on Emperor Constantine, surnamed the Great, for motives of political expediency, favored and adopted the new faith, the triumph of Christianity was secured.

WOMAN AMONG THE MOHAMMEDANS

Figure 28. Arabic Women in Ancient Times.

While thus the followers of Christ reformed the position of woman in the Roman empire, Mohammed, the founder of Islam or Mohammedanism, at the same time endeavored to better the condition of woman in the Orient. Born about the year 570 A. D. in Arabia he recognized, that the domestic life of the Arabs was marked by many embarrassing improprieties. Polygamy was customary everywhere, and while among the rich people the wife was nothing but a toy, for no other purpose but to satisfy passion, among the poorer classes she was merely a suppressed slave, who could be sent away, when she was no longer young, or had lost her good looks, or had become unable to work. Concubinage and prostitution prevailed among the population of the cities as well as among the Bedouins, who led the same nomadic life as had the patriarchs Abraham, Isaac and Jacob several thousand years ago.

To improve the position of woman, Mohammed inserted in the Koran, his great moral codex, a number of instructions, which shine forth like gold threads in the fabric of a beautiful curtain. He ordered the men to treat their wives with forbearance and respect, as was becoming in the stronger toward the weaker sex. Children were impressed to give love and comfort to their parents to the end of their days and show them the highest reverence.

To diminish polygamy and to give women a secure legal standing, Mohammed also reduced the number of lawful wives to four, and allowed this number to such men only as were wealthy enough to provide for certain comforts. Furthermore, he placed the men under the obligation, to be faithful to their wives and treat all with equal kindness.

To protect women from the many temptations of too close a social intercourse with men, Mohammed took pains to exclude women as much as possible from contact with the outer world. Therefore he insisted on the strict observance of the ancient Oriental custom that women must not appear in the streets or in presence of other men than their husbands except with their faces heavily veiled. This order has been observed in all Mohammedan countries up to the present day. Only slaves and peasant women are allowed to go unveiled, as the veil would hinder them at work. Therefore, outsiders can study the features of Mohammedan women only from members of the lower classes. To find out who is who among the veiled females seen in the streets of oriental cities is impossible even for their own husbands.

About the domestic life of Mohammedan women during former centuries we know practically nothing, as reliable reports by disinterested observers are wanting. But the fact that Mohammedan homes and family life were always secluded from the external world and inaccessible to Christian explorers travelling through oriental countries, rendered the subject peculiarly liable to highly exaggerated and sensational reports. Especially the life in the "Harem," the women's quarter, has been pictured innumerable times as a combination of boundless luxuriance, lascivity, frivolity, laziness and intrigues.

Figure 29. Veiled.

In contradiction several ladies, who had a chance to study Mohammedan life during the last century, have asserted, that these reports do not, by any means, correspond with the truth. There is for instance an essay of Else Marquardsen about the manners of the Turks, in which she discusses polygamy. She says:

"Throughout the course of many years I was allowed to visit the homes of many prominent people as well as of the poorer classes, but I remember only one case, where a man, a high official, had more than one wife. As a rule I found in all families a spirit of quiet faithfulness to duty, such as it is not always the case among us. The women, often compelled to live together with the mother or other female relatives of their husbands,

maintain a good-natured kindness toward each other, which is really solacing and knows no exception. The great devotion, shown to the mother by her son as well as by his wife, and which makes her the most respected member of the whole family, is an education in humility and self-control, the results of which fill one with admiration. As the life of the Mohammedan woman, of which her husband forms the center, is one of repose and seclusion, so she retains a child-like disposition of sentiment which is indeed touching. Unlike as it is with us, she is reared in full knowledge of the natural destination of woman. As soon as she has developed from childhood to womanhood, she is offered to a man, unknown to her, but whom she respects as the god-sent medium to impart the sacred mystery by which she may become a mother. As he gives her the crown of life, she honors him as her lord. But if it should be her fate to remain barren, then she does as Sarah, Leah and Rachel did several thousand years ago; she goes to find another woman, by whom her husband may have children."

The marriageable age for Mohammedan girls is about twelve, sometimes less and sometimes more, and the preliminaries are entirely a business matter conducted by the nearest relatives with much ceremony. After a definite contract is made it is then that the bride is permitted to see and speak to her future husband.

According to an article by Broughton Brandenburg about the district of Biskra, the night before the wedding the bride's hands and feet are steeped in henna, with which are stained the nails of all women who make any pretense of keeping up 78appearances. When the day comes on which the bride is to go to the house of her husband she is arrayed in rich robes; on her arms and ankles are bracelets, and about her slender waist she wears a corded girdle holding in place a broad plate of gold, silver and turquoise, usually an heirloom of great age and rare workmanship. The spangled bridal veil is cast over her head and she is led to the door by her parents and given over to a company of joyous friends, hired musicians and guests who parade through the streets beating the rawhide tambourines and cymbals, dancing and shouting. So the tumultuous pageant winds its way to the house of the groom, where the happy child takes off the girdle and plate, and hands them to her husband with a deep obeisance. After that, feasting and merry-making follow, and last as long as the bridegroom keeps his purse open.—

But the great restrictions to which, for her own protection, the Mohammedan woman was subjected by the Koran, also caused some great disadvantages. Neither Mohammed nor his successors had a proper appreciation of the dignity, the many possibilities and the real mission of woman. Regarding her chiefly as the medium for the propagation of the race, they neglected her intellectual life. In consequence she never had, in her strict seclusion, a chance to develop her mental qualities. Unable to read books and hearing nothing of the events of the outer world, she remained in the state of semi-slavery, never attaining the high position reached by many Christian women of to-day, namely that of being a real consort to the husband.

Figure 30. A Mohammedan Woman of Morocco.

So the very best influence of woman was wanting. And as in time polygamy and concubinage increased again among many Mohammedan nations, the men became enervated and unable to resist hostile assaults.

The most striking example is that of the Moors. After having conquered large parts of Northern Africa as well as of Spain, they were expelled again from Europe during the 15th Century. The charming Alhambra at Granada, the Alcazars of Seville and Toledo, the magnificent mosque at Cordova still preach the past glory of their former empire. But while we wander through the elaborate rooms, that once were occupied by the women of the califs and sultans, we cannot resist the conviction that these splendid halls were but golden cages for beautiful creatures, whose wings had been clipped.

PART III. WOMEN DURING THE MIDDLE AGES

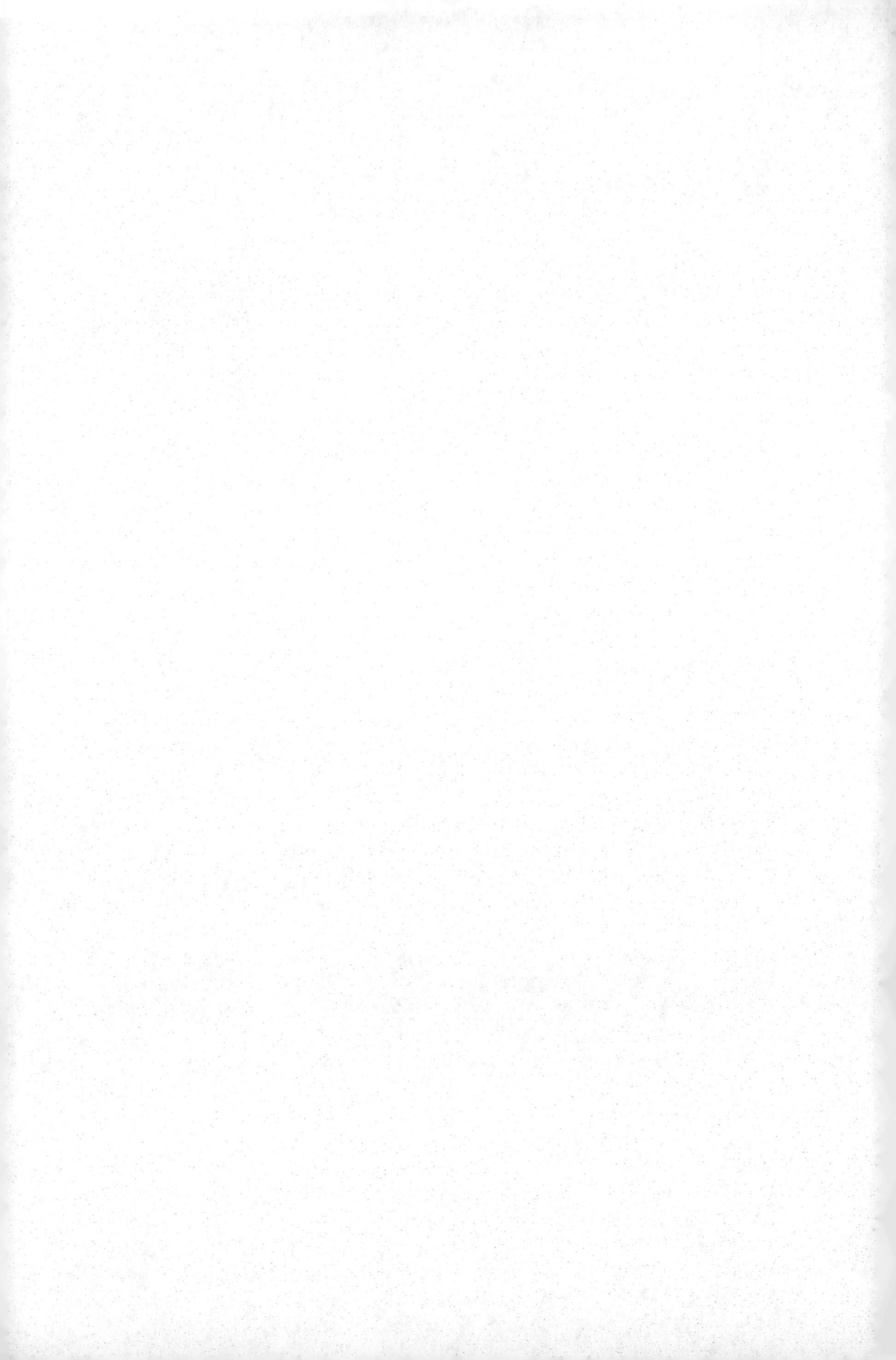

WOMEN DURING THE MIDDLE AGES

Figure 31. A Noblewoman of the 16th Century.

From the accounts, given by Tertullian and other writers about the life of the early Christians, it appears that their conceptions in regard to women gave promise for a better future. But during the Middle Ages, which extend from the downfall of Rome to the discovery of America, Christianity unfortunately failed to realize these promises.

First of all the ancient Oriental prejudice against women again took hold of the minds of many Christian leaders. Instead of making themselves champions of women's rights and interests, they curtailed women's influence in order to subject them to the dominion

of their husbands. In these efforts the "Christian Fathers" complied with those commands that Paul the Apostle had given in several of his epistles to the Corinthians, Philippians, and to Timothy. They read as follows:

> "The head of every man is Christ, and the head of every woman is the man, and the head of Christ is God. For the man is not of the woman but the woman of the man. Neither was the man created for the woman but the woman for the man."—
>
> "Let your women keep silence in the churches, for it is not permitted unto them to speak but they are commanded to be under obedience. And if they would learn anything let them ask their husbands at home."
>
> "Let the woman learn in silence with all subjection. But I suffer not a woman to teach, nor to usurp authority over the man, but to be in silence."—

These narrow views destroyed the beneficial influence of woman in Christian lands and retarded her emancipation for more than eighteen hundred years. Approving of Paul's commands, Ambrose, one of the eminent lights of the Church in the Fourth Century, said, to demonstrate the inferiority of woman: "Remember that God took a rib out of Adam's body, not a part of his soul, to make her!" Another of these leaders made the name "Eve" synonymous with "deceiver," accusing woman of having been the cause of men's expulsion from Paradise. St. John Chrysostom wrote: "Woman is the source of evil, the author of sin, the gate of the tomb, the entrance to hell, the cause of all our misfortunes." And St. John of Damascus told the world, that "woman is an evil animal, a hideous worm which makes its home in the heart of man." Other teachers agreed with Paul that woman must veil her head because she is not, as is man, in God's image!

In face of such vicious promulgations we must not be surprised that among the discussions of the early "Fathers" none was more important than that, "has woman a soul?" This question was argued in the Sixth Century at the Council of Macon. It is also recorded that a few of these pious leaders entertained the opinion that because of the great power and goodness of the Almighty "women may possibly be permitted to rise as men at the resurrection." And the Council of Auxerre, held in the Sixth Century, decided that women should wear gloves before they touched the holy sacrament.

As at the same time ascetic thinkers impressed the minds of the Christians with an inordinate estimate of the virtue of celibacy, conceptions of matrimony also changed considerably. While marriage was not condemned, it was, however, regarded as an inferior state, and it was held, that persons who had not married, but remained pure, were nobler and more exalted beings than those who had married. With the advance of such ascetic ideas a large family came to be regarded almost as a disgrace, as a proof of lasciviousness.—

All these doctrines of woman's inferiority in time corroded the ideas of the Christian nations about woman to such a degree that her position in the religious service as well as in law and in all the customs of the early Middle Ages sank to a very low level.

Another reason for the failure of Christianity in regard to woman's emancipation was that the minds of the leaders of the Church became occupied by aims which to realize seemed to them of far greater value and importance.

The early Christian communities had been simple associations of believers in a common faith. They had no settled form of doctrine or rules of discipline. They even had no body of magistrates. But the moment these associations began to advance and became a corporation, they started to mould a form of doctrine. At the same time the elders, who taught and preached, and morally governed the congregation, became priests, while those, who did service as overseers or inspectors, became bishops.

Among the latter the bishops of Rome adopted not only the title of Pontiff or High-Priest, but also assumed dictatorship over the bishops of all other dioceses. Professing to be of divine appointment and the representative of Christ they claimed in his name authority over all things, both temporal and spiritual. Accordingly they made the propagation of the Christian faith throughout the world their chief mission and organized for this purpose an army of clerical dignitaries, who held themselves responsible to no other authority but the Pontiff or Pope, to whom they were bound by the strongest vows. Also numerous orders of monks and nuns were established, who assisted greatly in the extension and strengthening of the Church.

The influence on human progress and culture of these vast religious armies has always been greatly overrated. No doubt, under the management of the monasteries and nunneries large tracts of virgin soil and forests were cultivated, and that architecture and art, as long as they served the interests of the Church, were patronized. But it is equally true that the Church tried to prevent its followers from thinking independently, that great masses of people, particularly those of the rural districts, were held in strict servitude and mental bondage, and that education and science were grossly neglected. Any attempts to question the authority of the Church or the truth of the Scriptures, were cursed as heresy and punished with death.

Among the first who had to suffer the wrath of the Popes, were the Waldenses, Albigenses, Stedingers, and several other Christian sects, which during the 9th, 10th and 11th Centuries had formed in various parts of Europe for no other object than the re-establishment of the simplicity and sincerity of the early Christian communities. As these sects were found at variance with the rules of the Church, they were decried as heretical, and almost extinguished.

Intolerant against all other creeds, the Popes also opened a series of wars against the Mohammedans, professedly for the purpose of delivering the "Holy Land" from the dominion of the "Infidels." Aside from these "Crusades" a similar war was directed against the most western branch of the Mohammedans, the Moors, who had occupied a large part of the Iberian Peninsula. These struggles ended in 1492 with the fall of Granada and the surrender of the famous fortress Alhambra. While in the treaty of peace certain stipulated privileges had been granted to the conquered, one of which provided for

free exercise of their religion, this liberty of worship was treacherously withdrawn in 1499 and the Moors either killed, expelled, or made Christians by forcible baptism. Those who survived by intermingling with the Spaniards produced a new race, the Andalusians, famous for their graceful women. The Spaniards adopted many of the Moorish manners and institutions, among them certain restrictions in the intercourse of the two sexes. Writers of the 15th Century state, that in these times the Spanish women used to sit in Oriental fashion, with legs crossed, on carpets and cushions, spending their time with embroideries and gossip, or telling the beads of the rosary. The husbands seldom sought their company, and even preferred to take their meals alone. Married ladies were not allowed to receive male visitors, and if their husbands brought friends along, they hardly dared to lift their eyes. The only breaks in this monotonous life were occasional calls by women friends, who were received with the greatest possible display of dress and jewelry. This unnatural segregation of the sexes still prevails in Spain to some extent and is chiefly due to the jealousy of men. Well aware of their own unfaithfulness and great inclination for love-adventures, they have no confidence in their wives either, but always watch them with suspicion.

We find similar conditions in many other parts of Southern Europe. But as restrictions are always apt to breed intrigues we hear everywhere of plots and love-affairs, such as Boccaccio has related in his "Decamerone." The stories of this famous book, which was written between 1344 and 1350, without question are based on actual events, frequently among the fashionable ladies and gentlemen of the age.

Far higher than in Southern Europe was the status of women in those countries occupied by nations of Germanic stock.

At the time of Tacitus the Germans had no settlements, but lived in isolated dwellings on the river banks or clearings in the majestic forests. With the migration of the nations, however, caused by the enormous pressure of vast Mongolian hordes upon the tribes of Eastern and Central Europe, the Germans were compelled to abandon this mode of life. For security's sake they gathered together in villages and cities. These they surrounded with heavy walls and towers, and protected them by castles, erected on steep cliffs and mountains.

The custody of these strongholds was entrusted to the most efficient warriors, who in time formed a separate class, the nobility, from which the heads of the whole nation, the princes, kings and emperors were chosen. The inhabitants of the cities formed the class of burghers, who devoted themselves to the trades and handicrafts. There was a third class, made up of the people remaining in the rural districts, the peasants.

Of course the positions of the women of these various classes differed widely. While the women of the peasants and craftsmen were busy with the functions of their every day's work, the women-folk of the rich merchants and the nobility had ample time to cultivate everything that makes life worth while. With blissful hearts they took part in all pleasures and festivals. And with the same feeling they accepted the tokens of respect and

admiration, extended to them by the knights as well as by the many minstrels and troubadours, who travelled throughout the country to entertain with their songs of love, adventure and heroism all who liked to listen.

Many songs of the 12th and the 13th Century express the high esteem of their authors for women. They also prove that the so-called "Minnedienst" of the German and French knights was to a great extent an ideal tribute and consisted chiefly in a restrained longing of the heart, in a pure remembrance of the beloved one.

One of the best known rhymes dates from 1120 and reads as follows:

> Du bist min, ih bin din:
> des solt du gewis sin.
> du bist beslozzen
> in minem herzen;
> verlorn ist das sluzzelin:
> du musst immer darinne sin.
> Thou art mine, I am thine!
> Pray, what could be just as fine?
> Thou art enclosed
> Within my heart;
> The key is lost, so, as it were—
> Thou must now stay forever there.

Figure 32. The Welcome to a Troubadour. After a painting by B. Bruene.

Among the most beautiful poems, written in praise of women, we also find the "May-song" of Walter von der Vogelweide. In modern German it reads as follows:

"Wenn die Blumen aus dem Grase dringen,
Gleich als lachten sie hinauf zur Sonne
Des Morgens früh an einem Maientag,
Und die kleinen Vöglein lieblich singen
Ihre schönsten Weisen, welche Wonne
Böt' wohl die Welt, die mehr ergötzen mag,
Ist's doch wie im Himmelreiche.
Fragt ihr, was sich dem vergleiche,
So sag' ich was viel wohler noch
Des öftern meinen Augen tat,
Und immer tut, erschau ich's noch:
Denkt ein edles schönes Fräulein schreite
Wohlgekleidet und bekränzt hernieder
Unter Leuten froh sich zu ergehen,
Hochgemut im höfischen Geleite.
Züchtig um sich blickend und durch Anmut glänzend,
Wie Sonne unter Sternen anzusehen.
Welche Wonne käme gleich
Solchen Weibes Huldgestalt?
Der Mai mit allen Wundergaben
Kann doch nichts so wonnigliches haben
Als ihren minniglichen Leib.
Wir lassen alle Blumen steh'n
Und blicken nach dem werten Weib."
When from the sod the flowerets spring,
And smile to meet the sun's bright ray,
When birds their sweetest carols sing,
In all the morning pride of May,
What lovelier than the prospects there?
Can earth boast anything more fair?
To me it seems an almost heaven,
So beauteous to my eyes that vision bright is given.
But when a lady chaste and fair,
Noble, and clad in rich attire,
Walks through the throng with gracious air,
As sun that bids the stars retire,—
Then where are all thy boastings, May?
What hast thou beautiful and gay,
Compared with that supreme delight?
We leave the loveliest flowers, and watch that lady bright.

Figure 33. A Lady's Room during the Middle Ages. After a drawing by F. A. Kaulbach.

Another German poet of the 13th Century was Heinrich von Meissen, better known under the name "Frauenlob." This sobriquet he received because he sang much in praise of women, as for instance:

> "O Frau, du selten reicher Hort,
> Dass ich zu dir hie sprech' aus reinem Munde.
> Ich lob' sie in des Himmels Pfort';
> Ihr Lob zu End' ich nimmer bringen kunnte.
> Dess lob' ich hier die Frauen zart mit Rechten,

Und wo im Land ich immer fahr'
Muss stets mein Herz für holde Frauen fechten."

And at another time he sings:

"Ich lob' die Frau für des Spiegel's Wonne:
Dem Manne bringt sie grosse Freud';
Recht als die klare Sonne
Durchleucht' den Tag zu dieser Zeit,
Also erfreut die Frau des Mann's Gemüte"—

When in 1318 he died, in Mayence, the women of that city, in appreciation of his devotion to their cause, carried his coffin solemnly to the cathedral, in the cloisters of which he was buried.

One of the most beautiful love-songs ever written dates from 1350. Having outlasted the centuries it is still sung and appreciated to-day wherever German is spoken.

Ach wie ist's möglich dann
Dass ich dich lassen kann,
Hab dich von Herzen lieb,
Das glaube mir.
Du hast die Seele mein
So ganz genommen ein
Dass ich kein' and're lieb'
Als dich allein.
Blau blüht ein Blümelein,
Das heisst Vergiss-nicht-mein;
Dies Blümlein leg' an's Herz
Und denk' an mich.
Wär ich ein Vögelein,
Bald wollt' ich bei dir sein;
Fürcht' Falk' und Habicht nicht,
Flög' gleich zu dir.
90Schöss' mich ein Jäger tot,
Fiel ich in deinen Schoss;
Sähst du mich traurig an,
Gern stürb' ich dann.
How can I leave thee so?
How can I bear to go?
That thou hast all my heart:
Trust me, mine own!
Thou hast this heart of mine
So closely bound to thine

None other can I love
But thee alone.
Blue is a floweret,
'Tis called Forget-me-not,
Wear it upon thy heart
And think of me!
Flower and hope may die,
Rich, dear, are you and I,
Our love can't pass away,
Sweetest, believe.
If I a bird could be,
Soon would I speed to thee,
Falcon nor hawk I'd fear
Flying to thee.
When by the fowler slain
I in thy lap should lie,
Thou sadly shouldst complain,
Gladly I'd die.

How deep-seated the respect for woman was among the German people in those times is also shown by the reception extended to Isabella, the sister of King Henry II. of England. When in 1235 she arrived at Cologne, to become the bride of Emperor Frederick II ten thousand citizens, headed by all the clergy in full ornate, went out to greet her with joyful songs. While all the bells were ringing, children and young girls bestrewed the bride's path with flowers.

From Cologne the bride went by boat up the River Rhine to Castle Stolzenfels. Here she was met by the Emperor, who received his betrothed on bended knee. From there both went to Worms, where the wedding was celebrated with extraordinary splendor.—

Among the nobility as well as among the patricians weddings were great feasts, which extended over weeks and to which all relatives and friends from near and far were invited. After the priest had given his blessing to the young couple, the servants prepared the banquet table. Bridegroom and bride, occupying the place of honor, sat side by side on the beautiful bridal chair, eating and drinking from the same plate and the same goblet, to indicate, that now they regarded themselves as one soul and one body.

If the young couple belonged to the nobility, the bridegroom led his bride to his castle in a pompous cavalcade. A number of shield-bearers, bedecked with flowers and ribbons, rode ahead, followed by a band of musicians and singers. Then came the bridal pair on horseback, as well as the parents of the bride, and the attendants. Such a cavalcade was hailed everywhere, especially in those villages which belonged to the dominion of the young nobleman. At the gate of the castle, however, the parents of the bridegroom and all the other inhabitants of the castle were waiting to welcome the new mistress with all honor.

Figure 34. A Bridal Party. After a painting by L. Herterich.

It must be said emphatically, that the great respect paid to their women by the Germans was indeed well deserved. For the majority of the German women were not merely good housekeepers, affectionate wives and loving mothers, but at the same time patronesses of everything that is beautiful. It was for them, that the homes became comfortable and artistic, as most of those exquisitely carved chests, buffets, tables, chairs and beds, which are now the show-pieces of our museums, were ordered by rich women fond of art. They adorned the cupboards of their cozy and paneled rooms with costly vessels of crystal and silver; they covered the floors with fine rugs and hung the walls with tapestries, etchings and paintings of famous masters.

This taste for the beautiful would not allow the exterior of the houses to be neglected. Carvings, paintings and flowers were seen everywhere; even the most insignificant objects, such as the weather-vanes on the roof, and the brass-knockers on the doors were ornamented.

THE GLORIOUS TIME OF THE RENAISSANCE

The close contact which, during the middle ages, existed between Germany and Italy also secured better conditions for the women of the latter country. The most remarkable change came, however, during the 14th and the 15th centuries, with that remarkable intellectual revolution known as the Renaissance.

This movement, one of the most significant in the evolution of woman, originated in Italy at a time when the whole country was suffering from ecclesiastic and feudal despotism. It was then that men and women of high standing, striving for greater spiritual freedom, became attracted by the almost forgotten works of Plato, Aristotle, Socrates, Seneca, Cicero, and other authors of the classic past. It is to the glory of Dante, Petrarch, Boccaccio, and other poets of Italy to have revived interest in these literary treasures. Eager to unlock these rich stores of beauty and wisdom, they collected the precious manuscripts and established libraries and museums for their preservation.

Many noblemen, patricians and merchant-princes, inspired by this sacred thirst for learning, and being aware that this effort was made in behalf of the emancipation of enslaved intelligence, aided the movement by their wealth. The art of printing with movable types, invented in 1450 by Johannes Gutenberg in Mayence, and introduced into Italy, France and Spain by German printers, made it possible to reproduce what the collectors had recovered. So learning remained no longer the pursuit of monks and recluses only, but became fashionable and pervaded all classes. Professors of classic literature and of humanism began to journey from city to city, opening schools and lecture-rooms, or taking engagements as tutors in the families of the princes, noblemen, and wealthy merchants.

The universities, founded at Bologna, Padua, Salerno and various other places, gave special attention to classical education and humanism. And, strange to say, all these schools and universities admitted women on equal terms with men. The number of women, who availed themselves of this privilege, may have been small, but evidently the

way was clear. There were even several ladies, who acquired the degrees of doctor and professor of Greek language and literature, or of civil and canon law. Among these learned women were *Britisia Gozzadina*, who held a chair in the university of Bologna; and *Olympia Morata*, who, with her German husband, came to Heidelberg, where the chair for Greek at the university was offered to her.

It was this revival of antique learning, art and science, and its application to the literature of the 16th Century, that shattered the narrow mental barriers imposed by mediæval orthodoxy.

The stimulating movement met with full success, when a number of Italian princesses, in sincere enthusiasm, took the leadership. Among these ladies were *Elisabeth Gonzaga*, Duchess of Urbino; *Isabella d'Este*, Marchioness of Mantua; *Caterina Sforza,* Countess of Forli; *Veronica Gambara,* Countess of Corregio; *Lucrezia Borgia*, Duchess of Ferrara; the poetess *Lucrezia Tornabuoni* of Florence, and *Cassandra Fidelis,* "the pride and glory of Venice." But above all stood the famous *Vittoria Colonna*, Marchioness Pescara, one of the most wonderful women of these great times.

Ariosto said of her: "She has more eloquence and breathes more sweetness than all other women, and gives such force to her lofty words that she adorns the heavens in our day with another sun. She has not only made herself immortal by her beautiful poems and style, than which I have heard none better, but she can raise from the tomb those of whom she speaks or writes, and make them live forever."

Michael Angelo, to whom she was a close friend as well as an inspiration, and a polar star, wrote: "By her genius I was raised toward the skies; in her soul my thought was born; without wings, I flew with her wings."

Such exceptional women made their courts and drawing rooms the gathering places of the most refined and beautiful ladies of the time, of great artists like Raphael Sanzio, Leonardo da Vinci, Michael Angelo, Titian, Corregio and Bellini, of famous authors, poets and philosophers like Tasso, Ariosto, Bembo, and of distinguished statesmen, dignitaries and men of the world. They met here to listen to interesting debates about Humanism, the new doctrine, that man must endeavor to reconstitute himself as a free being, and throw off the shackles, that held him the thrall of theological despotism. They also read the classic philosophers, enjoyed the inspiring works of composers, or harkened to the wonderful accounts of daring discoverers, just returned from adventurous expeditions to India and the New World.

Most attractive affairs were the festivals of the Roses, held in spring. Then poets and poetesses contested with their latest songs, rondos and sonnets, to be awarded laurel-wreaths or roses of gold and silver.

It was at such gatherings that intimate friends united sweet discourses and platonic adoration, as shown in the following charming poem, written in those idyllic times:

"Donne e donzelle e giovanette accorte
rallegrando si vanno a le gran feste
d'amor si punte e deste
che par ciascuna che d'amar appaghi
e l'altre a punto in gonnellette corte
ginocano a l'ombra delle gran foreste,
tanto leggiadre e preste,
quai solean ninfe stare appresso i laghi
e in giovanetti vaghi
veggio seguire e donnear costoro
e talora danzare a mano a mano."

Translated these rhymes mean:

"I behold lovely women and maidens as they joyfully hurry to the great feast. Struck and awakened by love they flourish with sweet desire. I see them at play in the shadows of the forest, and running with flowing garments, agile and graceful like nymphs at the border of the lakes. Bright young men follow these sweet women to amorous play. Here and there some of these happy couples disappear, wandering hand in hand."

It is difficult for us, to realize the great changes brought about by this movement in social manners as well as in the position of women. "To be a gentleman," so J. A. Symonds says in his book "Renaissance in Italy," "meant at this epoch to be a man acquainted with the rudiments at least of scholarship, refined in diction, capable of corresponding or of speaking in choice phrases, open to the beauty of the arts, intelligently interested in archæology, taking for his models of conduct the great men of antiquity rather than the saints of the church. He was also expected to prove himself an adept in physical exercises and in the courteous observances which survived from chivalry."

What was expected of a lady of rank we learn from a very interesting booklet, written in 1514 by Count Baldassare Castiglione, entitled "Libro del Cortegiano." According to this "Manual for Courtiers" a lady should not be inferior to her husband in intellectual accomplishment and be able to read and write Latin. In classic literature as well as in music and arts she should be versed to such an extent as to have a correct judgment of her own; while she should possess individuality, her behavior should be easy but graceful and blameless. It was also expected that she should cultivate her personal merits and beauty.

"Beauty," so the manual says, "is of far greater importance to a lady than to a gentleman, because it is a divine gift which loses its charm when connected with an unworthy person. In her whole appearance, in her words, actions and attitude a lady must remain different from man. While virility should distinguish him, a lady should never try to copy him and be masculine. By nature woman is not inferior to man, therefore she

should not imitate him. Both sexes are created to enjoy equal rights, but each sex has its own and individual right."—

Figure 35. In Italy during the Time of the Renaissance. After a painting by Jacques Wagrez.

From Italy the Revival of Learning with its new conceptions of philosophy and religion spread to France, Germany, the Netherlands, and England, stimulating everywhere great intellectual life and achievements.

In France it was ushered in by *Christine de Pisan*, the first French lady of the 14th Century who, at least in prose, gave evidence of a finished literary perception. In her works, which were often copied, she tried to rouse the self-respect of women by informing them about their sphere and duties. By her work "Cité des Dames" she made

them acquainted with the character of famous women of the past, and endeavored to inspire their minds in order that they might join in the ethical efforts of the time.

Christine de Pisan was perhaps also the first woman, who opened a sharp protest against the narrow views many men of her time had in regard to woman's abilities and position. Defying the prejudice of woman's inferiority, she gained a complete victory in her literary skirmishes over several clergymen of high standing.

Figure 36. Accused of Witchcraft. After a painting by F. Piloty.

In Germany the cities of Nuremberg, Augsburg, Strassburg and Basel became the centers of learned societies, who gathered around scholars like Schedel, Pirckheimer, Agricola, Peutinger, Reuchlin and Brant. Here also Dürer, Holbein, Cranach, Schongauer and Vischer enriched the world with works of art that rank among the greatest of the Middle Ages. But most important of all, in Germany that great religious movement started which was in truth the Teutonic Renaissance: the Reformation, in which Luther, Melanchton, Hutten and Erasmus were the leading spirits.

Kindred movements were started in Switzerland by Zwingli, in France by Lefevre d'Estaples, Berquin and Calvin; in England by Wycliffe, Bilney, Cranmer and Cromwell.

While so numerous men and women strove for greater physical and intellectual liberty, ecclesiastic despotism, to prevent anybody from thinking independently,

denounced all free thinkers as heretics who must be exterminated by fire and sword. The life of many brilliant men and women ended at the stake or on the scaffold. But far greater numbers perished through obscure superstition, for the spread of which the Church was in the first place responsible.

Chapter 16

THE DARKEST CHAPTER IN WOMAN'S HISTORY

The belief in witchcraft, witches, evil spirits and devils is as old as humanity. It prevailed among all primeval people as well as among all nations of the classic past and the middle ages. It still exists among many nations who call themselves civilized. Witches have been and are feared as persons, who maintain intercourse with evil spirits, demons or devils. They are believed to be able, through the assistance of these spirits, of inflicting injury on other people, who attract their dislike and hatred. In former times people were convinced, that such witches could transform themselves into animals, clouds, water, rocks, trees or anything else; that they could cause disastrous thunderstorms, hail, invasions of grasshoppers, whirlwinds and droughts; that they could steal the dew and the rain, hide the moon and the stars, and produce plagues in men and cattle.

From the Hebrews, who were firm believers in witchcraft and sorcery, this superstition was handed down to the early Christians, and with the extension of Christianity, it affected all other European nations. The earliest ecclesiastical decree against witchcraft appears to have been that of Ancyra, 315 A. D., condemning soothsayers to five years' penance. In canon law the Decretum subjected them to excommunication as idolators and enemies of Christ. And in accordance with the command of Moses: "Thou shalt not suffer a witch to live," all women suspected of witchcraft were killed.

Later on the Popes John XXII and Eugene IV issued bulls exhorting all Christians to greater diligence "against heretics as well as the human agents of the Prince of Darkness, and especially against those who have the power to produce bad weather." To exterminate these enemies of the Holy Faith all fighting forces of the church were set in motion, among them an institution, which had been founded in Spain during the 12th Century: the Inquisition.

As its name, derived from the Latin "inquirere," indicates, it was the office of this institution to inquire about, or spy into all sins committed against the Holy Faith and the authority of the church, and to deliver witches as well as heretics to the proper authorities for punishment.

Confirmed and sanctioned by the Popes, this Inquisition had already performed excellent work during the crusades against the Albigenses and Waldenses. But the most vigorous crusade against witchcraft began when in 1484 Pope Innocent VIII published his bull "Summis desiderantes affectibus," of which Andrew D. White in his "History of the Warfare of Science with Theology" has said that of all documents, ever issued, this has doubtless caused the greatest shedding of innocent blood.

By this bull several professors of theology were appointed as inquisitors for large parts of Germany, with full power to prevent the further spread of heresy and witchcraft. The clergy as well as all other authorities were warned that these inquisitors must not be hindered in any way nor by anyone. "All who try to do so, will be, whatever office they may hold, subdued by excommunication, suspension, interdict and other still more terrible punishments, without any appeal: and if necessary, they shall be turned over to the civil authorities. It shall not be permitted to anyone to act wantonly contrary to our message. Whoever may try to do so, should know that he directs upon himself the wrath of Almighty God as well as of the Apostles Peter and Paul."

Under the authority of this bull the inquisitors opened in Germany not only a systematic crusade against witchcraft, but at the same time prepared a manual, the Malleus Maleficarum, or "the Witch-Hammer," which became the great text-book on procedure in all witchcraft cases. Never before had a volume been published that contained an equal amount of idiotic superstition. And never before nor after has any book caused more unnecessary suffering, misery, and disaster. When J. Scherr, one of the foremost historians of Germany, said that this bungling composition was written with the venom of monks, who had become crazy with violent fanaticism, voluptuousness, avarice and the passion for cruelty, he spoke only too true.

Of the unfortunate human beings, who fell victims to this madness, the overwhelming majority were women.

In fact, the authors of the "Witch-Hammer" boldly asserted, that witchcraft is more natural to women than to men, on account of the inherent wickedness of their hearts.

> "What else is woman but a necessary evil, a domestic danger, an attractive temptation, and a natural mischief, painted with nice colors? According to her mind woman seems to belong to another species than man. She is more voluptuous, as is proven by many immodest and lustful acts. This fault became apparent in the creation of the first woman, who was formed out of a crooked rib."

The inquisitors go on to explain:

"Witchcraft is the most unpardonable among all acts of heresy and sins. Generally heretics are punished very severely. If they do not recant, they are burned. If they change for the better, they are imprisoned for life. But such dealing is not rigorous enough for witches. They must be annihilated, even if they regret their sins and announce their readiness to return to our Christian faith. Because the sins of the witches are far greater than the sins of the fallen angels and of the first men."

After having made these statements, the authors of the "Witch-Hammer" explain what witches are able to do to their unsuspecting fellow-men in violation to the rules of the church.

Decency forbids the translation and reprinting of those passages which deal with the character of the obscene acts, charged to witches. We must confine ourselves to the remark that they were accused of sexual intercourse with innumerable devils, and that, in describing the various forms of such intercourse, the authors of the "Witch-Hammer" revealed their own infernal depravity.

To point out only a few of the countless crimes ascribed to witches: it was asserted that witches, disguised as midwives, killed unborn children and tormented the unfortunate mothers by sharp thorns, bones and pieces of wood, produced in their wombs. Other witches, by looking at mothers and cows, made them dry; they also prevented milk from being churned into butter. By dipping brooms into water and swinging them in the air, numerous witches were accused of having caused terrible thunderstorms. Witches also stopped springs, wells and rivers from flowing; others caused an invasion of earthworms, mice, locusts, and other vermin.

To remain undetected in the performance of such hellish tricks, the witches transformed themselves into dogs, cats, owls, bats and other animals.

But the most horrible crime imputed to witches, was, that during certain nights they would go up chimneys and ride on broomsticks, goats, or pigs through the air to some bald hill, to take part in the celebration of the Witch-Sabbath. Here they would meet their master, Satan, whose upper half is that of a hairy man with a pale face and round fiery eyes. On his forehead he has three horns, the middle one serving as a lantern and radiating light similar to that of the full moon. The lower half of Satan's body is that of a buck, but the tail and the left foot are those of a cow, while the right foot has the hoof of a horse. Assisted by innumerable devils of lower degrees Satan would preside over the Sabbath, during which the most sacred ceremonies of the church were ridiculed. Having read the Mass, he would administer the Devil's Sacraments and the Devil's Supper, after which the whole assemblage would indulge in the most obscene orgies.

Even more nauseating volumes on witchcraft were published in Italy, Spain, France and the Netherlands. Their authors had wrenched the most insane confessions from

tortured women about their carnal intercourse with the Prince of Hell and with hosts of other evil spirits. Notwithstanding the absurdity of such confessions they were believed by the superstitious priests as well as by the people, because the Popes and all other dignitaries of the church approved of such books and summoned every true Christian to join in the universal warfare upon witchcraft.

As superstition, like hysteria and other mental diseases, is contagious, it cannot surprise us that the belief in witches also affected the countries in which the Reformation had taken root. We must consider that in these times education was still confined to a few. It was a privilege of the wealthy and of a small number of distinguished thinkers. Even these stood entirely under the influence of the Bible, and they believed, as the example of Luther proves, in the corporal existence of the devil and evil spirits. Among the common people, who grew up in blind credulity, enlightenment made very slow progress.

Thus, all Christianity became polluted with superstition and the belief in witchcraft. Furthermore, from the European countries it spread to every Spanish, French, Dutch and English colony founded in different parts of the world.

But there is also another explanation for the passionate zeal developed by the inquisitors. By the trials for witchcraft the church as well as the inquisitors and other officials grew enormously rich, as all property of the witches and their families was confiscated under the pretense that the taint of witchcraft hung to everything that had belonged to the condemned. If such property should remain, in the hands of their relatives it might cause them all kinds of misfortune and deliver them also into the hands of Satan.

Where thus suspicion, ignorance and avarice were lying in wait, no woman was sure of her life for one hour. No matter what her social position might be, the slightest grounds of suspicion, or the slandering denunciation by some enemy was sufficient to deliver her into the power of the inquisitors.

Generally the proceedings began with searching the body of the suspected witch for the mark of Satan, as it was asserted that all who consorted with devils had some secret mark about them, in some hidden place on their bodies, as, for instance, on the inside of the lips, between the hair of the eyebrows, in the hollows of the arm, inside of the thigh, or in still more private parts, from whence Satan drew nourishment. To find these marks, was the task of the "Witch-Prickers," who, after divesting the supposed witch of all clothing, minutely examined all parts of her body. If they found a mole or another peculiar blemish, they pricked it with a needle. If the place proved insensitive and did not bleed, this was an undeniable proof that the person had sold herself to the devil, and that she must be turned over to the inquisitors.

Then these human tigers began to ask questions, suggesting satisfactory answers, and if these answers were not equal to a confession of guilt, the prisoner was subjected to tortures which sooner or later surely brought out such answers and in such language as

was suggested to her by the inquisitors. And these answers were given though the poor creature knew that they would send her to the stake or scaffold.

To indicate the horrible sufferings, that hundreds of thousands of delicate and aged women had to go through, a few of the many implements of torture may be described. Robert G. Ingersoll in his great lecture "The Liberty of Man, Woman and Child" has said about them:

"I used to read in books how our fathers persecuted mankind. But I never appreciated it. I read it, but it did not burn itself into my soul. I did not really appreciate the infamies that have been committed in the name of religion, until I saw the iron arguments that Christians used. I saw the Thumb-screw—two little pieces of iron, armed on the inner surface with protuberances, to prevent their slipping; through each end a screw uniting the two pieces. And when some person denied the efficacy of baptism or her guilt of witchcraft, then they put his thumb between these pieces of iron and in the name of love and forgiveness, began to screw these pieces together. When this was done most men said "I will confess!" Probably I should have done the same and I would have said: "Stop! I will admit that there is one god or a million, one hell or a billion; suit yourselves; but stop!"—

"But there was now and then a person who would not swerve the breadth of a hair. Heroism did not excite the respect of our fathers. The person who would not confess or recant was not forgiven. They screwed the thumb-screws down to the last pang, and then threw their victim into some dungeon, where, in the throbbing silence and darkness, he might suffer the agonies of the fabled damned. This was done in the name of love—in the name of mercy—in the name of the compassionate Christ!

"I saw, too, what they called the Collar of Torture. Imagine a circle of iron, and on the inside a hundred points almost as sharp as needles. This argument was fastened about the throat of the sufferer. Then he could not walk, nor sit down, nor stir without the neck being punctured by these points. In a little while the throat would begin to swell, and suffocation would end the agonies.

"I saw another instrument, called the Scavenger's Daughter. Think of a pair of shears with handles, not only where they now are, but at the points as well, and just above the pivot that unites the blades, a circle of iron. In the upper handles the hands would be placed; in the lower the feet; and through the iron ring, at the center, the head of the victim would be forced. In this condition, he would be thrown prone upon the earth, and the strain on the muscles produced such agony that insanity would in pity end his pain."

"I saw the Rack. This was a box like the bed of a wagon, with a windlass at each end, with levers, and ratchets to prevent slipping; over each windlass went chains; some were fastened to the ankles of the sufferer; others to his wrists. And then priests, clergymen, divines, saints, began turning these windlasses, and kept turning until the ankles, the knees, the hips, the shoulders, the elbows, the wrists of the victim were all dislocated, and the sufferer was wet with the sweat of agony. And they had standing by a physician to feel his pulse. What for? To save his life? Yes. In mercy? No; simply that they might rack him once again.

"This was done, remember, in the name of civilization; in the name of law and order; in the name of mercy; in the name of religion; in the name of the most merciful Christ."

Christian people in England had invented a machine called the "Witches' Bridle." It was so constructed that by means of a loop which passed over the victim's head, a piece of iron having four points or prongs was forcibly thrust into the mouth. Two of these prongs pressed against the tongue and palate, the other outward to the cheeks. This infernal instrument was secured by a padlock. At the back of the collar was fixed a ring, by which to attach the witch to a staple in the wall of her cell. Thus "bridled," and day and night watched over by some person appointed by her inquisitors, the unhappy creature, after a few days of such torture, maddened by misery and pain, would be brought to the point of confessing anything in order to be rid of her wretched life.

But thumb-screws, the collar, the scavenger's daughter, the rack and the bridle were not the only means of inflicting pain devised by the ingenuity of cruelty. There was also the "Spider," a diabolic implement with curved claws, for tearing out a woman's breast. There were the iron Spanish Boots, the inner sides of which were set with points. After these machines had been placed around the lower legs of the victim they were screwed so tightly that often the shin-bones were crushed. To increase the horrible pain the torturer from time to time knocked with a hammer on the screws, so that sharp shocks like strokes of lightning shot through the victim's body.

Another implement was an iron band which was fastened around the head and screwed tight and tighter until the eyes of the maltreated person protruded and she went almost crazy.

If the rack had not brought confession, the inquisitors ordered the "Elevation."

After the writhing sufferer's hands had been tied to the back, a rope, running over a pulley on the ceiling, was fastened to the hands. Then, by pulling the rope, the body of the victim was slowly lifted until the contorted and dislocated arms stood over the head, while the feet were high above the floor. To render such torment more severe, heavy stones were fastened to the feet, and now and then the body was allowed to drop suddenly, only to be lifted again after a while. In this dangling position the heretic or witch was often left for hours, while the tormentors sat in some nearby saloon over their ale and wine.

There were many other methods of torment, each more cruel than the others, among them the gradual pouring of water drop by drop on a particular part of the head or body, or the pouring of water onto a piece of gauze in the back of the throat, thus gradually forcing the gauze into the stomach. Boiling hot oil, burning sulphur and pitch, or molten lead were poured on the naked body, or the poor creatures were incessantly pricked and prodded in their dungeons so that they could not rest a second for weeks at a time, until they were finally driven to despair and madness.

Figure 37. A Supposed Witch before the Tribunal of the Inquisition. After a painting by H. Steinheil.

No periods in human history are more terrible, revolting and depressing to contemplate than these times of the Inquisition and of persecution for witchcraft. The student, who has courage enough, to go through the blood-stained documents of these dreadful times, must feel as Ingersoll felt when he said:

"Sometimes, when I read and think about these frightful things, it seems to me that I have suffered all these horrors myself. It seems sometimes, as though I had stood upon the shore of exile and gazed with tearful eyes toward home and native land; as though my nails had been torn from my hands, and into the bleeding quick needles had been thrust; as though my feet had been crushed in iron boots; as though I had been chained in the cell of the Inquisition and listened with dying ears for the coming footsteps of release; as though I had stood upon the scaffold and had seen the glittering axe fall upon me; as though I had been upon the rack and had seen, bending above me, the white faces of hypocrite priests; as though I had been taken from my fireside, from my wife and children, taken to the public square, chained, as though fagots had been piled about me; as though the flames had climbed around my limbs and scorched my eyes to blindness, and as though my ashes had been scattered to the four winds, by all the countless hands of hate."

From the records of trials for witchcraft still preserved in the archives of many European cities, it appears that the majority of victims were aged women; very frequently

they had reared families and spent their youth and beauty in this self-denying work. But there are also many cases of the torturing of mere children; in several such cases little girls of seven and nine years gave affirmative answers to questions, as to whether they had held sexual intercourse with the devil. They even admitted to have given birth to children in consequence of such intercourse. A record covering the years 1627, 1628 and January, 1629, states that during this period in Wurzburg, Bavaria, one hundred and sixty-three persons were tortured, and burnt at the stake. Among them were seventy-two women, and twenty-six children under fourteen years. Among the latter were little girls of nine years or less, and one was a little blind girl.

On March 7, 1679, in Heimfels, Tyrol, a poor woman, Emerencia Pichler, was brought before the inquisitors. In spite of her solemn pledges by God and the Virgin that she knew nothing about witchcraft she was submitted to torture. On the third day of her sufferings the inquisitors wrung from the unfortunate creature a confession, that Satan had visited her one day, wearing a blue jacket, a white vest and red socks. In his company she made a flight to a high mountain, both riding on the same oven-shovel. Here they took part in the witches-sabbath, during which several infants were killed and eaten. The remains were used in concocting all kinds of ointments and powders, to be used in the producing of thunderstorms and plagues. The most horrible part of these confessions was that the woman, when questioned about accomplices, in her agonies named twenty-four persons, among them her own four children. Of course the poor woman withdrew her confessions, when the tortures were interrupted. Nevertheless she was found guilty. On her way to the place of execution she was twitched with red-hot pincers and afterwards burnt at the stake.

Her two oldest children, a boy of fourteen and a girl of twelve, were beheaded and their bodies burnt to ashes on July 29, 1679. Their little brother Sebastian, nine years old, and his sister Maria, six years old, were terribly flogged and forced to attend the execution of their mother and playmates.

Of all the other "accomplices," named by the woman, not one escaped the clutches of the inquisitors and death at the stake.

There are on record thousands and thousands of similar cases, many of them horrible beyond belief and defying description. No country in Europe escaped the visitation of such inquisitors, many of whom journeyed from place to place in search of victims. In numerous cities the arrival of these fiends was regarded with greater fear than famine or pestilence, especially by women, against whom their malice was chiefly directed. That there was cause for such fear, is proven by the fact that in Treves seven thousand women lost their lives. In Geneva five thousand were executed in a single month. And in Toulouse, France, four hundred witches were burnt in one day, dying the horrible death by fire for a crime which never existed save in the imagination of their benighted persecutors.—

Among the countless women burnt as witches was also Jeanette d'Arc, who to-day is glorified by the French nation as *Jeanne d'Arc*, the Maid of Orleans, and who has been lately canonized. Born about 1411 at Dom-Remy, a small village in the Champagne, she witnessed the conquest of Northern France by the English. While brooding over this mishap, it became fixed in her mind that she was destined to deliver France from these invaders. This impression was strengthened by a number of visions, in which she believed to see St. Michael, the archangel of judgments and of battles, who commanded her to take up arms and hurry to the assistance of the king. In February, 1429, she set out on her perilous journey to the court of the Dauphin at Chinon. Here she succeeded in convincing the king of the divinity of her mission, so that she was permitted to start with an army of 5000 men for the relief of Orleans. Clothed like a man in a coat of mail, and carrying a white standard of her own design, embroidered with lilies and the image of God, she inspired her followers with a religious enthusiasm. Favored by good luck she entered the besieged city on the 29th of April, 1429, and by incessant attacks so discouraged the enemy that they withdrew on the 8th of May. However, in several other enterprises her luck failed, and on the 24th of May, after an unsuccessful sortie, she was taken prisoner through treachery, because, being pursued by the enemy, some Frenchmen shut the gates of the fortress into which she should have escaped.

With her capture the halo of supernatural power that had surrounded her, vanished. Accused of being a heretic and a witch, she was turned over to the Inquisition for trial. Her examination lasted six days. Among other insidious and indelicate questions on the subject of her visions she was asked whether, when St. Michael appeared to her, he was naked, and if she had entertained sexual intercourse with the devil. But no point seemed graver to the judges than the sin of having assumed male attire. The judges told her that according to the canons, those who thus change the habit of their sex, are abominable in the sight of God.

The decision to which the inquisitors finally came, was that the girl was wholly the devil's; was impious in regard to her parents; had thirsted for Christian blood, adhered to a king who was a heretic and schismatic, and was herself a heretic, apostate and idolator. For all these crimes she was sentenced to death, and burnt alive on the market place of Rouen, May 30th, 1431.—

As has been stated already persecutions for witchcraft were not confined to European countries, but were also carried on by Christian priests and judges in all colonies established by Europeans on other continents. In the British colonies of North America the most sensational trial for witchcraft was that in Salem, Massachusetts, about which J. M. Buckley in an article written for the Century Magazine (Vol. XLIII, pp. 408–422) speaks as follows:

"The first settlers of New England brought across the Atlantic the sentiments which had been formed in their minds in Great Britain and on the Continent, as well as the tendencies which were the common heritage of such an ancestry. They were a very religious, and also a credulous people; having few books, no papers, little news, and virtually no science; removed by thousands of miles and months of time from Old-World civilization; living in the midst of an untamed wilderness, surrounded by Indians whom they believed to be under the control of the devil, and whose medicine-men they accounted wizards. Such a mental and moral soil was adapted to the growth of witchcraft, and to create an invincible determination to inflict the punishments pronounced against it in the Old Testament; but the co-operation of various exciting causes was necessary to a general agitation and a real epidemic.

Figure 38. Women, Condemned for Witchcraft, Burnt at the Stake.

"Salem witchcraft thus arose: The Reverend Mr. Parris, minister of the church in Salem village, had formerly lived in the West Indies, and brought some negro slaves back with him. These slaves talked with the children of the neighborhood, some of whom could not read, while the others had but little to read. In the winter of 1691–92 they formed a kind of circle which met at Mr. Parris' house, probably unknown to him, to practice palmistry and fortune-telling, and learn what they could of magic and necromancy.

"Before the winter was over some of them fully believed that they were under the influence of spirits. Epidemic hysteria arose; physicians could not explain their state; the cry was raised that they were bewitched; and some began to make charges against those whom they disliked of having bewitched them. In the end those of a stronger mind among them became managers and plotters directing the rest at their will. By the time public attention was attracted Mr. Parris had come to the conclusion that they were bewitched and, having a theory to maintain, encouraged and flattered them, and by his questions made even those who had not believed themselves bewitched think that they were.

"From March, 1692, to May, 1693, about two hundred persons were imprisoned. Of these some escaped by the help of friends, some by bribing their jailors; a number died in prison, and one hundred and fifty were set free at the close of the excitement by the proclamation of the Governor. Nineteen were executed, among them George Burroughs, a minister of the Gospel.

"When it is remembered that a number of these persons were among the most pious and amiable of the people of Salem; that they were related by blood, marriage, friendship, and Christian fellowship to many who cried out against them, both as accusers and supporters of the prosecutions, the transaction must be classed among the darkest in human history."

Several historians have made attempts to ascertain the number of men, women and children, who lost their lives through this abominable superstition. O. Waechter, who published a book about this subject, calculates that the number of victims must have been at least three millions! Imagine, what a terrible amount of sighs, tears, and physical and mental agonies this number represents!

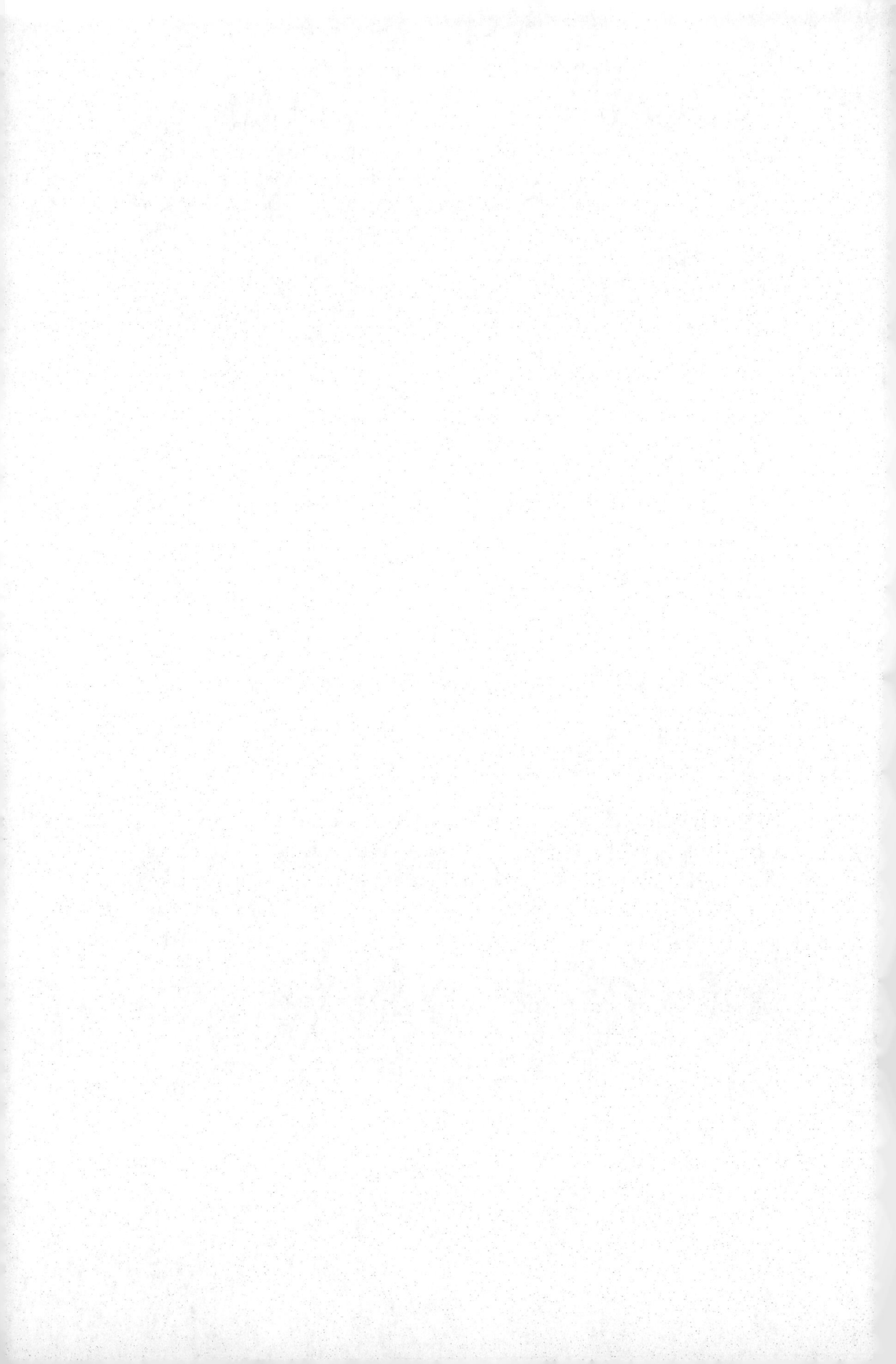

PART IV. WOMEN IN MODERN TIMES

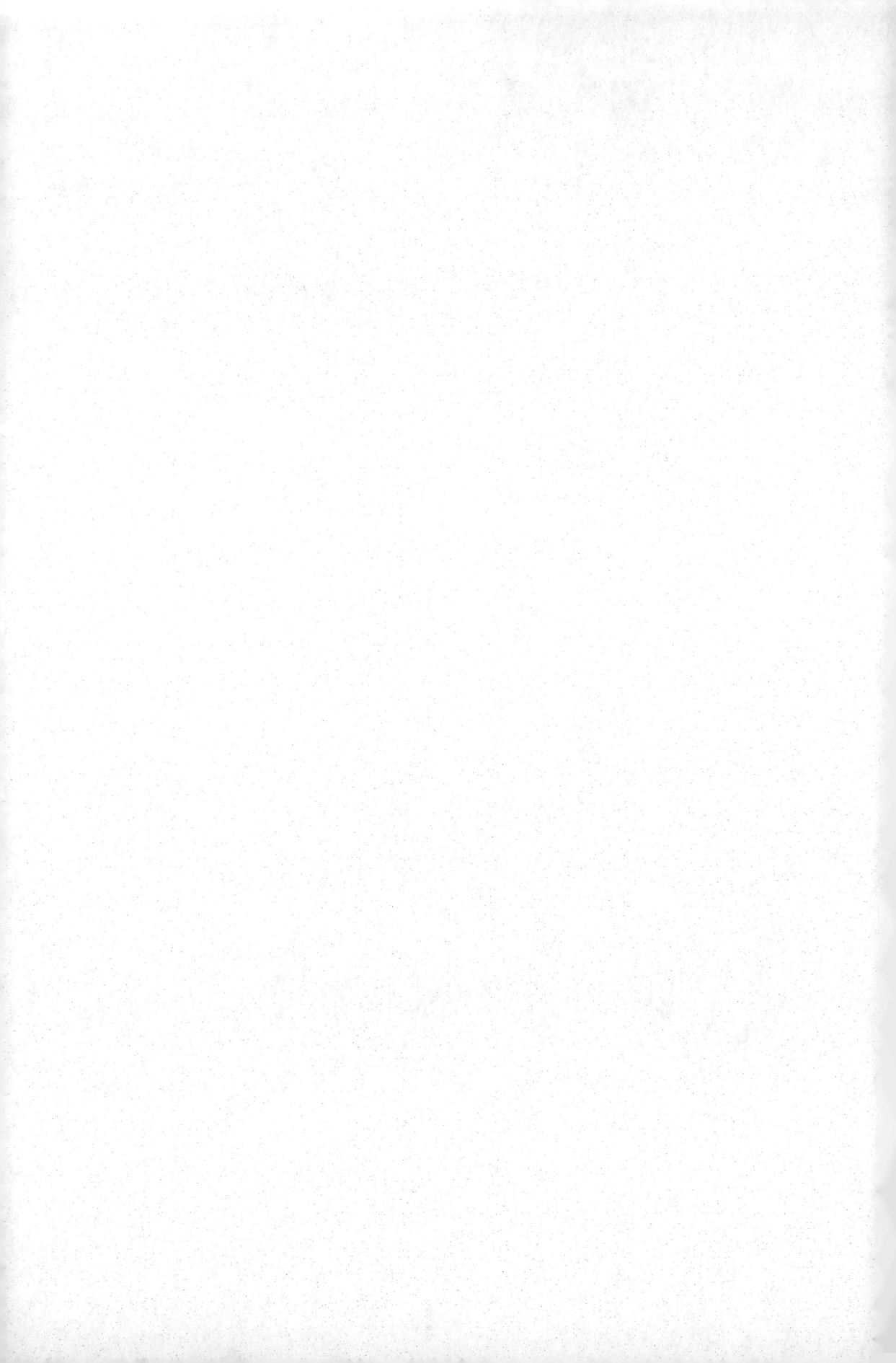

Chapter 17

WOMAN IN SLAVERY

Figure 39. Disposing of Exhausted Captives.

When our historians date the beginning of Modern Times from the discovery of America by Christopher Columbus, they are fully justified, as no other event has caused so many radical changes in the thoughts of men as well as in all commercial and social conditions. The earlier views about our terrestrial globe and its relation to the universe gave place to new and far greater conceptions. Almost every day brought new and astonishing disclosures in natural history, physics and other spheres of science.

The end of the 15th and the beginning of the 16th Century was also the time of the Renaissance as well as of the Reformation, of a revival of the wisdom of the classic past and of the rise and establishment of new sublime ideas about God and the destiny of man.

It could not fail that in this period of spiritual fermentation and inspiration the views about women, matrimony and woman's rights likewise underwent considerable changes. But before these new conceptions found general acceptance many mediæval traditions, prejudices and customs had to be overcome and cleared away.

While the discovery of America brought incredible riches to various European nations, it caused nothing but misery and disaster to the aborigines of the New World. And to many million Africans as well.

It must not be forgotten that the conquest of Mexico, Peru and other rich parts of America inflamed the greed of inumerable adventurers, and that these men, in order to wring gold and other treasures from the natives, resorted to the most heartless cruelties. We also must call to mind, that in company with these conquerors went hosts of monks and priests of all orders, eager to convert the "heathen" to the "only true creed." Ruthlessly invading the temples of the "infidels," they turned the banner of the Cross, this beacon light of promise, into an awful oriflame of war, spreading destruction and disaster. The well known accounts, given by the Spanish bishop Las Casas, disclose among other horrible events the fact—heretofore unheard of in human history—that whole bands and tribes of American Indians, to evade the tyranny of their European oppressors, slaughtered their own children, and then committed suicide.

These Indians had been compelled not only to work in the gold mines and in the pearl fisheries, but to perform all other labor that white men were unable or unwilling to do. As under the cruel treatment of their oppressors the natives rapidly dwindled away and whole islands became depopulated the Portuguese as well as the Spaniards resorted to the importation of negro slaves, whom they captured in Africa and brought to America.

It was not long before the profits, derived from this trade, attracted the eyes of English adventurers. The first to become engaged in that new branch of business, was William Hawkins. It was he who undertook the first regular slave hunts to the coast of Guinea and opened that shameful traffic in which England was engaged for nearly three centuries. His son, John Hawkins, sailing under a charter of Queen Elizabeth, continued the lucrative business and grew rich.

That this men-hunter imagined himself under the special protection of the heavenly father appears from several entries in his log-book. When, invading a negro village near Sierra Leone, he almost fell into captivity himself and would have been exposed to the same fate that he inflicted, without compunction, upon thousands of other unfortunate men and women, he wrote: "God, who worketh all things for the best, would not have it so, and by Him all escaped without danger; His name be praised for it." At another time, when his vessels were becalmed for a long time in midocean and great suffering ensued:

"But Almighty God, who never suffereth His elect to perish, sent us the ordinarie Breeze, which is the northwest wind."

To what extent the name of Christianity was abused, we see from the fact that Hawkins, when entering upon his greatest expedition with five ships in 1567 sacrilegiously named his flagship "Jesus Christ."

Because of the riches Hawkins brought to England, Queen Elizabeth knighted him and granted him a coat of arms, showing, on a black shield, a golden lion rampant over blue waves. Three golden doubloons above the lions represented the riches Hawkins had secured for England. To give due credit to the piety of this "nobleman," there was in the upper quartering of the shield a pilgrim's scallop-shell, flanked by two pilgrim's staffs, indicating that Hawkins' slave-hunts were genuine crusades, undertaken in the name of Christianity. For a crest this coat-of-arms shows the half-length figure of a negro, with golden armlets on his arms, but bound and captive.

In an article entitled "The American Slave," published in "Pearson's Magazine" for 1900, James S. Metcalf states that the slave trade quickly developed to tremendous extent and that from 1680 to 1786 there were carried from Africa to the British colonies in America 2,130,000 slaves, men as well as women. This does not include the number, vastly larger, taken to the Spanish and Portuguese colonies before, during and after the same period.

The same author states, that the traffic in human flesh was a recognized commerce at the London Exchange, and that, in 1771, the English alone sent to Africa 192 ships equipped for the trade and with a carrying capacity of 47,146 slaves per trip.

It was the tribal warfare among the aborigines of Africa that furnished the slave dealers with the greater part of their human merchandise. Small and unprotected villages were constantly in danger of being attacked by powerful roving bands. When in 1872 the famous explorer Nachtigal traveled through Central Africa, he witnessed a tragedy that happened at the shores of Chad Lake. Strong forces of Bagirmis made an assault on a negro village, to capture the inhabitants and carry them off for slaves. Alarmed by their guards, the negroes, terror-stricken, fled to some tree-huts, prepared for such emergency in a nearby forest. Here they considered themselves safe. But unfortunately the enemies were in possession of a few guns, with which they picked a number of the fugitives from the trees like birds. Falling from the dizzy heights, the wounded were hacked to pieces. After a while the cruel enemies succeeded in constructing some rough ladders, by which the trees were scaled. Unable to escape, many of the assaulted, preferring death to slavery, threw themselves upon the ground below, where they perished.

The most desperate fight ensued for the tree-house of the chief. It took several hours, before the enemies succeeded in reaching the lower platform, where within a rude enclosure food, water, and even a few goats had been hidden. Unable to hold this place, the chief with his two wives and four children withdrew to the highest branches. From

there he defended his family with such ability, that the foes, after having exhausted their supply in powder, were compelled to abandon the siege.—

Figure 40. A Raid of Slave-Dealers in Central Africa.

Figure 41. A Slave Transport in Central Africa.

The stronger portion of the captives made during such raids, were shackled hand and foot to prevent escape. The remainder often were killed and the flesh distributed among the victors, who, as a rule, after such a raid formed a small encampment, lighted their fires and gorged upon the human flesh. They then marched over to one of the numerous slave-markets on the rivers or the coasts, where they exchanged the captives with the slave-traders for beads, cloth, brass wire and other trinkets.

Woe to those who became sick or exhausted during the long march to the markets! If unable to stagger on any longer they were, to set an example for the others, either butchered on the spot, or left behind to perish by hunger and thirst, or to be torn by wild beasts.

In the further transportation of such kidnapped men and women no regard was paid to their comfort. In the best of slave-ships the height between decks in the quarters set aside for the living cargo was five feet and eight inches. Even in these not all the slaves had so much head room. Around the sides of the vessel, halfway up, ran a shelf, giving room for a double row of slaves, one above and one below. This was stowed with undersized negroes, including women, boys, and children. In the worst class of slavers the space between decks was no more than three feet, compelling the wretched occupants to make the entire journey in a sitting or crouching position, as they were oftentimes, in fact most of the times, so crowded together that lying down was an impossibility. In fact, the more ingenious traders often so figured out the available space that the slaves were packed in with their feet and legs across one another's laps. To prevent revolt, the men were manacled in couples with leg irons and stowed below. The irons were fastened to the ceiling. As a rule the women were not handcuffed but crowded into compartments

under grated hatches and locked doors. At sea there might be a faint possibility of a breath of air's penetrating into those quarters, but under all circumstances the mortality among the slaves was frightful.

"In the literature of the slave trade," says Metcalff, "the horrors of the path of commerce stand out as prominently as the persecutions of the Roman emperors in the history of Christianity. When the sea gives up its dead there will come from this highway of cruelty a prodigious army of martyrs to man's inhumanity to man. The best authorities agree in estimating that of all the slaves taken from Africa at least one-eighth—some authorities say more than a quarter—died or were killed in transit. It staggers the imagination to think of how thickly the traffic in these helpless savages, continued through almost four centuries, must have strewn with corpses the lower depths of the Atlantic.

"Of course it was necessary, if any part of the cargo was to be delivered alive, that the negroes should occasionally be brought on deck and exercised. This was done with a few at a time, although their masters never went so far as to free even these from their irons. Often it was found when a couple was to be brought up that one of them had died and that his mate had spent hours, days even, in the stifling atmosphere of between-decks, manacled to and in constant contact with a corpse. It is small wonder that, as often happened, when the slaves were brought on deck they began jumping overboard in couples, sooner than return to the heat, thirst, stench, and filth of the hold, where the scalding perspiration of one ran to the body of another and where men were constantly dying in their full view. Sooner than endure these tortures even the savage Africans sought refuge in death by starvation. This was a contingency provided for in advance by the experienced trader, and if the gentle persuasion of the thumb-screw failed to cure the would-be suicide, the ships were always provided with a clever device to compel the human animal to take the nourishment which kept in him the life without which he ceased to possess any pecuniary value. This instrument consisted of a pair of iron compasses, the legs of which were driven into the mouth when closed and then forced open and held open by the action of a screw. Even the African negro, stoic to the pains incident to a life of savagery, would renounce the privilege of death by starvation to escape the immediate agony of forcibly distended jaws, especially when at the same time his thumbs were under the pressure of the screw with blood exuding from their ends."

Branded like cattle, the negroes, after their arrival in the American harbor, were sold by auction. And now the slave was, as the Civil Code of Louisiana said, "subject to the power of his master in such a manner that the master may sell him, dispose of his person, and of his labor. He can do nothing, possess nothing, nor acquire anything but that may belong to his master."

Of course this master had also the right to punish the slave for any neglect or wrong. To be sure, there were laws against excessive punishment, but as most of the plantations were far from the cities, such laws were practically ineffective against those who wished to violate them.

We quote once more J. S. Metcalff:

"Almost every plantation had its whipping post, consisting of an upright set in the ground with a short crosspiece near the top. The thumbs or wrists of the negro to be whipped were securely tied together, and placed around the upright above the crosspiece, so that the toes barely touched the ground. Sometimes the offending slaves were sent to the nearest jail to be whipped by the jailor, who was an expert in his line of work, and provided with the right kind of whips as well as a strong arm and an accurate eye to make his blows inflict the most pain. In other cases, this official paid regular visits to the plantation, and inflicted the punishments accumulated since his preceding visit. Thus the terror of anticipation was often added to the agony of realization. These events were occasions on the plantations, and the other slaves were compelled to witness the punishments and sufferings of their fellows as a deterrent to wrongdoing on their own part. In the case of some offenders which seemed cardinal against the foundation principles of slavery, such as striking a master, engaging in a conspiracy with other slaves, or aiding a fugitive, the punishments were made extraordinarily severe, and slaves from surrounding plantations were obliged by their masters to gather to witness them.

"A case of this latter sort was the one of a negro and his wife, who had given their owner a severe beating. In spite of the fact that the first cause of the trouble was the rejection by the woman of the master's advances, the offence was so flagrant that neighboring slave-owners feared to let it go by without severe and public punishment. At the time set the slaves from neighboring plantations were gathered, and the man and woman fastened to posts near each other. The man was to receive a hundred and fifty lashes and the woman a hundred. As the first strokes fell on the man's back and loins he gave no sound, but the agony betrayed itself in the ashening of his dark skin, and in the involuntary contortion of his features. Meanwhile the woman encouraged him with crude expressions of pity and love. As the blows increased in number the torture became unbearable, and the sound of the regularly landing lash was punctuated with the shrieks of its agonized victim. Finally a blessed unconsciousness came to his relief, and he hung from the post a limp, unfeeling mass of bruised and bleeding flesh. While his back was being washed, the whipping of the woman began. The first blows brought shrieks of anguish from her lips, but as the whipping went on these subsided into a murmur of sobs, prayers, and appeals for mercy. With the exception of an occasional rest for the tired arm of the man wielding the whip, her punishment was carried to its end without her losing consciousness, although it was apparent that there had come some numbing influence to her faculties closely akin to insensibility. The man had now been restored to his senses and his punishment was resumed. When it was finished the wounds of both were washed with salt water, to intensify the effect of the blows, to prevent blood-poisoning and to heal the wounds more quickly, so that the slaves could resume their accustomed labor. This matter of the slave's ability to work was always taken into account, and we have one instance of two economical lady slave-owners in Georgia who always inflicted their punishments Sunday mornings, so that by Monday the slaves would be able to go into the fields."

As the slave-holders were absolute masters over the negroes, they made their dusky female slaves only too often the objects of their passions. The effects of this intermingling were soon seen in all slave-holding countries of America in the mixed character of the population, which, gradually extending itself as time wore on, resulted in the race of the mulattoes. From the intercourse of these again with the whites or among themselves, innumerable shades of color sprang up, giving rise to the distinctions of octoroons, quadroons, terceroons, quinteroons, etc. To all these people, regular or irregular in birth, light or dark in color, were given the various names of "people of color," "sang melée," or "mulattoes." Notwithstanding the fact, that some of these quadroons and octoroons could hardly be distinguished from white people in appearance, their condition followed always that of their mothers, and they were therefore chattels to be bought or sold.

"On the plantations where negro children were brought up to be sold, it was," as Metcalff states, "not an unheard-of thing for a master to sell his own son or daughter. In the break-up of family estates it sometimes happened that the heir was compelled to sell his own half-brother or half-sister. These relationships were seldom or never recognized."

In the slave-markets of New Orleans and the other large cities the personal appearance of the younger women was a decided element in fixing their value. The languorous beauty of the Southern quadroon and octoroon is famous the world over, and on the auction block and at private sale they brought the highest prices.

The glory of having written the first formal protest against slavery and its countless cruelties, belongs to a small band of Mennonites from Germany, who arrived in Philadelphia in 1683, in the neighborhood of which city they started a settlement called Germantown.

Becoming aware that in the colonies slaves were sold without the disapproval of the Puritans and Quakers, who claimed to be defenders of human rights, the Mennonites drew up a protest against slavery on February 18th, 1688. It was the first written in any language. This remarkable document, still preserved in the archives of the "Society of Friends" in Philadelphia, was directed to the Quakers and reads as follows:

"This is to ye Monthly Meeting at Richard Warrel's. These are the reasons why we are against the traffic of men Body, as followeth: Is there any that would be done or handled at this manner? to be sold or made a slave for all time of his life? How fearfull and fainthearted are many on sea when they see a strange vessel, being afraid it should be a Turk, and they should be taken and sold for slaves into Turkey. Now what is this better done as Turks do? Yea rather it is worse for them, which say they are Christians; for we hear that ye most part of such Negers are brought hither against their will and consent; and that many of them are stollen. Now, tho' they are black, we cannot conceive there is more liberty to have them slaves, as it is to have other white ones. There is a saying, that we shall doe to all men, like as we will be done our selves; making no difference of what generation, descent or colour they are. And those who steal or robb men, and those who

buy or purchase them, are they not alike? Here is liberty of conscience, which is right and reasonable; here ought to be likewise liberty of ye body, except of evil-doers, which is another case. But to bring men hither or to robb and sell them against their will, we stand against. In Europe there are many oppressed for conscience sake; and here there are those oppressed which are of a black colour. And we, who know that men must not commit adultery, some doe commit adultery in others, separating wifes from their husbands and giving them to others; and some sell the children of those poor creatures to other men. Oh! doe consider well this things, you who doe it, if you would be done at this manner, and if it is done according Christianity? You surpass Holland and Germany in this thing. This makes an ill report in all those countries of Europe, where they hear off, that ye Quakers doe here handel men like they handel there ye cattel. And for that reason some have no mind or inclination to come hither, and who shall maintain this your cause or plaid for it? Truly we can not do so, except you shall inform us better hereof, that Christians have liberty to practice this things. Pray! What thing on this world can be done worse towards us, then if men should robb or steal us away, and sell us for slaves to strange countries, separating husbands from their wifes and children. Being now this is not done at that manner, we will be done at, therefore we contradict and are against this traffick of menbody. And we who profess that it is not lawful to steal, must likewise avoid to purchase such things as are stollen, but rather help to stop this robbing and stealing if possible; and such men ought to be delivered out of ye hands of ye Robbers and sett free as well as in Europe. Then is Pennsylvania to have a good report, instead it hath now a bad one for this sake in other countries. Especially whereas ye Europeans are desirous to know in what manner ye Quackers doe rule in their Province; and most of them doe look upon us with an envious eye. But if this is done, well, what shall we say is done evil?

"If once these slaves (which they say are so wicked and stubborn men) should joint themselves, fight for their freedom and handel their masters and mastrisses as they did handel them before, will these masters and mastrisses tacke the sword at hand and warr against these poor slaves, like we are able to believe, some will not refuse to doe? Or have these Negers not as much right to fight for their freedom, as you have to keep them slaves?

"Now consider well this thing, if it is good or bad? and in case you find it to be good to handel these blacks at that manner, we desire and require you hereby lovingly, that you may inform us here in, which at this time never was done, that Christians have such a liberty to do so, to the end we shall be satisfied in this point, and satisfie likewise our good friends and acquaintances in our natif country, to whom it is a terrour or fairfull thing that men should be handeld so in Pennsylvania.

"This is from our Meeting at Germantown held ye 18. of the 2. month 1688. to be delivered to the monthly meeting at Richard Warrel's.

"gerret hendericks
derick op de graeff
Francis Daniell Pastorius
Abraham op Den graeff."

This document, set up by the humble inhabitants of Germantown, compelled the Quakers to think. Becoming aware that the traffic in human beings did not harmonize with the Christian religion, they introduced in 1711 an act to prevent the importation of negroes and Indians into Pennsylvania. Later on they also declared themselves against the slave trade. But as the Government found such laws inadmissible, the question dragged along, until 150 years later, by Lincoln's Emancipation Proclamation, this black spot on the escutcheon of the United States was wiped out.

The Germans of Pennsylvania were also compelled to protest against other gross abuses, of which white men and women had become the victims. To review early immigration into America means to open one of the blackest pages of Colonial history. The constant wars, prevailing in Europe, the horrible persecutions to which the followers of certain religious sects were exposed, the frequent times of famine and pestilence led many thousands of unhappy beings to sail for the New World, where such sufferings would not be encountered. But the means of travel, then existing, did not meet the demands. Vessels, fit for the transportation of large numbers, were few and their accommodations extremely poor. Authorities took no interest in the proper treatment of the emigrants. Everything was left to the owners of the ships, who were responsible to nobody.

What sort of people were these shippers? Many were smugglers and pirates, always on the lookout for prey. Others were slave-dealers, making fortunes in trading negro-slaves. No doubt, the moral standard of these gentlemen was very low. Do we wonder that many of these unscrupulous men established also a regular trade in *white* slaves, for which the increasing exodus from Europe to America opened most alluring inducements. If smart enough, they would amass great wealth and would no longer have to make the perilous voyage to Guinea, to kidnap black people at the risk of their own lives. For the white slaves could be seduced by a bait that had a flavor of high-spirited benevolence.

Pretending willingness to help all persons without means, the ship-owners offered to give such persons credit for their passage across the ocean, on condition that they would work for it after their arrival in America, by hiring out as servants for a certain length of time to colonists, who would advance their wages by paying the passage money to the ship-owners. As the persons were redeeming themselves by performing this service, they were therefore called "Redemptioners."

With this harmless-looking decoy many thousands of men and women were lured on to sign contracts, only to find out later that they had become victims of villainous knaves and had to pay for their inexperience with the best years of their lives.

The voyage across the ocean took as many weeks as it takes days at present. The ship-holds were in such horrible condition that words fail to describe them. And these dirty rooms were always packed beyond capacity. The food was poor and insufficient. Some captains kept their passengers on half rations from the day of the start, pretending that it was necessary to prevent famine. In consequence of the poor nourishment and the overcrowded quarters, all sorts of sickness prevailed and the mortality was terrific. For medical help and all other services excessive prices were charged. So it came that at the end of the journey almost all the passengers were deeply in debt. According to their amount and the physical condition of each immigrant the length of time was fixed for which he or she should serve any person, willing to pay the captain the amount of the immigrant's debt. This servitude extended always from four to eight years, and sometimes to more. The captains had no difficulty in turning the bonds, signed by redemptioners, into cash. Cheaper labor could be obtained nowhere, and for this reason the colonists were always eager to secure the services of redemptioners. The offers were made through the newspapers or at the "Vendu," the place where negroes were bought and sold. When applicants came, the redemptioner was not allowed to choose a master or to express wishes about the kind of work that would suit him. Members of the same family must not object to separation. So it happened frequently that a husband became parted from his wife or children, or children from their parents for many years or for life. As soon as the applicant paid the debt of a redemptioner, the latter was obliged to follow him. In case this master did not need his servant any longer, he could hire, transfer or sell him like chattel to someone else.

As in such a case the redemptioner received no duplicate of his contract, the poor creature depended entirely upon the good will of his new master, who had it in his power to keep him or her in servitude far beyond the expiration of the true contract time. If any dispute arose, a redemptioner enjoyed no greater protection than a negro, like whom he was treated in many respects. If found ten miles away from home without the written consent of his master, he would be regarded as a run-away and submitted to heavy physical punishment. Persons guilty of hiding or assisting such fugitives were fined 500 pounds of tobacco for each twenty-four hours such fugitive had remained under their roof. Who captured a run-away was entitled to a reward of 200 pounds of tobacco or 50 dollars. And to the run-away's servitude ten days were added for every twenty-four hours absent, to say nothing of the severe whipping he was liable to get.

The redemptioners went through all sorts of experiences, according to the different tempers of their masters. Some were lucky enough to find good homes, where they were well treated. But many fell into the hands of heartless, selfish people, who in their eagerness to get as much as possible out of the redemptioners, literally worked them to death, to say nothing of providing insufficient food, scanty clothing and poor lodging. Many owners made use of the right to punish redemptioners so frequently and so cruelly,

that a law became necessary whereby it was forbidden to apply to a servant more than ten lashes for each "fault."

Female redemptioners were quite often exposed to lives of shame, which some of the laws seemed to invite. For instance in Maryland a law was passed in 1663 providing that any freeborn white woman, who married a colored slave, should together with her offspring become the property of the owner of that slave.

Originally this abominable law was intended to deter white women from intermarriage with colored men. But many depraved colonists misused this law purposely and compelled their white female servants by threat or deceit to marry colored slaves, as the master then would legally secure permanent possession of the white freeborn woman as well as the children she might bear. Though everybody knew that such devilish tricks were practiced extensively, this law remained in force until 1721, when a peculiar incident led to its repeal. When Lord Baltimore, the founder of Maryland, visited his province in 1681, he brought over an Irish girl, Nellie, who had agreed to redeem the cost of passage to America by doing service. Before her time ended, Lord Baltimore returned to England. Prior to his departure he sold the unexpired term of Nellie's service to a resident of Maryland, who some weeks thereafter gave Nellie to one of his negroes, making her thereby, together with two children that were born, forever his slave. When Lord Baltimore heard of this, he caused the abolishment of the law of 1663. But all efforts to release his former servant and her children were in vain. The case dragged along for years, until the courts decided, that Nellie and her children must remain slaves, as the latter were born before the annulment of the law.

Incidents of similar character stirred the German citizens of Philadelphia to revolt against the unjust treatment to which their immigrant countrymen and women were subjected. At a meeting on Christmas Day of 1764, they formed "*The German Society of Pennsylvania*," with the purpose of securing laws for the abolishment of all abuses which had grown out of the treatment of immigrants. Such a law was secured on May 18th of the following year.

The "German Society of Pennsylvania" became the model for many similar institutions in all parts of America. By uncovering evils and by vigorous persecutions of guilty persons, by continuously framing and recommending effective laws, these societies secured at last a better treatment of the immigrants on the ocean as well as after landing. With full justice these societies may be called the true originators of our modern immigration laws.—

They also established the "Legal Aid Societies," to assist poor people in need of legal advice and help. As these institutions spread over hundreds of cities of America as well as of Europe, we see that since the Christmas meeting in Philadelphia in 1764 untold millions of people have profited by the earnest work, begun by that small band of Germans, who had the welfare of their poor countrymen at heart, and showed what genuine Christmas spirit can do for humanity, if it is only put to a proper purpose.

There existed yet another form of female slavery, the worst of all. With the development of the feudal system in mediæval Europe, which made the poor man, especially the peasant, dependent on the lord or owner of the land he cultivated, the lords appropriated in time unlimited sway over their vassals. Among other rights they claimed not only that to marry him or her to whomsoever the lord might chose, but also absolute control of the vassal's newly wedded bride for the first three days and nights. This custom, known by a variety of names, as "jus primæ noctis, droit de cuissage," "marchetta" or "marquette," had the sanction of the state as well as of the church and compelled newly married women to the most dishonorable servitude. If the female serf pleased the lord he enjoyed her, and it was from this custom, that the eldest son of the serf was always held as the son of the lord, "as perchance it was he, who begot him."

If it should happen that the young bride did not meet the fancy of the lord, he let her alone, but in such case the husband had to redeem her by paying the lord a certain amount of money, the name of which betrayed its nature.

Matilde Joslyn Gage in her able book "Woman, Church and State" has devoted a whole chapter to the history of marquette and says:

> "The seigneural tenure of the feudal period was a law of Christian Europe more dishonorable than the worship of Astarte at Babylon. In order to fully comprehend the vileness of marquette we must remember that it did not originate in the pagan country many thousand years since; that it was not a heathen custom transplanted to Europe with many others adopted by the church, but that it arose in Christian countries a thousand years after the origin of that religion, continuing in existence until within the last century."

She further states that in France even the Bishops of Amiens and the canons of the cathedral of Lyons possessed the right over the women of their vassals, and that in several counties of the Piccardy the curés imitated the bishops and took the right of cuissage, when the bishop had become too old to take his right. She also states, that

> "marquette began to be abolished in France toward the end of the 16th Century, but still existed in the 19th Century in the County of Auvergne, and that the lower orders of the clergy were very unwilling to relinquish this usage, vigorously protesting to their archbishops against the deprivation of this right, declaring they could not be dispossessed.
>
> "But finally the reproach and infamy connected with the 'droit de cuissage' became so great, and the peasants became so recalcitrant over this nefarious exaction, that ultimately both lords spiritual and lords temporal, fearing for their own safety, commenced to lessen their demands."

From a letter, reproduced in the same book, it appears that instances of the survival of the feudal idea as to the right of the lord to the persons of his vassal woman occurred within the last decenniums of the Nineteenth Century. This letter, written by Mr. D. R. Locke, and dated December, 1891, reads:

"One of the Landlords was shot a few years ago and a great ado was made about it. In this case as in most of the others it was not a question of rent. My Lord had visited his estates to see how much more money could be taken out of his tenants, and his lecherous eyes happened to rest upon a very beautiful girl, the eldest daughter of a widow with seven children. Now this girl was betrothed to a nice sort of boy, who, having been in America, knew a thing or two. My Lord, through his agent, who is always a pimp as well as a brigand, ordered Kitty to come to the castle. Kitty, knowing very well what that means, refused. "Very well," says the agent, "yer mother is in arrear for rent, and you had better see My Lord, or I shall be compelled to evict her."

—Kitty knew what that meant also. It meant that her gray-haired mother, her six helpless brothers and sisters would be pitched out by the roadside to die of starvation and exposure, and so Kitty, without saying a word to her mother or anyone else, went to the castle and was kept there three days, till My Lord was tired of her, when she was permitted to go. She went to her lover, like an honest girl as she was, and told him she would not marry him, but refused to give any reason. Finally the truth was wrenched out of her, and Mike went and found a shot-gun that had escaped the eye of the royal constabulary, and he got powder and shot and old nails, and he lay behind a hedge under a tree for several days. Finally one day My Lord came riding by all so gay, and that gun went off. There was a hole, a blessed hole, clear through him, and he never was so good a man as before because there was less of him. Then Mike went out and told Kitty to be of good cheer and not to be cast down, that the little difference between him and My Lord had been settled, and that they would be married as soon as possible. And they were married, and I had the pleasure of taking in my hand the very hand that fired the blessed shot, and of seeing the wife, to avenge whose cruel wrongs the shot was fired.

In the same work we read that another of these British lords in Ireland, Leitram, was noted for his attempts to dishonor the wives and daughters of the peasantry upon his vast estate. His character was equal to that of the worst feudal barons, and like these he used his power as magistrate and noble, in addition to that of landlord, to accomplish his purpose. After an assault upon a beautiful and intelligent girl, by a brutal retainer of his lordship, his tenantry finally declared it necessary to resort to the last means in their power to preserve the honor of their wives and daughters. Six men were chosen as the instruments of their crude justice. They took an oath to be true to the end, in life or death, purchased arms, and seeking a convenient opportunity shot the tyrant to death. Nor were those firing the fatal shots ever discovered.

THE DAWNING OF BRIGHTER DAYS

As the Reformation aimed at the restitution of the purity and simplicity of the first Christian communities, the position of woman in the Church as well as in private life was of course also considered.

As has been shown in former chapters, the authorities of the mediæval Christian Church regarded the daughters of Eve not only as creatures inferior to man, but also as the medium preferred by Satan above all others to lead man astray. Seeing in woman nothing but a necessary evil, they claimed also that a nun is purer than a mother, just as a celibate monk is holier than a father. This prejudice of benighted theologians against woman had influenced the conduct of the State toward the woman and made her everywhere the victim of unjust laws. For a long time in certain countries to ask rights for women exposed one to the suspicion of infidelity.

Therefore it must be regarded as an event of greatest importance in the history of woman, when Martin Luther, the most prominent figure in the Reformation, decided to take a wife. He married *Catherine von Bora*, a lady twenty-four years of age, of a noble Saxon family.

She had left the convent of Nimbschen together with eight other nuns in order to worship Christ without being compelled to observe endless ceremonies, which gave neither light to the mind nor peace to the soul. Protected by pious citizens of Torgau, the former nuns had lived together in retirement. Luther married his betrothed on June 11, 1525, with Lucas Cranach and another friend as witnesses. The ceremony was performed by Melanchton.

The marriage, blessed with six children, was a very happy one. Catherine proved to be a congenial mate, of whom Luther always spoke as "his heartily beloved house-frau." The great reformer himself was a tender husband, and the most loving of fathers. Nothing he liked better than to sit amidst his dear ones, enjoying a glass of wine and those beautiful folk-songs, in which German literature is so rich.

Figure 42. The Wedding of Martin Luther to Catherine Von Bora. After a painting by P. Thumann.

Many of these little poems breathe the sincere respect and high appreciation, in which woman was held by the Germans since time immemorial. There is for instance Simon Dach's well known poem "Anne of Tharau." Written in 1637, it reads:

"Aennchen von Tharau ist's die mir gefällt,
Sie ist mein Leben, mein Gut und mein Geld;
Aennchen von Tharau hat wieder ihr Herz
Auf mich gerichtet in Lieb und in Schmerz.
Aennchen von Tharau, mein Reichtum, mein Gut,
Du meine Seele, mein Fleisch und mein Blut.
Würdest du gleich einmal von mir getrennt,
Lebtest dort, wo man die Sonne nicht kennt,
Ich will doch dir folgen durch Wälder und Meer,
Durch Schnee und Eis und durch feindliches Heer,
Aennchen von Tharau, mein Licht, meine Sonn',
Mein Leben schliess ich um deines herum.—
Annie of Tharau, 'tis she that I love,

She is my life and all riches above;
Annie of Tharau has giv'n me her heart,
We shall be lovers till death us do part!
Annie of Tharau, my kingdom, my wealth,
Soul of my body, and blood of my health.
Say you should ever be parted from me,
Say that you dwelt where the sun they scarce see,
Where you go I go, o'er oceans and lands,
Prisons and fetters, and enemies' hands.
Annie of Tharau, my sun and sunshine,
This life of mine will I throw around thine."

And who would be able to pay to female virtues a higher tribute than did Paul Fleming in a poem, directed to his betrothed:

"Ein getreues Herz zu wissen
Ist des höchsten Schatzes Preis;
Der ist selig zu begrüssen
Der ein solches Kleinod weiss.
Mir ist wohl bei tiefstem Schmerz
Denn ich weiss ein treues Herz.
To call a faithful heart thine own
That's life's true and only pleasure,
And happy is the man alone
To whom was given such a treasure.
The deepest anguish does not smart
For I know a faithful heart."

This poem was written at the time, when the tempests of the Thirty Years' War swept over Germany, ruining that country beyond recognition. Hundreds of cities and villages were burned by Spanish, Italian, Hungarian, Dutch and Swedish soldiers, who made the unfortunate country their battleground. Of the seventeen million inhabitants thirteen millions were killed or swept away by starvation and the pest. Agriculture, commerce, industries and arts were annihilated. Of many villages nothing remained but their names. According to the chronicles of these times, one could wander for many miles without seeing a living creature except wolves and raven. All joy and happiness, in which the German people had been so rich, were extinguished. To women the cup of sorrow would never become empty, as hate, revenge, cruelty, and the lowest passions combined to fill their lives with endless mental and physical agonies.

During these dreadful times such social gatherings as had become the fashion among the refined people of Italy during the period of the Renaissance, were of course out of the question. Far happier in this respect was France, where the era of the "Salons" began,

many of which became known throughout Europe, for the inspiration and refinement that spread out from them.

It was to the exceptional qualities of a young and noble-minded woman of Italian birth, that the first salon in France owed its origin and its distinctive character. This lady was *Catherine Pisani*, the daughter of Jean de Vivonne, Marquis of Pisani. Born at Rome in 1588, she married the French Marquis of Rambouillet, with whom she moved to Paris. Repelled by the gilded hollowness and license of the court of King Henry IV. she retired, about the year 1608, to her husband's stately palace, which became famous as the "Hotel Rambouillet." Its pride was a suite of salons or parlors, arranged for purposes of reception and so devised as to allow many visitors to move easily. With their draperies in blue and gold, their cozy corners, choice works of art, Venetian lamps, and crystal vases always filled with fragrant flowers, these rooms were indeed ideal places for social and literary gatherings.

As Amelia Gere Mason has described in a series of articles about the French Salons, written for the "Century Magazine" of 1890, Mm. de Rambouillet "sought to assemble here all that was most distinguished, whether for wit, beauty, talent, or birth, into an atmosphere of refinement and simple elegance which would tone down all discordant elements and raise life to the level of a fine art. There was a strongly intellectual flavor in the amusements, as well as in the discussions of this salon, and the place of honor was given to genius, learning, and good manners, rather than to rank. But the spirit was by no means purely literary. The exclusive spirit of the old aristocracy, with its hauteur and its lofty patronage, found itself face to face with fresh ideals. The position of the hostess enabled her to break the traditional barriers and form a society upon a new basis, but, in spite of the mingling of classes hitherto separated, the dominant life was that of the noblesse. Women of rank gave the tone and made the laws. Their code of etiquette was severe. They aimed to combine the graces of Italy with the chivalry of Spain. The model man must have a keen sense of honor and wit without pedantry; he must be brave, heroic, generous, gallant, but he must also possess good breeding and gentle courtesy. The coarse passions and depraved manners which had disgraced the gay court of Henry IV. were refined into subtle sentiments, and women were raised upon a pedestal to be respectfully and platonically adored. In this reaction from extreme license familiarity was forbidden, and language was subjected to a critical censorship."

This definition of the salon of "the incomparable Arthenice"—an anagram for Mme. de Rambouillet, devised by two poets of renown—we find confirmed by the words of many distinguished men, who were fortunate enough to be admitted to this circle. Among them were Corneille, Descartes, and all the founders of the Académie Française.

"Do you remember," so said the eminent Abbé Fléchier many years later, "the salons which are still regarded with so much veneration, where the spirit was purified, where virtue was revered under the name of the 'incomparable Arthenice'; where people of

merit and quality assembled who composed a select court, numerous without confusion, modest without constraint, learned without pride, polished without affectation?"—

The salon of Mme. de Rambouillet continued till the death of its mistress, the 27th of December, 1665, having been, as Saint-Simon writes, "a tribunal with which it was necessary to count, and whose decisions upon the conduct and reputation of people of the court and the world had great weight."

There were other salons, modeled more or less after the present one. When the Hotel de Rambouillet was closed, Mademoiselle *Madeleine de Scudéry* held regular reunions by receiving her friends on Saturdays. Among this "Société du Samedi" were many authors and artists, who conversed upon all topics of the day, from fashion to politics, from literature and the arts to the last item of gossip. They read their works and vied with one another in improvising verses.

About the personality of Mlle. de Scudéry Abbé de Pure wrote: "One may call her the muse of our age and the prodigy of her sex. It is not only her goodness and her sweetness, but her intellect shines with so much modesty, her sentiments are expressed with so much reserve, she speaks with so much discretion, and all that she says is so fit and reasonable, that one cannot help both admiring and loving her. Comparing what one sees of her, and what one owes to her personally, with what she writes, one prefers, without hesitation, her conversation to her works. Although her mind is wonderfully great, her heart outweighs it. It is in the heart of this illustrious woman that one finds true and pure generosity, an immovable constancy, a sincere and solid friendship."

Fearing to lose her liberty Mlle. de Scudéry never married. "I know," she writes, "that there are many estimable men who merit all my esteem and who can retain a part of my friendship; but as soon as I regard them as husbands I regard them as masters, and so apt to become tyrants that I must hate them from that moment; and I thank the gods for giving me an inclination very much averse to marriage."

Under the pseudonym of "Sappho" Mlle. de Scudéry was acknowledged as the first "blue-stocking" of France and of the world. Several of her novels, in which she aimed at universal accomplishments, were the delight of all Europe. Having studied mankind in her contemporaries, she knew how to analyze and describe their characters with fidelity and point.

Another noteworthy salon of the 17th Century was that of the beautiful and amiable *Marquise de Sablé*, one of the favorites of Mme. de Rambouillet. It was she who set the fashion, at that time, of condensing the thoughts and experiences of life into maxims and epigrams. While this was her special gift to literature, her influence became also felt through what she inspired others to do. A few of her maxims, as proven in Mrs. Mason's articles about the French Salons, are worth copying, as they show the estimate Mme. De Sablé placed upon form and measure in the conduct of life.

"A bad manner spoils everything, even justice and reason. The *how* constitutes the best part of things; and the air which one gives thoughts, gilds, modifies and softens the most disagreeable."—

"There is a certain command in the manner of speaking and acting which makes itself felt everywhere, and which gains, in advance, consideration and respect."—

"Wherever it is, love is always the master. It seems truly that it is to the soul of the one who loves, what the soul is to the body it animates."—

With the death of the Marquise de Sablé in 1678 the last salon of the brilliant era of the Renaissance was closed. With the approach of that period of affected and artificial life, known as the Rococo, new types of women came to the surface, gay, witty, piquant and amusing, but lax and without great moral sense or spiritual aspiration. The dangerous influence of the many mistresses of Louis XIV and Louis XV, of Mesdames de Montespan, Maintenon and Pompadour pervaded the atmosphere, and turned the salons into headquarters of intrigue and political conspiracy. Especially at the time of the clever Mme. de Pompadour women were everywhere the power, without which no movement could be carried through successfully. "These women," said the famous philosophical historian Montesquieu, "form a kind of republic, whose members, always active, aid and serve one another. It is a new state within the state; and whoever observes the action of those in power, if he does not know the women who govern them, is like a man who sees the action of a machine but does not know its secret springs."

Montesquieu himself, when in Paris, made the salons of *Madame de Tencin and Madame d'Aiguillon* his favorite resorts.

Here he discussed with other brilliant thinkers of the time literary and political questions, and those theories, which he embodied in the most famous of his works: "Esprit des Lois" (the Spirit of the Laws). This book, dealing with law in general, with forms of government, military arrangements, taxation, economic matters, religion and individual liberty, was the first open attack on absolutism. Put on the Index by the Pope it was nevertheless eagerly read and discussed everywhere, and thus it became one of the factors leading to the French Revolution.—

Among the salons of the 18th Century, known for their influence on scientific and political life, the most remarkable was that of the *Marquise de Lambert*. Her magnificent apartments in the famous Palais Mazarin, decorated by artists like Watteau, were a rendezvous for the most eminent men and women, among them the best of the "Forty Immortals," or members of the Académie Française. As candidates for vacant chairs in this body were often proposed here the Salon Lambert was called "the Antechamber to Immortality."

The quality of the character and intellect of the hostess of this salon may be judged from a few of the bits of advice she wrote to her son. "I exhort you much more to cultivate your heart than to perfect your mind; the true greatness of the man is in the heart."—"Let your studies flow into your manners, and your readings show themselves in

your virtues."—"It is merit which should separate you from the people, not dignity nor pride."—"Too much modesty is a languor of the soul, which prevents it from taking flight and carrying itself rapidly towards glory."—"Seek the society of your superiors, in order to accustom yourself to respect and politeness. With equals one grows negligent; the mind falls asleep." She urged her daughter to treat servants with kindness. "One of the ancients says they should be regarded as unfortunate friends. Think that humanity and Christianity equalize all."—

Up to the latter half of the 18th Century the salon had become the most characteristic feature of Parisian society. Having multiplied indefinitely, they catered to all tastes and thoughts. Besides the rallying points for philosophers, literateurs and femmes d'esprit, there were other salons, where sly maitresses and political adventurers met the corrupt officials of the Government. Still other salons served as meeting places of fiery spirits, who, disgusted with the debauchery and unrestrained immorality of the ruling classes, made the discussion of politics and the deliverance of the oppressed people their chief topic.

Like the French Renaissance so the English Renaissance received its first impulse from Italy. But less concerned with culture as such, it was more practical in England and distinguished itself chiefly by the greater attention given to education. While the sons and daughters of the nobility were carefully trained by tutors, the children of the middle class received an education in grammar schools founded during the reign of King Henry VIII.

This interest in education was greatly stimulated by the doctrines of the Reformation, which had spread from Germany to England, and which were favored by the king, as they served his political interests as well as his passion for the beautiful *Anne Boleyn*, one of the queen's ladies-in-waiting. That he divorced his wife and married Anne Boleyn, and that she, on September 7th, 1533, gave birth to a girl, are facts familiar to everyone acquainted with English history.

This girl later on ascended the throne and as *Queen Elizabeth* became famous as one of the most remarkable and illustrious of all female sovereigns.

Most remarkable was her attitude toward Rome. When the "Virgin Queen" in her twenty-fifth year ascended the throne, it was not only as queen, but also as the head of the rebellious Church. Religious strife had already passed the point of reconciliation and Elizabeth's position was extremely difficult, as the Catholic party was still very strong and was bent on maintaining the connection with Rome. Aware of this fact, the Pope, claiming England as a fief of the Holy See, refused to recognize Elizabeth's title to the crown, and demanded that she should renounce all her pretensions so much the more since she was an illegitimate child. But whereas many monarchs would have cringed before the Pope, Elizabeth ignored his demands and answered the subsequent bull by Pope Pius V., by which all Catholics were released from their allegiance to the queen, by the famous Acts of Supremacy and Uniformity. Striking directly at the papal power, these acts compelled all clergymen and public functionaries to renounce the temporal and

spiritual jurisdiction of every foreign prince and prelate; and all ministers, whether beneficed or not, were forbidden to use any but the established liturgy. These statutes were carried out with considerable severity, and many Catholics suffered death. Thus bending priests and prelates to her fiery will, the queen made England a bulwark of Protestantism.

That the long reign of Elizabeth, which lasted from 1558 to 1603, was also a period of brilliant prosperity and advancement, during which England put forth her brightest genius, valor, and enterprise, has been recorded by history. It is also a well-known fact that the learning of Elizabeth was considerable, even in that age of learned ladies. Horace Walpole has assigned her a place in his "Catalogue of Royal and Noble Authors," and a list of thirteen literary productions, chiefly translations from the Greek, Latin, and French, are attached to her name.

There were quite a number of English ladies interested in literature and poetry. The most remarkable was *Mary Astell*, born in 1668 at Newcastle-on-Tyne. Having received a careful education by her uncle, a clergyman, she continued her studies in London. Here her attention and efforts were especially directed to the mental uplift of her own sex, and in 1697 she published a work entitled, "A Serious Proposal to the Ladies, Wherein a Method is Offered for the Improvement of Their Minds." With the same end in view she elaborated a scheme for a ladies' college, which was favorably entertained by Queen Anne, and would have been carried out had not Bishop Burnet interfered.

During the reign of Queen Elizabeth England was called "the Paradise of Women," on account of the great liberty, granted to them in all social affairs. There exists an interesting account of a Dutch traveller, Van Meteren, who spent some time in England. With surprise he saw that here the members of the fair sex enjoyed considerable freedom. "They are," so he says, "not shut up as in Spain and elsewhere, and yet the young girls are better behaved than in the Netherlands. Having fine complexions, they also do not paint like the Italians and others. They sit before their doors, decked in fine clothes, in order to see and be seen by the passers-by. In all banquets and feasts they are shown the greatest honor: they are placed at the upper end of the table where they are the first served. All the rest of their time they employ in walking and riding, in playing cards, or visiting their friends and keeping company, conversing with their equals and neighbors, and making merry with them at child-birth, christening, churchings and funerals. And all this with the permission and knowledge of their husbands."

In strange contrast herewith was the legal position of women. It was, as D. Staars says in his interesting book "The English Woman,"

"entirely detrimental. They were under the absolute authority of their husbands. In regard to property, husband and wife were considered by the law as forming one indivisible person. Therefore a husband could not make a deed of gift to his wife, or make a contract with her. The subordinate position of the married women was evident in

the whole of her existence. The husband was his wife's guardian, and if anyone carried her off he had a right to claim damages. He could also inflict corporal punishment on her sufficient to correct her. All the property which she might afterwards acquire, became by her marriage the common property of husband and wife, but only the husband had a right to the income, because he alone had control and administration of the property. Not only lands, but also funds, furniture, plate, and even the bed and ornaments of a woman, all became the husband's property on the wedding day, and he could sell or dispose of it as he pleased. A married woman could not even make a will. Only when she became a widow, her clothes and personal possessions again became her own property, provided, however, that her husband had not otherwise disposed of them in his will. Furthermore, she had a right to the income of a third of all the husband's property."

These unsatisfactory conditions later on caused the English women to join their American sisters in the struggle for emancipation.

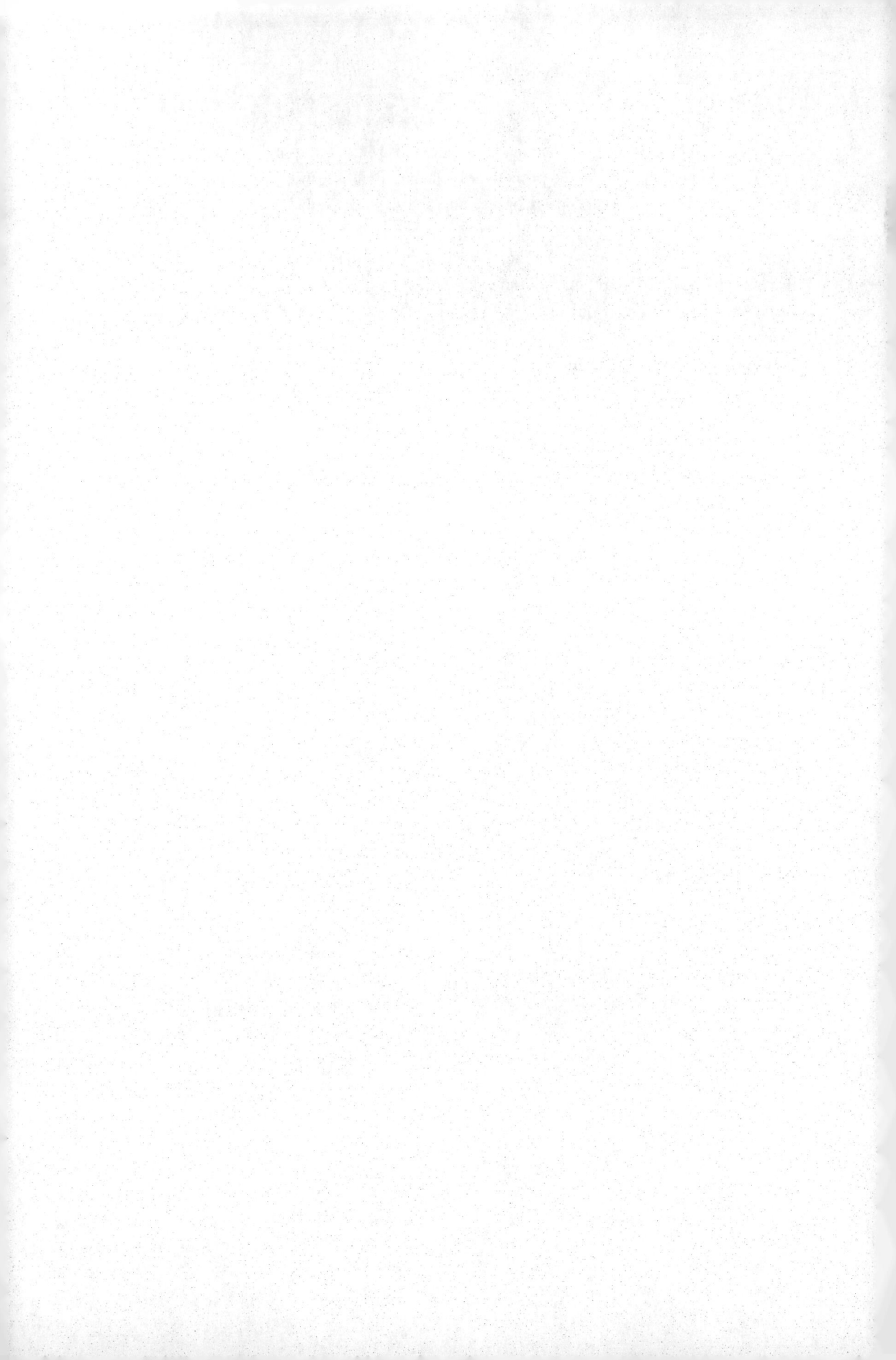

PIONEER WOMEN IN THE NEW WORLD

At the same time that ladies and gentlemen of refinement discussed human rights and liberty in the elegant salons of Italy and France, a race of hardy men and women amid the wilderness of the New World was engaged in establishing crude settlements, from which later on the spirit of genuine freedom should radiate throughout the world.

When toward the end of the 16th Century European explorers arrived on the eastern coast of the North American continent, they found what later times demonstrated beyond dispute: the richest and finest land on the face of the globe. The unsurpassed beauty and grandeur of the scenery stirred their hearts with surprise and admiration. They became enthusiastic about everything, and in their reports described the newly discovered country as the most wonderful they had ever seen.

The more these explorers saw of America, the more their amazement increased. When Henry Hudson in 1609 discovered that noble river which now bears his name, its magnificent shores were a revelation to him, who was accustomed to the modest surroundings of the Netherlands.

The French, who entered North America by the way of the St. Lawrence River, met with still greater surprises. The Great Lakes, stretching like oceans toward the setting sun, thundering Niagara, the royal Ohio, the majestic Mississippi, and the beautiful forests girding these shores, made their hearts beat with wonder and delight and filled their imagination with dreams of vast empires full of wealth. Beyond the "Father of Waters" and the regions of forest, the explorers found the "Prairies," boundless seas of fragrant grass and beautiful flowers. Beyond these plains rose majestic mountain-chains, with lovely valleys and parks, and snow-capped domes, towering above the clouds.

Figure 43. Pioneers. Modeled by A. Jaegers.

Such majestic nature must of necessity exert a most powerful influence on all who came in contact with it. Many of those immigrants who in their native countries had been restrained by narrow traditions and customs, and oppressed by despotic rulers, were here given the first chance to develop and prove their abilities. The unlimited freedom of the boundless forests, plains, and mountains stimulated their energy and imbued them with a spirit of enterprise, hitherto unknown.

New types of heroic men, such as never had lived in Europe, sprang into existence: the trappers, traders and "voyageurs," who in the pursuit of the lucrative fur trade

penetrated the vast continent in all directions, fighting their way through countless hardships and dangers.

Later on these daring forerunners of civilization were followed by settlers, who, with their families, established the first permanent homes: single log houses and hamlets, like little islands in the vast ocean of the primeval forest.

Figure 44. The First Cabin.

These "backwoodsmen," completely isolated from the civilized world and compelled to wage constant battle with hostile nature as well as with ferocious savages and wild animals, have been justly glorified as heroes. They were at once explorers, carpenters, builders, woodmen, farmers, breeders, trappers, hunters and fighters,—in short, everything. But their wives and daughters, who accompanied them, certainly deserve to be honored too, as one can hardly conceive situations more trying than those which these courageous women had to face.

First of all there were the daily labors of the household and farm, the unceasing cares of motherhood, the toils and sufferings in times of drought or sickness. Because of the isolation of their homesteads, void of even the slightest comforts and improvements, these women had to toil from early morning till late in the night. They worked with their husbands, clearing the lands. They planted and raised the vegetables in the little kitchen gardens. They prepared the meals, baked the bread, did the washing and scrubbing, the milking, preserving, pickling, churning and brewing. They also broke and heckled the flax, from which they spun the linens. They sheared the sheep and transformed the wool into yarn and cloth, which they dyed, cut and turned into suits and dresses. They knitted the socks and underwear, made the candles and many of the furnishings, in short, they

produced whatever the family needed and consumed, giving all and asking little. They even helped to defend the cabin and the settlement in times of danger.

Figure 45. Defending a Settlement. After an old engraving.

In the days of the Indian wars and of the Revolution such danger was always imminent, particularly when the men were working in the fields, or out hunting to provide food for the family. Then the women, with loaded guns, stood guard to protect the home and children from lurking enemies.

The chronicles relating incidents of border warfare abound with stories of heroines who played conspicuous parts in the defense of single log houses, as well as of stations and forts. Moulding the bullets and loading the guns, they handed them to the men, who could consequently fire three times where they otherwise could have fired but once. If there happened to be a lull during the fight, the women carried water and food to the smoke-blackened fighters, tended the wounded, baked bread and cared for the children. In cases of emergency, they stood at the loop-holes, firing the rifles with all the skill and precision of men.

When, during the War of Independence, the Mohawk Valley became the scene of many horrible ravages by the Indians and Tories, Christian Schell, a Palatine, together with his wife and six sons, occupied a lonely log house. It was in the early hours of August 6, 1781, when 48 Indians and 16 Tories made a sudden raid upon this family. Schell and his sons were working in the field, but detected the enemy soon enough to make their escape to the house. All succeeded in reaching it, except the two youngest

lads, who were captured by an Indian. The latter was shot by Schell, but it was impossible to free the boys, as they were hurried off by other Indians.

Then the battle commenced and an almost incessant firing was kept up until night, *Mrs. Schell* assisting her husband and sons in loading the guns. Several times the attacks of the enemy were repelled. But when darkness had set in, McDonald, the leader of the Tories, succeeded in reaching the door of the cabin and attempted to force an entrance by using a crowbar he had found in front of the house. Suddenly a shot from Schell hit him in the leg and brought him down. Quick as lightning the bold German unbarred the door, grasped the wounded man and dragged him in a prisoner, thus saving the house from being set fire to, for in such a case the leader of the attacking party within, would likewise have perished in the flames.

Enraged by the capture of their leader, the enemy made several furious assaults. Jumping close to the house, they thrust their guns through the loop-holes and began to fire into the building. But Mrs. Schell, cool and courageous, seized an axe and by well-directed blows spoiled every gun by destroying the barrels. As the men opened a terrific fire from above at the same time, the besiegers fell back in a hurry, and the following morning disappeared, having suffered a loss of twenty-three dead and wounded.

Another example of noble-spirited womanhood is that of *Elizabeth Zane*, a young girl of seventeen years, living near Fort Henry in West Virginia. When in November, 1782, the fort was besieged by several hundred Indians and the little garrison of forty-two men had been reduced to only twelve, the situation became extremely desperate, as the supply of powder was nearly exhausted.

There was a full keg of powder hidden in the cabin of the Zanes, but this hut stood some ninety yards from the gate of the fort and could be reached only by passing the whole distance under fire of the Indians, a feat which seemed altogether hopeless. But the perilous attempt had to be made. When the commander of the fort called for volunteers, several responded, among them, to the general surprise, Elizabeth Zane. She argued that the garrison of the fort was already too weak for the life of one of the soldiers to be risked. As her own life was of no importance, she claimed the privilege of attempting the dangerous task. Refusing to listen to any objection, Miss Zane slipped out of the gate and strolled leisurely to her home, as though there were no redskins in the whole world. The Indians, wondering what it meant, made no attempt to molest the girl.

Entering the cabin, she found the keg of powder, and a few minutes later reappeared with the keg concealed under a tablecloth. Not before the girl had gone some distance did the Indians realize the meaning of the girl's mission and at once opened a brisk fire on her. But the girl sped with the fleetness of a fawn and reached the fort in safety amid a shower of bullets, several of which passed through her clothes. By this daring act the little garrison was so inspired and fought with such tenacity that the Indians despaired of capturing the fort and finally retreated.—

In 1787 John Merrill, a settler in Nelson County, Kentucky, was awakened one night by the furious barking of his dogs. Opening the door of his cabin to reconnoitre, he was shot by several Indians, but managed to bar the door, before sinking dead to the floor. His wife, a woman of great energy and strength, jumped out of bed, grasped a large axe and sprang forward to be prepared for the coming attack. Scarcely had she reached the door when the Indians began to chop it down with their tomahawks. But as soon as the savages sought to enter the breach, the woman, making a terrific effort, killed or badly wounded four of the enemy.

Foiled in their attempt to force the door, some of the redskins climbed onto the roof of the cabin and tried to enter by way of the chimney. But again the solitary woman confronted them. Snatching her featherbed and hastily ripping it open, she flung its contents upon the still glowing embers. At once a furious blaze and stifling smoke ascended the chimney, overcoming two of the Indians. Dazed, they fell down into the fire, where they were instantly dispatched with the axe. Then, with a quick side stroke, the woman inflicted a terrible gash in the cheek of the only remaining savage, whose head just appeared in the breach of the door. With a horrible yell the intruder withdrew, to be seen no more.

In Western Pennsylvania, in the year 1792, there stood some twenty-five miles from Pittsburgh the crude cabin of a settler, named Harbisson. One day, during his absence, the home was attacked by Indians, who, after ransacking the house, carried off the wife prisoner. But there were three children, two boys aged five and three respectively, and an infant. As the mother had no hand for the little fellow of three, one of the savages relieved her from this embarrassment by grasping the child, whirling it through the air and smashing his head against a tree. And when the older brother began to weep, his crying was stopped forever by cutting his throat. The mother fainted at the horrible sight, but the savages brought her back to consciousness again by giving her a few blows across the face. At night the poor woman noticed one of the savages busying himself with making two small hoops. The captive watched him with languid curiosity and saw that he had something in his hand. Then a flash of horror-struck recognition flickered in the woman's eyes. She saw the bloody scalps of her children, which the savage was stretching on the hoops to dry. "Few mothers," so the unfortunate woman said afterwards, "have been subjected to such dreadful trials. Those who did not see the scalps of their own children torn from their heads and handled in such a way, cannot imagine the horrible pain that tortured my heart!"

In the dark of the second night the poor mother managed to make her escape. It rained in torrents, but hugging the baby to her breast, she entered the endless forest and wandered the whole night and the next days, making her way to the settlements. She arrived there on the sixth day after incredible sufferings and almost starved. So changed was she by the many hardships, that her nearest neighbors failed to recognize her. The

skin and flesh of her feet and legs was hanging in pieces, pierced by hundreds of thorns, some of which went through her feet and came out a long time afterwards at the top.—

Figure 46. Slaughtered. A scene during the Seminole Indian War.

Such were the hardships and dangers the women of the settlers had to brave. But they endured their sufferings like heroines. In recognition of this fact it may justly be said that the establishment of the Republic of the United States of America, one of the grandest achievements in all history, would not have been possible without their aid. For it was among these hardy men and women that the spirit of American liberty was born. Their surroundings and manner of life compelled them to rely on themselves in everything. And while they assisted one another in all embarrassments and perils, they made their own regulations and selected their own officials, fully aware, that the laws of England would never suffice for the wilderness.

From those autonomous settlements the spirit of independence spread in time to all the towns and cities on the coast, inspiring many of their inhabitants with the same enthusiasm for liberty. In New York and other places the People's Party was organized, which strongly opposed the insolence and encroachments of the Government and aristocrats. Among its members was Peter Zenger, the fearless printer, whose caustic articles in the "New York Weekly Journal" in 1735 led to that famous trial, whereby one of the highest privileges—*the freedom of the press*—became established in America. And when in complete disregard of this significant omen England continued in her selfish policies toward the colonies, curtailing all privileges which had been granted to them by

their charters, the spirit of rebellion spread like wildfire, and the great struggle for independence began.

When a Declaration of Independence was considered, the men, selected to draw up such a document, were greatly influenced by two noble-minded women, whose names should not be omitted in a history of remarkable women: *Mrs. Mercy Otis Warren*, and *Abigail Smith Adams*. Mrs. Warren was a sister of James Otis, the famous lawyer, whose fiery words did so much to arouse the colonists against British aggression. She was one of the first persons who advocated separation, and she energetically impressed this view upon John Adams before the opening of the first Congress. With Abigail Smith Adams, the wife of John Adams, she shared the belief, that the declaration should not consider the freedom of man alone, but that of woman also. How outspoken Mrs. Adams was in her views about this question, appears in a letter she wrote in March, 1776, to her husband, who was then attending the Continental Congress. In this letter she says:

> "I long to hear you have declared an independency; and, by the way, in the new code of laws which I suppose it will be necessary for you to make, I desire you would remember the ladies, and be more generous and favorable to them than your ancestors. Do not put such unlimited power into the hands of husbands. Remember, all men would be tyrants if they could. If particular care and attention are not paid to the ladies, we are determined to foment a rebellion, and will not hold ourselves bound to obey any laws in which we have no voice or representation."—

Figure 47. Struggling For Independence.

The Declaration of Independence, accepted on July 4th, 1776, in Philadelphia, by an assembly of delegates from all the colonies, is the greatest and most important political document that was ever set up and signed by men. Although the representatives knew that it would produce a long and terrific war against the most powerful and most inconsiderate government of the world, they solemnly agreed to choose liberty or death. Liberty to make their own laws and to elect their own officials, liberty of religion, liberty of speech and press, liberty of trade and commerce, liberty for man, woman and child.

The eminent significance of the declaration becomes apparent from the following sentences:

> "We hold these truths to be self-evident, that all men are created equal; that they are endowed by their Creator with certain inalienable rights; that among these are life, liberty and the pursuit of happiness. That, to secure these rights, governments are instituted among men, deriving their just powers from the consent of the governed. That, whenever any form of government becomes destructive of these ends, it is the right of the people to alter or to abolish it, and to institute new government, laying its foundation on such principles, and organizing its powers in such form, as to them shall seem most likely to effect their safety and happiness."

While the Declaration of Independence is silent in regard to women, there are, however, positive proofs of the fact, that the men of 1776 regarded their faithful partners in all struggles and danger decidedly as their equals and entitled to the same rights and privileges. Two days before the signing of the Declaration of Independence, on July 2, 1776, the Provincial Assembly of New Jersey, when writing the constitution of that province, adopted the provision, that

> "*all inhabitants* of this colony, of full age, who are worth fifty pounds money clear estate in the same, and have resided within the county in which they claim to vote for twelve months immediately preceding the election, shall be entitled to vote for representatives in council and assembly, and also for all other public officers that shall be elected by the people of the county at large."—

Under this provision, women and free colored men of property exercised the electoral franchise for thirty years, voting also in the Presidential election of 1804, when Thomas Jefferson was re-elected for a second term. The acts of the New Jersey Legislature of 1790 clearly recognized the women, voters, saying:

"No person shall be entitled to vote in any other town-house or precinct than that in which *he* or *she* doth actually reside at the time of election."

At first the law was construed to admit single women only, but afterward it was made to include females eighteen years old, married or single, without distinction of race. But as most of the women were on the side of the Federation and always delivered a heavy

vote, a Democratic legislature, to defranchise Federalists, passed in 1807 an act defining the qualifications of electors, excluding women and free colored men by the use of the words "White *male* citizens." This was a partisan piece of legislature, clearly in violation of the constitutional guarantee, and made under the pretext that male voters, by disguising themselves as women and negroes, had voted several times. It was on the strength of this pretext that the unconstitutional act was passed and upheld.

It is on record that in Virginia likewise women at an early day exercised the right of voting. But it is unknown, for what reason this right was not preserved.

Chapter 20

WOMEN OF THE FRENCH REVOLUTION

There are few events in history that created such world-wide interest as the triumphant success of the American War for Liberation. The deepest impression was made on the French nation, which for centuries had suffered under the tyranny and coercion of extravagant kings, corrupt officials, greedy clergy and feudal nobility. In sharp contrast to the prodigality and lasciviousness of the court and its armies of courtiers and courtesans, who all revelled in luxuries, there was among the people a general feeling of misery and despair. Finances were in a frightful condition; public scandals were every-day occurrences; famines were frequent; the old creeds had lost their power to arouse enthusiasm, while out-worn institutions and customs still encumbered the land, and with their dead weight pressed men down. The deep longing to be delivered from all these parasites and encumbrances, the urgent need of reforms and relief was evident everywhere. In the streets, in all cafés, clubs and salons the discussion of politics was the foremost topic.

The most conspicuous among such political salons were those of *Théroigne de Méricourt, Marie Olympe de Gouges, and Madame Roland.*

The first of these three ladies was a quick-witted, strikingly handsome woman, intensely passionate in temper, and commanding an almost volcanic power of eloquence. Her salon was the birth-place of the "Club des Amis de la Loi," the most noteworthy members of which were Jerome Pétion, author of "Les Lois Civiles," and Camille Desmoulins, author of "La France Libre." Both writers were among the leaders of the revolution, and it was Desmoulins, who in July, 1789, inflamed the people by his violent speeches to take up arms and storm the Bastille. At the fall of this ill-reputed prison Théroigne de Méricourt came prominently into notice and it was she who proposed to erect a temple for the National Assembly on the site of the razed fortress.

With her friends she also had a hand in framing the "Déclaration des Droits de l'Homme," which, together with the American Declaration of Independence, ranks

among the greatest human documents of history. The most important points of this charter of the French Revolution are: that all men are born and continue free and equal in rights; that Society is an association of men to preserve the natural rights of men; that Sovereignty is vested in the nation; that all Authority, held by an individual or a body of men, comes expressly from the nation; that Liberty is the power of doing what we will, so long as it does not injure the same right of others; that the law can forbid only such actions as are mischievous to society; that Law is the expression of the general will; that all citizens have a right to take part, through their representatives, in the making of laws; that laws must be equal to all; that all citizens have equal rights to fulfill all offices in the state; that society has a right to demand from every public servant an account of his administration; that all men are free to hold what religious views they will, provided that they are not subversive of public order; that freedom of speech, of writing and printing is one of the most precious of the rights of man and that public force is needed to guarantee these rights; that property is an inviolable and sacred right, of which no one can be deprived, save when public necessity, legally established, evidently demands it, and then only with the condition of a just and previously determined indemnity.

With the adoption of this declaration by the national assembly, all hereditary distinctions, such as nobility and peerage, feudal regime, titles, and orders of chivalry were abolished, also venality or hereditary succession in offices, feudal privileges, religious vows or other engagements which might be at variance with natural rights or the constitution.—

Early in October, 1789, Théroigne de Méricourt also took a leading part in the march of the women to Versailles and it was she who by the violence of her speech won the royalist soldiers over to the revolution and so enforced the return of the royal family to Paris.

Being accused of dangerous conduct and of having been engaged in a plot against the life of the queen Marie Antoinette, the daughter of Empress Maria Theresia of Austria, during a visit to Liége she was seized by warrant of the Austrian Government and for some time interned at the fortress of Kufstein. After her release in January, 1792, she returned to Paris, where she was hailed as a martyr of liberty. Resuming her former role she again became very active in all public affairs. On June 20, 1792, she even commanded in person the 3d Corps of the so-called army of the Faubourges, and marched with them to the palace, where the king, wearing the red cap, met the revolutionists and assured them "that he would do whatever the constitution ordained that he should do." But as soon afterwards the king's secret connections with Austria and Prussia became public, the insurrection broke loose again, resulting in the massacre of the national guard on August 10th, in the Place Véndome. It was here, that Théroigne sprang at Suleau, a pamphleteer in royal service, and dragged him among the infuriated mob, where he was instantly killed.—

It was a year before these incidents that Madame Roland opened a salon in Paris, whither her husband had been sent as the deputy from Lyons to the constituent assembly. Her salon had nothing in common with those frequented by people seeking recreation in conversation and belle esprit. Generally there were no women present except the hostess. But her salon was the rendezvous of such fiery spirits as Mirabeau, Brissot, Vergniaud, Robespierre and others, interested in the great movement, which was soon to reach its climax. It was in this salon that Madame Roland impressed her enthusiasm for a republic upon those men who likewise strove for progress and liberty. Here also she conceived the plan of a journal, entitled "The Republican," which, however, was suppressed after its second issue. Here she penned that famous letter to the king, which, as it remained unanswered, was read aloud by her husband, the king's appointed Minister of the Interior, in full council and in the king's presence. Containing many terrible truths as to the royal refusal to sanction the decrees of the national assembly and as to the king's position in the state, this letter initiated the dethronement of the king and the abolition of royalty.—

It was in these troubled times, also, that another remarkable woman attracted great attention by matching the "Declaration of the rights of man" with a "Declaration des Droits de la Femme," a declaration of the rights of women. In this document she preached for the first time not only the principle of equality of both sexes but she also demanded the right of women to vote and to hold public offices. This document was published just at the time when the equality of both sexes before the law and the guillotine had become a recognized fact, when not only the head of the king but also that of the queen Marie Antoinette had rolled into the dust. Pointing to these events Olympe de Gouges closed her manifesto with the flaming words: "When women have the right to ascend the scaffold then they must have the right to mount the platform of the orator!"

When Olympe de Gouges wrote these lines, she hardly anticipated her own fate. Provoking in some way the anger of Robespierre, this rabid tyrant did send her also to the guillotine.—

Théroigne de Méricourt likewise fell a victim of the furious hostility, which in 1793 arose between the two leading parties, the Girondists and the Montagnards, the latter party led by those most extreme autocrats as Marat, Danton and Robespierre. When Théroigne, being aware that her own party, the Gironde, was in peril at the hands of these bloodthirsty men, one day urged the mob to moderate their courses, she was seized, stripped naked and flogged in the public garden of the Tuilleries. This infamous affront affected her so that she became a raving maniac, never recovering her reason.—

For Madame Roland and her husband too the day of darkness was soon to come. They found that they could no longer control those passions which they had helped to call forth. Repulsed by the incredible excesses, which were committed during the progress of the revolution, Mr. Roland sent in his resignation on January 22, 1793, the day after the execution of the king.

Figure 48. The Roll-Call for the Guillotine. After the painting by C. L. Mueller.

But all his and his wife's efforts to regulate and elevate the Revolution failed. Both became more and more the butt of calumny and the object of increasing dislike on the part of the ultra-revolutionists, whose leaders, Marat and Danton, heaped the foulest falsehoods upon them. At the instigation of these men Madame Roland was arrested early on the morning of the last of July, 1793, and thrown into the same prison cell, that had been occupied by Charlotte Corday a short time before. On November the 8th she was conveyed to the guillotine. Before yielding her head to the block, she bowed before the statue of Liberty, erected in the Place de la Revolution, uttering her famous apostrophe: "O Liberty! what crimes are committed in thy name!"—

After the elimination of the three leading spirits of woman's emancipation all attempts to claim political rights for women were sternly repressed. The bold deed of Charlotte Corday, who on July 17th, 1793, killed Marat, the chief of the Mountain party, had given to his followers a warning of what resolute women were able to do. And so all female clubs and political meetings were forbidden by the Convention. Women were even excluded from the galleries of the hall where it sat, and Chaumette warned them that by entering into politics they would violate the law of nature and would be punished accordingly. French girls were also entirely excluded from all educational reforms that were instituted by the Convention and, later on, by Napoleon, who always maintained that female education should be of the most rudimentary description.

At the same time that Olympe de Gouges, Théroigne de Méricourt and Madame Roland took such a conspicuous part in the French Revolution, there appeared in England a most remarkable book, which might be called the first comprehensive attempt to establish the equality of the sexes. Its authoress was *Mary Wollstonecraft*, a woman of Irish extraction, born at Hoxton on April 27, 1759. Compelled to earn her own living,

she, together with her sisters, had conducted a school for girls. Later on she held a position as governess in the family of Lord Kingsborough, in Ireland. Among her early publications are "Thoughts on the Education of Daughters" (1787) and "The Female Reader" (1789). That she followed the events of the French Revolution with the utmost interest, appears from her book: "An Historical and Moral View of the Origin and Progress of the French Revolution, and the Effects it has Produced in Europe." It was intended to comprise several volumes, but after the first one had been published in 1790, the work remained unfinished. Two years later, in 1792, appeared the work with which the name of Mary Wollstonecraft is always associated, as from this book was born one of the grandest movements which exists in the world to-day—the *Woman Suffrage Movement.*

This book, entitled "A Vindication of the Rights of Woman," was a sharp protest against the assumption that woman is only a plaything of man. It is also a demand on her to become his equal and his companion.

In the preface the authoress states the "main argument" of her work, "built on this simple principle that, if woman be not prepared by education to become the companion of man, she will stop the progress of knowledge, for truth must be common to all, or it will be inefficacious with respect to its influence or general practice." In carrying out this argument she explains that woman can never be free until she is free economically; it makes no difference how poetic, romantic and chivalrous we become,—the fact is, there can be little equality between the sexes as long as the male partner has entire charge of the purse. Woman may be free socially; she may get rid of all sexual superstition, and she may crack and cast from her all theological trammels: but of what value is all this if she is still dependent upon man for food, raiment and shelter? What good does it do her to say "My body is my own, subject to the whims and lusts of no man," if upon that very man depends her livelihood? Woman's economic dependence is the root of that tree which nourishes the poisonous fruits of her subjection and abject slavery. Only when woman is on equal terms with man, can she be really virtuous and useful. But this result can only be obtained by rejecting the fallacious idea of weakness and refusing man's help.

After that the authoress states, that woman by open air exercise can become healthy and strong. By study she can acquire a solid education and useful knowledge, and thus become fit to earn her own living. Marriage will then cease to be her sole hope of salvation. If she marries she must not expect infinite romantic love from her husband, that would be an endeavor to perpetuate what is transitory in its very essence. From her husband she should require esteem and friendship. But before she can ask for or inspire these sentiments she must have shown herself a lofty mind and a sincere, benevolent, and independent temper.

"But this ideal will remain a myth unless the system of education is entirely changed. It is the duty of the Government to organize schools and colleges, for boys and girls, both rich and poor, and of all ages."

Mary Wollstonecraft recommends that boys and girls should study together. She does not regard as an evil the attachment which might result under these conditions. On the contrary, she is an advocate of early marriage, and believes that the physical and moral health of young people would be greatly benefited thereby. "Do not separate the sexes, but accustom them to each other from infancy!" she demands. "By this plan such a degree of equality should be established between the sexes as would break up gallantry and coquetry, yet allow friendship and love to temper the heart for the discharge of higher duties."

Thus asking the widest opportunities of education for women, she demands also her participation in industry, political knowledge, and the rights of representation.

While Mary Wollstonecraft in this manner advanced progressive ideas, she also discussed several questions, dangerous and explosive at that time. In regard to marriage she recommended emancipation from the coercions and ceremonies imposed upon all Christians by the Church. And where love had ceased, divorce should be made easy. These points, together with her extraordinary plainness of speech and her denial of the eternity of the torments of hell, caused an outcry of all classes, to whom the dust of tradition was sacred, or who saw their assumed authority endangered. The air grew thick with insults and insinuations, hurled at the champion of such principles by churchmen feeding on their worn-out thistle-creeds. There were also the shrill, polished shrieks of society, whose antiquated dogmas Mary Wollstonecraft had repudiated. But the impulse, given by her, did not die. It became the heritage of later and more advanced generations, who have tried to realize the ideas of this most remarkable woman of the 18th Century.

WOMAN'S ENTRY INTO INDUSTRY

Since the stirring years of the American War of Independence and of the French Revolution the question of woman's rights and woman suffrage has remained constantly before the public. Its significance greatly increased when with the invention of steam-engines, with the rapid growth and extension of trade and commerce, and with the introduction of modern methods all conditions of industrial life likewise became revolutionized. Many of those industries in which women participated, were transferred from the homes to factories, where the workmen and women were placed at machines, producing within one day greater quantities of goods than the laborers formerly had manufactured within weeks or months.

With this industrial revolution came, however, also many evils. The laborers remained no longer masters of their own time and efforts. While hitherto they had been the owners of their little industry, now the factory owners and the great industries began to own them. They found themselves bound by strict rules, not of their own making, but prescribed and enforced by their employers, many of whom had not the slightest consideration for the people that worked for them. Just as soulless as their machines, and thinking only of gain, they abused their employees wherever possible, and in doing so often resorted to the meanest tricks.

Nowhere did such evils become so appalling as in England, where the politicians subordinated all other considerations to industry. It was here that in order to reduce the small wages of the workman cheap woman- and child-labor was first introduced on a large scale, and feeble, defenseless creatures, without experience and organization, were subjected to the most cruel oppression and exploitation.

At the end of the 18th and during the first half of the 19th Century large numbers of women and pauper children were shipped from the agricultural districts of Southern England to the northern districts to work in the factories which had been established there in consequence of the superior water-power.

Tender women and girls, and even children from six to ten years were placed in cotton mills, where they were compelled to work in overcrowded rooms thirteen to fourteen hours daily. Robert Mackenzie in his book "The Nineteenth Century," p. 77, states, that the accommodations provided for these people were of the most wretched nature.

"If such children became over-tired and fell asleep they were flogged. Sometimes through exhaustion they fell upon the machinery and were injured—possibly crushed,—an occurrence which caused little concern to any except the mothers, who had learned to bear their pangs in silence. These children, who were stunted in size and disposed to various acute diseases, were often scrofulous and consumptive."

The Encyclopædia Britannica, in an article on Socialism, describes the conditions of the working people in England at that time as follows:

"The English worker had no fixed interest in the soil. He had no voice either in local or national government. He had little education or none at all. His dwelling was wretched in the extreme. The right even of combination was denied him. The wages of the agricultural laborer were miserably low. The workman's share in the benefits of the industrial revolution was doubtful. Great numbers of his class were reduced to utter poverty and ruin by the great changes consequent to the introduction of improved machinery; the tendency to readjustment was slow and continually disturbed by fresh change. The hours of work were mercilessly long. He had to compete against the labor of women, and of children brought frequently at the age of five or six from the workhouses. These children had to work the same long hours as the adults, and they were sometimes strapped by the overseers till the blood came. Destitute as they so often were of parental protection and oversight, with both sexes huddled together under immoral and unsanitary conditions, it was only natural that they should fall into the worst habits and that their offspring should to such a lamentable degree be vicious, improvident, and physically degenerate."

A report, delivered at the "International Congress of Women," held in July, 1899, at London, states that the weak legs of those children, which were not strong enough to support the body for hours, were sustained by boots of wood and lead, in which they were obliged to stand. Hence the high scale of mortality among the children.

Most revolting conditions prevailed in the English coal mines. Married women, girls and children worked here, harnessed to trucks and nearly naked, dragging on their hands and knees loads of coal through long low galleries to the pit mouth.

When some philanthropists made complaints about these conditions, Parliament instituted a commission to inquire into the state of working women in these mines and the wages paid them. From its official report we quote the following:

"Betty Harris, one of the numerous persons examined, aged thirty-seven, drawer in the coal-pit, said: 'I have a belt around my waist and a chain between my legs to the truck, and I go on my hands and feet. The road is very steep and we have to hold by a rope, and when there is no rope, by anything we can catch hold of. There are six women and about six boys and girls in the pit I work in; it is very wet, and the water comes over our clog-tops always, and I have seen it up to my thighs; my clothes are always wet.'—

"Margaret Hibbs, aged eighteen, said: 'My employment after reaching the wall-face (the place where the coal is broken) is to fill my bagie or stype with two and a half or three hundred-weight of coal; I then hook it on to my chain and drag it through the seam, which is from twenty-six to twenty-eight inches high, till I get to the main road, a good distance, probably two hundred to four hundred yards. The pavement I drag over is wet, and I am obliged at all times to crawl on my hands and feet with my bagie hung to the chain and ropes. It is sad, sweating, sore and fatiguing work, and frequently maims the women.'

"Robert Bald, the government coal-viewer, stated: In surveying the workings of an extensive colliery underground a married woman came forward groaning under an excessive weight of coal, trembling in every nerve, and almost unable to keep her knees from sinking under her. On coming up she said in a plaintive and melancholy voice: 'Oh sir, this is sore, sore, sore work!'

"And a sub-commissioner said: 'It is almost incredible that human beings can submit to such employment—crawling on hands and knees, harnessed like horses, over soft, slushy floors, more difficult than dragging the same weight through our lowest sewers.'"—

Mackenzie, in his above mentioned book, states that

"there was no machinery in these English coal-pits to drag the coal to the surface, and women climbed long wooden stairs with baskets of coal upon their backs. Children of six were habitually employed. Their hours of labor were fourteen to sixteen daily. The horrors among which they lived induced disease and early death. Law did not seem to reach to the depths of a coal-pit, and the hapless children were often mutilated and occasionally killed with perfect impunity by the brutalized miners among whom they labored."

Other authorities state that the women were paid less than 20 cents per day! For the same kind of work men got three times as much pay; but the employers preferred girls and women to do the work "because of their lower wages and greater docility!" In the iron districts of the Midlands women earned for very hard work 4 to 5 shillings a week, (= $1.25) while the men received 14 shillings.

These small wages, which forced upon the laborers the most barren mode of living, were, however, taken away again from them through the meanest tricks, devised by the employers particularly through the so-called Truck System. Under this abominable system the employers, instead of paying the wages in cash, forced their employees to take

checks or orders, redeemable in all kinds of necessities and goods, but valid only in those "truck stores" or "tommy shops" run by the employers, or in which they had an interest. By cheating the workmen with goods of inferior quality, by overcharging them at the same time, by pressing them to take goods far beyond their need and wages, and by making long intervals—often from 40 to 60 days—between the real pay days, they forced the laborers into debt and absolute slavery.

The situation of many thousands of those women who tried to make a living as seamstresses was also desperate. Always put off with wages far below the demands of a modest existence, they were real martyrs of labor. Thomas Hood, one of the foremost English poets of the first half of the 19th Century, gave in his famous "Song of the Shirt" a most touching picture of such woman's toil and misery, of woman in her wasted life and in her hurried death. His poem reads:

> With fingers weary and worn,
> With eyelids heavy and red,
> A woman sat, in unwomanly rags,
> Plying her needle and thread—
> Stitch! stitch! stitch!
> In poverty, hunger and dirt,
> And still with a voice of dolorous pitch,
> She sang the "Song of the Shirt!"
> "Work! work! work!
> While the cock is crowing aloof!
> And work—work—work,
> Till the stars shine through the roof!
> It's Oh! to be a slave
> Along with the barbarous Turk,
> Where woman has never a soul to save,
> If this is Christian work!
> "Work—work—work
> Till the brain begins to swim;
> Work—work—work
> Till the eyes are heavy and dim!
> Seam, and gusset, and band,
> Band, and gusset, and seam,
> Till over the button I fall asleep,
> And sew them on in a dream!
> "Oh, Men, with Sisters dear!
> Oh, Men, with Mothers and Wives!
> It is not linen you're wearing out,
> But human creatures' lives!
> Stitch—stitch—stitch,
> In poverty, hunger, and dirt,

Sewing at once, with a double thread,
A Shroud as well as a Shirt.
"But why do I talk of Death?
That Phantom of grisly bone,
I hardly fear his terrible shape,
It seems so like my own,
Because of the fasts I keep;
Oh, God! that bread be so dear,
And flesh and blood so cheap!
"Work—work—work!
My labor never flags;
And what are its wages? A bed of straw,
A crust of bread—and rags.
That shatter'd roof—and this naked floor—
A table—a broken chair—
And a wall so blank, my shadow I thank
For sometimes falling there!
"Work—work—work!
From weary chime to chime,
Work—work—work—
As prisoners work for crime!
Band, and gusset, and seam,
Seam, and gusset, and band,
Till the heart is sick, and the brain benumb'd
As well as the weary hand.
"Work—work—work,
In the dull December light,
And work—work—work,
When the weather is warm and bright—
While underneath the eaves
The brooding swallows cling,
As if to show me the sunny backs
And twit me with the spring.
"Oh! but to breathe the breath
Of the cowslip and primrose sweet—
With the sky above my head,
And the grass beneath my feet,
For only one short hour
To feel as I used to feel,
Before I knew the woes of want
And the walk that costs a meal.
"Oh! but for one short hour!
A respite however brief!
No blessed leisure for Love or Hope,

But only time for Grief!
A little weeping would ease my heart,
But in their briny bed
My tears must stop, for every drop
Hinders needle and thread!"
With fingers weary and worn,
With eyelids heavy and red,
A woman sat in unwomanly rags,
Plying her needle and thread thread—
Stitch! stitch! stitch!
In poverty, hunger, and dirt,
And still with a voice of dolorous pitch,
Would that its tone could reach the Rich!
She sang the "Song of the Shirt!"

Constantly struggling with want and poverty and seeing health menaced by the machines, the working classes of England were filled with bitterness, when they found that their complaints brought no relief, while the law-makers, sitting in Parliament, favored any demands of the employers and of the big interests. To forget for a few hours their hopeless existence, large numbers of men and women resorted to liquor, hereby hastening their final collapse and ruin.

Such was the life led by English laborers during the greater part of the Nineteenth Century. Feeble attempts to improve these deplorable conditions were made through a series of "Factory Acts," the immediate cause for which was the fearful spread of epidemic diseases which wrought dreadful havoc among the laborers, especially among the women and children. If we glance over these factory acts, as they are sketched in the Encyclopædia Britannica, we find that even under these acts children below the age of nine were permitted in silk factories, and that they were required to work twelve hours a day, exclusive of an hour and a half for meal times. An act of 1833 provided that young persons from thirteen to eighteen and women were restricted to 68 hours a week. Ten years later a mining act was passed which prohibited underground work for children under ten and for women. In 1867 the Workshop Regulation Act fixed the working day for children from 6 a. m. to 8 p. m. = 14 hours, and for young persons and women from 5 a. m. to 9 p. m. = 16 hours! After having made such sad disclosures, the Encyclopædia Britannica dared to say:

"By these various enactments the state has emphatically taken under its protection
the whole class of children and young persons employed in manufacturing industries. It
has done this in the name of the moral and physical health of the community."

The despicable methods employed by the British mine and factory owners in their dealings with the working classes spread to the Continent as well as to America. In France, Germany and Austria they led to those desperate struggles between capital and labor, out of which was born that most remarkable movement of the 19th Century called "Socialism."

In the United States soon enough attempts were made to imitate the detestable methods of the British mine and factory owners. But as the character of the population was quite different, the abuse of the working men and women never became so appalling as in Great Britain.

The first industry to be established in factories was the weaving of cotton in the New England States, where a number of rapid streams, among them the Merrimac, the Connecticut and the Housatonic, furnished excellent water-power. And as during the pioneer and colonial times the housewives and daughters had spun and woven all the cloth and linen for family use, there was an ample number of expert workers at hand. After the first weaving machines were brought over from Europe, in 1814, Dover, Lowell, Waltham, Great Falls and Newmarket became the principal centers of the cotton industry.

Here the daughters of the farmers and settlers did the work that formerly their mothers had done at home. Only they did it faster, by tending the machines all day long. At first the girls did not know that the employers might try to make the people in the factories work longer hours without any rest and adequate pay. Soon enough they found this out. But as the girls had inherited the independent spirit of their fathers and grandfathers, trouble began to brew. In December, 1828, four hundred girls in Dover, New Hampshire, formed a procession and marched out of the factory, in order to show their indignation at the growing oppression by their employers. They clad their complaints in verses, one of which ran:

> "Who among the Dover girls could ever bear
> The shocking fate of slaves to share!"

Unorganized as they were at that time, they did not succeed in gaining all they desired. But five years later they walked out again, eight hundred strong, adopting resolutions stating that they had not been treated as "daughters of freemen" by their employers and the unfriendly newspapers. At the same time in Lowell, Mass., at a signal given by a Dover girl, two thousand girls, who had formed a *"Factory Girls' Association,"* joined in a sympathy strike, marched around town and issued the following proclamation:

"Our present object is to have union and exertion, and we remain in possession of our own unquestionable rights. We circulate this paper, wishing to obtain the names of all who imbibe the spirit of our patriotic ancestors, who preferred privation to bondage and parted with all that renders life desirable—and even life itself—to produce independence for their children. The oppressing hand of avarice would enslave us, and to gain their object they very gravely tell us of the pressure of the times; this we are already sensible of and deplore it. If any are in want of assistance, the ladies will be compassionate and assist them, but we prefer to have the disposing of our charities in our own hands, and, as we are free, we would remain in possession of what kind Providence has bestowed upon us, and remain daughters of freemen still.

Figure 49. Spinners in the Colonial Times. After a painting by Carl Marr, now in the Metropolitan Museum of Art, New York.

"Union Is Power."

"All who patronize this effort we wish to have discontinue their labor until terms of reconciliation are made.

"Resolved. That we will not go back into the mills to work unless our wages are continued to us as they have been.

"Resolved, That none of us will go back unless they receive us all as one.

"Resolved, That if any have not money enough to carry them home they shall be supplied.

"Let oppression shrug her shoulders,
And a haughty tyrant frown,
And little upstart Ignorance
In mockery look down.
Yet I value not the feeble threats,
Of Tories in disguise,
While the flag of independence,
O'er our noble nation flies."

In 1843 the girls in the cotton mills of Pittsburg, Pa., whose working hours had been from five o'clock in the morning till a quarter of seven in the evening, rebelled also, when their employers attempted to increase the time one hour each day without extra pay. Two years later they co-operated with the factory girls of New England, concurring in the proposal to "declare their independence of the oppressive manufacturing power" unless the work day was limited to ten hours.

The policy of these fighters for better conditions is outlined in the constitution of the *"Lowell Female Labor Reform Association,"* which had been organized in 1845. Article IX says:

"The members of this association disapprove of all hostile measures, strikes and turn-outs until all pacific measures prove abortive, and then that it is the imperious duty of everyone to assert and maintain that independence which our brave ancestors bequeathed to us and sealed with their blood."

The spirit of these working women is likewise shown in the preamble adopted at the annual meeting of the association in January, 1846. It reads:

"It now only remains for us to throw off the shackles which are binding us in ignorance and servitude and which prevent us from rising to that scale of being for which God designed us. With the present system of labor it is impossible. There must be reasonable hours for manual labor and a just portion of time allowed for the cultivation of the mental and moral faculties, and no other way can the great work be accomplished. It is evident that with the present system of labor the minds of the mass must remain uncultivated, their morals unimproved. Shall we, operatives of America, the land where democracy claims to be the principle by which we live and by which we are governed, see the evil daily increasing which separates more widely and more effectually the favored few and the unfortunate many without one exertion to stay the progress? God forbid! Let the daughters of New England kindle the spark of Philanthropy in every heart till its brightness shall fill the whole earth."

Not satisfied with securing thousands of signatures of factory operatives, who petitioned the legislature for a ten-hour day, prominent members of the union went before the Massachusetts legislative committee early in 1845 and testified as to the conditions in textile mills. This was the first American governmental investigation of labor conditions, and it was due almost solely to the petitions of the working women. About the same time the union appointed a committee to investigate and expose false statements published in newspapers concerning the factory operatives. Nor was this all. In their work of publicity they did not hesitate to call public men to account for assailing or ignoring their movement.

The chairman of the legislative committee, before whom the working girls had testified, was the representative from the Lowell district, and should, therefore, have shown special interest in the complaints of the girls. Instead, he had treated them in a high-handed manner, withholding at the same time from the Legislature some of the most important facts presented by the Lowell girls. The latter expressed their just indignation in the following resolution, which was circulated before the elections of that year:

> "Resolved, That the Female Labor Reform Labor Association deeply deplore the lack of independence, honesty and humanity in the committee to whom were referred sundry petitions relative to the hours of labor, especially in the chairman of that committee; and as he is merely a corporation machine, or tool, we will use our best endeavors and influence to keep him in the "City of Spindles," where he belongs, and not trouble Boston folks with him."

That the "endeavors" of the girls met with full success is evident from a second resolution published after election day:

> "Resolved, That the members of this association tender their grateful acknowledgments to the voters of Lowell for consigning William Schouler to the obscurity he so justly deserves for treating so ungentlemanly the defense made by the delegates of this association before the special committee of the legislature, to whom was referred petitions for the reduction of the hours of labor, of which he was chairman."

The result of all this agitation against long hours of work was that in 1847, 1848, and 1851 the first ten-hour laws were passed in New Hampshire, Pennsylvania and New Jersey.

The success, won by the textile workers, inspired women workers in the tailoring and sewing trade, in the manufacture of shoes, cigars, and other necessities to similar efforts. In the tailoring and sewing trade wages were extremely low, as sweat-shop conditions existed from the beginning, and the trade was overcrowded.

In 1845 New York City alone had over 10,000 sewing women, the majority of whom worked from twelve to sixteen hours a day to earn only from two to three dollars a week!

As similar conditions prevailed in other occupations, the number of poorly paid women wage-earners in New York City in 1865 was between 50,000 to 70,000, of whom 20,000 were in a constant fight with starvation, and of whom 7,000 lived in cellars. Their situation grew from bad to worse, as at the same time that they were falling into a state of physical and mental deterioration, the improvements in many machines made greater and greater demands on the capability of those who were operating them.

Thus the situation became such as was sketched by W. I. Thomas in an article written some fifteen years ago for the "American Magazine," in which he said:

"The machine is a wonderful expression of man's ingenuity, of his effort to create an artificial workman, to whom no wages have to be paid, but it falls just short of human intelligence. It has no discriminative judgment, no control of the work as a whole. It can only finish the work handed out to it, but it does this with superhuman energy. The manufacturer has, then, to purchase enough intelligence to supplement the machine, and he secures as low a grade of this as the nature of the machine will permit. The child, the woman and the immigrant are frequently adequate to furnish that oversight and judgment necessary to supplement the activity of the machine, and the more ignorant and necessitous the human being the more the profit to the industry. But now comes the ironical and pitiful part. The machine which was invented to save human energy, and which is so great a boon when the individual controls it, is a terrible thing when it controls the individual. Power-driven, it has almost no limit to its speed, and no limit whatever to its endurance, and it has no nerves. When, therefore, under the pressure of business competition the machine is speeded up and the girl operating it is speeded up to its pace, *we have finally a situation in which the machine destroys the worker*."

The rapidly increasing misery among such exhausted women workers aroused public attention and led to the formation of a number of woman's organizations with the purpose to investigate abuses among such women workers, to teach them the value of trade unions, to agitate equal pay for equal work, to shorten the number of working hours, and to abolish child labor and prison work. The first national women's trade union, formed in the United States, was that of the *"Daughters of St. Crispin."* It held its first convention on July 28, 1869, at Lynn, Massachusetts. The delegates represented not only the local lodges of that state, but also lodges of Maine, New York, Pennsylvania, Illinois, and California.

With the organization of the *"Knights of Labor"* in 1869, and the *"American Federation of Labor"* the position of woman in the American labor movement became more firmly established, as both federations made it one of their principal objects "to secure for both sexes equal pay for equal work." They also appointed special committees to investigate the conditions of working women, and to organize them for concerted action.

Other potent factors arising in this line were the "*National Consumers' League*" and the "*Women's Trade Union League*." The founding of the first federation was due to efforts to better the conditions of women in department stores. In 1890 a group of saleswomen of New York City pointed to the fact that girls in fashionable department stores were receiving wages too low to allow them a decent living. They also complained that these girls were forced to stand from ten to fourteen hours a day, and that sanitary conditions in the cloak and lunch rooms were such as to endanger health and life. While the plan of these saleswomen, to unite all women clerks of the city into a labor union, failed, their complaints, however, attracted the attention of a number of influential ladies interested in philanthropic efforts. They investigated the charges against the department stores, and what they discovered made them resolve that conditions demanded radical changes. In May, 1890, they called a mass meeting of prominent women and proposed a constructive plan for raising the standard in shop conditions, not by *blacklisting* any firm guilty of bad conduct, but by *white-listing* those firms which treated their employees humanely. "We can make and publish," so the presiding lady said, "a list of all the shops where employees receive fair treatment, and we can agree to patronize only those shops. By acting openly, and publishing our White List we shall be able to create an immense public opinion in favor of just employers." In other words, it was by the spirit of praise rather than condemnation that these ladies sought to stimulate stores to raise their standards.

Adopting the name "*Consumers' League of New York*," the society organized on January 1, 1891, and published its first White List. It was a disappointingly small one, as it contained the names of only eight firms. Still more disappointing was the indifference of the many hundred other firms toward this reform movement. But soon enough these firms found that the League had also introduced into the New York Assembly a bill which became known as the "Mercantile Employers Bill." It aimed to regulate the employment of women and children in all mercantile establishments, and to place all retail stores, from the smallest to the largest, under the inspection of the State Factory Department.

Of course the merchants took prompt steps to defeat this obnoxious bill, and they were most complacent when their representatives in the Assembly succeeded in strangling it. But the bill appeared again and again, finally resulting in the appointment of a State Commission for the investigation of the conditions. As Reta Childe Dorr in her book "What Eight Million Women Want" graphically relates,

> "The findings of this Commission were sensational enough. Merchants reluctantly testified to employing grown women at a salary of *thirty-three cents a day*. They confessed to employing little girls of eleven and twelve years, in defiance of the child-labor law. They declared that pasteboard and wooden stock boxes were good enough seats for saleswomen; that they should not expect to sit down in business hours, anyhow.

They defended, on what they called economic grounds, their long hours and uncompensated overtime. They defended their system of fines, which sometimes took away from a girl almost the entire amount of her weekly salary. They threatened, if a ten-hour law for women under twenty-one years old were passed, to employ older women. Thus thousands of young and helpless girls would be thrown out of employment, and forced to appeal to charity."

The Senate heard the report of the Commission, and in spite of the merchants' protests, the women's bill was passed without a dissenting vote. Its most important provision was the ten-hour limit which it placed on the work of women under twenty-one. The bill also provided seats for saleswomen, and specified the number of seats, one to every three clerks. It forbade the employment of children, except those holding working-certificates from the authorities.

But soon it was found that the smart representatives of the merchants had succeeded in attaching to the bill a so-called "joker," by which the inspection of the stores was entrusted to the local boards of health. As the officials of these boards, supposedly experts, proved, in fact, ignorant of industrial conditions and their relation to health and sanitation, the true objects of the bill could not be enforced. So the Consumers' League was compelled to wage another tedious war, until it finally succeeded in convincing the Legislature that the inspection of all department and retail stores should be turned over to the State Factory Department. When this was done, there were reported in the first three months of the enforcement of the Mercantile Law over 1200 violations in Greater New York. At the same time 923 under-age children were taken out of their positions as cash girls, stock girls, and wrappers, and sent back to school.

It was natural that the good results and the purely benevolent motives of the Consumers' League attracted wide attention. Similar Associations were formed in many other cities and states. The movement spread so rapidly, that in 1899 it was possible to organize "*The National Consumers' League*," with branches in twenty-two states.

Encouraged by such success, the league now began to study the working conditions of girls employed in restaurants. It was found that in many cases these conditions were even worse than in the department stores. Girls of twenty years were found working as cooks from 6:30 in the morning to 11:30 at night, with no time off on Sundays or holidays! This meant 119 hours a week, more than twice the time the law permits for factory employees. Other girls, employed as waitresses, were serving every day from 7:30 a. m. to 10:30 p. m., or 105 hours each week! In going back and forth, they walked several miles a day, carrying heavy trays at the same time. In rush hours they worked at a constant nervous tension, for speed is one of their requirements. And they must not only remember a dizzying list of orders, but must fill them quickly and keep their temper under the exactions of the most rasping customer.

Based on such findings, the Consumers' League of New York caused the framing of a bill by which the hours of women in restaurants were limited to 54 hours weekly, which gave the girls one day of rest in seven, and prohibited their working between 10 p. m. and 6 a. m. In October, 1917, this bill became a law. In a number of other states minimum wage laws have also been secured.

The Consumers' League of Philadelphia took pains to investigate conditions in the silk mills of Pennsylvania. It was found that besides overwork and underpay there were often other evils, due to an erring as well as inhuman policy on the part of the employers. Like the owners of the department stores many of these men were possessed by the idea that the right to sit down would encourage slow work and laziness. Accordingly the girls in these mills were forced to stand from early morning till late at night, day after day, and month after month.

The secretary of the Consumers' League, who, under an assumed name, worked for some time in various mills, in order to study conditions, wrote:

"The harmful effect of continuous standing, upon young and growing girls, is too well established a fact to require any elaboration. In addition to the permanent ill effects, much immediate and unnecessary suffering, especially in hot weather, is inflicted by the prohibition of sitting. I could always detect the existence of this rule by a glance at the stocking-feet of the workers, and at the rows of discarded shoes beneath the frames. For after a few hours the strain upon the swollen feet becomes intolerable, and one girl after another discards her shoes."—

Another harsh and very common practice of employers is to cover the lower sashes of the windows with paint, and to fasten them so that they cannot be raised in hot weather. This is done "so that the girls don't waste time looking out."

The cruelty of these unnecessary rules is often aggravated by a most amazing lack of the common decencies and necessities of cleanliness.

One of the most difficult tasks of the Consumers' League was to overcome the absolute unwillingness of storekeepers to compensate their saleswomen for overtime. If it would be possible to compute the amount of such unpaid labor performed after the regular hours in many stores as well as in the bookkeeping and auditing departments, especially during the Christmas season, the sum would be startling indeed. A circular issued by the Women's Trade Union League of Chicago some years ago stated that the 3000 clerks in only one department store of that city had been required to work during the holiday season overtime to the total amount of 96,000 hours, without receiving any compensation. At the rate of only ten cents an hour these clerks suffered a loss of $9,600, at the rate of 25 cents an hour a loss of $24,000.

The first *"Women's Trade Union League"* was organized in 1875 by *Mrs. Emma Paterson*, the wife of an English trade unionist. While travelling in America, she had observed that women workers of various trades had formed unions, among which the

"Umbrella Makers' Union," the "Women's Typographical Union" and the "Women's Protective Union" were the most prominent. Convinced that the utility of such combinations could be still more increased, Mrs. Paterson, after her return to England, organized a federation of such women's unions, the *"British Women's Trade Union League,"* which later on became the model for a similar organization in America. It was founded on November 14th, 1903, for the one main purpose to organize all women workers into trade unions, in order to protect them from exploitation, to help them raise their wages, shorten their hours, and improve sanitary conditions of the work shops. Becoming affiliated with the "American Federation of Labor," the league gained a splendid victory during the years 1909 to 1911, when a series of huge strikes in the sewing trades spread over the East and the Middle West. Also an agreement was arrived at, that the principle of preference to unionists, first enforced in Australia, should be acknowledged. Under this plan manufacturers, when hiring help, must give to union workers of the necessary qualifications and degree of skill precedence over non-union workers.

At all times ready to express the sentiments and voice the aspirations of those who toil, the "Women s Trade Union League" represents to-day over 100,000 working women. While it has had a wonderful effect in improving standards of wages, hours and sanitary conditions in what was originally an underpaid and unhealthy industry, it also has become the pioneer in another direction, that of education in the labor movement. At the initiative of a group of girls an educational movement was started which has extended into organizations including some half a million workers, men as well as women. In public schools of New York, Philadelphia, Boston, Chicago, Los Angeles, and other cities educators of national reputation are co-operating with teachers and delegates from labor unions in giving lecture courses for adults on such subjects as social interpretation of literature, evolution of the labor movement, problems of reconstruction, social problems, trade unionism and co-operation, etc. At the same time a movement for co-operative housing has been developing. "The New York Ladies' Waist and Dressmaker's Union" for instance has bought in 1919 at a cost of several hundred thousand dollars a magnificent summer home for the exclusive use of its members. This "Unity House" at Forest Park, Pennsylvania, has accommodations for 500 guests. Situated at a beautiful lake, surrounded by shady forests and green lawns, provided with tennis courts, a library and reading rooms, it is an ideal recreation ground of first order. The money for this estate was brought up by the 30,000 members of the union, each contributing one day's wages.

In New York City also a co-operative "Unity House" has been established with quarters for fifty girls. A great extension of this movement in the city is planned. The Philadelphia group of the same union is following these examples and has acquired a fine estate worth $40,000.

At present the various woman's organizations of the United States as well as of other countries aim at the following issues:

1. To limit the working day for women to eight hours.
2. To demand for women equal pay with men for equal work.
3. To establish for all the various occupations minimum wage scales, sufficient to grant all women workers an adequate living.
4. To secure safe and sanitary working conditions, and clinics for the treatment of diseases resulting from certain industrial occupations.
5. To secure industrial insurance laws.
6. To secure for all women full citizenship with the right to vote in all municipal and national elections.

As woman's future position will depend on the realization of these demands, their discussion is of utmost importance.

THE MOVEMENT FOR AN EIGHT-HOUR DAY

As has been shown in a former chapter, innumerable valuable lives of workmen, women and, in former years, children have been sacrificed through the unreasonable exploitation by employers, who in their greed for profits had lost all consideration for the welfare of their fellow-men. Hundreds of thousands of laborers have been slowly worked to death as no sufficient amount of time for recuperation was granted them.

The only possible excuse for such incredible waste of human lives is that neither the employers nor the law-makers of those bygone days realized that the physical and mental abilities of the large laboring classes belong to the resources of a nation just as truly as do the water-power, the soil, the mineral deposits, the forests, and other natural means. Moreover, nobody was aware of the fact that it is one of the supreme duties of a wise government to guard these resources, so fundamentally necessary to the prosperity of a nation, from unscrupulous exploitation and possible destruction.

The danger of the reckless exploitation of laborers, especially of women workers, has increased considerably with the improvement of many machines, the greater speed and output of which demand far greater attention and strain than before on the part of the men or women operating them.

This is what Newton D. Baker, Secretary of War, said in 1917 at the annual meeting of the National Consumers' League:

> "Machinery has given us one great delusion. People have imagined that when a machine was operated by a steam engine or by an electric motor, the steam engine or the

electric motor actually did all the work, and the people who were attending it while it operated were more or less negligible. As a consequence, we indulged in the very unfortunate and often fatal belief that unlimited hours of labor were possible because it was the machines which were doing the work. We overlooked the fact, which we have lately begun to appreciate, that the person who tends the power-driven machine is far more susceptible to exhaustion, is far more open to fatigue and to the poisons that affect the system and that come from over-exertion than ever before."

Mrs. Florence Kelley, the able General Secretary of the National Consumers' League, who studied woman's occupation in the sewing trade, states that of late years the speed of the sewing machines has been increased so that girls using these improved machines are now responsible for twenty times as many stitches as twenty years ago, and that many girls and women, not capable of the sustained speed involved in this improvement, are no longer eligible for this occupation. Those who continue in the trade are required to feed twice as many garments to the machine as were required five years ago. The strain upon their eyes is, however, far more than twice what it was before the improvement. In the case of machines carrying multiple needles this is obvious; but it is true of the single needle machines as well.

When a girl cannot keep the pace she is thrown out. A comment frequently made by the girls about such an unfortunate comrade is: "She got too slow. She couldn't keep up with her machine any longer." It amounts to this, that the girl can earn a living wage, if she is unusually gifted, until she is worn out.

The nerve strain caused by innumerable rapid-working machines of the present day has become obvious in many cases. As the compressed air-hammer has shattered the nerves of many robust men, so the latest machines used in the sewing and other trades have impaired the health of many women.

"Such nerve strain," says Rheta Childe Dorr, "cannot be regulated. It is a Gordian knot that cannot be untied. The only thing to do is to cut it. The only solution of it is a shortened work-day. This is true for men as well as for women, but, in all probability, not to the same degree. Nerve strain affects men, certainly, and it demands, even in their case, a progressively shortened work-day as an alternative to a progressively shortened work-life. But with women the case becomes infinitely more urgent, infinitely more tragic, in exact proportion as woman's nervous system is more unstable than man's and more easily shaken from its equilibrium."

The advantages of an eight-hour day with rest at night for women and children have been summed up as follows:

1. Where the working day is short, the workers are less predisposed to diseases arising from fatigue. They are correspondingly less in danger of being out of work, for sickness is in turn one of the great causes of unemployment.
2. Accidents have diminished conspicuously wherever working hours have been reduced.
3. The workers have better opportunity for continuing their education out of working hours. Where they do this intelligently they become more valuable and are correspondingly less likely to become victims of unemployment.
4. A short working day established by law tends automatically to regularize work. The interest of the employer is to have all hands continuously active, and no one sitting idly waiting for needles, or thread, or materials, or for machines to be repaired. Every effort is bent towards having work ready for every hour of every working day in the year. In unregulated industry, on the contrary, there are cruel alternations of idleness and overwork.
5. For married women wage-earners it is especially necessary to have the working day short and work regular. For when they leave their workplace it is to cook, sew, and clean at home, sometimes even to care for the sick.—

In the movement for an eight-hour day for the women workers its advocates have already succeeded in Australia, Great Britain, Germany, Denmark, Porto Rico, and Mexico. The eight-hour day has also been secured for all employees of the U. S. Government and for the women and workmen of a large number of the states.

EQUAL PAY FOR EQUAL WORK

That women are entitled to equal pay with men for equal work, was recognized by the ancient Babylonians five or six thousand years ago. The justice of this demand is so self-evident, that it would hardly seem to need any discussion. Notwithstanding all labor organizations have been compelled to place it on their program, as many factory owners employed the cheaper woman- and child-labor only in order to underbid and reduce the wages of the male laborers. As female laborers have been much more poorly organized than men, they have been less capable of maintaining their claims.

The first equal opportunity and equal pay laws were passed in the State of Washington. In 1890 a section was added to her Labor Laws reading as follows:

"Hereafter in this state every avenue of employment shall be open to women; and any business, vocation, profession, and calling followed and pursued by men may be followed and pursued by women, and no person shall be disqualified from engaging in or pursuing any business, vocation, profession, calling or employment on account of sex."

Section 5 of Industrial Welfare Commission of the State of Washington, Order of September 10, 1918, is the first general equal pay law:

"That women doing equal work with men in any occupation, trade, or industry in this state shall receive the same compensation therefor as men during work of the same character and of like quantity and quality, the determination of what constitutes equal work to rest with the Industrial Welfare Commission."

THE MEANING OF THE MINIMUM WAGE

The interests of every community demand that all workers, male as well as female, shall receive a fair living wage, to save them from pernicious effects upon their health and morals. The dangers to the health of women have been found to be twofold: lack of adequate nourishment and lack of medical care in sickness. Careful investigations as well as statistics have proven that with insufficient wages food is necessarily cut down below the requirements of subsistence, and health inevitably suffers. In order to meet unavoidable expenses for lodging and clothing, workingwomen reduce their diet to the lowest possible point.

On the moral side, authorities agree in the opinion that, while underpayment and the consequent struggle to live may not be the primary cause for entering upon an immoral life, it is inevitably a highly important factor. When wages are too low to supply nourishment and other human needs, temptation is more readily yielded to.

The discovery that inadequate wages menace the morals of women and through them the interests and the good name of the community in which they work, has had much to do with the adoption of minimum-wage laws in America as well as in other parts of the world.

In the United States the first minimum-wage orders were those of the Oregon Industrial Commission, which fixed $8.64 as the legal weekly minimum for manufacturing establishments, and $9.25 for mercantile establishments, in the City of Portland. These rates were based upon the testimony of workers and employers gathered by the Oregon Consumers' League. The testimony had shown that the prevailing wage for beginners in department stores was $3.00 a week; that nearly half of these girls and women employed were receiving less than $9.00, and that female clerks never received above $10.00 a week, no matter how long the term of their service.

After learning from the employers what wages were actually paid, the Oregon investigators sought to determine the amount necessary to protect the health and morals of the women workers through an examination of market prices and a careful study of the actual expenditures of the workers. One hundred and sixteen department-store workers furnished the information for the following table of averages:

	Living at Home	*Adrift*
Rent	$315.51	$118.00
Board		196.25
Carfare	31.20	23.42
Clothing	161.36	139.63
Laundry	24.28	16.27
Doctor and Dentist	29.23	23.82
Lodge and Church	12.19	9.72
Recreation	21.48	36.62
Books, etc.	10.11	6.69
Total Expenses	$605.36	$570.42
The total wages received in the average:		
Total Wages	$459.50	$480.57
Deficit	$145.86	$89.85

These figures show that a majority of these women actually received less than it cost them to live.

Investigations carried on in order to find how these women met the difference, disclosed that many of them, whether living at home or boarding, did extra chores in the morning before going to work and after work-hours in the evening. Others went into debt. And still others became "charity girls"—that is, they kept company with "gentlemen friends," who came up for the balance, sometimes under promise of marriage when these "friends" should feel able to set up a household. That such promises are not always kept and that the girls quite often sink to lower levels, are facts well known.

The first law embodying the principle of the minimum wage was enacted in New Zealand 25 years ago. From there it spread gradually to the other Australian States. In 1896 Victoria, the largest industrial State of Australia, passed the first act providing for special boards to fix minimum wages in different trades. Beginning with a few sweat-shop industries, the movement has grown by successive special acts, until, in 1916, there were about 150 trades or occupations in which minimum wages were set by special wage boards.

The same general plan was followed by Great Britain in the trade boards act of 1909. This bill, introduced in Parliament by delegates of the English Anti-sweating League and of the National Consumers' League in January, 1909, was passed and signed in time to take effect at New Years, 1910.

In the United States, up to the end of 1918, minimum-wage laws had been enacted in Arizona, Arkansas, California, Colorado, Kansas, Massachusetts, Minnesota, Nebraska, Oregon, Utah, Washington, Wisconsin and in the District of Columbia, guaranteeing a living wage to women workers, especially in unorganized trades.

EFFORTS TO SECURE SAFE AND SANITARY WORKING CONDITIONS AND CLINICS FOR THE TREATMENT OF DISEASES RESULTING FROM INDUSTRIAL OCCUPATIONS

When in the industries human power began to be supplanted by steam-driven machines, when competition grew fierce and fiercer, it was found that with the ever increasing speed of the whirling wheels the dangers that threatened the workmen increased enormously. The use of almost every machine has brought with it some peculiar peril, this one crushing a finger or cutting a limb of the person in charge; that one tearing out an arm or killing the operator if for a fraction of a second his thoughts strayed from his work, or if he became drowsy after long hours of work.

It was also found that many persons, engaged in certain occupations, became afflicted by peculiar diseases, unknown before and strictly confined to the persons doing that special work.

According to conservative estimates, of the 38,000,000 wage earners of the United States, in every year 30,000 to 33,000 are killed by industrial accidents. In addition, there are approximately 2,000,000 non-fatal accidents.

Imagine a plain strewn with 35,000 corpses and two million men and women crying out under the pain of severe lacerations, burns, cuts, bruises, dislocations and fractures! Imagine the horrible sight of so many human beings with limbs torn into shreds, with faces having empty eye-holes, with breasts heaving from the effect of poisonous gases! If such numbers of men and women were killed and wounded in one day at one place, the whole world would be terrified, and register the day as the most dreadful in history. But as these losses extend over a whole year and a large territory, our nation takes only slight notice of them, hardly thinking of the fact, that these immense losses and sufferings are terrible realities, which affect the economic wealth of our nation as a whole in a very serious way.

These conditions are the more deplorable as the majority of such accidents could be avoided by intelligent and rational methods, as is done in other civilized countries, where the possibilities for successful prevention of accidents have been clearly demonstrated.

Granting that many of such industrial accidents are the result of ignorance, reckless indifference or carelessness, the fact remains that much that could be done in our country for the protection of working people is neglected.

When in Europe with the increase of industries the number of accidents and "professional diseases" swelled in proportion, some philanthropists and economists, interested in the welfare of their fellow-citizens and convinced that every life saved is a national asset, became alarmed and searched for means to prevent such calamities. When in 1855 the first World's Exposition was held at Paris, it had a special department in which were exhibited inventions for the safety of working people. Later on a permanent "Musée social" was established.

Since then similar institutions have been opened in Berlin, Munich, Vienna, Amsterdam, Brussels, Zurich, Copenhagen, Stockholm, Budapest, Milan, Moscow, and several other places. These museums contain the latest and most select inventions for the restriction of accidents and in the interest of industrial hygiene. And as all exhibits are arranged in separate groups according to the various professions, every manufacturer and every working man and woman can inform himself without loss of time about all new inventions relating to his special trade.

Perhaps the most comprehensive and most scientific of these museums is that of Charlottenburg, a suburb of Berlin. Its wonderfully interesting character is evident from the moment one enters the magnificent building, which occupies a whole city block. There are long rows of figures equipped with the various types of masks and helmets used by miners, divers, fire-fighters, and laborers, working in rooms filled with poisonous gases, dust, or irrespirable smoke. There are all the implements and attachments for the protection of persons working on men-killing machines.

There are casts in plaster and reproductions in wax illustrating all the dreadful skin diseases and deformities of the limbs, by which the laborers engaged in certain industries become afflicted. Other exhibits illustrate what measures should be taken for the improvement of the conditions of the working classes; how to furnish the best nourishment at the lowest cost; how to settle laborers in pleasant colonies, and how to treat those, who have become sick or afflicted with industrial diseases.

Among the most important exhibits are the statistics of three institutions provided for all persons employed in workshops and factories.

Germany was first among the nations to recognize the need of reforms in the social conditions of the working classes. Before 1870 wages had been low, and many of the evils that developed in other industrial countries had spread to Germany. Believing that the working classes have a right to be considered by the State the Government in 1881 initiated the era of "State social politics," which brought about an enormous change in the condition of the working classes. Besides many reforms in regard to the length of the working hours and to women's and children's labor, this State socialism provided for three important institutions: first, a compulsory insurance against sickness; second, a compulsory insurance against accidents; third, a compulsory insurance against invalidity and old age.

To the funds of the first class all laborers earning less than 2000 marks a year must pay two-thirds, and the employer one-third of the weekly premiums. In case of sickness, the insured person receives half the amount for twenty-six weeks. Doctors, hospitals and medicines are free. In 1913 14,555,609 laborers, men and women, were protected in this way. Many poor mothers were supported for several weeks before and after confinement. To prevent sickness, especially tuberculosis, the institution supported numbers of sanitariums and recreation homes, where thousands of people, who would otherwise have perished, regained their health.

The insurance fees against accidents had to be paid entirely by the employer. In case of an accident, it was not the employer in whose factory it had happened who was held responsible, but the whole group of employers in the same branch of industry. Every group was compelled to establish an insurance company. In 1913 there were 25,800,000 men and women thus protected. An injured laborer received, during the time of his disability, two-thirds of his wages, also free medical treatment. In case of his death the family received at once fifteen per cent. of his annual wages and an annual support of sixty per cent. As the employers naturally wish to keep the amount of expenses as low as possible, this kind of compulsory insurance greatly stimulated the invention and institution of measures by which accidents may be prevented.

The premiums for the insurance against invalidity and old age were paid half by the employees and half by the employer. Support was given to invalids without regard to age, and to persons above seventy years. To every lawful pension the Government contributed 50 marks. In 1914 16,551,500 people were protected by this insurance. In the one year of 1913, the amount distributed among needy people by these three branches of insurance was 775,000,000 marks. The miners of Germany were protected by similar institutions. The splendid results of such compulsory insurance induced the Government to prepare a special insurance for widows and orphans. It may be mentioned that the management of these insurance companies was entirely in the hands of the working classes and the employers.

All in all, the "Permanent Expositions for the Welfare of the Working Classes," as they exist in Berlin and in other European capitals, demonstrate what intelligent nations can do for the protection and the welfare of their laborers. How many millions of useful lives have been saved by the inventions brought here to the knowledge of the public, and what vast amounts of suffering, sorrow and tears have been averted, we can only guess.

In view of these facts it must be stated that our United States, which of all countries is the greatest in industry and suffers most heavily through industrial accidents and diseases, is among the most backward in regard to social legislation as well as in the effort to interest employers and employees in these welfare institutions which are of such vital value for both parties.

Yes, there was in 1910 a "Museum of Safety" established in New York, but so far it has remained the only one in the entire western hemisphere. And, as it is housed in the

lower floors of an insignificant building in 24th Street, it has failed to attract the attention and the support of the masses.

In my opinion, every state should have a permanent museum which brings to public knowledge all inventions relating to the special industries and trades followed by its population. The agricultural states may confine themselves to exhibits by which accidents connected with the pursuit of agriculture can be prevented. The mining states may give preference to everything that increases safety in the mines. The states bordering our oceans and great lakes should collect all devices that make navigation safer; our industrial states must direct their efforts to collect such inventions as may restrict accidents in workshops and factories. If this should be done, and if our governments, legislators and factory inspectors would demand the installation of such inventions, the terrific number of victims that perish every year upon our industrial battlefields would most assuredly be greatly diminished. It is to these aims that our statesmen as well as our male and female workers should direct their utmost endeavors.

Chapter 22

WOMEN AS MINISTERS OF THE GOSPEL

Perhaps in no other field of human activity has the disinclination of Christian men to make any concessions to women been so strong as in all matters regarding the church. While women were permitted to sit on thrones and rule vast empires, theological prejudice would not allow them to officiate at the altar or to occupy the pulpit. This vehement opposition was due to mediæval traditions and customs. The saying of the Apostle Paul: "I suffer not a woman to teach, nor to usurp authority over the man, but to be in silence," had been an inviolable law to all Catholic and Protestant dignitaries of the church. And so during the whole Middle Ages the idea was prevalent that a masculine priesthood alone was acceptable to God.

The first attempt to overthrow these views was made in 1634 by *Anne Hutchinson*, who came from Lincolnshire to Boston. Joining a church there she found that the male members used to meet every week to discuss the sermon they had heard the preceding Sunday. Believing that the power of the Holy Ghost dwells in every believer, and that the inward revelations of the spirit, the conscious judgment of the mind, are a paramount authority. Mrs. Hutchinson established similar meetings for the women. Soon she had large audiences, in which she set forth sentiments of her own. But disputes arose among her followers and their opponents, which grew so hot, that the continued existence of the two opposing parties was considered inconsistent with public peace. A convention of ministers, the first synod in America, was called in 1637, which condemned the opinions of Mrs. Hutchinson, and caused her to be summoned before the General Court. After a trial of two days, she was convicted of censuring the ministers and advancing errors, and sentenced to banishment from Massachusetts. She found refuge in Rhode Island, but moved later on to the Dutch settlements, where she as well as her children were killed by Indians.

In 1774 another English woman, *Anne Lee*, immigrated to New York. Professing to have received a special persuasion, she organized at Watervliet, N. Y., the first

community of Shakers, to which she promulgated a doctrine of celibacy. Their previous training had led members of this sect to expect that the second coming of Christ would be in the form of a woman; as Eve was the mother of all living, so in their new leader the Shakers recognized "the first mother or spiritual parent in the line of the female." These Shakers gave their women an equal share with men in the service and government of their society.

With the history of the "Salvation Army" likewise the names of several women are closely connected. This religious body was organized in 1865 on military lines by Rev. William Booth. In his revival and mission work among the lower classes of England he found in his wife Catherine a perfect helpmate. Together they conquered with their revivals first London, then the province, then the United Kingdom, and afterwards country after country in every part of the world.

In England *Mrs. Booth* was the first woman preacher, and if she had done nothing else but vindicate the right of woman to speak in public and preach the Gospel, she would have done great work. But she did far more than this. By making her whole life, and every thought and action subservient to the cause of the Salvation Army, she brought comfort and happiness to many thousands of poor souls.

The work of this "Mother of the Army" was continued by her daughter, *Evangeline Booth,* known in the history of the organization as "The Commander"; by *Emma Booth-Tucker,* known as "The Consul"; by *Mrs. W. Branwell Booth*, "The General," and by *Elizabeth Swift Brengle,* known as "The Colonel."

The first woman in the Christian world to be ecclesiastically ordained was *Antoinette Brown Blackwell*, an American 186woman who had graduated from Oberlin, Ohio. She was ordained in 1852 in South Butler, N. Y., by a council called by the First Congregational Church. *Rev. Olympia Brown* was the next woman ordained ten years later. In December, 1863, the *Rev. Augusta J. Chapin* was the first woman to receive the title of Doctor of Divinity.

Since the ordination of these women the number of female "clergymen" in the various denominations has increased rapidly. According to the Census of 1910 their number within the United States was 7395 in that year. The success of woman in the pulpit is no longer a question but an affirmation. This is what Rev. Phebe A. Hanford said on the subject:

"Other things being equal, why may not a woman preach and pray and perform pastoral duty as well as a man? Why should she not preside at the Lord's table, consecrate in baptism the child whose parents would dedicate their choicest possessions to God, or the adult who would thus express his faith in Christ and his determination that "whatever others may do he will serve the Lord"? When two loving hearts desire to join hands and walk the earthly pathway side by side, why should not a woman minister pronounce the sacred formula and convey the sanction of the Law and the Gospel to their matrimonial purpose? And when the voice of consolation is sorely needed, and the

solemn words are to be spoken which consign the silent dust to its last resting-place, why should not a womanly woman officiate as well as any tender-hearted and eloquent man? Surely woman is proverbially compassionate; and that she is often eloquent with voice and pen, and with poetic expression and the fervor of truth which can reach the heart, who can deny?"

Figure 50. Catherine Booth, The "Mother of the Salvation Army."

WOMAN IN THE MEDICAL PROFESSION

It is hard to realize in these days of professional equality between the sexes that only half a century ago a woman who desired to study medicine was considered such a phenomenon that her morality and the purity of her motives were questioned. And yet this desire is only natural, as the life of every woman has moments when she has to call for medical help. There are especially the transition to womanhood, all the experiences of motherhood, and the many ailments peculiar to women. To be compelled to consult in these cases a male physician, is for many bashful girls and women such a repellant thought, that they quite often postpone it from week to week, until too late.

No doubt such were the reasons and experiences which caused *Agnodice*, an Athenian girl, born about 300 B. C., to disguise her sex in order that she might study medicine. Like Dr. Mary Walker in the 19th Century, she donned male attire and became a disciple of Herophilus, an eminent physician and anatomist of the Alexandrian School. Her specialty was midwifery and women's diseases, and when she started to practice herself, she met with such great success that her male colleagues became jealous and tried to prevent her from practicing by accusing her of corruption before the Areopagus. But the result of the proceedings was quite contrary to their expectations, as a law was immediately passed allowing all freeborn women to learn midwifery.

Since then female physicians practiced in Hellas as well as in Alexandria and in Rome. And when in the 9th Century after Christ the famous Schola Salernitana was established at Salerno, a department for women's diseases was included, with a number of female professors as teachers. The names of several of these professors are still known; the most noted was the celebrated *Tortula*, who lived in the 11th Century. *Abella, Constanza, Calendas*, and *Hildegarde* too have been praised for their great ability.

This eminent position held by women in the medical profession declined slowly after the 12th Century, and practically disappeared after the 16th Century. The cause for this relapse was undoubtedly the increasing hostility of the Christian Church toward any

occupation of women with sciences. This prejudice remained alive up to modern times. It was dominant in 1845 when a young American woman, *Elizabeth Blackwell*, decided to study medicine. The same motives as had moved the Athenian Agnodice and the loss of a dear woman friend caused the young American to write to various physicians asking as to the wisdom and possibility of a woman becoming a doctor. The answers she received were unanimously to the effect that while the idea was a valuable one it was impossible of accomplishment for many reasons. This verdict only served to intensify her determination to accomplish her purpose. After two years of private study she went to Philadelphia, which in those days, 1847, was considered the seat of medical learning in this country, and made application to the four medical colleges for admission as a regular student. But such a revolutionary idea was not to be entertained, and all the doors remained closed to her. One kindly Quaker adviser said to her: "Elizabeth, it is of no use trying. Thee cannot gain admission to these schools. Thee must go to Paris and don masculine attire to gain the necessary knowledge."

It had now become a moral crusade with Miss Blackwell, and the justice and common sense of her undertaking seemed so supreme that she determined to push the warfare to the farthest limit. After similarly unsuccessful attempts in New York, she obtained a complete list of all the smaller institutions of the Northern States, examined their prospectuses, and sent applications for admission to twelve of the most promising. After long delay an answer came from the medical department of the small university at Geneva, in the western part of New York State. It seems that the faculty had submitted Miss Blackwell's letter to the medical class, who adopted the following resolutions:

> "Resolved—That one of the radical principles of a republican government is the universal education of both sexes; that to every branch of scientific education the door should be open equally to all; that the application of Elizabeth Blackwell to become a member of our class meets our entire approbation; and in extending our unanimous invitation we pledge ourselves that no conduct of ours shall cause her to regret her attendance at this institution."

Their gallantry won the day, the faculty cordially opened the doors of the institution, and she began her studies there at once.

Being the first female student in the small place her appearance of course gave rise to many comments. Many people looked at this new woman in wonder; some even inclined to regard her as a lunatic, or a disorderly person. But her behavior and seriousness compelled respect, and when in 1849 she received her degree, the public press very generally commented upon the event in favorable terms and even in Europe some notice of it was taken. She found fewer obstacles in her path in her studies abroad, especially in Paris. After her return to America she began practice in New York City, and here again she had to do pioneer work. The medical fraternity stood aloof, refusing to consult with

her, and society 189in general somewhat distrusted the innovation. But in time her work received just recognition and the status of women in the profession became fully established. In 1868 Dr. Blackwell founded the "Woman's Medical College of New York." The later years of her life were spent in England, where she also did much in moulding public opinion along the lines of philanthropy, especially in opening hospitals and dispensaries for women and children.

A few years after Miss Blackwell had received her diploma, another remarkable woman, *Florence Nightingale*, aroused world-wide admiration by her noble service during the Crimean war of 1853–56. Intensely devoted to the alleviation of suffering, she had since 1849 paid great attention to the sanitary conditions of civilian as well as military hospitals, which in many cases she found rather poor. In 1851 she went into training as a nurse, and when in 1853 war was declared with Russia, and the hospitals on the Bosphorus were soon crowded with the sick and wounded, she offered the English Government to go out and organize a nursing department at Scutari. Starting with a unit of thirty-seven nurses, she arrived at Constantinople when the mortality in the hospitals had become appalling. Seeing clearly the cause for this frightful state in the bad sanitary arrangements of the hospitals, Miss Nightingale devoted incessant labor to the removal of these causes, as well as to the mitigation of their effects, with such success, that in the English army the death-rate fell from 22¼% to only 2¼%.

After her return to England, in 1856, the Government as well as Queen Victoria and the public were not slow to acknowledge her splendid services. While the Queen presented her with a cross set with diamonds, the people subscribed a fund of several hundred thousand dollars for the purpose of enabling her to found an institution for the training of a superior order of nurses in connection with the St. Thomas's and King's College Hospitals. Miss Nightingale also enriched the medical literature by two valuable books, "Notes on Nursing" and "Notes on Hospitals," in which she gave the results of her lifelong observations.

The example of Miss Nightingale had much to do with calling forth the exertions of American women during the Civil War. As soon as there were wounded soldiers to heal, and military hospitals to serve, the patriotic and benevolent women of America remembered the great work of Florence Nightingale, and hastened to the front. As A. W. Calhoun states in his "Social History of the American Family," by 1864 there were busy in the North 250 women physicians. Women planned and organized also the "U. S. Sanitary Commission," for the alleviation of the sufferings of the battlefield. Its pre-eminent utility was universally recognized. It caused likewise several great charity fairs, the last two of which were held in New York and Philadelphia and yielded $1,000,000 and $1,200,000 respectively.

Among the female physicians, who did service during the Civil War, the most noteworthy was *Dr. Mary E. Walker*. Having studied medicine at the Medical College in Syracuse, N. Y., she was the first woman commissioned to serve on the surgical staff of

any army in time of war. On assuming her duties as surgeon in the war, she found hospital efficiency and hoopskirts incompatible; so she sacrificed the skirt and donned a man's coat and trousers. In recognition of her able services Congress not only awarded her a Medal of Honor, but also allowed her—the only instance in history—by a special act to continue to wear male attire. Dr. Walker declared many times that her sole reason for advocating dress reform for women were hygienic ones. A real pioneer in her profession, she also maintained for many years a farm for sufferers from tuberculosis and carried on a school for prevention of that disease modelled after a plan of her own.

Among the women, whose names appear in the history of the Civil War, one of the most brilliant was *Miss Clara Barton*. Devoting herself to the care of the wounded soldiers, she won for herself as superintendent of the hospitals in the army of the James the surname "the Florence Nightingale of America." During the Franco-Prussian War of 1870–71 she joined the German branch of the Red Cross Society, that noble institution, which in 1859 had been founded by Henry Durant, a citizen of Geneva, Switzerland.

Inspired by the example of Miss Nightingale, and horrified by the ghastly scenes of the Italian battlefields, he resolved to work for the proper treatment and nursing of wounded soldiers, while still on the ground. At his strong appeal the Swiss Federal Council invited all European nations to a convention in order to discuss proper steps to be taken in this direction. Attended by delegates from Baden, Belgium, Denmark, France, the Netherlands, Prussia, Switzerland and Wurtemberg, the convention met on August 22, 1864, in Geneva, and decided, that henceforth not only all places where wounded soldiers are treated, but also all persons, engaged in this samaritan service, should be regarded as neutrals and distinguished by white flags or white bands showing a red cross. Such places must not be attacked, but protected by the soldiers of all combating armies.

In the further history and evolution of this international *Society of the Red Cross* women have played a most prominent part. Miss Barton established during the Franco-Prussian War several military hospitals and, by conducting them, distinguished herself so that she was decorated with the Iron Cross. After her return to the United States she organized in 1882 the "American Red Cross Society," of which she became the first president. The work of Miss Barton and the Red Cross in the Spanish-American War and the great help given to the sufferers after the great tidal wave in Galveston, Texas, caused the United States Senate and the Texas Legislature to adopt resolutions of thanks.

All these great efforts of women could not fail to create a most favorable impression toward woman's activity in medicine. In England an act of 1868 for the first time opened the study of pharmacy to women; and after a long struggle they obtained their footing as physicians. In 1874 a special medical school was opened for women in London. In 1876 an act authorized every recognized medical body to open its doors to women. In 1878 a supplemental charter enabled the University of London to grant degrees to women in all its faculties, including medicine. As a result up to the close of 1895 264 women had been placed on the British register as duly qualified medical practitioners.

In the United States similar progress was made.

According to the census of 1910, there were 7399 women physicians and surgeons in the United States.

Whereas fifty years ago there was great objection to admitting women to the medical societies, now the men of the profession welcome women physicians to the societies and to their discussions, and are more than willing to consult with them. The advantage of employing women physicians has been recognized likewise by many hospitals, sanitariums and insane asylums; the courts too recognize the justice of women's preferring women in the physical examination required by law. There can be no doubt, that the 20th Century opens to women physicians undreamed-of possibilities in science and in the art of healing.

Chapter 24

WOMAN IN THE PROFESSION OF THE LAW

When in the year of our Lord 1869 American papers reported that in Iowa a woman had been admitted to the bar, most readers were inclined to regard this "bit of news" as one of the many jokes, sprung occasionally upon credulous people in order to warn them what the "new woman" might be able to do. But in this case the "joke" turned out to be a fact. And if people had been somewhat better acquainted with their Bibles, they would have known that the woman lawyer of Iowa was only another confirmation of Rabbi Ben Akiba's famous saying: "There is nothing new under the sun!"

Open your Bible and read in Chapter 4 of the Judges IV about *Deborah*, the Joan of Arc of the Hebrews. Of this most extraordinary woman recorded in Jewish history it is stated that she was a prophetess as well as a judge, "to whom the children of Israel came for judgment."

The Greeks and Romans too had female lawyers. From writers of the classic past we know that *Aspasia* pleaded causes in the Athenian forum, and *Amenia Sentia* and *Hortensia* in the Roman forum. And Valerius Maximus (Hist. lib. VIII, Chapter 3) states that the right of Roman women to follow the profession of advocate was taken away in consequence of the obnoxious conduct of *Caliphurnia*, who, from "excess of boldness" and "by reason of making the tribunals resound with howlings uncommon in the forum," was forbidden to plead. The law, made to meet the especial case of Caliphurnia, ultimately "under the influence of the anti-feministic tendencies" of the period, was converted into a general one. In its wording the law sets forth that the original reason for woman's exclusion "rested solely on the doings of said person."

The "howlings of Caliphurnia" furnished the legislators of all later periods with a welcome pretext to exclude women from practice of the law, and it was not till 1869 that a woman again obtained admission to the bar. This pioneer was *Miss Arabella A. Mansfield* of Mount Pleasant, Iowa, who was admitted to the Iowa bar in 1869, under the statute providing only for admission of "white male citizens."

The next female lawyer was *Mrs. Belva Ann Lockwood*, a graduate of the Law School of the National University at Washington, D. C. Having been admitted in 1873 to practice before the Supreme Court of the District of Columbia, she applied in October, 1876, for admission as practitioner of the Supreme Court of the United States, but was rejected under the following decision:

> "By the uniform practice of the Court from its organization to the present time, and by the fair construction of its rules, none but men are admitted to practice before it as attorneys and counselors. This is in accordance with immemorial usage in England, and the law and practice in all the States, until within a recent period; and the Court does not feel called upon to make a change until such a change is required by statute or a more extended practice in the highest courts of the States."

Figure 51. Belva A. Lockwood.

But if the members of the Supreme Court had entertained the hope of scaring away women once and for all, they soon enough found that they were mistaken. Mrs. Lockwood drafted a bill and secured its passage in Congress, providing "that any woman who shall have been a member of the bar of the highest court of any State or Territory, or of the Supreme Court of the District of Columbia, for the space of three years, and shall have maintained a good standing before such court, and who shall be a person of good moral character, shall, on motion, and the production of such record, be admitted to practice before the Supreme Court of the United States." This bill was approved on February 15th, 1879. Since then Mrs. Lockwood as well as a number of other female lawyers have been admitted under this law to practice before the highest court of the United States.

A "Woman's International Bar Association" was organized in 1888, for the purpose of establishing law schools for women and of promoting the interests of female lawyers as well as of securing better legal conditions for women.

According to the Census of 1910 there were 1010 woman lawyers in the United States.

"Having taken up the law," so said Miss Edith J. Griswold, herself a counsellor-at-law, "woman will not rest until she stands on a level with man, and the end of the Twentieth Century will probably find an equilibrium in the United States Government that can only be obtained (as in the home government) by the equal balancing of the different propensities of male and female mind in the making and enforcing of laws. The prophecy that the time is coming when woman will govern seems ludicrous, and yet it is no more ludicrous than the present lopsided arrangement whereby man has the exclusive power of government. With the rapid advance of woman conditions are being manifested that require woman's judgment, and to obtain true justice in matters relating to both sexes an equal number of men and women should compose both the court and the jury. By the end of the Twentieth Century, I believe, a woman's judgment will carry as much weight as a man's, and the opinions handed down from our higher courts will have to be concurred in by an equal number of male and female judges."

WOMEN AS INVENTORS

Sometimes, when the merits of the woman movement were discussed, its opponents made it their trump that the female sex is without any inventive spirit and that this want should be regarded as a convincing evidence for the inferiority of woman s mind. That this assertion was never true at all, but made in absolute ignorance of the real facts, becomes evident, when we recall, that primeval and aboriginal women have been the inventors of our most important industries, of agriculture, weaving, basketry, pottery, tannery, brewing, and many other peaceful arts. And there is not the slightest doubt, that during the times of Antiquity and the Middle Ages women have been the greatest factor in the evolution of these industries, in which they remained constantly busy.

Among the few instances of which records have been preserved, is that of *Barbara Uttmann*, a German woman of Annaberg, Saxony, who in 1561 invented the Cluny-lace. Herewith she opened, for the extremely poor people of the Erzgebirge, at the most critical time, a new and well paying industry, in which in 1800 about 35,000 girls and women were busy.

Another important invention was made in 1792 in America by the widow of General Nathaniel Green. It was the so-called cotton gin by which the difficult work to separate the seed from the lint was greatly simplified. To pick the seed from one pound of cotton had been formerly considered a good day's work. With the aid of the cotton gin, which consists of a series of saws revolving between the interstices of an iron bed upon which the cotton is placed so as to be drawn through whilst the seeds are left behind, several hundred pounds of cotton can be cleaned in the same time. This invention stimulated enormously the cultivation of cotton and the manufacture of cotton goods in America. In the South, where so far cotton had been produced only in small quantities, it now became the main product. While in 1792 the quantity exported from the United States was 138,324 pounds, it increased by the year 1800 to nearly 18,000,000 pounds. In the North it led to the establishment of cotton mills and factories on a large scale.

As only few countries have taken the trouble to prepare statistics about inventions made by women it is impossible to give reliable facts about what women have contributed to human culture in this line.

Their most intensive activity has been observed in the United States, especially since with the founding of woman's colleges and the opening of the universities, the education of the female sex became a more careful and broader one.

The U. S. Patent Office at Washington, D. C., has published "Lists of Women Inventors," in three volumes, covering the period from 1790 to March 1, 1895. From these lists it appears that till 1849 only 32 inventions by women have been registered at the Patent Office. This number increased to 290 during the period from 1850 to 1870; during 1870–1890 to 2568, and up to 1910 to 7942. These numbers prove that with the increase of woman's knowledge and with the closer contact with modern industrial life her inventive spirit has likewise developed. Also the inventions became more manifold. While prior to 1850 they were almost exclusively confined to dress and household, they now cover all fields of human activity.

This fact became most evident during the terrible years of the World War. Some time ago the "Women Lawyer Journal" reported that of all the many inventions registered since 1914, fifty per cent. have been entered by women. Among these inventions have been such for the better protection of soldiers and aeronauts as well as for the greater comfort of the wounded and crippled. Other inventions meant improvement in wireless telegraphy, gas masks, submarine boats and hundreds of other objects.

EMINENT FEMALE SCIENTISTS

Just as hostile as had been the clergy to the admission of women to ecclesiastical office, so unwilling were many prejudiced scholars to admit women into the sacred realms of science. By hundreds of arguments they tried to prove the inability of women to do any deeply scientific work. They explained that the hard study would impair their health, their chances of marriage, and their true destination as mothers. Higher education would make women unfit for domestic life, and, besides, they would hardly produce anything of real scientific value.

If these learned gentlemen would have taken the trouble to make themselves somewhat more acquainted with the history of science they would have found the names of numerous women on record, who, at their time, were among the leaders in the most abstruse sciences. Several centuries before Christ Hellas as well as Rome had a number of brilliant female philosophers, among them *Damo*, the daughter of Pythagoras, who lived about 580–500 B. C. She was one of his favorite disciples, and to her the great savant entrusted all his writings, enjoining her not to make public all the secrets of his philosophy. This command she strictly obeyed, though tempted by large offers while she was struggling with poverty.

Socrates, the great philosopher, declares that he learned of a woman, *Diotima*, the "divine philosophy," how to find from corporeal beauty the beauty of the soul, the angelical mind. Diotima lived in Greece, about 468 B. C.

Arete is known as the daughter of Aristippus of Cyrene, the founder of the Cyrenaic system of philosophy, who flourished about 380 B. C. She was carefully instructed by her father, and after his death taught his system with great success. *Leontium*, living about 350 B. C., was a disciple of Epicure, and wrote in defense of his philosophy. *Tymicha*, a Lacedaemonian, was the most celebrated female philosopher of the Pythagorean school. When she, in 330 B. C., was brought before Dionysius, the tyrant of Syracuse, as a prisoner, he made her very advantageous offers, if she would reveal the mysteries of

Pythagorean science; but she rejected them all with scorn and contempt. And when he threatened her with torture, she instantly bit off her tongue, and spat it in the tyrant's face, to show him that no pain could make her violate the pledge of secrecy.

Of *Hipparchia*, a lady of Thrace, who lived about 328 B. C., it is known that her attachment to learning was so great, that having attended several lectures of Crates, the cynic, she resolved to marry him though he was old, ugly, and deformed. She accompanied him everywhere to public entertainments and other places, which was not customary with Greecian women. She also wrote several philosophical theses, and reasonings and questions proposed to Theodorus, the atheist; but none of her writings are extant.

Ancient Rome too had a number of female philosophers, among them *Cornelia*, "the mother of the Gracchi." She frequently gave public lectures and was more fortunate with her disciples than with her sons. It was Cicero, who said of her that, had she not been a woman, she would have deserved the first place among philosophers. In what esteem she was held is shown by the fact that a statue was erected to her with the inscription, "Cornelia, Mater Gracchorum." She died about 230 B. C.

The most renowned female philosopher of the classic times was *Hypatia*, the lovely daughter of Theon, the head of the famous Alexandrian School in Alexandria, Egypt. Born in 370 A. D., Hypatia was taught by her father and acquired such extensive knowledge and learning, that the Bycantine Church historian Socrates, as well as Nicephorus placed her far above all the philosophers of her time. Several other learned contemporaries praise her in similar terms. Sinesius, bishop of Ptolemais, never mentions her without the profoundest respect, and in terms of affection little short of adoration. In a letter to his brother Euoptius he writes: "Salute the most honored and the most beloved of God, the Philosopher Hypatia, and that happy society, which enjoys the blessing of her divine voice." And in a long epistle he sends her with the manuscript of a book, he asks her opinion and states his resolution not to publish the book without her approbation.

Hypatia succeeded her father in the government of the Alexandrian School, teaching from the chair where Ammonius, Hieracles, and other celebrated philosophers had taught; and this at a time, when men of immense learning abounded in Alexandria and in other parts of the Roman empire. In fact her renown was so universally acknowledged, that she had always a crowded auditorium. What a subject for an able artist, to present this beautiful woman in her chair, with the flower of all the youth of Africa, Asia and Europe sitting at her feet, eagerly imbibing knowledge from this oracle of wisdom.

Socrates states that she was consulted by the magistrates of Alexandria in all important cases. This frequently brought her among the greatest assemblages of men without causing the least censure of her manners. "Considering the confidence and authority which she had acquired by her learning," says Socrates, "she sometimes came to the judges with singular modesty. Nor was she anything abashed to appear thus among

a crowd of men; for all persons, by reason of her extraordinary discretion, did at the same time both reverence and admire her."

Unfortunately this wonderful woman was to become a martyr of science. The population of Alexandria was split into three hostile groups—the Pagans, the Jews, and the Christians. The latter, under the leadership of the patriarch Cyril, assailed in violent zeal Jews as well as pagans, and heretics or supposed heretics alike, driving them by thousands from the city, destroying their synagogues and temples, and pillaging their houses. It was during one of these riots, that the illustrious Hypatia was attacked by a mob of vicious monks, torn from her carriage, dragged into a church, stripped naked and clubbed to death. Then the murderers in fanatic frenzy tore the body to pieces, carried the limbs to a public square and burnt them to ashes. This happened in Lent 415.

All the writings of Hypatia, among them her treatise "On the Astronomical Canon of Diophantus" and another "On the Conics of Apollonius" are lost. Most probably they too were destroyed by the fanatic Christian mobs, who, after the murder of Hypatia, extinguished the Greek School of philosophers and scientists at Alexandria.—

Astronomy, probably the most ancient of the sciences, has since early days exerted a singular attraction on women.

Herman Davis, in his essay "Women Astronomers," published in the reports of Columbia University, New York, gives the names of a large number of women astronomers, beginning with several of classic times. Of the Egyptians he mentions *Aganice, Athyrta, Berenice, Hipparchia* and *Occelo*, who were connected with the Alexandrian School. Of the Greeks he names *Aristocle* and *Athenais*, and of Thessaly *Aglaonice*. But nothing definite is known about their achievement.

Davis likewise gives an account of *Hildegarde*, abbess of the monastery on Mount St. Rupert near Bingen on the Rhine. This learned woman, who lived from 1099 to 1180, wrote a book in Latin, in which some marvelous statements are claimed to have been made: 1. that the Sun is in the midst of the firmament retaining by its force the stars which move around it; 2. that when it is cold in the Northern hemisphere it is warm in the Southern, that the celestial temperature may thus be in equilibrium; 3. that the stars not only shine with unequal brilliancy but are themselves really unequal in magnitude; 4. that as blood moves in the veins and makes them pulsate, so do the stars move and send forth 200pulsations of light.

> "If even one-half of these marvelous statements are found in Hildegarde's writings as early as the 12th Century," says Davis, "then this woman may well be classed with the great forerunners of modern astronomy, with Copernicus, Galileo and Newton, for she was three centuries earlier than the first of them."

The first female astronomer of whom we have more intimate information, was *Marie Cunitz*, born in 1610 as the eldest daughter of a physician in Silesia. Commanding an

extraordinary general culture, her principal study was mathematics and astronomy. Her tables, published under the title "Urania Propitia, sive Tabulæ Astronomicæ," gained for her a great reputation, and the by-name "the Silesian Pallas." Dedicated to the Emperor Ferdinand III the book was published in Latin and in German in 1650 and 1651.

Another noted astronomer was *Caroline Lucretia Herschel*, born in 1750 at Hanover, Germany. In 1772 she accompanied her brother William to England, and when he accepted the office of astronomer-royal, she became his constant assistant in his observations. In this capacity she succeeded in discovering independently eight comets, five of which had not been observed before. Also she discovered many of the small stellar nebulæ which were included in her brother's catalogue. For her many contributions to astronomy in 1835 she was presented by the Astronomical Society with their gold medal, and was also elected an honorary member.

When the memoirs of Miss Herschel were published, the editor, in describing her character, said:

> "Great men and great causes have always some helper of whom the outside world knows but little. These helpers and sustainers have the same quality in common— absolute devotion and unwavering faith in the individual or the cause. Seeking nothing for themselves, thinking nothing of themselves, they have all the intense power of sympathy, a noble love of giving themselves for the service of others. Of this noble company of unknown helpers Caroline Herschel was one."—

This capacity of self-denial distinguished likewise a number of other women, whose names are known in the history of astronomy, as for instance *Theresa and Madeline Manfredi*, the daughters of Eustachio Manfredi, from 1674 to 1739 director of the observatory of Bologna. Further, *Marie Margarethe Kirch*, who assisted her husband, the astronomer Kirch, in the upper Lausatia; Madame *Lepante*, the wife of the famous clock-maker Jean Andre Lepante; and nearer our own time, there is *Maria Mitchell*, born 1818 at Nantucket, Mass., who at an early age became the assistant of her father. Carrying on a series of independent observations, she was in 1865 appointed professor of astronomy in Vassar College.

Emilie de Bréteuil, Antonie C. Asher, Elizabeth von Matt, Wilhelmine Witte and *Agnes Mary Clerke* likewise distinguished themselves in astronomy. The last named lady published in 1885 a "History of Astronomy" and in 1890 "The System of the Stars." These writings, conspicuous for a careful sifting and due assimilation of facts, with a happy diction that is at the same time both popular and scientific, place the author in the foremost rank of writers on astronomy.—

As an eminent mathematician, linguist and philosopher *Maria Gaetana Agnesi* is known to every student of science. Born 1718 at Milan, she gave early indication of extraordinary ability and devoted herself to the abstract sciences. In mathematics she

attained such consummate skill, that, when her father, professor of mathematics at Bologna, died, the Pope allowed her to succeed him. In this capacity she wrote her famous work: "Instituzions Analitiche ad Uso Gioventu Italiana," which was published at Milan in 1748. Its first volume treats of the analysis of finite quantities, and the second of the analysis of infinitesimals. The able mathematician John Colson, professor at the University of Cambridge, considered this work so excellent, that he studied Italian in order to translate it into English. Under the title "Analytical Institutions" this translation was published in 1801, to do honor to Maria Agnesi, and also to prove that women have minds capable of comprehending the most abstruse studies.

Another female mathematician, *Sophie Germain*, born in 1776 in Paris, won the grand prize, offered by the Institute of France for the best memoir giving the mathematical theory of elastic surfaces and comparing it with experience. This question had come up in 1808. Great mathematicians were not wanting in Paris at that time—Lagrange, Laplace, Poisson, Fourier, and others, but none of them were inclined to tackle the question. Lagrange, in fact, had said that it could not be solved by any of the then known mathematical methods. The offer was twice renewed by the Institute, and in 1816 the prize was conferred upon Sophie Germain, who in 1808 as well as in 1810 had made two unsuccessful attempts to solve the difficult question. The same woman distinguished herself by a number of other valuable papers and philosophical writings.

In more recent years *Sonja Kowalewska*, a Russian, who had studied mathematics at the universities of Berlin and Goettingen, became famous as the winner of the Prix Bordin, offered by the Academy of Paris. Later on, as a professor of mathematics in Stockholm, she wrote a number of excellent professional works, but died there in her fortieth year.

Among the British scientific writers of the 19th Century the most famous was *Mary Somerville*, whom Laplace called the most learned woman of her age and the only woman who understood his works. In translating his brilliant work "Mécanique Celeste," she greatly popularized its form. Its publication in 1831 under the title of "The Mechanism of the Heavens" at once made her famous. Her own works: "Connections of Physical Science," "Physical Geography" and "Molecular and Microscopic Science" have been declared masterworks, distinguished by a clear and crisp style, and the underlying enthusiasm for the subject.

In the history of chemistry the name of *Marie Curie* will be forever connected with the wonderful discovery of Radium and Radio-activity. Born on November 7, 1867, at Warsaw as Marja Sklodowska she came to Paris in 1888 and studied at the Faculté des Sciences. In 1895 she married Professor Pierre Curie and joined him in his chemical investigations. It was in 1898 that she published a most valuable work on metals in solution. Her investigations in collaboration with her husband led to the discovery of two new bodies: Polonium and Radium, which are found in certain minerals, especially in pitch blende in a state of extreme solution; as a matter of fact, to the extent only of a few

decigrammes to the ton of mineral for Radium, and much less in the case of Polonium. The separation of these elements presented extreme difficulties.

Further investigations led to the observation of most interesting phenomena in connection with these bodies—chemical effects, luminous effects, effects of heating, etc. New realms of science were disclosed—the science of Radio-active phenomena. In recognition of these discoveries in 1903 the Nobel Prize was awarded to Professor Curie and his wife. And when Mrs. Curie, after the tragic death of her husband, accomplished the "isolation" of Radium and also determined its atomic weight, she was awarded the Nobel Prize for a second time in 1911. At present Mrs. Curie is Director of the Physico-Chemical Department of the University of Paris.

For valuable research work in bacteriology *Dr. Rhoda Erdmann*, a former assistant of the famous professor Robert Koch in Berlin, became most favorably known. Having published several excellent treatises on the amoeba and protozoa, she followed in 1913 a call to the Sheffield-Institute of Yale University.

In the wide fields of archæology and ethnology likewise several women have achieved remarkable results. Among those scientists who devoted themselves to the study of archæology and the ancient history of America the name of *Zelia Nuttall* is well known. She is the author of many interesting essays on the relics left by the Aztecs, Toltecs, and Mayas. Science is also indebted to her for the so-called "Codex Nuttall," now preserved in the Peabody-Museum at Cambridge, Mass.

Another noteworthy ethnologist was Erminnie Adele Smith, who, as compiler of the famous Iroquois-English Dictionary, was distinguished by being elected the first woman member of the New York Academy of Science.

Alice Cunningham Fletcher made most valuable investigations about the religious and social conditions of several Indian tribes of the Far West, especially of the Sioux, Omaha, and Pawnee Indians. Her very exhaustive studies have been published in the Annual Reports of the Bureau of American Ethnology.

The same reports contain highly interesting papers by Matilda Cox Stevenson and Tilly E. Stevenson about the mythology, esoteric societies and sociology of the Zuni Indians.

Miss Elsie Clews Parsons in New York has published valuable monographs about the folk-lore of the Pueblo Indians and the Negroes of the Bahama Islands. A. M. Czaplicka, Mary Kingsley, Barbara Freire-Marreco, Adele Breton, Mrs. Jochelson-Brodsky, and Maria Tubino are likewise most favorably known as writers on archæology and ethnology.

For a number of years Johanna Mestorf has held the position of director of the Museum of Antiquities of Schleswig-Holstein.

Cornelia Horsford, the learned daughter of the late Professor Eben Horsford of Cambridge, Mass., made great efforts to settle many questions in regard to the early voyages of discovery by the Norsemen to Greenland and Vinland. In the pursuit of these

studies she sent several scientific expeditions to Iceland as well as to Greenland and published a number of valuable essays, among them "Graves of the Northmen"; "Dwellings of the Saga Time in Iceland, Greenland and Vinland"; "Vinland and its Ruins"; and "Ruins of the Saga-Times."

Anne Pratt is known as an able botanist. And Eleanor Anne Ormerod has been hailed in England as "the Protector of Agriculture," as she organized the valuable "Annual Series of Reports on Injurious Insects and Pests," distributed by the Government.

Among the explorers of the Dark Continent a Dutch lady, Miss Alexandrine Tinné, created a sensation by her daring journeys in the upper Nile regions. During her first expedition, which lasted from 1861 to 1864, she penetrated great stretches of unknown territory, and was the first to enter the land of the Niam Niam. Several members of her expedition died from the terrible hardships that had to be overcome. After her return to Cairo Miss Tinné started in January, 1869, on a still more hazardous expedition, which was to proceed from Tripoli to Lake Tchad, and from there by way of Wadai, Darfur, and Kordofan to the Upper Nile. But while her caravan was on the route from Murzuk to Rhat, the daring explorer was murdered by her own escort.

An English lady, Florence Caroline Dixie, explored the wilderness of Central Patagonia. Isabelle Bishop became known for her extensive travels through Asia, and the masterful descriptions of those countries she had traversed. Her best work is "Korea and Her Neighbors."

Therese, Princess of Bavaria, wrote several highly interesting works about her extensive travels in Colombia, Ecuador, Bolivia, Chile, and the tropical regions of Brazil. Cecilie Seler, the wife of the famous archæologist Eduard Seler, is the author of the valuable book "On Ancient Roads in Mexico and Guatemala."

While these examples—which might be increased by many others—give ample proof of woman's ability in regard to scientific work, it must be stated, that, up to the middle of the 19th Century, men did very little to encourage their struggling sisters in this line of activity. Indeed, there are not a few instances of strong disinclination on the part of statesmen as well as of scientists, to smooth woman's road to higher education. Centuries passed before women succeeded in gaining the right to follow their studies in colleges and universities, a right they had enjoyed in Italy during the 10th and 11th Centuries as well as during the Renaissance.

The first institution of modern times, that admitted women on the same footing with men, was Oberlin College in Ohio, founded in 1833 and open to all irrespective of sex and color. The first woman who graduated here was Miss Zerniah Porter, who in 1838 received her diploma in the so-called literary course. The State universities of the West that were founded later on all followed the example set by Oberlin College and gradually the older ones adopted the same policy, so that all over the West and South, where the State university is a strong influence, these institutions are open to women. Throughout these regions women's education is for this reason almost synonymous with co-

education. In the Eastern part of the United States, however, the private college predominates, and there is a greater degree of separation. But even here the restrictions are gradually being removed, and most of the men's colleges and universities admit women to some departments with some restrictions, or have an affiliated woman's college.

America has also a number of independent colleges exclusively for women. The best known among them are Vassar College, at Poughkeepsie, New York, organized in 1861, with 1124 students and 144 teachers in 1918; Wellesley College in Massachusetts, organized in 1875, and with 1612 students and 138 teachers in 1918; Bryn Mawr in Pennsylvania organized in 1880, and with 489 students and 63 teachers in 1918; Smith College at Northampton, Mass.

France began to open its universities to women in 1858; England followed in 1864; Switzerland in 1866; Sweden in 1870; Denmark, Holland, Finland and India in 1875; Italy and Belgium in 1876; Australia in 1878; Norway in 1884; Iceland in 1886; Hungary in 1895; Austria in 1897; Prussia in 1899, and Germany in 1900.

To-day no one clings any longer to the old prejudices against the abilities of women. College education among women has become so common as to attract little or no attention. It is regarded as the essential training for intellectual, professional and business life, and it is no longer an effort to secure it, but rather to make it of the greatest possible value to the students and to the community. As women do a large proportion of the teaching in public schools as well as in colleges for both sexes, the education of the citizens of the 20th Century depends largely upon the opportunities available to women in the past, present and future.—

As educators as well as founders of learned institutions large numbers of women became most favorably known. There was for instance *Jeanne Louise Henriette Campan*. When the tempests of the French Revolution began to rage, she held a position at the royal court as reader to the young princesses. Thrown on her own resources after the dethronement and execution of the King and the Queen she established a school at Saint-Germain. The institution prospered, and was patronized by Mme. Beauharnais, whose influence led to the appointment of Mme. Campan as superintendent of the Academy founded by Napoleon at Ecouen, for the education of the daughters and sisters of members of the Legion of Honor. While in this position Mme. Campan wrote a treatise "De l'Education des Femmes."

Emmy Hart Willard in 1823 founded Troy Female Seminary at Troy, N. Y., over which she presided until 1838. Mary Mason Lyon established in 1836 Mount Holyoke Female Seminary, of which she was president until her death in 1849.

Elizabeth Palmer Peabody in Boston was largely instrumental in introducing Froebel's kindergarten system in the United States. She likewise wrote a number of educational works. In England Emily Anne Shireff was active as President of the Froebel Society of England. Barbara Leigh Smith Bodichon, who worked for the extension of

university education to women, aided in 1868 in establishing Girton College, at Cambridge, England. Anne Jemima Clough founded in 1867 the North of England Council for Promoting the Higher Education of Women, and in 1875 the Newnham College for Women.

The name of Sophie Smith is remembered as the founder of Smith College at Northampton, Mass., the first woman's college in New England; the name of Annie N. Meyer as the founder of Barnard College, the woman's department of Columbia University in New York.

Marie Montessori was the inventor of a new system of teaching.

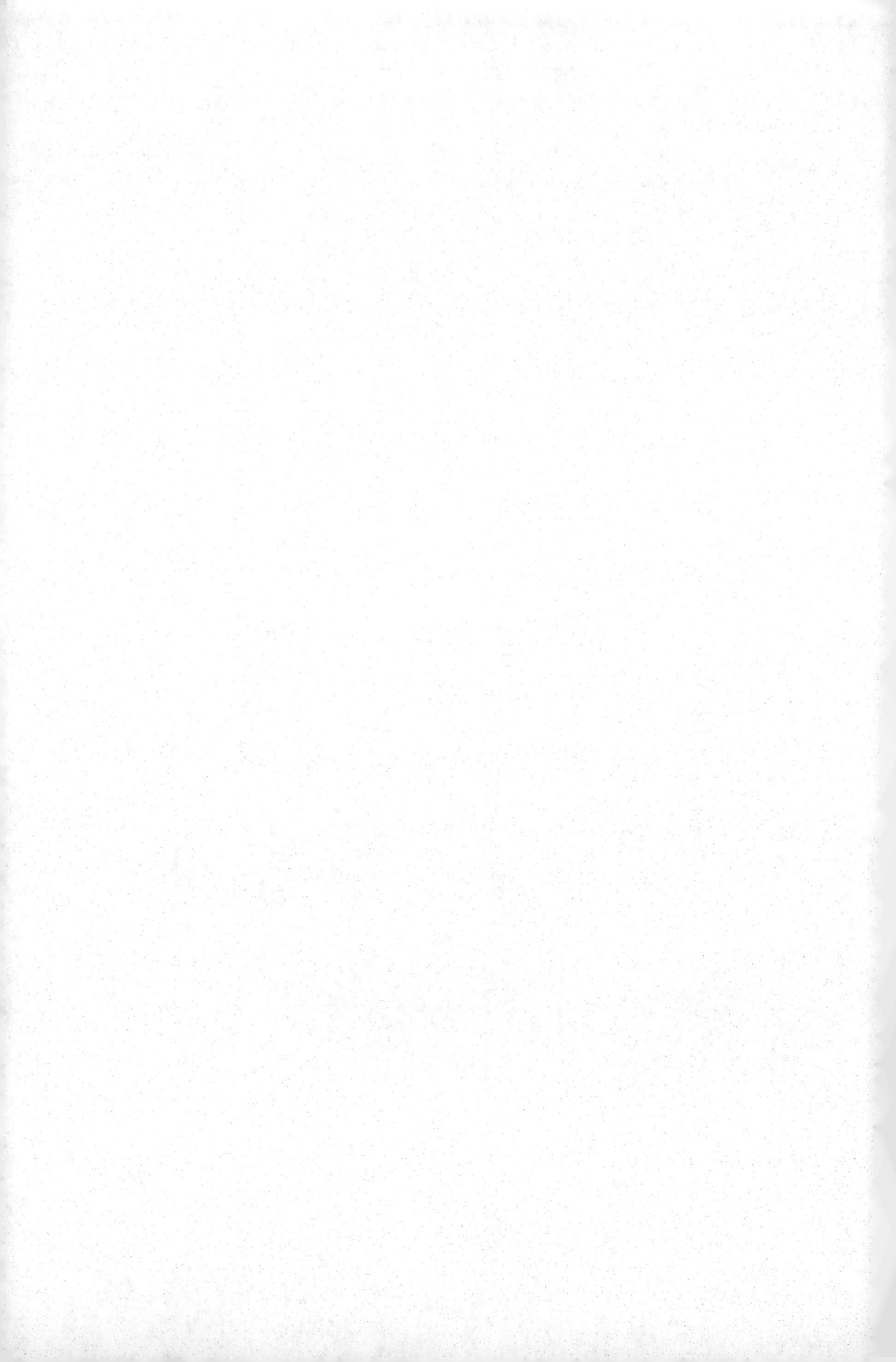

Chapter 27

NOTEWORTHY WOMEN IN WORLD LITERATURE

Reviewing the countless contributions women have made to literature is a task that can be mastered only by devoting to this subject several ponderous volumes. Whether such an attempt has even been made we are unable to say. But the theme is so attractive that I hope that some competent woman author may be inspired to undertake this task. What more beautiful mission could she have than to study and analyze all the scattered evidences of brilliant intellect, rich in imagination, deep emotion, power of expression, soaring enthusiasm, scintillating wit, and profound sorrow, to be found in many of the books written by women since the days of *Sappho* and *Erinna*.

Only fragments remain of the beautiful odes, hymns and love-songs produced by the poetesses of the classic past. But that they inspired all Hellas and Rome we know from the testimony of the foremost authors and critics of their time. When Meleager of Gadara, the famous sophist and poet, selected the choicest poems of his predecessors and wove them into that delicious "Garland," to be hung outside the gate of the Gardens of the Hesperides, he did not forget Sappho, because "though her flowers were few, they were all roses." And a critic, writing five hundred years after Erinna's death, speaks of still hearing her swan-note clear above the jangling chatter of the jays, and of still thinking those three hundred hexameter verses sung by this girl of nineteen in "The Distaff" as lovely as the loveliest of Homer. There is also a report, that Corinna, a native of Tanagra, in Bœotia, won five times in poetical contests the prize in competition with Pindar, the greatest lyric poet of Greece.

With greater kindness fate treated the works of Alphaizuli, a Moorish poetess, who lived in Seville during the 8th Century A. D. Of her, who was called "the Arabian Sappho," two volumes of excellent verses are preserved in the library of the Escurial. Likewise Labana and Leela, two Moorish poetesses, were famous throughout beautiful Andalusia during the 10th and the 13th Century. Of Valada, the daughter of the Moorish King Almostakeph, of Corduba, her contemporaries report that she several times

contended with scholars noted for their eloquence and knowledge, and quite often bore away the palm.

That such contests were held in great favor by learned ladies, appears from the institution of those famous poetical festivals known as "Jeux Floraux" or Floral Games. They are said to have been established in the 11th or the 12th Century by a gay company of French minstrels, called "the seven troubadours." But in time they had become forgotten. It is due to Clemence Isaure, a poetess born in 1464 at Toulouse, that these festivals were renewed. Fixing the first of May as the day of these Floral Games, she invited all poets and poetesses to participate in peaceful contest, assigning as prizes for the victors five different flowers, wrought in gold and silver. There was an amaranth of gold for the best ode; a silver violet for a poem of from sixty to one hundred Alexandrine lines; a silver eglantine for the best prose composition; a silver marigold for an elegy, and a silver lily for a hymn.

These contests have been held in Toulouse through all the centuries. They were recognized by the French Government in 1694, and confirmed by letters-patent from the king. Some twenty-five years ago they were likewise introduced into Germany, and held first in Cologne.

The brilliant age of the Renaissance produced several women writers and poets, whose works are still read. The literary annals of Italy shine with such illustrious names as Cassandra Fidelis, the Venetian; Veronica Gambara, of Brescia; Lucia Bertana, of Bologna; Tarquenia Molza, of Modena; Gaspara Stampa, of Padua; and the great Vittoria Colonna, of Marino, whose sonnets as well as her beauty and virtues were extolled by all contemporaries.

In Spain Marianne de Carbajal and Maria de Zayas, during the 17th Century, the classic period of Spanish literature, became the pride of their country.

In France Marguerite d'Angouleme wrote a delightful book, "the Heptameron," similar in plan to the famous "Decamerone" by Boccaccio. In the middle of the 16th Century Louise Labbé, known in French literature as "La belle cordière," produced her "Debat de Folie et d'Amour," a work full of wit, originality and beauty. Erasmus and La Fontaine were both indebted to it; the former for the idea of "The Praise of Folly," and the latter for "L'Amour et la Folie." In truth, La Fontaine's poem is only a versification of the prose story of Louise Labbé.

Of the illustrious French women, who during the 16th, 17th and 18th Centuries made their "salons" the gathering-places for men and women of letters, several became widely known for their own poems and works of fiction. As for instance Madeline de Scudéry, Anne de Seguier, Claudine de Tencin, Madame de la Sabliére, Madeline de Souvré, and Anne Dacier, of whom Voltaire said, that no woman ever rendered greater services to literature.

In the literature of the 19th Century Anne Louise Germaine Necker, Baroness de Stael-Holstein, held a singular position. Many of her contemporaries exalted her as "the

founder of the romantic movement" who gave "ideas" to the world. To-day she is almost forgotten, and her novels and plays, among them "Corinne" and "Sophie and Jane Grey" lie undisturbed and dusty on the library shelves.

Perhaps her most remarkable contribution to literature was her book "L'Allemagne," which was announced in 1810. It gave a most intelligent exposition of the science, literature, arts, philosophy, and other characteristics of the Germans, gathered from the author's own observations. The work, written with a spirited independence, quite at variance with the deadening political influence of Napoleon, irritated the emperor to such a degree that he ordered the minister of police to seize and destroy the whole edition of 10,000 copies. Besides this he exiled the author from France. When, after the overthrow of Napoleon, she returned to Paris, she had her book printed again, and had the satisfaction of seeing it eagerly read by millions of Frenchmen.

Figure 52. A Floral Game during the 14th Century. After a painting by F. Padilla.

Of all French authoresses of the 19th Century Armantine Lucile Aurore Dudevant, or "George Sand," holds the supreme rank. In the long line of her thoughtful, concentrated and meditative novels "Valentine," "Indiana," "Lelia," "Mauprat," and "Le Meunier d' Angibault" are real gems of fiction, whose influence can be traced in many later works by writers of France and other nations.

Of her contemporaries Louise Révoil Colet, Eugenie de Guérin, Pauline de la Ferronay Craven, and, above all, Delphine de Girardin must be mentioned, whose "Letters Parisiennes" as well as her poems, novels, dramas and comedies belong to the most excellent productions of the 19th Century. By her dramatic pieces "L'Ecole des Journalistes," "Judith," "Cleopatra," "C'est la faute du mari," "Lady Tartufe," and others

she reaped a wide popularity. In the literary society of her time she exercised no small personal influence. Balzac, Alfred de Musset, Gautier, and Victor Hugo were among the frequenters of her salon.

Among the British woman writers of the latter part of the 18th Century Jane Austen was the most distinguished. Her novels "Sense and Sensibility," "Pride and Prejudice," "Emma," "Northanger Abbey" and "Persuasion" have been likened to the carefully-executed paintings of the Dutch masters for their charming pictures of quiet, natural life.

Ann Ward Radcliffe wrote three novels unsurpassed of their kind in English literature: "The Romance of the Forest," "The Mysteries of Udolpho," and "The Italian." They are distinguished for originality, ingenuity of plot, fertility of incident, and skill in devising apparently supernatural occurrences capable of explanation by human agency and natural coincidence.

Mary Russell Mitford edited several volumes of sketches of rural character and scenery, delightful and finished in style, and unrivalled in her manner of description. It is by these sketches of English life that she obtained the greatest share of her popularity. She wrote also an opera called "Sadak and Kalasrade," and four tragedies, "Julian," "Foscari," "Rienzi," and "Charles the First." All were successful; "Rienzi," in particular, long continued a favorite.

Elizabeth Inchbald's two novels "The Simple Story" and "Nature and Art," have long ranked among standard works. Besides novels she wrote a number of dramas, some of which were very successful.

Maria Edgeworth published a new work almost every year from the beginning of the 19th Century to 1825. The novels "Castle Rackrent," "Belinda," "Vivian." "Harrington and Ormond," and many others followed each other rapidly, and all were welcomed and approved by the public. Her best and last work of fiction, "Helen," appeared in 1834.

Mary Shelley, the wife of the famous poet Percy Shelley, is renowned as the author of the romances "Frankenstein," "Valperga, or the Life and Adventures of Castruccio, Prince of Lucca"; "Falkner"; "Lodore," and "The Fortunes of Perkin Warbeck." A most peculiar work is "The Last Men," a fiction of the final agonies of human society owing to the universal spread of pestilence.

Among the dramatists of the 19th Century Joanna Baillie was the foremost. In her "Plays of Passion" she illustrates each of the deepest and strongest passions of the human mind, such as Hate, Love, Jealousy, Fear, by a tragedy and a comedy. Other dramas were "The Family Legend"; "Henriquez"; "The Separation," and other plays, which show remarkable power of analysis, and observation. They are all written in vigorous style.

Of the numerous novelists of the 19th Century Charlotte Bronté was received with universal delight. Her novels "Jane Eyre," "Shirley" and "Villette" have all the vigor and individuality of poetic genius. She was "a star-like soul, whose genius followed no tradition and left no successors."

Elizabeth Cleghorn Gaskell will be remembered for her intensely interesting books "Mary Barton," "North and South," the exquisitely humorous "Cranford," and "Cousin Phyllis," which has been fitly called an idyll in prose.

The prolific Catherine Grace Gore gives in the novels "The Banker's Wife," "Cecil, or the Adventures of a Coxcomb," "Greville," and "Ormington," masterful pictures of the life and pursuits of the English upper classes.

Caroline Elizabeth Norton, after having given in her novel "The Undying One" a version of the legend of the Wandering Jew, became in her book "A voice from the Factories" a most eloquent priestess of reforms. She condemned especially child labor, the darkest blot on the social conditions of England.

In the middle of the 19th Century Mary A. Evans became famous under her nom de plume "George Eliot." Having translated in 1844 David Strauss' brilliant work "Das Leben Jesu," and Spinoza's "Ethics," she published in 1858 her novel "Adam Bede," which placed her at once in the front rank of modern authors. Her later novels "The Mill on the Floss," "Silas Marner," "Romola" and "Felix Holt" proved so many contributions to her fame.

In recent times the works of Mary Edgeworth, Charlotte R. Lenox, Anne M. Fielding Hall, Mary Braddon, Elizabeth Sheppard, Louise de la Ramée (Ouida), Matilde Blind, Anna Seward and Charlotte M. Younge have won much appreciation.

Of the woman-authors born in Scotland, Margaret Oliphant wrote "Chronicles of Carlingford" and the charming novels "Merkland"; "The Quiet Heart"; "Zaidee," all of which are exquisite delineations of Scottish life and character. Another Scottish woman-author deserving of mention is Mary Ferrier, whose novels "Marriage," "The Inheritance," and "Destiny" breathe much originality and humor.

Of the Irish novelists Julia Kavanagh and Margaret Hamilton Hungerford must be mentioned, the former for her volumes "French Women of Letters"; and "English Women of Letters," as well as for her novels "Adele"; "The Pearl Fountain"; "Sibyl's Second Love"; and "Daisy Burns." Marg. Hungerford's novel "Molly Brown" has been much admired.

Mary Augusta Ward, born in Tasmania, became favorably known through her principal novel "Robert Elsmere," which delineates effectively the modern spiritual unrest and attempts to proclaim an ideal religion.

Another noteworthy author of Tasmania is Louisa Anne Meredith.

England has of course also a long roll of able poetesses, among them Sarah Flower Adams, who wrote the beautiful hymn "Nearer, My God, to Thee." Alison Cockburn, Anne Barnard and Caroline Oliphant are the authors of many fine Scotch songs and ballads, among them the famous poems "Flowers of the Forest" and "Auld Robin Gray."

In recognition of the grace and delicacy of her lyrics Elizabeth Barrett Browning has been called "the most distinguished poet of her sex that England ever produced," but at the same time "the most unreadable." Her fame rests chiefly on her "Drama of Exile," the

"Casa Guidi Windows," and "Aurora Leigh." The latter is a social epic, which contains many noble passages that give evidence of great originality and power.

Sarah Coleridge has been much admired for the gracefulness and the beautiful language of her poems "Phantasmion, a Fairy Tale"; "Sylvan Stay," and "One Face Alone."

The poems of Felicia Hemans have been the result of a fine imagination and temperament, and of a life spent in romantic seclusion. Many of them, as for instance "Homes of England," "The Treasures of the Deep," "The Better Land," and "The Wreck" rank among the best ever produced.

Adelaide Ann Proctor, Catherine Fowler Philips, Christina Rosetti, Mary Blackford Tighe, and Caroline Oliphant have been the authoresses of many poems, still cherished for their beauty and nobility of thought.

The United Kingdom has also several woman historians, among them Catharine Macaulay, whose "History of England," in six volumes, appeared in 1763.

The love and reverence she was taught from childhood to cherish for the queens of her country induced Miss Agnes Strickland, of Roydon Hall, Suffolk, to write her great work "The Lives of the Queens of England." Its twelve volumes appeared at intervals from 1840 till 1848. In 1850 she began to publish a similar series about the "Lives of the Queens of Scotland," completing it in eight volumes in 1859. Unresting in her industry, she wrote likewise "The Lives of the Last Four Stuart Princesses," published in 1872.

Harriet Martineau too deserves an honorable place among English women of letters. Her series of tales designed as "Illustrations of Political Economy" and "Illustrations of Taxation" brought her at once into great prominence. Later on she produced an amazing quantity of works, relating to the laws of man's nature and development, mesmerism, travel, and other subjects.

In American literature woman's activity began with Anne Bradstreet, the daughter of Governor Bradstreet of Massachusetts. To him she dedicated the first volume of poetry published on the Western hemisphere. Printed in 1642, it had the somewhat verbose title: "Several Poems, compiled with great variety of wit and learning, full of delight; wherein especially is contained a complete discourse and description of the four elements, constitutions, ages of man, seasons of the year, together with an exact epitome of the three first monarchies, viz.: the Assyrian, Persian, Greecian, and Roman Commonwealth, from the beginning to the end of their last king, with divers other pleasant and serious poems. By a Gentlewoman of New England." Three editions of this collection appeared.

Of several poems, directed to her husband, we give the following lines:

> "If ever two were one, then surely we;
> If ever man were loved by wife, then thee;
> If ever wife were happy in a man,
> Compare with me, ye women, if ye can!"

Hannah Adams, born in 1755, was the first American woman who made literature her profession. Interested in religious controversy she compiled a "View of Religions," in three parts. After that she wrote "Evidences of Christianity," a "History of the Jews," and a "History of New England." As far as pecuniary matters went, she was, however, singularly unsuccessful, probably from her want of knowledge of business, and ignorance in worldly matters. At the time when she was engaged in compiling her books, so rare were woman-writers in America, that she was looked upon as one of the wonders of her age.

In 1790 appeared a novel, "Charlotte Temple," a story of love, betrayal, and desertion, by Mrs. Susanna Haswell Rowson, a book of which more than a hundred editions are known.

With the beginning of the 19th Century the number of American authoresses increased rapidly. Catharine and Susan Sedgwick wrote their "New England Tales," which were received with such favor, that Catharine in 1824 published a novel in two volumes, entitled "Redwood," a work which met with great success, was republished in England, and translated into French and Italian. It was followed by a large number of other novels, which were greatly appreciated for their purity of language and grace of style.

Somewhat later Lydia Maria Child developed as one of the first and foremost progressive writers. Having commenced her literary life with "Hobomok, a Story of the Pilgrims," she later on devoted herself to the cause of woman and the abolition of slavery. She wrote a "History of Woman," which was followed in 1833 by a strong "Appeal for that Class of Americans Called Africans," the first anti-slavery work ever printed in book form in America. In 1841 she moved to New York and assisted her husband in editing "The National Anti-Slavery Standard."

As is very generally known, her contemporary, Harriet Beecher Stowe, too, was interested in the question of abolition. In 1850 she wrote for the "National Era," an anti-slavery paper, a serial entitled "Uncle Tom's Cabin." When this novel was republished in book form it met with tremendous success. In the United States between 300,000 and 400,000 copies were sold within three years, and the printing press had to run day in and out to meet the demand. In Europe the book was devoured with the same deep interest. There are thirty-five different editions in English, and translations in at least twenty different languages. As the novel was also dramatized in various forms, it became a great factor in the abolishment of slavery.

Of the later stories by Mrs. Stowe "The Minister's Wooing," a tale of New England life in the latter part of the 18th Century, has been pronounced to be her best. But her reputation, while it lasts, will rest chiefly upon "Uncle Tom's Cabin."

Sarah Margaret Fuller too belongs to those authors who espoused the cause of woman's rights. In "The Dial," a little quarterly journal, the organ of the transcendentalists and of the famous community at Brook Farm, she first published "The

Great Lawsuit." It formed the nucleus of a larger volume entitled "Woman in the Nineteenth Century." Far in advance of the ideas of her times, it is with its noble sentiments and valuable hints a spirited plea for the rights of the female sex.

Elizabeth Ellet is favorably known for her valuable work "The Women of the American Revolution," published in 1848 in three volumes. It was followed in 1850 by the "Domestic History of the American Revolution," designed to give an inside view into the spirit of that period, and to describe the social and domestic conditions of the colonists and their feelings during the war.

Ann Sophia Stephens, and Emma D. Southworth were likewise immensely popular fiction writers during the first half of the 19th Century. So was Maria S. Cummins, who in "The Lamplighter" achieved a success comparable to that of Mrs. Stowe's "Uncle Tom."

The many short stories and novels of Mary Virginia Terhune, who wrote under the pseudonym of Marion Harland; the romances of Harriet Prescott Spofford, Miriam Coles Harris, Elizabeth Barstow Stoddard, and Adeline Whitney, are now almost forgotten. Also the novels of Lydia Sigourney of Norwich, Connecticut, who holds the record of being one of the most prolific female writers in America. She produced not less than fifty-seven volumes, among them "Letters to Mothers"; "Water-Drops," a contribution to the temperance-cause; "Pleasant Memories in Pleasant Lands"; "Pocahontas"; and "Traits of the Aborigines of America," a descriptive poem in five cantos.

Elizabeth Stuart Phelps enjoyed with her "Sunny Side" and other tales a phenomenal success. Her daughter, Elizabeth Stuart Phelps Ward, was in her time regarded as the greatest American woman novelist, who has most influenced the women of the United States. "The Silent Partner"; "Hedged In"; "Dr. Zay"; "The Story of Avis" as almost all other stories of the Phelps are laid in New England and exquisitely describe its nature, past, and present conditions.

Jane Goodwin Austin, Rose Terry Cooke, Annie Trumbull Slosson, Clara Louise Burnham, Alice Brown and Mary E. Wilkins Freeman belong also to the woman-authors whose works deal with colonial and present-day life in the New England States.

Of the woman-authors, who realized the possibilities of the romantic life and history of the early settlers and pioneers, Mary Johnston and Mary Hartwell Catherwood were the most successful. To the former we are indebted for the romances "Prisoners of Hope," and "To Have and to Hold"; to the latter for the novels "The Lady of Fort St. John," "The White Islander," "Old Kaskaskia," "Lazarre" and others.

Under the pen name of Charles Egbert Craddock Mary Noailles Murfree published a series of highly interesting short stories "In the Tennessee Mountains." Displaying an intimate knowledge of the mountaineers of Eastern Tennessee, and full of life, these stories attracted at once wide attention. They were followed later on by a large number of other novels, of which "The Prophet of the Great Smoky Mountains," "In the Clouds,"

"The Frontiersmen" and "The Storm Centre" have secured to Miss Murfree a place of honor among present-day writers.

Alice French under her well-known pen name Octave Thanet sketched in her short stories life in Iowa and Arkansas; Ruth McEnery Stuart wrote amusing stories of negro life in Louisiana.

Gertrude Franklin Atherton achieved a wide reputation with her charming romances of early Californian life, among which "The Doomswoman" and "The Californians" are the most remarkable. Of her later novels "The Conqueror" and "A Whirl Asunder" need to be mentioned.

Mary Hallock Foote, having likewise studied the conditions of the Far West, in her admirable stories "The Led-Horse Claim," "Cœur d'Alene," and "The Chosen Valley" carries the reader into the romance of Western mining camps and of the virgin wilderness.

Helen Hunt Jackson, whose literary productions, over the signature "H. H.," began to attract attention about 1870, offered a truly native flower to American literature in her poetic book "Ramona." Intensely alive and involving the reader in its movement, it yet contains an idyl of singular loveliness. "Ramona," says Helen J. Cone in an essay about American literature, "stands as the most finished, though not the most striking, example that what American women have done notably in literature they have done nobly."

The various works of Constance Fenimore Woolson, a grand-niece of Fenimore Cooper, also enjoyed general approval. In her best known novels: "East Angels," "Jupiter Lights," and "Horace Chase" she attained a high standard of excellence.

Frances Hodgson Burnett created in her book "Through One Administration" a pathetic story of the intricate political life in Washington. Furthermore she gave in "Louisiana" and in "The Pretty Sister of José" charming pictures of Southern conditions.

Mrs. Burton N. Harrison and Edith Wharton delighted their many readers with highly interesting novels and short stories of New York City Life, full of local color. Of the former author's works "The Anglomaniacs," "Golden Rod," and "The Circle of a Century" show her great skill in the dialogue. Of the many novels and short stories of Miss Wharton "The House of Mirth,", "The Greater Inclination," "Sanctuary," and "Crucial Instances" are perhaps the best.

Among the American novelists of our present days Margaret Deland is without question one of the most popular. Her novels "John Ward," "Sidney," "Tommy Dove," "Philip and His Wife," "The Wisdom of Fools," "Dr. Lavendar's People," and "The Awakening of Helen Richie" rank among the best in American fiction.

The literary work of Anna Katherine Green, Kate Douglas Wiggins, Molly Elliot Seawell, Ellen Glasgow, Mary Shipman Andrews, Leona Dalrymple, Margaret Sherwood, and many other woman authors, excellent as much as it is, can only be referred to summarily.

To enrol the names of those American women who since the days of Anne Bradstreet have expressed their thoughts and emotions in poetry, would be a task far exceeding the limits of this volume. Confining ourselves to the most noteworthy, we mention first the sisters Alice and Phœbe Cary. Among their many splendid poems and novels "Hualco, a Romance of the Golden Age of Tezcuco," is founded upon adventures of a young Mexican chief, as related by several Spanish historians of the time of the conquest. Of Alice Cary exist several hymns, one of which is almost a classic in the purity of its sentiment.

The poetic spirit of Julia Ward Howe found expression in "Passion Flowers" (1854) and "Lyrics" (1866). Her most memorable poem is the "Battle Hymn of the Republic," which breathes fervent patriotism and gives expression to the deep moral purpose of the Civil War.

The poetry of Helen Jackson unquestionably takes rank above that of any American woman. Emerson rated it above that of almost all American men. Her works include simple poetry of domestic life as well as love-poems of extraordinary intensity and imaginative fullness, furthermore, verses showing most intimate sympathy with external nature; and lastly, a few poems of the highest dignity and melody in the nature of odes, such as "A Christmas Symphony" and "A Funeral March."

The numerous lyrics of Elizabeth Oakes Smith, E. O. Kinney, Frances S. Osgood, Anne L. Botta, Sarah Helen Whitman, Maria Lowell, Harriet W. Sewall, Emily Judson and many other women poets of the last half century show a development corresponding to that traceable in the field of American fiction.

In recent times a large number of gifted women have contributed to the general chorus new notes of unusual strength and beauty. Many names deserve a place upon the honor roll; among them Margaret J. Preston, Elizabeth Allen, Julia Dorr, Mary E. Bradley, Nora Perry, Mary C. Hudson, Margaret Sangster, Charlotte Bates, May Riley Smith, Edna Dean Proctor, Elizabeth Stuart Phelps, Alice Wellington Rollins, Edith Thomas, Emma Lazarus, Kate Osgood, and Ella Wheeler Wilcox.

In other branches of literature, to which comparatively few women have chosen to devote themselves, as for instance in history, several American women have shown remarkable talent and thoroughness.

First among these historians stands Mrs. Mercy Otis Warren, the same who with Mrs. Abigail Smith Adams, the wife of President John Adams, shared the belief that the Declaration of Independence should consider not the freedom of man alone, but that of woman also. Having warmly entered the contest between England and America, Mrs. Warren had corresponded with many of the leading men of the time; these often consulted her, and acknowledged the soundness of her judgment on many of the important events before and after the war. The most valuable of her writings appeared in 1805, under the title "The History of the Rise, Progress, and Termination of the American Revolution, interspersed with Biographical, Political, and Moral Observations." The three

volumes of this work, dedicated to George Washington, are valuable as a true record of the events and feelings of those great times.

To Martha Lamb the citizens of the metropolis on the Hudson River are indebted for a comprehensive "History of New York City." Agnes Laut penned a series of articles about the discovery of the farthest Northwest. Ellen Mackay Hutchinson compiled with Edmund Clarence Stedman "A Library of American Literature," which in 1888 appeared in ten volumes; it shows excellent judgment, knowledge and care. Ida Tarbell produced among many other works a "Life of Abraham Lincoln" and an exceedingly interesting "History of the Standard Oil Company." Katherine Coman published the "Industrial History of the United States."

"A Century of Dishonor" is the title of a sensational book, written by Helen Hunt Jackson, and published in 1881. During her extensive travels in the Far West the author became deeply interested in the much maltreated Indians. Disgusted by the shameless robberies and lawless acts committed by many Indian Agents on the reservations, Mrs. Jackson wrote her book, which is one of the strongest indictments ever directed against the Government. Through this volume she succeeded in doing much to ameliorate the unfortunate conditions of the Red Race.

Mrs. John A. Logan compiled a valuable volume, entitled "The Part taken by Women in American History."

Woman's status in the laws of the forty-eight states belonging to the United States of America has been treated by Rose Falls Bres in the valuable book "The Law and the Woman," published in 1917 at New York.

The great movement for Women Suffrage found of course likewise its historians. Four of the most prominent leaders and best authorities: Elizabeth Cady Stanton, Susan B. Anthony, Matilda Joslyn Gage, and Ida Husted Harper combined for the difficult task of collecting, sifting, and putting together the immense mass of material. Their "History of Woman Suffrage," published in five huge volumes, is not only a noble record, but at the same time a magnificent monument to women's courage, indefatigability and perseverance.

A considerable number of women have also contributed to the literature about suffrage, social culture, labor questions, and kindred subjects. Anna G. Spencer produced the book "Woman's Share in Social Culture"; Charlotte P. Gilman devoted a volume to "Home" and a second volume to "Woman and Economics"; Alice M. Earle described "Childlife in Colonial Times"; Ellen Key gave a study of "Love and Marriage"; Mary Eastman published "Woman's Work in America"; Olive Schreiner wrote "Woman and Labor," and Elisabeth Butler "Woman in the Trades." To Jane Addams the world is indebted for several well written works, among them: "Democracy and Social Ethics"; "The Spirit of Youth"; "An Ancient Evil and a New Conscience," and "New Ideals of Peace." She gave a record of her great settlement work in Chicago in her delightful book "Twenty Years at Hull House."

For many centuries the Germans have been known as great writers, poets and philosophers. Perhaps no other nation has contributed so much to the world's literature. Before the unfortunate year of 1914 the annual output of Germany in works of science, art, philosophy, technics and fiction far surpassed that of any other country, even that of France, Great Britain and America combined.

In these contributions German women have a conspicuous share. Their great interest in this line of activity can be traced back to the early days of the Middle Ages, when nuns like Hroswitha glorified the deeds of great emperors, or, like the Abbess of Hohenburg, undertook the bold enterprise of compiling a cyclopædia of general knowledge.

Germany had also the first periodicals for women, the earliest dating back to 1644, much read and patronized by the members of the gentle sex. Its title "Frauenzimmer-Gesprächspiele" ("Playful discussion for ladies") indicates that it was devoted exclusively to matters of the "eternal feminine."

A similar periodical was "Die vernünftigen Tadlerinnen" ("The reasonable fault-finders"), edited by Johann Christoph Gottsched, professor of philosophy and poetry at the University at Leipzig. The most faithful of his assistants and collaborators was his wife, known in German literature as Louise Adelgunde Gottschedin. To the "Deutsche Schaubühne," likewise published by her husband, she contributed several translations of French Dramas and five comedies of her own, which are still of interest as they illustrate the manners of the time, the middle of the 18th Century.

Meta Moller, the wife of the famous poet Klopstock, Friedericke C. Neuber, and Rahel Levin, the wife of the historian Varnhagen von Ense, made similar use of their great literary abilities. The salon of Mrs. Varnhagen in Berlin from 1814 to 1830 was the meeting place for the most celebrated intellects of Germany, among them Humboldt, Fichte, Schleiermacher, von Kleist, and Heinrich Heine.

The great poetess Annette von Droste-Hülshoff (1797–1848) wrote a most powerful novel, "Die Judenbuche", which is based on the belief that murderers are forced by a mysterious power to return to the scene of their crimes.

The prolific but now almost forgotten writers Karoline Pichler, Henriette Paalzow, Otilie Wildermut, Countess Ida Hahn-Hahn, Fanny Lewald and Louise Mühlbach were followed in the second part of the 19th Century by Eugenie John, better known under her nom de plume Marlitt. Her novels "Das Geheimniss der alten Mamsell" ("Old Mamselle's Secret"), "Heideprinzesschen" ("The Princess of the Moor"), "Gold Else" ("Gold Elsie") and others met with tremendous success and have been in translations also enjoyed by many English and American readers.

With like enthusiasm the women of Germany read the novels of Wilhelmine Heimburg, Louise von Francois ("Die letzte Reckenburgerin") and Marie von Ebner-Eschenbach. The latter is regarded as the greatest of all modern novelists of Germany, Paul Heyse not excepted. When the University in Vienna bestowed upon her the degree of Doctor phil. honoris causa, the enormous body of her readers heartily rejoiced. Her

most famous novel is "Das Gemeindekind" ("The child of the Parish"). She also published a volume of "Aphorisms."

Wilhelmine von Hillern's once much read novel "Die Geierwally" has been surpassed by far more valuable works of Ilse Frapan, Ida Boy-Ed, Helene Pichler, Margarete von Bülow, Bianca Bobertag, Ossip Schubin, Helene Böhlau, Emma Vely, Emmy von Dinklage, Dora Dunker, Marie von Bunsen, Sophie Junghans, Louise Westkirch, Clara Blüthgen, Olga Wohlbrück, Carry Brachvogel and a number of other modern writers.

Among them Enrica von Handel-Mazetti and Ricarda Huch are distinguished by their great ability in drawing strong characters as well as deeply affecting situations. The first of the two authors transports her readers in the two novels "Meinrad Helmpergers denkwürdiges Jahr" and "Jesse und Maria" to the turbulent times of the 17th and 18th Centuries, when a superstitious world was upset by cruel warfare between Catholics and Protestants. Ricarda Huch created works of equal value in the novels "Erinnerungen von Ludolf Urslen dem Jüngeren" ("Reminiscences of Ludolf Urslen, Junior"), "Aus der Triumphgasse" ("From the Alley of Triumph") and "The Verteidigung Roms" ("The Defense of Rome").

Elizabeth von Heyking carried the reader to the more recent times of the Chinese Boxer War with her admirable novel "Briefe die ihn nicht erreichten" ("Letters he did not get").

Clara Viebig belongs likewise to the great novelists of modern times. Having manifested in her first collection of short stories, "Kinder der Eifel" ("Children of the Eifel Plateau"), a most extraordinary gift of observation and description, she brought this talent to full development in her splendid novels "Rheinlandstoechter" ("Daughters of the Rhein"), "Das schlafende Heer" ("The sleeping army") and "Absolve te."

Gabriele Reuter treated in her novels "Aus guter Familie" ("Of good family"), "Frau Bürgelin und ihre Söhne," "Ellen von der Weiden," and "Liselotte von Reckling" various phases of the woman's question. In the first book she protests against the injustice created by custom and tradition, which allows men to propose, while women are condemned to remain silent.

Finally we must mention the noble woman who, most intensely realizing the deep longing of mankind for peace, with her famous book "Die Waffen nieder!" ("Lay down your arms!") exerted probably the greatest influence any author ever had through a single volume: the Austrian Bertha von Suttner. The powerful appeal of this great book, which was translated into more than twenty different languages, led Alfred B. Nobel, a rich Swedish scientist and the inventor of dynamite, to bequeath the annual interest of his great fortune to whoever has contributed most to the peaceful progress of mankind during the year immediately preceding. It was not more than just that the great merit of Madame von Suttner was acknowledged by awarding to her in 1905 the Nobel Prize for peace.

Having devoted her whole life to the cause of peace, Bertha von Suttner died in June, 1914, while engaged in preparations for an International Peace Congress to be held in September of that same year in Vienna. Fate spared her the bitter disappointment to see the outbreak of the most cruel and destructive war in history. But her call "Lay down your arms!" will live. It will remain the watchword and summons of all who with this high-priestess of peace believe that war is the most unreasonable and most criminal act men can commit.

Of course, German women have also contributed to the literature about the woman's question. Perhaps the most valuable work in this line is Dr. Kaethe Schirmacher's book "Die moderne Frauenbewegung," giving a history of the woman's rights movement in all countries of the world. As there has been no English book covering this broad subject, it was translated by C. C. Eckhardt and in 1912 published at New York under the title "The Modern Woman's Rights Movement."

Rich as German literature is in prose works of women writers, its poems and lyrics written by women are no less noteworthy. There can be no doubt that many of the beautiful folk songs of the Middle Ages were created by women. For instance the following was discovered in a collection of songs of the 13th Century, compiled by the nuns of a convent at Blaubeuren, Bavaria:

> Kume, kum, geselle min,
> ih enbite harte din,
> ih enbite harte din,
> kume, kum, geselle min!
> Süsser rosen-varmer munt,
> kum und mache mich gesunt,
> kum und mache mich gesunt,
> süsser rosen-varmer munt!

That women took deep interest in folk-songs we know from the fact that several of the most valuable collections of mediæval songs came down to us through women like Clara Haetzler, a nun in Augsburg, and Katharine Zell. The latter states that these lovely poems were sung by workmen and vintages as well as by the mothers at the cradle, and by the servants while they were washing the dishes.

It is not before the 17th Century that women authors of poems begin to write under their names. Among them we find the countesses Anna Sophie von Hesse-Darmstadt (1638–1683) and Amalia Juliane von Schwarzburg-Rudolstadt. The latter was the author of about six hundred songs, of which the funeral-hymn "Wer weiss wie nahe mir mein Ende" is sung in all Protestant churches of Germany to-day.

The 18th Century produced a number of other women poets, among them Louise Adelgunde Gottsched, Dorothea, Countess von Zinzendorf, Anna Louise Karsch, Sidonie Zäunemann, and Christine Marianne von Ziegler. The last two enjoyed the special

patronage of the Emperor, who bestowed upon them the title "Kayserlich gekrönte Poetinnen."

With the beginning of the 19th Century appeared new groups of women poets, among them Bettina von Arnim, Karoline von Günderode, Elisabeth Kulmann, Louise Brachmann, Betty Paoli, Louise von Ploennies and Adelheid von Stolterfoth, the "Philomele of the Rhine," so called for her lovely songs and tales in praise of that noble river. In 1797 one of the greatest female poets of all times was born: Annette von Droste-Hülshoff, a native of Westphalia. Compelled to lead a quiet, secluded life by the delicate state of her health, she devoted herself to study and literature, and wrote a number of masterful ballads of which "The Battle in Loenerbruch" has few equals in powerful and realistic description. Her poem "Die beschränkte Frau" is one of the gems of German poetry.

Among the large numbers of German poets of the latter part of the 19th and the beginning of the 20th Century Isolde Kurz, Lulu von Strauss, Margarete Beutler, Agnes Miegel, Tekla Lingen, Ricarda Huch, Frieda Schanz, Anna Ritter, Hedwig Dransfeld, Wilhelmine Wickenburg-Almasy, Hermione von Preuschen, Klara Müller-Jahnke, Hedda Sauer, Maria Eugenie delle Grazie, Angelika von Hörmann, Marie Janitschek, Ada Christen, Mia Holm, Alberta von Puttkammer, Anna Klie, are the names of a few of the many distinguished poets of our present days.

Among American women of German descent we find likewise a number of gifted poets. The two anthologies "Deutsch in Amerika" (Chicago, 1892) and "Vom Lande des Sternenbanners" (Ellenville, N. Y., 1905) contain many contributions of Dorothea Boettcher, Elizabeth Mesch, Edna Fern, Amalie von Ende, Marianne Kuenhold, Maria Raible, Minna Kleeberg, Bella Fiebing, Henni Hubel, Martha Toeplitz, and others, distinguished in form as well as rich in imagination and powerful in expression. Several German-American women also became favorably known by valuable works in prose, as for instance Therese Albertine Louise Jacob, the wife of Professor Robinson, of New York. Under the name of Talvj, she wrote historical works about Captain John Smith and the colonization of New England, and a "Historical Review of the Language and Literature of the Slavic Nations, with a Sketch of their Popular Poetry." Of her many poems and translations Goethe spoke with great admiration. Her novels are far superior to the average in style and interest.

In the Netherlands the novels of Elizabeth Bekker were extremely popular at the end of the 18th Century. She ranks high among Dutch authors. Her "Historie van William Levend," the "Historie van Sara Burgerhart," "Abraham Blankaart" and "Cornelia Wildshut" are her greatest works. The poems of Agathe Dekken are to this day esteemed masterpieces of Dutch poetry. During the 19th Century Mrs. Bosboom-Toussaint's novels, and Helen Swarth's poems "Passiebloemen" have been widely read.

The most eminent woman writer of Denmark was Thomasine Kristine Baroness Gyllembourg-Ehrensvärd, who introduced into Danish literature a novel vein of realism

and domestic humor. Although she has had many imitators, she is still without a rival. Hadda Raonkilde has exerted a powerful influence upon Scandinavian literature.

The two most successful women-novelists of Norway are Anna Magdalene Thoresen and Jacobine Camilla Collet, author of the excellent novel "Amtmandens Döttre" ("The Governor's Daughters"). In 1894 all Norway celebrated her eightieth birthday as a national holiday.

The most eminent Swedish novelist of the 19th Century was Frederika Bremer. Her "Sketches of Every Day Life" attracted immediate attention. But this success was far surpassed by the novels "The H—— Family" and "The Neighbors." Both manifest the author's purity, simplicity, and love of domestic life. These books as well as almost all of the author's later works have been translated into English, German and French.

Another Swedish author of note was Anne Charlotte Edgren. Of Emily Carlen's novels "The Rose of Thistle Island" and "The Magic Goblet" are most appreciated. Anna Maria Lenngren belongs likewise to the most popular Swedish writers. The Swedish Academy ordered a medal cast in her honor. And of the Swedish authors of the 20th Century Selma Lagerloef was in 1909 awarded the Nobel Prize for her beautiful modern saga "Goesta Berling."

Finland and Poland too have noteworthy women-writers. Finland, "Country of the thousand lakes," was the birth-place of Sarah Wacklin, Wilhelmina Nordström and Helen Westermark. The literature of Poland was enriched by the poems and novels of Elizabeth Jaraczewska, Lucya Rautenstrauss, Narcyza Zwichowska and Comtesse Mostowska.

Spain has produced in modern times several remarkable woman authors: Gertrudis de Avellaneda, Maria de Pinar-Sinues, and Angela Grassi. Italy has the excellent novelists Rosa Taddei, Francesca Lutti, Matilda Serao, Grazia Pierantoni-Mancini, Fanny Zampini-Salazar, and the Marchesa Vincenza de Felice-Lancellotti. Furthermore Ada Negri, one of the most powerful poets of all times.

Having glanced at woman's part in world's literature, a few words should be said about women journalists. During the middle of the last century the publishers of several leading newspapers of England and America, desiring to infuse new life into their papers, added a number of women to their staffs. The complete success of this experiment was confirmed by the rapid increase in the number of such women journalists. Whereas in 1845 England had only 15 of them, this number grew to more than 800 in 1891. In the United States the number increased from 350 in 1889 to 2193 in 1910. Many of these women journalists received careful training in the special schools of journalism at the universities of New York, Philadelphia, and elsewhere.

Jeannette Gilder, herself a journalist, writes about her profession:

> "Woman as a mere fashion writer is a thing of the past. To-day she expects to rank with the man writer. In the future she will expect to be his superior, for a woman is not stationary in her ambitions, she likes variety. A man is wedded to his old clothes. He

sighs when he has to throw aside the old and comfortably fitting coat for a new one not so comfortably fitting. A woman sighs when she has to wear an old dress. She would like fashions to change every week instead of every three months, as they do now. This love for variety in personal matters is carried into her professional life. If she reports a Salvation Army meeting to-day she hails with glee an opportunity to report an automobile race to-morrow. With boundless ambition, with adaptability, energy and a pleasing style, there is nothing to keep women from monopolizing the journalistic profession if they put their minds to it. The only trouble is they are apt to marry and leave the ranks. But, then there are others standing ready to fill the vacant places. In the next hundred years why may we not see all newspapers owned by women, edited by women, written by women, with women compositors and women pressmen. Already there is one such in France."

WOMEN IN MUSIC AND DRAMA

The prejudice which excluded women for centuries from the realms of science, interfered likewise with their participation in music and art. Up to the midst of the 19th Century almost all European conservatories and art academies were closed to female students. Previous to 1876 no women students of the violin were allowed at the High School in London, and for a long time they could not compete for prizes or receive diplomas. When Elizabeth Sterling presented her beautiful CXXX Psalm for five voices and orchestra to the university at Oxford for the degree of Mus. Bac., the degree, although the work was accepted and its merits acknowledged, could not be given for want of power to confer this degree upon a woman!

As the views of publishers of music and of conductors of orchestras were influenced by similar prejudices, nobody should wonder that women's work in music has shown comparatively unsatisfactory results.

Yet, in spite of all these obstacles, there have been a number of women composers, whose works were appreciated by all their contemporaries. During the glorious time of the Renaissance Francesca Caccini, born in 1581 at Florence, was the pride of her city because of her magnificent church music and madrigals. Compositions of Vittoria Aleotti, a native of Argenta, were likewise much admired, especially her great opus, which was published at Venice, in 1593, under the flowery title "Ghirlanda dei Madrigali a 4 voci." Maddalena Casulana of Brescia, produced also a number of fine madrigals, which were issued in two volumes in 1568 and 1583. Cornelia Calegari, of Bergamo, Barbara Strozzi, of Venice, belong also to the Italian composers of the Renaissance. Maria Teresa Agnesi, born during the 18th Century, produced a number of cantatas, and three operas, "Sophonisbe," "Ciro in Armenia," and "Nitocri," which were the delight of all Italy.

In Austria at the same time appeared Maria Teresa Paradies, born at Vienna in 1759. Notwithstanding her blindness, dating from her fourth year, she had become a most

remarkable pianist and composer, dictating her cantatas and several operettas. In 1784 she set out on a concert tour through Germany and England, everywhere exciting admiration by her rare endowments. She often moved her audiences to tears by a cantata, the words of which were written by the blind poet Pfeffel, in which her own fate was depicted. During the later part of her life she presided over an excellent musical institute in Vienna.

In another native of Vienna, Marianne Martinez, the qualities of many distinguished artists were combined. Not only did she sing beautifully, but she was likewise an excellent pianist; her compositions showed a vigor of conception together with extensive learning. She composed several cantatas, and a miserere, with orchestral accompaniment. Her oratorio "Isacca" was in 1788 produced by the Tonkuenstler Gesellschaft. Her salons, in which she gave weekly concerts, were the rendezvous of many musical celebrities.

Foremost among the women-composers of Germany was Clara Josephine Wieck-Schumann, the accomplished pianist and unexcelled interpreter of her husband's, Robert Schumann's, splendid works. She also produced a large number of songs of great merit, many of which have been published.

Francesca Lebrun, born 1756 at Mannheim, wrote several sonatas for piano, and trios for piano, violin and cello. Louise Reichard, of Berlin, Corona Schroeter, the famous artist of the 18th Century, Fanny Cecilia Hensel, born 1805 in Hamburg, and Josephine Lang, born 1815 in Munich, composed very beautiful songs. A "Suite for Pianoforte" (Op. 2) by Adele aus der Ohe has likewise received highest praise.

Among the women composers of France Elizabeth Claude Guerre, born at Paris in 1669; Edme Sophie Gail Garré, born in 1775, and Louise Bertin were the pioneers. Elizabeth Guerre's opera "Cephale et Pœris" was performed at the Royal Academie. She also composed a Te Deum, and a number of cantatas.

The most successful composer of recent years was Cécile Louise Stephanie Chaminade, born at Paris in 1861. Her most ambitious compositions are "Les Amazones," a lyric symphony with choruses; "La Sevillane"; "Callirhœ"; "Etude Symphonique," and a large number of compositions for piano, many of which became very popular.

Of Augusta Mary Ann Holmes, likewise a native of Paris, the opera "Hero et Leandre" had great success.

Of the women composers of England M. Virginia Gabriel was very popular. She wrote the cantatas "Evangeline" and "Dreamland," and the operettas "Grass Widows," "Widows Bewitched" and "Who's the Heir?" Leza Lehman was the author of the song cycle "In a Persian Garden," and of "Nonsense Songs." Clara Angela Macirone's anthem "By the Waters of Babylon" has been sung in all the cathedrals of Great Britain.

Lady Helen Dufferin is known principally for her songs and ballads, which, both for comic humor and pathos, rank among the best in the English language. "The Irish

Emigrant's Lament" compares favorably with any English lyric. Charlotte Sainton Dolby, Elizabeth Mounsey and Harriet Abrams composed likewise numerous songs, and Kate Fanny Loder the operette "Fleur d'Epine."

There exist also many splendid compositions by American women. When in 1893 the Woman's Building at the World's Columbian Exposition at Chicago was dedicated, Mrs. H. A. Beach's "Jubilate" was received with greatest enthusiasm. Also her "Gaelic Symphony" was played by many famous orchestras.

The "Dramatic Overture" (Op. 12) of Miss Margaret Ruthven Lang has been frequently performed by the famous Boston Symphony Orchestra.

Of the innumerable virtuosos, who interpreted works of the above-named composers and others, the American violinists Arma Senkrah and Maud Powell, the Italian Teresina Tua, the German Maria Soldat, and the South-American pianists Terese Careno and Giomar Novaez, not to forget the Hungarian Sophie Menter and the Russian Annette Essipoff have been the most eminent.

"Dem Mimen flicht die Nachwelt keine Kränze," the great German poet Schiller has said in one of his poems, pointing out that, while the painter, sculptor, composer and writer transmit their works to remote generations, the glory won by the actor and singer exhales with their disappearance from the stage as quickly as does the fragrance of a delicate flower. The record of the performer's and singer's gift remains only as a tradition, as a legend.

So it is. The majority of those actors and singers, who in bygone times held large audiences spellbound, are forgotten. There are only few exceptions which in the history of dramatic art and music will remain. So for instance with the history of the English stage of the latter part of the 17th Century the names of two great actresses are inseparably connected: Gwynn and Elizabeth Barry. The former especially was the darling of the people, and much favored by King Charles II. During the following century Anne Oldfield, Mary Porter, Elizabeth Billington, Anne Spranger Barry, Hannah Pritchard, Mary Robinson, Jane Pope, Susanne Cibber, Frances Abington and Margaret Woffington were celebrated for their talent, charm, and elegance. Of Sarah Siddons, called "the Incomparable," it has been reported that by means of her excellent art as well as by her beauty, dignity and personal distinction she reduced her audiences to an awe-struck reverence. Edmund Gosse, in an article devoted to the memory of Sarah Siddons says: "Under the effect she produced, women as well as men lost all command over themselves, and sobbed, moaned, and even howled with emotion. Young ladies used suddenly to shriek; men were carried out, gibbering, in hysterics."

Of the many excellent English actresses of the 19th Century and of our present days Louise Nisbett, Mary Stirling, Elizabeth O'Neill, Helen Faucit, Lillian Neilson, Deborah Lacy, Frances Kemble, Adelaide Kemble-Sartoris, Charlotte Dolby, Ellen Terry, Gertrude and Rose Coghlan have to be mentioned. Also we must remember the great

triumphs of Nellie Melba, a native of Australia, but at home on the stages and in the concert halls of Europe as well as of America.

The United States produced likewise a number of brilliant actresses and opera stars. Among the former were Clara Fisher, Mary Vincent, Laura Keene, Anna Gilbert, Anna and Cora Ritshie, not to forget Mary Ann Dyke-Duff, whom the elder Booth declared to be "the greatest actress in the world." Furthermore, there was the classic Mary Anderson, who was followed later on by such eminent performers as Ida Conquest, Adelaide Phillips, Julia Marlowe, Leslie Carter, Maud Adams, and Ethel Barrymore.

Our United States have been also the native land of the famous opera stars Minni Hauck, Lillian Nordica, Emma Eames, Olive Fremstadt, Florence Macbeth, Mary Garden, Anna Case and Geraldine Farrar.

Germany and Austria too have produced numbers of accomplished actresses and singers who stood high in public esteem and thrilled vast audiences by splendid revelations of their art. The name of Charlotte Wolter is forever connected with the famous Burgtheater in Vienna as the greatest tragedienne in the history of that famous institution. To the many actresses, whose fame is not limited to their native countries but has extended to America as well, belong the following stars of the 19th Century: Marie Seebach, Ottilie Genee, Kathie Schratt, Hedwig Niemann-Rabe, Fanny Janauschek, Magda Irschik, Anna Haverland, Marie Geistinger, Agnes Sorma, Helene Odilon, Francisca Ellmenreich, Fanny Eysolt, Irene Triebsch and Else Lehmann.

As stars in grand opera and concert singers the most famous of the former century have been Henriette Sontag, Pauline Lucca, Marie Schroeder-Hanfstängl, Teresa Tietiens, Etelka Gerster, Lilli Lehmann, Fanny Moran-Olden, Rosa Sucher, Amalie Materna, Marie Brema, Katharine Klaffsky and Marianne Brand. Our present generation has paid tribute to Milka Ternina, Marie Rappold, Alma Gluck, Elene Gerhard, Johanna Gadski, Julia Culp, Ernestine Schumann-Heink, Melanie Kurt, Margarete Ober, and Frida Hempel.

With the history of the French drama the names of the great tragediennes Elizabeth Rachel and Sarah Bernhardt are inseparably connected, while in opera Madeline Arnould, Magdalene Marie Desgarcins, Louise Françoise Contat, Marie Felicite Malibran, Louise Angelique Bertin, Sophie Cruvelli, Emma Calvé, Lucienne Breval, Felia Litvinne and Desiré Artot have been stars of the first order.

Italy gave birth to the famous actresses and singers Guilia Grisi, Marietta Alboni, Angelica Catalani, Adelaide Ristori, Eleonora Duse, L. Scalchi, Louisa Tetrazzina, and Amelia Galli-Curci.

Poland had her superb Helena Modjeska and Marcella Sembrich; Bohemia the marvelous Emmy Destinn.

Sweden treasures the memory of Jenny Lind and Christine Nilsson as superlative artists. Jenny Lind was called "the Swedish Nightingale," and was famous for her great charm as well as for her musical gifts. Her splendid tour in America under the

management of P. T. Barnum in 1849 was one of the greatest artistic and financial triumphs ever achieved by one single artist.

A somewhat international position has been held by the famous Adelina Patti, born in 1843 at Madrid, as the daughter of a Sicilian tenor and the Spanish Signora Barilli. Taught singing by the Moravian Maurice Strakosch, she commanded an unusually high soprano of rich bell-like tone and remarkable evenness, and was equally at home in the tenderness of deep passion and the sprightly vivacity of comedy, and in oratorio. For these reasons she has been regarded as one of the greatest singers of all times. That her reputation was founded on her rare qualities, is best shown by the testimony of two of her fellow-artists, Marcella Sembrich and Lilli Lehmann. The former expressed her admiration in the words: "When one speaks of Patti one speaks of something that occurred only once in the history of the world." The latter, famous in a totally different school of her art, wrote the following lines:

"In Adelaine Patti everything was united—the splendid voice, paired with great talent for singing. All was absolutely good, correct and flawless, the voice like a bell that you seemed to hear long after the singing had ceased."

WHAT WOMEN HAVE ACCOMPLISHED IN ART

As is familiar to every student of the classic past the Greeks and Romans hailed a female deity, Pallas Athene, or Minerva, as the protectress of their arts and industries. She was believed to have invented spinning, weaving, embroidering, painting, and every other handicraft that has brought mankind comfort and happiness.

Of course this goddess had many eager women disciples. There was hardly any Greek or Roman woman without a thorough command of the above named crafts. Since the days of Homer, who praised Penelope, the beautiful wife of Ulysses, for her skill in tapestry-weaving, all women devoted themselves to useful arts. In Ephesus Pliny admired a picture of Diana, painted by Timarata, the gifted daughter of an able artist. He also praises Laya for her excellent miniature portraits on ivory, which were held in great favor by the rich ladies of Rome. The names of several other female artists are known, but unfortunately none of their works have come down to us.

Enthusiastic authors of the Middle Ages glorify Agnes, Abbess of Quedlinburg, for her great skill in illuminating manuscripts with figures, beautiful initial letters and elaborate border ornaments, which she enriched with all the splendor of color and gilding.

It was only natural, that the magnificent works of art, produced by Raphael, Leonardo da Vinci, Titian, Correggio, Tintoretto and other great masters of the Italian Renaissance, inspired the women who came in daily contact with these men; especially their daughters, many of whom inherited their fathers' enthusiasm for beauty and art. Constantly witnessing the origin and progress of the products of their fathers' genius, it could not fail that such women likewise devoted themselves to art. As did Lavinia Fontana, the daughter of Prospero Fontana of Bologna, whom Michael Angelo recommended to Pope Julius III., in whose service he remained for many years. Lavinia was born in Rome in 1552. Inspired by her father's art, she too won great fame. The old patrician palaces of Rome, Bologna, and other Italian cities still contain many portraits of

beautiful women and illustrious men, who once were among her sitters. She likewise painted various other works which show great care and delicacy.

Among her most admired works are a Venus, now in the Museum at Berlin; the Virgin lifting a veil from the sleeping infant Christ, now in the Escurial; and the Queen of Sheba visiting Solomon. Her masterpiece, however, is her own portrait, which shows her in all her radiant beauty.

Sofonisba Anguisciola, born in 1533 at Cremona, likewise ranks high among the foremost portrait painters of the 16th Century. On recommendation of the Duke of Alba, Philippe II., King of Spain, invited her to his court in Madrid, where she was received with extraordinary honors. Here she painted numerous portraits of the king as well as of the queen, the infantas and the members of the court. A few specimens of her art are still to be seen in the Escurial at Madrid and at Florence. Van Dyck acknowledged himself more benefited by her than by his study of all other masters.

Marietta Tintoretto, born in 1560, a daughter of the great Venetian artist Jacopo Robusti, commonly called Tintoretto, was one of the most appreciated portrait painters in the "Queen City of the Adriatic." She was so favorably known for the beauty of her work and the exactness of resemblance that she was solicited by Emperor Maximilian as well as by Philippe II., King of Spain, to visit their courts. But her affectionate attachment to her father was so great that she declined these honors, and remained in Venice, where she died in 1590.

The 17th Century likewise produced a number of excellent women artists. Bologna, the birth-place of so many famous men and women, was also the native town of Elizabeth Sirani, who, born in 1638 to Gian Andrea Sirani, a painter of some reputation, attracted attention to her attempts at drawing when scarcely more than an infant. Her rare talents developed as she grew older. Before she had attained her eighteenth year, she had finished several paintings, which were greatly admired and given places of honor in various churches. Her most admired work, a Lord's Supper, grand in conception, is in the church of the Certosini, and is considered one of the best examples of the Bolognesian School of art. Unfortunately this promising woman died suddenly when only twenty-seven years of age.

Rosalba Carriera, a Venetian, born in 1675, became famous over all Europe for her admirable miniature- and crayon- or pastel-portraits, which, through her, became the fashion of the 18th Century.

Among the Dutch artists of the 17th Century Maria van Osterwyck and Rachel Ruisch excelled in painting flowers and fruits. Elisabeth Cheron, a French woman, born in Paris in 1648, was famous for her miniatures and historical subjects.

England too had some fine women artists: Mary Beale, born 1632 in Suffolk, and Anne Killigrew, born in London. Both are known for excellent portraits of notable persons. The National Portrait Gallery in London contains for instance Mary Beale's portraits of King Charles II., of the Duke of Norfolk, and of Cowley.

Figure 53. Marie S. LeBrun with Her Daughter. After her own painting.

The 18th Century produced two women artists, who were among the leaders of their time: Angelica Kauffmann and Marie LeBrun. Angelica Kauffmann, the daughter of an artist, was born in 1740 at Coire in Switzerland, from where she went later on to Italy, to study the great masters. In 1765 she came to London. Here she painted many excellent portraits as well as numerous classic and allegorical subjects. In 1781 she returned to Italy. Here she was always much feted and admired for her talents as well as for her personal charm. Goethe, who met Angelica Kauffmann in Rome, admired her works very much. "No living painter," so he wrote in a letter, "excels her in dignity or in the delicate taste with which she handles the pencil." And Raphael Mengs, one of the most brilliant artists of the Rococo, praised her in the following words: "As an artist Angelica Kauffmann is the pride of the female sex in all times and all nations. Nothing is wanting; composition, coloring, fancy, all are here." When she died in November, 1807, she was

honored by a splendid funeral under the direction of Canova. The entire Academy of St. Luke at Rome with numerous ecclesiastics and virtuosi followed her funeral train and, as at the burial of Raphael, two of her latest paintings were carried behind her coffin in the procession.

Of Madame LeBrun, who was born in 1755 in France, it has been said that "a more ideal artist never lived." The well-known portrait of herself and her daughter has been termed "the tenderest of all pictures." She also painted several portraits of the unfortunate Queen Marie Antoinette. The Louvre has one of her best paintings: "Peace bringing back Abundance."

Madame LeBrun was one of the most prolific artists of all times. In her autobiography, entitled "Souvenirs," she states that she finished six hundred and sixty-two portraits, fifteen large compositions, and two hundred landscapes, the latter sketched during her travels in Switzerland and England.

During the 18th Century Germany was the scene of the greatest activity of women artists. France held the second place and Italy the third, thus reversing the conditions of preceding centuries. Flanders and Antwerp too were famous for women artists, some of whom went to other countries where they were recognized for their talent and attainments.

The most famous woman artist of the 19th Century was Rosa Bonheur, born in 1832 at Bordeaux, the daughter of Raymond Bonheur, an artist of merit. From him she received her first instructions. In 1841 she began exhibiting in the Paris Salon, with several small animal paintings, indicating the direction in which she was to attain her future eminence. Her great success in painting animals was due to her conscientious study of living subjects. One of her masterpieces, "Plowing with Oxen," ranks among the gems of the Luxembourg. Another excellent painting, "The Horse Fair," was the chief attraction of the Paris Salon in 1853, and later on became the property of the New York Metropolitan Museum of Art. Of all animal paintings ever executed, this one is perhaps the most animated, and the best in composition as well as in color. Another canvass, "Horses Threshing Corn," shows the same merits. Containing ten horses in full life size, it is the largest animal picture ever produced.

Another painting, "The Monarch of the Glen," received much praise at the World's Columbian Exposition.

In just appreciation of her genius Rosa Bonheur was proposed in 1853 for the Cross of the Legion of Honor, but because of her sex the decoration was withheld until 1865.—

One of the four daughters of an early German pioneer of California, who distinguished themselves in different lines of activity, Anne Elizabeth Klumpke followed in the footsteps of Rosa Bonheur, of whom she became a close friend, and who, in appreciation of her great talent, bequeathed to her her beautiful chateau as well as her entire fortune.

Figure 54. The Horse Fair. After the painting by Rosa Bonheur in the New York Metropolitan Museum of Art.

The second half of the 19th and the beginning of the 20th Century produced a surprising abundance of women artists, some of whom gained the most coveted prizes and medals offered by the great annual exhibitions in Paris, London, Berlin, Munich and other centers of art. Clara Erskine Clemens in her book "Women in the Fine Arts" has compiled notes about several hundred of them, without enumerating them all. To mention a few of the most excellent, we name of the German artists Louise Parmentier Begas, Tina Blau, Dora Hitz, Lucia von Gelder, Herminie von Janda, Countess Marie Kalckreuth, Minna Stock, Toni Stadler, Frieda Ritter, Margarethe von Schack, Vilma Parlaghy, and Margarethe Waldau.

Italy names among its best modern painters Alceste Campriani, Ada Negri, Juana Romani, Erminia de Sanctis, and Clelia Bompiani.

The French extol the genius of Louise Labé, Marceline Desbordes-Valmore and Louise Ackermann.

Belgium and Holland number among their women artists Therese Schwartze, Adele Kindt and Henriette Ronner; Spain points with pride to the works of Fernanda Frances y Arribas, Adele Gines and Antonia de Banuelos. Denmark's famous artist, Elizabet Jerichau Baumann, is remembered especially for her magnificent painting "Christian Martyrs in the Catacombs"; Switzerland has two portraitists of the first order, Louise Catherine Breslau and Aimée Rapin, while Russia produced in Marie Bashkirttseff an artist of rare ability.

Perhaps in no other country is the number of female artists so large as in England. We will name only a few of them. Laura Alma Tadema was the gifted daughter of the famous artist Laurenz Alma Tadema. Margaret Sarah Carpenter won wide reputation as a gifted portrait painter. Ethel Wright's beautiful painting "The Song of the Ages" belongs to the best examples of English art. Clara Montalba is favorably known for her splendid

scenes of Venice, and landscapes of the Adriatic coasts. Elizabeth Thompson demonstrated by many excellent sketches and pictures that women are not afraid to make a specialty of battle scenes.

Ambitious American women are likewise hard at work gaining honor and laurels in the various fields of art. The morning promises fair, as there are already many shining names upon the scroll. To begin with one of the middle of the last century, we mention Cornelia Adele Facett, whose chief work, "The Election Commission in Open Session," contains 258 portraits of men and women, prominent in the political, literary, scientific and social circles of their time. It adorns the Senate Chamber in the Capitol at Washington.

The most brilliant woman artist of the United States is without question Cecilia Beaux, a Philadelphian, who, as a portrait painter, compares with the very best of any nation. Her portrait of a "Girl in White," owned by the Metropolitan Museum of Art in New York, verifies what a critic said about her:

> "Miss Beaux has approached the task of painting the society woman of to-day, not as one to whom this type is known only by exterior, but with a sympathy as complete as a similar tradition and artistic temperament will allow. Thus she starts with an advantage denied to all but a very few American portrait painters, and this explains the instinctive way in which she gives to her pictured subjects an air of natural ease and good breeding."

Sadie Waters, born in St. Louis, produced a number of religious paintings, her best and largest showing the Madonna in a bower of roses.

Violet Oakley of New Jersey had a prominent part in decorating the new Capitol at Harrisburg, Pennsylvania, one of the most elaborate and costly public buildings in America. The mural painting "The Romance of the Founding of the State" in the Governor's room is her work.

Anna Mary Richards excelled as a marine painter. Her large canvass "The Wild Horses of the Sea" has been especially admired.

Anny Shaw, Grace Hudson, Lucie Fairchild Fuller, Mary Cassatt, and Matilde Lotz are among the latest women artists of America, favorably known for many creditable works.

Although comparatively few women have devoted themselves to sculpture, there are several among them well worth mentioning.

The first female sculptor of whom anything is known, was Sabina von Steinbach, a daughter of Erwin von Steinbach, the famous architect of the magnificent cathedral at Strassburg, in Alsace. After the southern portal of this minster had been erected, Sabina adorned it with the statues of the apostles, one of which, that of John, held in his hands a scroll with the following inscription:

"Gratia divinæ pietatis adesto Savinæ,
De petra dura per quam sum facta figura."
"The grace of God be with thee, O Sabina,
Whose hands from this hard stone have formed my image."

Nothing further is known about this artist of the end of the 13th Century.

Properzia de Rossi was an Italian woman sculptor, born near the end of the 15th Century at Bologna or Modena. The first-named city cherishes still a number of her works, among them a fine marble statue of Count Guido de Pepoli, and several figures that adorn the three gates of the facade of St. Petroneus. Vasari in his biographies of celebrated artists calls her "a virtuous maiden, possessing every merit of her sex, together with science and learning all men may envy." And when she died in 1530, the following epitaph was written in her praise:

Fero splendor di due begit occhi accrebbe
Gia marmi a marmi; e stupor nuovo e strano
Ruvidi marmi delicta mano
Fea dianzi vivi, ahi! morte invidia n'ebbe.

In modern Germany Anna von Kahle, Marie Schlafhorst, Dora Beer, Helene Quitmann, Henny Geyer Spiegel and Lilly Finzelberg have done much excellent work.

In France several statues by Jeanne Hasse, a Parisian, have been purchased by the government and presented to various provincial museums.

In England Mary Thornycroft, daughter and pupil of John Francis, the sculptor, has won the praise of the severest critics.

In America Annie Whitney's statue of "Lady Godiva" as well as her "Africa" and "Roma" have been much praised.

Helen Farnworth Mears is well known for her "Fountain of Life." Vinnie Ream Hoxie modelled a life-size statue of Lincoln, which stands in the rotunda of the Capitol at Washington. A statue of Farragut in Farragut Square is by the same artist.

Another American woman sculptor of renown was Harriet Hosmer, born in 1830 in Watertown, Mass. Having received her first instruction in Boston and St. Louis, she went to Rome in 1852 where she became a pupil of Gibson. Of her various works, the best known are "Beatrice Cenci in Her Cell"; "Willo'-the-Wisp"; "The Sleeping and the Waking Faun"; and a colossal statue of "Zenobia, Queen of Palmyra, in Chains." She exhibited a statue of Queen Isabella of Spain at the World's Columbian Exposition. A statue of "Puck" was so spirited and original, that it was ordered more than thirty times, is also her work.

Emma Stebbins (1815–1882) produced a statue of Horace Mann for Boston, and a large fountain for Central Park, New York, the subject being "The Angel of the Waters."

The Metropolitan Museum of Art in New York has in its collections several works by Frances Grimes, Laura Gardin, Malvina Hoffman, and Evelyn Longman. Miss Hoffman's best known work, "The Russian Bachanale," showing two almost nude dancing figures in bronze, was in 1919 presented by an American connoisseur to the famous Gardens of the Luxembourg in Paris.

The United States of America produced also the first women architects. In 1881 Louise Bethune took the lead. Somewhat later the New York firm Hands & Gannon, both members of which were women, designed the plans for numerous schools, hospitals, and model homes for the working people. Elizabeth Holman in Philadelphia became favorably known for her excellent designs for theatres, hotels, and cottages. Mrs. Wagner in Pittsburgh made a specialty of university buildings, churches and chapels.

Miss Sophie G. Hayden of Boston, a graduate of the architectural school of the Massachusetts Institute of Technology, was the architect of the beautiful Women's Pavilion at the World's Columbian Exposition. The task of adorning this building with sculptures, emblematic of woman's great work in the world, was after an extremely vigorous contest awarded to Miss Alice Rideout, of San Francisco. Women architects likewise designed the imposing woman's palaces at the expositions in St. Louis, Atlanta, and San Francisco. Since then the number of women in this line of activity has steadily increased. According to the Census of 1910 the United States had in that year 1037 women architects, designers and draftsmen.

Thus we find woman hard at work in all the various realms of art. And since her joy in beauty is supreme, we may well expect that her expression of the highest beauty, the spiritual, will in time favorably compare with that of her brother-artists.

GREAT MONUMENTS OF WOMAN'S PHILANTHROPY

Woman and philanthropy have always been inseparably connected, for charity has been regarded in all ages as one of the noblest virtues of the gentle sex.

There is scarcely any country which does not cherish the memory of some women for great works of charity. Germany, for instance, has the lovely story of Elizabeth, the wife of Ludwig IV., landgrave of Thuringia, who reigned during the first half of the 13th Century. Feeling an aversion to worldly pleasures, and making the early Christians her example, Elizabeth devoted herself to works of benevolence. In these she was so liberal, that her husband became uneasy, fearing she might impoverish his estate by her alms-giving. He accordingly bade her to give less to the poor. But secretly she spent just as much. One day, while she was carrying a heavy load of bread in her basket, she was stopped by her husband, who inquired what she was hiding. "Roses, my Lord, roses!" she said, hoping that he would not investigate. But when he insisted on seeing them, she was forced to open her basket and, oh wonder! all the loaves of bread had turned into the most beautiful roses.—

America remembers Dorothea Dix as one of the most distinguished women it ever has produced. Compelled by declining health to go to Europe from 1834 to 1837, she had ample opportunity to study in Liverpool and other cities of England the terrible conditions of the poor, especially of the inmates of poor-houses and insane-asylums. As at that time similar institutions in America were just as bad, she gave after her return to the United States all her time, strength and influence to ameliorate suffering, and to persuade the public to furnish suitable asylums, also to improve the moral discipline of prisons and penitentiaries. For this purpose she visited every State east of the Rocky Mountains, seeking out intelligent and benevolent people, and trying to kindle in their hearts the same enthusiasm that filled her own.

Fearless in lifting her voice against abuses, she was so persistent in reiterating her protests and in pleading needed reforms, that attention had to be given her. The founding

of many state hospitals and insane-asylums in the United States as well as in Nova Scotia and Newfoundland is due to her indefatigable work.

A similar case is that of Margaret Fuller, the famous author. Warmly espousing the cause of reform in many directions and making herself the champion of truth and human rights at any cost, she visited prisons and charitable institutions and talked freely with the female inmates. It was on the common ground of womanhood that she approached these degraded of her own sex, true to her unalterable faith in awakening whatever divine spark might be there. She was surprised herself at the results—the touching traits and the possibilities that still survived in beings so forlorn and degraded. Many of them expressed a wish to see her alone, in order to confide to her the secrets of their ruined lives, and their ardent desire to enter a new course whereby they might regain respectability. Thus making herself the friend of the friendless, Margaret Fuller began what we call to-day "settlement work."

In the matter of prison reform the name of Elizabeth Guerney Fry (1780–1845) will likewise be remembered as one of the first women promoters in this line of charity. An accidental visit to Newgate Prison in London disclosed to her the horrible conditions prevailing in this ill-reputed dungeon. Like most prisons at the time it was dark, damp, and cold in winter. The prisoners were usually half-starved, and clad in rags; often loaded with chains, and oftener yet pestered by vermin and rats. The ward, into which Miss Fry penetrated, although strongly dissuaded by the officials, was like a den of wild beasts. It was filled with a hundred and sixty women and children, gambling, fighting, swearing, yelling, dancing. It justly deserved its name of "hell above ground." The general disorder and abject misery of the women confined there so impressed Miss Fry, that she took immediate and effectual means to relieve them. The first step in the great public work of her life was the forming of "The Association for the Improvement of the Female Prisoners in Newgate," in April, 1817. Its aim was the establishment of what is now regarded as "prison discipline," such as entire separation of the sexes, classification of criminals, female supervision for the women, and adequate provision for their religious and secular instruction, as also for their useful employment. Disregarding sarcastic critics, who protested against the "ultra-humanitarianism which sought to make jails too comfortable and tended to pamper criminals," Miss Fry pursued her way and finally brought about the passing of Acts (1823–24), in which it was laid down that over and above safe custody it was essential to preserve health, improve morals, and enforce useful labor in all prisons. Not content with these results, Miss Fry likewise inspected during the time from 1818 to 1841 the principal prisons of Scotland, Ireland, France, Switzerland, Belgium, Holland, Southern Germany, and Denmark, everywhere conferring personally with the leading prison officials. By keeping up a constant correspondence with them she had the satisfaction of hearing from almost every quarter of Europe that the authorities were giving an ever increasing consideration to her suggestions.—

Following the example set by Miss Fry, women in many countries aided in forming societies for the improvement of prison-discipline. They also established reformatories for women and juvenile delinquents. For instance Mrs. Abbey Hopper Gibbons assisted in founding the "Women's Prison Association of New York" in 1844 and the "Isaac T. Hopper Home." Its objects were: "First, the improvement of the condition of the prisoners, whether detained on trial or finally convicted, or as witnesses; secondly, the support and encouragement of reformed convicts after their discharge, by affording them an opportunity of obtaining an honest livelihood, and sustaining them in their efforts to reform."

The association employs an executive secretary who visits all the places where women are detained in the State or City of New York, keeps track of the housing conditions and studies the treatment of the prisoners. On the basis of this exact knowledge, the Association has proposed various reforms; for example the establishment of Bedford Reformatory was largely due to the efforts of this society, and the appointment of police matrons in the city station houses. Through the instrumentality of Mrs. Hopper Gibbons the "New York State Reformatory for Women and Girls" was established by the Legislature.

Through the efforts of Linda Gilbert various prisons throughout the country were provided with libraries. She also secured the incorporation of the "Gilbert Library and Prisoners' Aid Society" under the laws of the State of New York. Furthermore she procured employment for thousands of ex-convicts, and aided others in establishing in business in a small way.—

To enumerate what women have contributed to culture as founders and patronesses of infant homes, foundling and orphan asylums, industrial schools and homes for boys and girls, of refuges for unfortunate women, invalids and the aged, of hospitals for destitute children and for people afflicted with tuberculosis, cancer, and incurable diseases, is a task impossible for the limited space of this book. Besides, all information is fragmentary and far too insufficient to give a true idea of the vast sums and immense amount of time, labor, and effort, devoted by women to these works of charity. Constantly on the lookout to alleviate sorrow and provide comfort, they have not forgotten even those lonely men, who do duty in remote light houses and life-saving stations. It was through the efforts of women that these involuntary hermits, who often do not come in touch with other human beings for several months, are regularly provided with interesting books and entertaining games.

Mrs. Matilde Ziegler of New York has taken a special interest in the blind. Mrs. Ziegler, at an expense of $20,000 a year, founded a monthly magazine for the blind, which has a printing press of double the capacity of any printing plant for the blind in any other country. Blind girls do all the work connected with this magazine.

Georgia Trader in Cincinnati established school classes for the blind and a library with over 25,000 volumes, from which books in raised type are sent to the blind all over

the country, free of any charge. She also founded a working-home for blind girls, where they are profitably employed in weaving rugs, and in various artistic work and handicraft.

Jane Addams in 1889 opened in Chicago a social settlement, known as "Hull House." Wonderful work in sociology is done there. Many thousands of men, women and children are instructed in all kinds of handicraft, and directed to places, where they can make an honest and profitable living. They have also access to an excellent library, comfortable club rooms, lecture-halls, kindergarten, play-grounds and other institutions.

Miss Addams is to-day recognized as one of the foremost women in her line of work, and by her example as well as through her public lectures and able books, has probably done more than anybody else for the extension of practical sociology.

Women have also taken charge of thousands of tired working-girls and sent them to the country for a short rest during the summer, thus enabling them to take up their lives of toil with renewed vigor and courage.

Similar organizations have established vacation schools to save children from the demoralization of the long summer idleness, and to secure for them fresh air vacations.

Moved by a sincere desire to improve the conditions of the despised and maltreated American Indians, Helen Hunt Jackson, Alice Fletcher, and Mary L. Bonney succeeded after indefatigable efforts in awakening interest among the legislators in their work. Miss Fletcher, in her valuable book "Indian Civilization and Education," gave such ample proof of her special qualifications that she was appointed by President Cleveland in 1887 as a special agent of the Government, to allot lands to various Indian tribes. Mary L. Bonney devoted herself principally to educational work and, in 1881, was foremost in the task of organizing the "Indian Treaty-Keeping and Protective Association" by which the many unlawful encroachments of white settlers, and the oppression of the Red Men by government agents were stopped.

In their efforts to alleviate the hard lot of negro slaves, Lucretia Mott, Sarah and Angelica Grimke, Harriet Beecher Stowe, and many others, braved criticism, insults and social ostracism.

By organizing societies for the prevention of cruelty to children and animals, women have taken care of those who cannot speak for themselves. In many cities they have likewise provided drinking fountains for men and for animals.

All women members of the "National Association of the Audubon Societies," that protect bird-life in America, bind themselves never to decorate their hats with plumes and feathers. They have also secured laws that forbid hunters to kill useful birds, and prevent milliners from buying or exhibiting feathers and stuffed skins of such birds.

As generous patronesses of education, science and art many women have set themselves lasting monuments.

Catherine L. Wolfe donated to the Metropolitan Museum of Art in New York not only her magnificent collection of paintings, but likewise a fund of $200,000 for its preservation and increase. A million dollars was also bequeathed by her to several

educational institutions founded by her father and herself. She is also known as the founder of the New York Home for Incurables.

Mary Tileston Hemenway supported the so-called Hemenway Expeditions for the archæological exploration of certain regions of Arizona and New Mexico.

Jane Lathrop Stanford, wife of Leland Stanford, railway constructor, and U. S. Senator from California, founded in memory of her son the "Leland Stanford Jr. University" at Palo Alto, near San Francisco. At her own expense Mrs. Stanford established a museum, connected with the university, containing objects of art, and many things she had collected during her extensive travels. At her death the entire estate of the Stanfords, amounting to about $50,000,000, was left to endow this great university. Her San Francisco home, on Nob Hill, became an art gallery and museum.

Phœbe Hearst, wife of George Hearst, and mother of William Randolph Hearst, made large donations to the University of California. These included $800,000 for the erection and equipment of the Hearst Memorial Mining Building. She also made provision for twenty scholarships for women, and founded a number of free libraries in mining towns with which her husband had been associated. Mrs. Hearst was also actively interested in every kind of organization for the welfare of women. Furthermore she established and maintained two kindergarten schools in San Francisco, and three in Washington, one of which is for colored children. Her most important gift to the District of Columbia was the National Cathedral School for Girls, erected on a beautiful site on the outskirts of the city.

Margaret Olivia Sage, the widow of Russell Sage, donated between seventy-five and eighty million dollars for charitable and educational purposes. With ten millions she established in 1907 the "Sage Foundation for Social Betterment." Its purpose is the improvement of social and living conditions in the United States. It does not attempt to relieve individual or family need, but tries to seek out and eliminate causes of this evil. It furthers education that more directly affects social and living conditions, such as industrial education, education in household arts, and the training of social workers. In the pursuit of these aims the Sage Foundation subsidized worthy activities and organizations; it has established investigational and propagandist departments of its own; invested its funds in activities with a social purpose; and published extensively books and pamphlets on social subjects. Since the work of the Russell Sage Foundation aids social advance for people of every nation, Mrs. Sage became one of the benefactors not only of this country, but of the world.

Among the many donations Mrs. Sage made to other institutions, were $600,000 to the Troy Female Seminary, which was one of the first schools in America for the higher education of girls; $1,600,000 to the Woman's Hospital of New York; $1,600,000 to the Children's Aid Society; $1,600,000 to the Metropolitan Museum of Art; $1,600,000 to the American Museum of Natural History; and $1,600,000 to Syracuse University.

The list here given mentions only a few of the innumerable philanthropic works of American women. Similar lists could be made for all other countries, but the material has never been properly collected. Besides, by far the greatest number of such benevolent acts have been performed without public knowledge. But wherever we go, we find women active, helpful, and persevering, always rejoicing in the accomplishment of good.

THE HUNDRED YEARS' BATTLE FOR WOMAN SUFFRAGE

"If particular care and attention are not paid to the ladies, we are determined to foment a rebellion, and will not hold ourselves bound to obey any laws in which we have no voice or representation."

This was the warning directed by Mrs. John Adams in March, 1776, to her husband while he was attending the Continental Congress, assembled in Philadelphia to consider the Declaration of Independence.

When this document was framed and adopted without recognizing the rights of women, Mrs. Adams and a number of other women, deeply indignant, made good the threat of Mrs. Adams and opened that most remarkable warfare, which has lasted for more than a hundred years and may be called "Woman's Battle for Suffrage."

That they were deeply disappointed by the inattention of Congress, may be inferred from a letter by Hannah Lee, the sister of General Lee, in which she asks her brother to demand from Congress suffrage for women, as otherwise they would not pay any taxes. The same request was made by various other prominent women, who pointed to the fact that, while their husbands and sons had fought for the inherent rights of men, they had likewise fought for the rights of women. But as at that time American women were not organized their demands failed to make the necessary impression and remained unheeded. Besides, the majority of American women receiving only a very limited education, took little interest in the question, because of their ignorance of its importance. Thus, the subject of woman's rights and suffrage dragged on until women had discovered, that there is strength in numbers, in federation, and that federation is the preliminary requirement to make victory possible.

The evolution of women's clubs during the 19th Century is one of the most striking and most important phenomena in woman's history. The movement began with the

sewing or spinning circles of long ago, and made a great stride when the custom was initiated of some members reading while the others sewed. Later on these circles evolved into reading-clubs, which again developed into literary societies and associations for public improvement, aiming at the establishment of public schools and libraries, the erection of hospitals, orphan asylums, the sanitation of the streets, and other public works.

Such women's clubs were not even afraid to tackle such most difficult problems as the abolition of slavery, which, at the end of the 18th and the beginning of the 19th Century, became the burning question of the time. The hot discussion of this problem split the population of the United States into two hostile factions, of which the South with its partisans in the North made desperate efforts to prevent the free expression of opinion respecting the institution of slavery. In the slave States even the Christian churches used their influence in favor of the maintenance of slavery.

Among the first and strongest advocates of abolition were Sarah and Angelina Grimke, the daughters of a family of Salzburgers, who during the 18th Century had immigrated into South Carolina and Georgia. Shocked by the inhuman treatment and cruelties inflicted upon the slaves all round, and suffering intensely from the stand taken by their own relatives, the sisters resolved to fight these abuses.

While visiting Philadelphia, Sarah came under the influence of the Quakers, and read the strong protest against slavery, which Pastorius and the settlers of Germantown in 1688 had directed to the Quaker meeting. Returning to her home, Sarah besought her relatives to free their slaves. Failing in this effort, she left her home, joined the Quaker society of the "Friends" in Philadelphia, and in 1835 directed an "Appeal to the Christian Women of the South," imploring them to become active on behalf of the slaves. This pamphlet aroused such a profound sensation wherever it was read, that when some time afterward Miss Grimke expressed a desire to visit her former home, the mayor of Charleston called upon her mother and informed her that the police had been instructed to prevent her daughter's landing when the steamer should come into port. He also would see to it that she might not communicate with any person, by letter or otherwise, and that, if she should elude the vigilance of the police and go ashore, she was to be arrested and imprisoned until the return of the vessel. As threats of personal violence were also made, Miss Grimke abandoned her visit, but published soon afterward "An Epistle to the Clergy of the Southern States," and, at the same time, began to address meetings in Pennsylvania as well as in the New England States, in order to rouse the dormant moral sense of the hearers to protest against the colossal sin of the nation. She was assisted by her sister Angelina and such eloquent speakers as Lucretia Mott, Elizabeth Stanton, William Lloyd Garrison and others. These agitators finally created such a stir, that the conservatives and opponents of abolition decided that they must be silenced. Quite often their meetings were disturbed by mobs; halls were refused them, and violence was threatened. The General Association of Congregational Ministers of Massachusetts passed a resolution

censuring the Grimke sisters, and issued a pastoral letter containing a tirade against "female preachers." But in spite of all efforts, public sentiment in the North in favor of abolition steadily grew, until it became evident that the question could not be settled without an armed conflict.

At a gathering of abolitionists, held on July 19th, 1848, at the home of Mrs. Elizabeth Cady Stanton in Seneca, N.Y., the question of women's rights was eagerly discussed. Mrs. Stanton, the daughter of a lawyer, had found by frequent visits to her father's office that according to the then existing laws, which had been adopted from England, married women had no right of disposal over their own inherited property, their own income, or their own children, no matter how unfit, degraded, and cruel their husbands might be. There was even no redress for corporal punishment which the husbands might inflict on their wives.

Figure 55. Elizabeth Cady Stanton.

Another woman, present at the gathering, was Lucretia Mott, a Quaker teacher. It had been her experience, that female teachers, having paid for their education just as much as

the males, obtained, when teaching, only half of the compensation granted to male teachers.

But the indignation of the two women over the inferior position of woman had been especially excited while attending the World's Anti-Slavery Convention, held in 1840 at London. Both women, together with Mrs. Wendell Phillips, had been appointed delegates by the abolitionists of America, and as they were able speakers, much had been expected from their eloquence. But when the women submitted their credentials, they discovered that the English abolitionists had not reformed their antiquated views of male predominance and would not admit any woman as delegate nor on the platform. When the question was submitted to vote, the women were excluded by a large majority. This flat refusal to recognize woman's right to an equal participation in all social, political, and religious affairs brought what is termed "the Woman Question" into greater prominence than ever before. The gathering in the Wesleyan chapel, at Seneca Falls, N.Y., Mrs. Stanton's home, is known as the First Woman's Rights Convention. Held on the 19th and 20th of July, 1848, it was attended by 68 women and 38 men. The simultaneous discussion of the subject of slavery and the natural rights of man had as their logical consequence, on the part of women, the demand of a privilege exercised in many cases by persons far below them in intelligence and education. They asserted that many of their number were taxpayers, that all were interested in good government, and that it would be unjust for women of intelligence to be deprived of a vote while ignorant negroes could have a voice in the government. Furthermore they asserted that the participation of women would have a purifying effect on politics.

At the close of the second day the convention adopted the following:
Declaration of Sentiments.

"The history of mankind is a history of repeated injuries and usurpations on the part of man toward woman, having in direct object the establishment of an absolute tyranny over her. To prove this, let facts be submitted to a candid world.

"He has never permitted her to exercise her inalienable right to the elective franchise.

"He has compelled her to submit to laws in the formation of which she had no voice.

"He has withheld from her rights which are given to the most ignorant and degraded men—both natives and foreigners.

"Having deprived her of this first right of a citizen, the elective franchise, thereby leaving her without representation in the halls of legislation, he has oppressed her on all sides.

"He has made her, if married, in the eye of the law, civilly dead.

"He has taken from her all right in property, even to the wages she earns.

"He has so framed the laws of divorce as to what shall be the proper causes, and, in case of separation, to whom the guardianship of the children shall be given, as to be wholly regardless of the happiness of women—the law in all cases going upon a false supposition of the supremacy of man, and giving all power into his hands.

"After depriving her of all rights as a married woman, if single and the owner of property, he has taxed her to support a government which recognizes her only when her property can be made profitable to it.

"He has monopolized nearly all the profitable employments, and from those she is permitted to follow she receives but a scanty remuneration. He closes against her all the avenues of wealth and distinction which he considers most honorable to himself. As a teacher of theology, medicine, or law, she is not known.

"He allows her in church, as well as state, but a subordinate position, claiming Apostolic authority for her exclusion from the ministry and, with some exceptions, from any public participation in the affairs of the church.

"He has created a false public sentiment by giving to the world a different code of morals for men and women, by which moral delinquencies which exclude women from society are not only tolerated but deemed of little account in man.

"He has usurped the prerogative of Jehovah himself, claiming it as his right to assign for her a sphere of action, when that belongs to her conscience and God.

"He has endeavored, in every way that he could, to destroy her confidence in her own powers, to lessen her self-respect, and to make her willing to lead a dependent and abject life.

"Now, in view of this disfranchisement of one-half the people of this country, their social and religious degradation; in view of the unjust laws mentioned, and because women do feel themselves aggrieved, oppressed and fraudulently deprived of their most sacred rights, we insist that they have immediate admission to all the rights and privileges which belong to them as citizens of the United States."

Of course, this declaration, modeled after the immortal Declaration of 1776, did not fail to create a sensation everywhere. Other conventions were held in Rochester and Syracuse, N.Y., and in Salem, Ohio. They brought to the front a number of wonderful women, whose names were henceforth connected with this movement, first among them Susan B. Anthony, Lucy Stone, Paulina Wright Davis and Anna Howard Shaw. In October, 1850, the First National Woman's Rights Convention was held at Worcester, Mass. Attended by delegates from nine states it was distinguished by addresses and papers of the highest character, which filled the audiences with enthusiasm. A National Committee was formed, under whose management conventions were held annually in various cities. An account of the convention, written by Mrs. John Stuart Mill, in the "Westminster Review," London, marked the beginning of the movement for woman suffrage in Great Britain. But in spite of all efforts and agitation, progress was but slow. The first result was not gained before 1861, when Kansas granted school suffrage to women, a step that was not followed by other states for many years afterwards.

How averse the stronger sex was to grant women suffrage became evident, when in 1868 the 14th and 15th amendments to the Constitution of the United States were adopted. These amendments abolished slavery and gave the freed negroes of the South all

privileges of citizenship, including the right to vote. Section 1 of the 15th amendment reads:

"The right of citizens to vote shall not be denied or abridged by the United States, or by any State, on account of race, color, or previous condition of servitude."

As the advocates of woman suffrage were American citizens, they held themselves entitled to the same rights as granted to the negroes. But their demands to be registered as legal voters were denied by the registrars of elections. Now the women appealed to the courts, to see if their claim would be sustained by invoking the aid of those constitutional amendments above cited. But the uniform decision in each court was that these amendments had in no way changed or abridged the right of each State to restrict suffrage to males, and that they applied only to the men of color and to existing rights and privileges. An appeal to the Supreme Court resulted in the decision that this body was in accordance with the decisions of the State courts.

To test the application of the 14th and 15th amendments to the Constitution Susan B. Anthony,—who in 1860 with others had been successful in securing the passage of an Act of the New York Legislation, giving to married women the possession of their earnings, as well as the guardianship of their children,—cast in 1872 ballots at the State and Congressional elections in New York. Miss Anthony was indicted and in 1873 found guilty of criminal offense against the United States for knowingly voting for congressmen without having a lawful right to vote, which offense was punishable, under Act of Congress, by a heavy fine or imprisonment. Fined $100 for illegal voting, Miss Anthony declared that she would never pay the penalty, and in fact it has never been collected.

Undaunted by the decision of the Court, Miss Anthony in 1875 proposed the following amendment to Article 1 of the Constitution:

"Section 1. The right of citizens of the United States to vote shall not be denied or abridged by the United States or by any State on account of sex.
"Section 2. Congress shall have power by appropriate legislation to enforce the provisions of this article."

This resolution was introduced by Senator Sargent of California in 1878, but was rejected several times. In 1887 it secured in the Senate only 14 affirmative to 34 negative votes.

But several years before the indictment of Miss Anthony woman suffrage had already won its first victory, in the Territory of Wyoming. The Organic Act for the regulation of the Territorial governments provides that at the first election in any Territory male citizens of the age of twenty-one years shall vote, but "at all subsequent elections the qualifications of voters and for holding office shall be such as may be prescribed by the legislative assembly of each Territory."

Figure 56. Susan B. Anthony.

Under this act the first legislative assembly of Wyoming, in 1869, granted women the right to vote and to hold office upon the same terms as men. An effort made in 1871, to repeal this statute, failed, and to the men of Wyoming belongs the honor, of having been first to recognize the rights of women.

A further gain was made when the Republican National Convention of 1872 and 1876 resolved that "the honest demands" of women for additional rights should be treated with respectful consideration.

Of still greater importance was the organization of two national Woman Suffrage Associations, the one with headquarters in New York, the other in Boston. A union of these two bodies was effected in 1890 under the title of "The National American Woman Suffrage Association."

Mrs. Stanton was elected president of the new organization. When in 1892 she resigned from her office because of advancing age, she was followed by Miss Anthony, who in 1900 resigned at the age of 80. Her successors were Miss Anna Howard Shaw and Mrs. Carrie Chapman Catt.

Under the able leadership of these brilliant women victory was now followed by victory. Up to 1914 Colorado, Idaho, Washington, California, Arizona, Kansas, Oregon, Nevada, Utah and Montana had joined the ranks of Woman Suffrage States; also the Territory of Alaska.

To these Western regions the Eastern and Southern States formed a strange contrast, as so far the suffragists had been unable to conquer one of them. For this surprising fact I

fail to find any other explanation but that the Western men are much more conscious of a great historical truth, which the men in the East and South seem to have almost forgotten, namely: that to the women the founding of real culture in America is due. Having heroically shared with their husbands all hardships and dangers, having gone with them on their hazardous journeys into the wilderness, even on their long voyages across the prairies and Rocky Mountains to far Oregon and California, the women provided the first permanent homes and filled them with comfort, sunshine and happiness. In recognition of these facts the Western men granted their partners only a well deserved tribute of gratitude.

In many places the men expressed their respect for the gentler sex by electing women to important public offices, and in almost all cases these positions have been filled to the fullest satisfaction.

The steady progress of woman suffrage in the United States was followed by the women of other countries with intense interest, especially by those of Great Britain and Australia. Encouraged to like activity, they demonstrated with convincing clearness the injustice of the legislatures toward women and thus prepared the way for a similar movement in favor of woman suffrage. The result was that the English government in 1869 adopted the Municipal Reform Act, which permits women to vote in all municipal elections. An Act of 1870 gave them the school vote. The Act of 1888 made them voters for the county councils. An Act of 1894 abolished in all departments of local government the qualification of sex.

New Zealand, one of the most progressive of all countries, went even farther. The women there were granted suffrage in 1893 on the same basis with men. A similar step was taken in the following year by South Australia. And when in 1901 the Commonwealth of Australia was formed by the federation of the six provinces, or states, of New South Wales, Victoria, Queensland, South Australia, Western Australia and Tasmania, one of the first steps was to give all women full national suffrage.

In the countries of continental Europe the evolution of local women's organizations to State- and National Unions had been the same as in the United States and in England. But the majority of these societies remained conservative in regard to woman suffrage. Germany since 1813 has had the "Vaterlaendische Frauenverein" (Patriotic Women's League), a union of wonderful helpers for suffering humanity, both in peace and in war. Since 1865 a "General Association of German Women" tried to secure new rights for women, both along political and economic lines. A "Society for Woman Suffrage" was not formed before 1902. But only two years later the "International Suffrage Alliance" was formed in Berlin, with Mrs. Carrie Chapman Catt, of New York, as president. The progressive movement in Germany took largely the form of educational and industrial training. And the women shared the national belief that education precedes every good, and that for their legal and political protection from injustice they might rely upon their male relatives.

Figure 57. Dr. Anna Howard Shaw.

In certain districts of Germany, Austria, Denmark, Hungary and Russia women who owned property, were permitted to cast their votes on various communal matters, either by proxy or in person. In Belgium, the Netherlands, France, Italy, Switzerland, Roumania and Bulgaria women had no political rights whatever, but were permitted to vote for certain state boards—educational, philanthropic, correctional and industrial. In France, women as a rule showed little sympathy with suffrage, retaining their racial instinct that they might accomplish more through social influence, personal suasion and the special charms of their sex than by working openly through the ballot.

In Switzerland few women had the courage to seek emancipation, as those who favored the movement were looked upon as disreputable persons without regard for

social laws. In Portugal and Spain women remained absolutely indifferent. Sweden had given women the right to vote in all elections, except for representatives, while Finland and Norway in 1906 and 1907 granted full suffrage rights and eligibility to women upon exceedingly generous terms.

Figure 58. Carrie Chapman Catt.

Since the beginning of the 20th Century the Modern Woman's Rights Movement has also caused significant changes in the status of the women of the Balkan States, and of the countries of the Orient and the Far East. Restrictions and obstacles, placed on woman by tradition and religious rules, have been abolished. Many Mohammedan women for instance appear to-day on the streets without veils, a thing that no prominent woman could do formerly. The establishment of girls' schools, woman's colleges, universities, woman clubs and journals mark likewise the progress of the movement. And in Servia, Bulgaria, Greece, Turkey, Egypt and Japan exist federations of women's clubs, which can be regarded as political organizations.

Thus, at the beginning of the memorable year of 1914 woman throughout the civilized world had gained various degrees of freedom in the exercise of her political rights.

Chapter 32

WHY WOMEN WANT AND NEED THE VOTE

Few questions have been so universally and intensely discussed as the right and expediency of Woman Suffrage. Its opponents assert that the true woman needs no governing authority conferred upon her by law. While discussing this question one "gentleman" said "that the highest evidence of respect that man could exhibit toward woman, and the noblest service he could perform for her, were to vote Nay to the proposition that would take from her the diadem of pearls, the talisman of faith, hope and love, by which all other requests are won from men, and substitute for it the iron crown of authority."

The chief arguments brought forward against woman suffrage are: that the majority of the women never desired it, because they were already represented by their husbands, fathers and brothers; that there were already too many voters, and that by admitting women to suffrage the whole machinery and cost of voting would be doubled without changing the result; that women would not have time to perform their political duties without neglecting their higher duties at home; that women were too emotional and sentimental to be entrusted with the ballot; that women would cease to vote after the novelty had worn off; that the introduction of women into political life would increase its bitterness, and would abolish chivalry with its refining influence on men; that the franchise, in a large majority of instances, would be exercised under the influence of priests, parsons, and ministers, under the power of religious prejudice, and that religious feuds would affect political life much more than under present circumstances. And finally it has been asserted that woman suffrage would place a new and terrible strain upon family relations as the introduction of political disputes into domestic life would lead to quarrels and divorce.

These arguments were answered in an editorial of the "New York American" of October 6, 1912, as follows:

"The ballot is the weapon that men use in defending their rights. It is the voice with which men express their opinions, their wishes, as to law, in the more settled civilization where the ballot is the recognized power. Little by little the mass of the people—that is to say, of the men—have got the ballot. Originally there was no ballot. Savage tribes held disorganized meetings, and shouted their opinions. The loudest shouters won, and the man who could hit the hardest led the others. Little by little the big man formed his own opinions, alone reached his own decisions, and the others had nothing to say. The expression of opinion was confined to one, or to a few leaders, gathered under a chief, or, where religion ruled, opinion was controlled by the priests in the old temples making up their minds what would be good for them, and forcing their will on ignorant people. For many centuries the kings, the nobles and the priests ruled—and the people had nothing to say. Men and women alike were without the vote.

"Little by little, the men got the vote, and now, in civilized countries, universal suffrage became the rule, as regards men. The women were shut out because men always have had the idea that voting was in some way connected with fighting. Their thoughts went back to the old savage mob shouting its determination to attack and kill—leaving the women at home. And the ignoring of women persists, although little by little the voting power has been used, not to make war, but to prevent war.

"Now, in every country calling itself civilized, the chief use of the ballot is to express ideas of peace—justice. The ballot that was once the expression of man's fighting quality is now the expression of his better nature, and for that reason it is time to give that ballot to the better half of the human race, to the women that have civilized it.

"Supporters of women suffrage are, and for many years have been, the best men in the country. Men that are unselfish, just, scorning ridicule, and proud to vindicate the rights of their own mothers and sisters, have long demanded votes for women. The women that have worked and fought for the suffrage have been, beyond all comparison, the best women of this and other countries. Humorists used to talk of "short-haired women and long-haired men" as the advocates of woman suffrage. That is a foolish and false division. The women with good foreheads, earnest, gentle and dignified faces have been the advocates of votes for women. The women with low foreheads, plastered with hair, the women with their faces painted, the women with a hundred thoughts for dress and no thought for anything else, have been the opponents of women suffrage. And the men, brutal, conceited, looking upon woman as a piece of property, created for man's pleasure or for his service, have been the men that opposed suffrage. Another class opposed to woman suffrage is the most dangerous class of all. That is the class that would keep in ignorance women, and men, too, if it could. Those that prey upon the ignorance and superstition of women are anxious that women shall know as little as possible. They do not want the women to vote, for voting means thinking, and thinking means freedom. Wherever women have voted they have bettered conditions."—

Lecky in his valuable book "Democracy and Liberty" writes on page 547: "It has been gravely alleged that the whole character of the female sex would be revolutionized, or at least seriously impaired, if they were brought by the suffrage into public life. There

is perhaps no subject in which exaggerations so enormous and so grotesque may be found in the writings of considerable men. Considered in itself, the process of voting is now merely that of marking once in several years a ballot-paper in a quiet room, and it may be easily accomplished in five minutes. And can it reasonably be said that the time or thought which an average male elector bestows on the formation of his political opinions is such as to interfere in any appreciable degree with the currents of his thoughts, with the tendencies of his character or life? Men wrote on this subject as if public life and interests formed the main occupation of an ordinary voter. It is said that domestic life should be the one sphere of woman. Very many women—especially those to whom the vote would be conceded—have no domestic, or but few domestic duties to attend to, and are compelled, if they are not wholly frivolous or wholly apathic, to seek spheres of useful activity beyond their homes. Even a full domestic life is scarcely more absorbing to a woman than professional life to a man. Scarcely any woman is so engrossed in it that she cannot bestow on public affairs an amount of time and intelligence equal to that which is bestowed on it by thousands of masculine voters. Nothing can be more fantastic than to argue as if electors were a select body, mainly occupied with political studies and public interests.

> "Women form a great section of the community, and they have many special interests. The opening to them of employments, professions and endowments; the regulation of their labor; questions of women's property and succession; the punishment of crimes against women; female education; laws relating to marriage, guardianship, and divorce, may all be cited; and in the great drink question they are even more interested than men, for though they are the more sober sex, they are also the sex which suffers most from the consequences of intemperance. With such a catalogue of special interests it is impossible to say that they have not a claim to representation."—

Among the arguments in favor of woman suffrage the most important are the following: As women are citizens of a Government of the people, by the people, and for the people, and as women are people, who wish to do their civic duty, it is unfair that they should be governed by laws in the making of which they have no voice. As women are equally concerned with men in good and bad government, and equally responsible for civic righteousness, and as they must obey the laws just as men do, they should vote equally with men.

If it is true that "taxation without representation is tyranny" then tax-paying women who support the government by paying taxes, should have the right to vote to elect such representatives, who protect them against unjust taxation.

Working women need the ballot to regulate the conditions under which they work. Millions of women are wage-earners and their health is often endangered by bad working conditions and sweat-shop methods that can only be remedied by legislation.

Business women need the ballot to secure for themselves a fair opportunity in their business, and to protect themselves against adverse legislation.

Mothers and housekeepers need the vote to regulate the moral and sanitary conditions under which their families must live. Women are forever told that their place is in the home. But what do men expect of them in the home? Merely to stay there is not enough. They are a failure unless they do certain things for the home. They must minister, as far as their means allow, to the health and welfare, moral as well as physical, of their family, and especially of the children. They, more than anybody else, are held responsible for what becomes of the children. Women are responsible for the cleanliness of the house, for the wholesomeness of the food, for their children's health and morals. But mothers cannot control these things, if the neighbors are allowed to live in filth, if dealers are permitted to sell poor or adulterated food, if the plumbing in the house is unsanitary, if garbage accumulates and the halls and stairs are left dirty. They can take every care to avoid fire, but if the house has been badly built, if the fire-escapes are insufficient or not fire-proof, they cannot guard their children from the horrors of being maimed or killed by fire. They can open the windows to give the children the air that we are told is so necessary. But if the air is laden with infection and contagious diseases, they cannot protect the children from this danger. They can send the children out for air and exercise, but if the conditions that surround them in the streets are immoral and degrading, they cannot protect them from these influences. Women alone cannot make these things right. But the City administration can do it. The administration is elected by the people, to protect the interests of the people. As men hold women responsible for the conditions under which the children live, the women should have something to say about the city's housekeeping, even if they must introduce an occasional house-cleaning.

What enormous influence women are able to exert in vital questions has been demonstrated in the Temperance Movement; which originated in the United States. Since the beginning of the colonization of the Western Hemisphere Americans have been heavy consumers of rum, whiskey, and other intoxicating liquors. "Everybody drank, and on all occasions," says a writer who has left us a pen picture of these bibulous days. Drunkenness and all the evils resulting from it increased with the gradual development of the "saloon" and the habit of "treating," two institutions peculiar to America and almost unknown in Europe.

For generations the women were the greatest sufferers from the intemperance of the men, because many husbands came home besotted, their faculties benumbed to an unconsciousness of their own degradation, with wages gone, and employment forfeited. The purer and gentler the wife in such case, the more intense her suffering. So it was but natural, that when the first "Anti-Spirits Association" was formed in 1808 in Greenfield, Saratoga County, New York, several women should join it. The movement made rapid progress, and in 1826 the "American Temperance Society" was founded. In 1829 and 1830 similar associations were started in Ireland and England; and in 1846 the first

"World's Temperance Convention" was held at London. In 1873 women became a real force in the field when the women inhabitants of Hillsborough, a small town in Ohio, started what became known as "The Women's Crusade."

Frances E. Willard, one of its principal leaders, described the proceedings in the following graphic manner: "Usually the women came in a long procession from their rendezvous at some church, where they had held a morning prayer meeting. Marching two and two in a column, they entered the saloon with kind faces, and the sweet songs of church and home upon their lips, while some Madonna-like leader with the Gospel in her looks, took her stand beside the bar and gently asked if she might read God's word and offer prayer. After that the ladies seated themselves, took their knitting or embroidery, and watched the men who patronized the saloons. While some of them cursed the women openly, and some quietly slunk out of sight, others began to sign the pledge these women brought with them. In the meantime one of the ladies pleaded with the proprietor to give up his business. Many of these liquor dealers surrendered and then followed stirring scenes, and amid songs and the ringing of the church bells the contents of barrels and bottles were gurgling into the gutter, while the whole town assembled to rejoice in this new fashion of exorcising the evil spirits.

> "Not everywhere the ladies met with success. In Cincinnati such a procession of women, including the wives of leading pastors, were arrested and locked up in jail; at other places dogs were set on the crusaders, or they were smoked out, or had the hose turned on them."

The movement, wholly emotional, and in many cases hysterical, spread throughout the country like a prairie fire. In 1874 it led to the organization of "The Woman's Christian Temperance Union," and, in 1883, to the founding of "The World's Women's Temperance Union," the members of which wear a white ribbon and have the motto: "Woman will bless and brighten every place she enters, and she will enter every place."

Since the founding of this world's union the movement has extended over many countries and has branched out into a multitude of organizations. Their influence has been widely felt in legislatures, and in all elections in which laws have been voted upon for the regulation of the production and sale of liquors.—

Another question in which women are deeply concerned is that of Child-labor, the reckless exploitation of children in the interest of industry. Evidences that in England the dreadful abuses, committed by unscrupulous mine- and factory-owners, as described in a former chapter, have continued to the present times, were submitted to the International Women's Congress, held in 1899 in London. It was reported that at that time 144,026 children below the age of 12 years were employed in workshops, mines, factories and warehouses. Of these children had not yet reached the age of 7 years; 1120 were under 8; 4211 under 9; 11,027 under 10, and 122,131 under 11 years of age. Miss Montessori, the

Italian delegate to the Congress, described the hard work of the children employed in the sulphur mines of Sicily. As they have to carry heavy loads on their shoulders through low gangways and over steep ladders and stairways, they are compelled to walk in a stooped position, and therefore in time become deformed and crippled.

In the United States the question of child-labor is likewise a matter of deep concern to men as well as to women. As every State has its own Legislature, there exists a varied assortment of child-labor laws. Ten or fifteen years ago several states had none whatever. Others prohibited the employment of children under ten years, while still others had an age limit of twelve or fourteen years. The same diversity prevailed in regard to the hours of labor. Some states had no legislation in this direction, while others forbade any child to work longer than ten hours daily.

During the year 1890 there was a total of 860,786 children between the ages of ten and fifteen years at work in various occupations in the United States. A report of the Bureau of Mines of Pennsylvania for 1901 stated 24,023 of the employees of the anthracite coal mines in Pennsylvania were children.

In 1918 investigators of the children's bureau of the Department of Labor reported that the number of minors employed in factories, mines and quarries has increased at a rapid rate since the U. S. Supreme Court, on June 5th, 1918, nullified the child-labor act of 1916 as unconstitutional. Not only are a greatly increased number of children employed, but they are kept at work longer hours than before. Since the future of such children as well as the future of the country depend to a very great extent upon what legislators do in regard to children, it is obvious that women are deeply concerned in this question.—

The need of women's participation in government and of an "occasional house-cleaning" in the Legislatures as well as in the Municipal Administrations becomes evident, when we realize that one of the most revolting crimes is committed daily in our communities, quite often with the silent protection of corrupt officials and politicians. We refer to the White Slave Trade. As few people have any definite idea of its extent and terrors, some authentic facts are here given, which, at the same time, demonstrate men's indifference as well as the urgent need of woman's interference for its suppression.

As everybody knows, the traffic in young girls for purposes of prostitution is as old as humanity. It has flourished in all ages and in all countries. But it was during the 19th Century that it found its systematic organization and its most extensive development.

With alarming frequency, the papers report that some young woman or girl is "missing," having stepped out of her home on some household errand, and from this moment having vanished as though swallowed by the earth. Such was the case of Dorothy Arnold, who some years ago left her cosy home in New York, to do some shopping in a department store. She never returned and no trace of her was ever discovered. This particular case attracted wide attention all over the United States, as

Miss Arnold, a beautiful girl of eighteen, was the daughter of wealthy parents, who spent a fortune in desperate but futile attempts to recover their child.—

Every year hundreds of similar cases occur in our country, some in San Francisco, some in New York, Baltimore, St. Louis, Chicago and elsewhere. If the exact number of such missing girls could be known, the public might well be shocked; and horrified if it would know the sad lot that befalls the majority of these unfortunate girls. Where efforts to ascertain their fate have met with success, it was found that in ninety out of a hundred cases such girls became victims of the most detestable fiends on earth, human ghouls, who make fortunes by luring innocent and inexperienced women into the most degrading slavery.

There were many events that favored the development of the white slave trade. The discovery of gold in California and the construction of many transcontinental railroads were followed by the opening of the rich mining- and lumber-districts in the northwestern and western parts of the United States, and in Canada. In more recent years came the opening of the gold and diamond fields in South Africa, of the gold grounds in Alaska, the construction of the Panama Canal and the great transcontinental railroads through Siberia and Africa. All these great undertakings attracted many thousands of men, who were ready to squander their earnings in gambling, drinking and any other kind of dissipation. Women, of course, stood at the head of things in demand. And as there are always people eager to profit by catering to such passions, the white slave trade assumed most threatening proportions.

To ensnare victims, the slave dealers insert enticing advertisements offering profitable positions to waitresses, chambermaids, servants, governesses, and other female help in hotels, boarding houses and private families. They send their "procurers" or agents to the dance-halls and cheap pleasure resorts, and to those industrial towns, where large numbers of poorly paid young girls toil in mills and factories. Here they approach their prey under all kinds of disguises and pretenses. One especially ingenious procurer of New York has been credited with gaining the acquaintance of young girls in the garb of a priest. And George Kibbe Turner in an article "The Daughters of the Poor" (published in 1910 in McClure's Magazine) made the statement that a gang of such fiends worked under the name "The New York Independent Benevolent Association"!

However, the chief recruiting-grounds for the white slave trade are the miserable Jewish Ghettos of Poland, Russia, Galicia, Hungary, Austria and Roumania, where always numbers of degraded men can be found, ready to sell their own kindred for any price offered. With the help of such procurers four principal centers of the white slave trade were created: Lemberg, London, Paris and New York, with branches in all parts of America, Africa and Asia.

Of course such a villainous trade would not be possible without the silent protection of corrupt officials and political machines, who share in its enormous profits. Inside information on this subject was received through the disclosures, made during the latter

parts of the last century about conditions in the mining and lumber regions of Michigan and Wisconsin. In January, 1887, Representative Breen appeared before the House Judiciary Committee of the legislature of Michigan and stated the existence of a regular trade in young and innocent girls for purposes of prostitution between Chicago, Duluth and other cities with the mining and lumber districts south of Lake Superior. As he said that the horrors of the camps into which these girls were lured beggared description, several newspapers, among them the "Chicago Herald" and "The New York World," dispatched representatives, disguised as woodmen, to those regions to investigate the truth of these statements. They found that almost without exception the girls, kept in these camps, had been secured under promise of respectable employment. The houses, in which they were imprisoned, were surrounded by stockades twenty or thirty feet in height, the one door guarded night and day by a man with a rifle, while within were a number of bulldogs to prevent the girls from escaping. In the largest of such lumber camps dens from twenty to seventy-five girls were found.

On January 24, 1887, the "New York World" published the story of an unfortunate girl, who had been lured by an advertisement to work in a lumberman's hotel in the North. Believing the position to be respectable, she went there, but after her arrival at the place she was taken to a rough two-story building surrounded by a slab fence twenty feet high, within which was a cordon of bulldogs, thirteen in number, chained to iron stakes driven into the ground. In this place she was compelled, like all the other girls, of which there were always from eleven to thirty, to drink and dance with the men of the mining and lumber camps. They were not permitted to refuse any request of those visitors. A complaint of any kind, even of sickness, meant a whipping, frequently with a rawhide upon the naked body, sometimes with the butt of a revolver. When the log drives were going on, there would be hundreds of men there night and day, not human beings, but fiends.

"Oh, it was awful, awful!" cried the girl after her release. "I would rather stay in prison until I die than go back there for one day. I tried to escape three times and was caught. They unchained the dogs and let them get so near me that I cried out in terror and begged them to take the dogs away and I would go back. Then, of course, I was beaten. I tried, too, to smuggle out notes to the Sheriff through visitors, but they would take them to the proprietor instead, and he would pay for them. Once I did get a note to the Deputy Sheriff at Florence, Wisconsin, and he came and inquired. But the proprietor gave him $50, and he went away. I was awfully beaten then. While I lived this life, from March until September, two inmates died, both from brutal treatment. They were as good as murdered. Nearly all the girls came without knowing the character of the house, and first implored to get away. The county officers came to the places to drink and dance with the girls. They are controlled by a rich man in Iron Mountain, who owns these houses and rents them for $100 a month."

That the den keepers were always on good terms with the officials, appears also from the following report of the "Chicago Herald" of April 17, 1892, in which attention is called to the continuance of the horrible conditions in the mining- and lumber-camps. "Four years ago, when "The Herald" exposed the pinery dens, Marinette was known as the wickedest city in the country. It was the rendezvous of every species of bad men. Thugs, thieves and gamblers practically held possession of the town. Their influence was felt in all municipal affairs. Certain officers of the law seemed in active sympathy with them, and it was almost impossible to secure the arrest and conviction of men guilty of infamous crimes. Dives of the vilest character ran open on the outskirts of the town. Their inmates, recruited from all parts of the country by the subtle arts of well known procurers, were kept in a state of abject slavery. Iron balls and chains, suffocating cords and the whistling lash were used on refractory girls and women. Bodies of ill-starred victims were sometimes found in the woods, but the discovery was rarely followed by investigation. The dive keepers were wealthy and knew how to ease the conscience of any over-zealous officer."

Another report states:

"Many den-keepers wield a powerful influence in the local elections; one of the worst of such, after paying the constable $12 for the return of a girl who had tried to escape, beat her with a revolver until tired and was then only prevented by a woodman from turning loose a bulldog upon her; but such was his political influence that he was elected justice of the peace the following spring!"—

About the same time, at a session of the National Social Purity Congress held in Baltimore, the following statement was made:

"Of the 230,000 erring girls in this country, over half have been snared or sold into their lives of shame. Their average life is five years. Forty-six thousand are carted out to Potters Field every year. Over one hundred American homes have to be desolated every day to recruit the ranks of shame. Isn't it time for somebody to try to save these girls from falling into those dens of iniquity? Twenty million Christians can rescue 230,000 erring girls, or surely the religion of Jesus Christ is a failure."

Terrible happenings, as for instance the murder of Ruth Cruger of New York in 1917, and similar cases in February and March, 1919, have disclosed that gangs of white slave traders still exist in America and do a flourishing business. The prices paid to agents depend upon the girl's youth and beauty, ranging from $20 to $1000, and even more.

The enormous and thoroughly organized traffic in girl-children in England was exposed by the revelations of the "Pall Mall Gazette," which roused the people to earnest efforts against this commerce and secured the formation of the "Society for the Prevention of Traffic in English Girls." In giving details of this traffic the paper said:

"London, the great metropolis of Christian England, the largest city of ancient and modern times, is acknowledged by statisticians and sociologists to be the point where crime, vice, despair, and misery are found in their deepest depth and greatest diversity. Not Babylon of old, whose name is the synonym of all that is vile; not Rome, "Mother of Harlots," not Corinth, in whose temple a thousand girls were kept for prostitution in service of God, not the most savage lands in all their barbarity have ever shown a thousandth part of the human woe to be found in the city of London, that culmination of modern Christian civilization. The nameless crimes of Sodom and Gomorrah, the vileness of ancient Greece, which garnered its most heroic men, its most profound philosophers, are but amusements among young men of the highest rank in England; West End, the home of rank and wealth, of university education, being the central hell of this extended radius of vice."

As in many countries priests and police departments have failed to stop this heinous traffic in young girls, women must step in, and, by their votes, must place such legislators and police commissioners in office, that proper laws and their strict enforcement can be expected.

In Germany the "white slave trade" is practically unknown. For many years two women associations have existed,—a Protestant and a Catholic,—whose representatives, recognizable by distinct arm bands, patrol all important railway stations, in order to furnish correct information to incoming girls who are looking for positions, and to escort them to the homes of the associations, where they may stay till respectable places have been found for them.

It is obvious, that the problems connected with the temperance question, child-labor and the white slave trade are of vital importance to every woman and mother. Salvation must come through the woman's ballot. They must defend themselves and their children as men have done: by co-operating in the elections, by controlling those that make the laws, and by controlling those who are appointed to enforce them.

A few words may be said in regard to the claim that woman would cease to vote "after the novelty of her new toy had worn off." Statistics as well as the testimony of competent observers confute this claim. In all states where women enjoy full suffrage, they have shown themselves eager to vote. In Idaho the Chief Justice and all the justices of the State Supreme Court signed a statement that "the large vote cast by the women establishes the fact that they take a lively interest." In Wyoming, Colorado and other full suffrage states it has been observed that 90 per cent. of the women vote.

In Australia, in 1903, at the first national election in which women took part, 359,315 women voted; in 1906, 431,033; in 1910, 601,946.

In New Zealand the number has increased at each triennial parliamentary election. In 1893 90,290 women voted; in 1896, 108,793; in 1899, 119,550; in 1902, 138,565; in 1905, 175,046; in 1908, 190,114; in 1911, 221,858.

The following is a testimonial from Sir Joseph Ward, Prime Minister of New Zealand, in regard to Woman Suffrage in practice:

Prime Minister's Office,

Wellington, Oct. 17th, 1907.

Woman Suffrage exists in New Zealand because it dawned upon the minds of thinking men that they were daily wasting an almost unlimited supply of mental and moral force. From the time their baby hands had found support and safety by holding the folds of their mother's gowns, they had trusted the happiness of their lives hourly to the common sense, the purity and the sympathy of women. Strange to say, in one department of life alone, and that perhaps the most important, viz.: the political, had they denied the right of speech and of direct influence to women. Men of different countries had for centuries preached and written of evils which deformed their systems of Government and even tainted the aspirations of statesmen for just laws within the state, and equitable relations abroad. Nevertheless these men neglected, or refused to avail themselves of the support and counsel of women's hearts and women's brains, which they accepted on other matters. Indeed, they were ready to listen to foolish arguments against the idea of women entering political life; such as: women would lose their grace, modesty, and love of home if they voted; since they could not be soldiers, they had no right to control questions of peace and war.

In New Zealand we have not found that making a "pencil mark on a voting paper" once in three years has resulted in any loss of grace or beauty among our women, or even in neglect of home duties. On the contrary the women's vote has had a distinctly clarifying effect on the process of elections. The old evil memories of election day, the ribaldry, the fighting, have been succeeded by a decorous gravity befitting people exercising their highest national privilege. When the contention, that women should not be entitled to vote because they cannot bear arms, is used by one whose mother could only make his life and citizenship possible by passing through pain and danger greater than the average soldier has to face, it becomes inconsistently ridiculous. Besides, many men (clergymen, government officials, etc., etc.), are exempt from actual military service, and that fact has never been used to deprive them of a vote. The main argument, however, which weighed with us, was that of right, of abstract right. If the foundation of government is the consent of the governed, it appears monstrously unfair that one half of the population should not be represented or have any share in it. Therefore, after long and grave consideration, we gave our women an equal right with men in deciding on the qualifications of candidates to represent them in Parliament.

We have no reason to regret the decision. I feel confident that if any great crisis in national morals should arise, the women's vote would press with irresistable weight in the direction of clean, honest and efficient legislation. New Zealand has not repented having abolished set disqualifications among those men and women who have unitedly helped to build the foundations of a nation. I write as one who advocated the extension of

the franchise to women before my entry into Parliament twenty years ago. I have always supported it in Parliament, and, while closely watching its effect, have never seen any genuine cause for believing that it has not worked for the good of the Dominion.

Similar testimonials have been given by the governors of all Western States of the Union.

Governor Bryant B. Brooks of Wyoming said:

> "Nothing can be so far from the truth as the idea that Woman Suffrage has the slightest tendency to disrupt the home. Indeed it has the very opposite effect. As a result of it politics is talked freely in the family circle, and political questions are settled by intelligent discussion. This has a great and good influence on the growing generation. The children grow up in an atmosphere that encourages intelligent consideration and debate of public problems, and are thus better equipped to deal with public questions when they reach voting age."

Governor Shafroth of Colorado said:

> "Our State has Woman Suffrage for many years, and has found it of inestimable benefit to her people," and Governor James H. Brady of Idaho said: "Woman Suffrage has been an unqualified success, not only in Idaho, but in all Western States adopting the principle."

Figure 59. Preparing Bandages.

WOMAN'S ACTIVITY DURING THE WORLD WAR

When in August, 1914, the most dreadful disaster that ever befell humanity burst upon the European nations, women at first stood paralyzed with fear and terror, foreseeing the tremendous burden and sacrifices they would have to bear. But after every hope for a peaceful solution had vanished and nothing remained but to face the inevitable, they rallied and prepared to weather the coming hurricane.

The manner in which they met it during the long and terrible years of 1914, 1915, 1916, 1917 and 1918 was perhaps the greatest revelation the world has ever experienced. Never before have members of the "weaker sex" braved such a catastrophe more heroically and made such supreme sacrifices. In fact, woman's activity during the World War has been a grand manifestation, which stands out in glorious colors from a black background of man's hatred, revengefulness, slander, calumniation, treason, avarice, atrocities, and murder.

When the vast armies were mobilized it became necessary to close the innumerable gaps caused by the sudden drafting and departure of so many million men. To refill the positions they had occupied, was the most urgent necessity, as otherwise the whole machinery of national life would become disorganized, and that at the most critical time.

At once immense numbers of women and girls responded to the call. They went into the tramway and railway service to act as ticket sellers and punchers, as conductors, brakemen and motormen. They replaced the letter carriers and chauffeurs; they climbed the lofty seats formerly occupied by cab-drivers and postilions. Mounting motor-cycles they delivered telegrams and performed other urgent errands. They formed street-cleaning and fire-brigades and took care of the sanitation and protection of the cities. In the offices and stores they assumed the duties of the bookkeeper and floor-walker; in the schools they substituted for male teachers who had followed the call of the war trumpet. They repaired telegraph-wires and installed telephones; they became blacksmiths and repaired the roofs of houses. They cleaned windows and chimneys, delivered newspapers

and carried the coal from the wagon into the bins and bunkers. They acted as "ice-men" and collected the garbage and ashes. They tilled the fields and vegetable gardens, and brought in the crops and the harvests. They thrashed the wheat and served in the mills as well as in the bakeries. They furnished clothes, and made and mended shoes. They finished the public roads and other works that had been left uncompleted. They built houses and tore down others. In Berlin the excavation for a new underground railway, badly needed, was done by women, and half of the gangs that worked on the railroad tracks were made up of girls.

In England as well as in France and Germany thousands of women could be seen in the ship-yards working side by side with men on the scaffolds, at bolting and riveting, forging and casting, as if they had always done this work. In fact, women did everything that heretofore had been regarded as "man's work."

But they did much more. Hundreds of thousands of women entered the gun- and ammunition factories in order that the armies might not lack ample means for the defense of the country.

Figure 60. Women Filling Shells In A British Ammunition Factory.

Donning overalls, oil-cloth caps and gas masks they became engaged in the hazardous manufacture of high explosives, of filling and packing the deadly gas-shells and other projectiles. At the same time millions of busy hands prepared the bandages and other necessities for the treatment of the wounded. Whole brigades of Red Cross nurses were formed and went to the battlefields and hospitals, to attend those who in the grim

conflict might lose their limbs, their eye-sight, or become sufferers from the effect of poisonous gases.

All too soon long trains and hospital-ships brought in such unfortunates, at first a few hundred, then in ever increasing numbers, by the thousands and by tens of thousands. Within a few months most of the countries engaged in the dreadful struggle were turned into immense hospitals, filled with moaning and suffering. What noble and indefatigable women did here to alleviate this misery and distress, can never be fully told and will never be forgotten. Whoever was witness of the self-control and perseverance shown year after year by many Red Cross nurses will always think of them with reverence.

There is not a single Army Medical Corps of the many nations engaged in the World War, which does not freely admit, that the immense amount of work could not have been done without the help of women. In a tribute to the Red Cross Major-General Merritte W. Ireland, Surgeon-General U. S. Army, said:

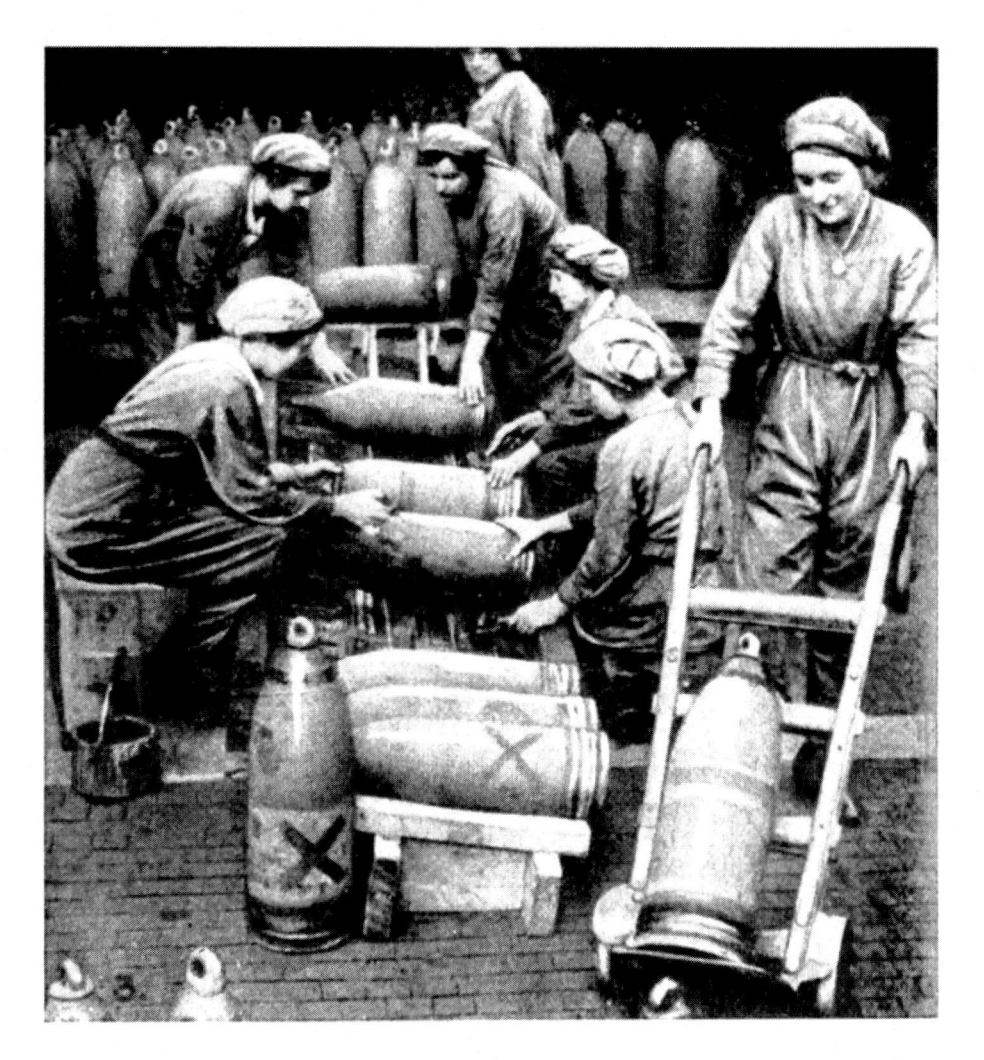

Figure 61. Women in a Shell Factory.

"Probably the greatest single service rendered by the Red Cross home forces was the supply of trained nurses it furnished our hospitals. The Army Medical Corps trains a few nurses, but could never hope to turn out the large number provided through Miss Delano's department. If we needed a thousand nurses for a given work, we telegraphed the War Department. The War Department notified Miss Delano. And the nurses arrived on schedule.

"An especially notable service rendered by Red Cross nurses occurred during the early American campaign when our men were brigaded with French divisions. When wounded, they were, of course, taken to French hospitals. Unable to answer questions or tell their needs, they were in a very unhappy plight. Scores of Red Cross nurses speaking both French and English were immediately sent to these hospitals—and the problem was solved.

"The work of the Red Cross was often the theme of discussions at American General Headquarters at Chaumont. I remember that it was enlarged upon there in a conversation between General Pershing, Mr. H. P. Davison, the Chairman of the War Council of the American Red Cross, and myself. We were speaking of the value of the service rendered by the millions of our women and how they helped keep the influence of home about the boys at the front. And General Pershing said: "The women of the United States deserve a large share of the credit for the success of the American forces."

"Our Army officers have often admired not only the spirit but the efficiency of the American Red Cross organization. It provided an inexhaustible store of supplies; it possessed a remarkable facility for adapting itself to any emergency, however unexpected; and its personnel always evinced the finest readiness for co-operation. The millions of surgical dressings, knitted articles, refugee garments, and other supplies it contributed—for these things alone it would have deserved the Army's unstinted praise. All the splints used in all our hospitals in France, both of the Army and of the Red Cross, came from the Red Cross. It furnished more than a quarter of a billion surgical dressings. It sent over enough sweaters for every man in our overseas forces to possess one."

Similar tributes have been freely extended to the nurses of all other Red Cross branches, which co-operated with the Medical Corps of the various powers engaged in the terrible war.

While performing their merciful work, many women had to bear the depressing anxiety caused by husbands, sons, or brothers, fighting in the trenches or on the ocean; or for those unfortunates who as prisoners had fallen into the hands of the enemy.

The women of the Central powers had to face many additional problems of the most perplexing nature. As the soil of Germany and Austria does not yield enough to support the whole population, and as all imports of foodstuffs were cut off by hostile fleets, provisions became more scarce and more expensive from day to day. There was not sufficient milk to keep the millions of babies alive; and not enough food to save adults from slow starvation. To stretch the scant supplies the most careful and rigid methods of administration had to be invented and applied. Public kitchens were established to reduce

the cost of living to the lowest point possible. In Berlin twenty-three committees of the National Women's Service with several thousand voluntary workers were running such charitable kitchens, from which tens of thousands regularly received their daily meals. The same organizations later on supervised the system of bread-, milk-, grocery- and butter-cards, when the increasing shortage of food forced the governments to the severest restrictions.

Figure 62. A Good Samaritan.

Among the many German relief organizations those of the Red Cross took the leading place. Originally divided into five main sections under the general control of a central committee and designed to combat of sickness and destitution in the civil population, it now was increased to twenty-three divisions. Their welfare work assumed such importance during the progress of the war that it had to be subdivided into three groups, the first of which became engaged in fighting tuberculosis and contagious diseases, the second in the protection of infancy and motherhood, the third in family welfare work in the narrower meaning of the term. In all these branches the organization of the Red Cross provided the framework within which the numerous national, state and local social activities of the country grouped themselves naturally in accordance with their separate functions.

The activity of the organizations during the years 1917, 1918, and 1919, the dreadful years of general distress and starvation, forms one of the most pathetic chapters in woman's history. Not only the food, but the cotton, wool, leather, rubber, fat, oil, soap, and hundreds of other necessities gave out completely. People were compelled to live on substitutes. And as these became too scarce or too expensive, they lived on substitutes for

these substitutes. Imagine the heartrending pain mothers were bearing when at the end of 1918 and in 1919 large numbers of mayors of German cities and numerous professors of medicine were compelled to send urgent appeals for help to all medical faculties of the world, stating that since the signing of the truce 800,000 people in Germany had died from starvation.

"Many millions of human beings," one of the appeals reads, "are living on only half or even less than half the quantity of food necessary to sustain life. Utterly exhausted they have lost all power of resistance and succumb to any kind of sickness that may befall them. The worst sufferers are the children and those mothers, who fast for the sake of their children. There are too the neurasthenics of all kinds, the numbers of which have, for four years, increased immensely. Furthermore, there are the overworked, and those who have become sick through the unheard-of monotony of food and from the absolute absence of every stimulant. Their existence becomes more unbearable from day to day. While the physicians of Germany are profoundly impressed with the terrible ravages caused by hunger, they have absolutely no means of combating them."

While during these dreadful times millions of women devoted themselves to the noble work of healing the terrible wounds and sufferings, other groups eagerly tried to bring about a cessation of hostilities. Immediately after the first declaration of war, the "International Woman Suffrage Alliance" directed an urgent appeal to the British Foreign Office as well as to all Foreign Embassies in London, to leave untried no method of conciliation or arbitration to avert the threatening disaster. Numerous women's societies in Holland, Sweden, Germany and Switzerland arose simultaneously and joined the good cause. Soon a great movement for peace began to sweep through the women of the entire world.

But women's efforts to bring the conflict to a standstill lacked as yet the necessary strength. They were overpowered by the influence and machinations of those statesmen, financiers, publishers of newspapers and countless others, who wanted war. And so nothing remained for women but to repeat ever and again their protests against the madness of men.

When in December, 1914, suffering Christianity prepared to celebrate the natal day of the Messiah, the Prince of Peace, a noble-minded woman of London, *Miss Emily Hobhouse*, wrote the following letter:

"To American Women, Friends of Humanity and Peace!

"Friends:—May I appeal to you in the name of Humanity, on behalf of the children of Europe, before whom suffering or death has already taken place, and whose future is fraught with pain? In you lies our hope of help for them, for you are free to speak and act.

"Will you not come to our troubled world, unite with the women of other neutral lands and initiate a crusade—a real 'holy' war, fought with the swords of the Spirit?

"Appalling as is this massacre of the manhood of Europe, that is not the worst. As long as men adopt barbaric methods of settling disputes they must abide by the consequences; but for those innocent victims, the non-combatants—women, babes, old and sick—I crave your help. Their names and numbers will never be known. They are multiplying in Poland and Galicia, in Belgium and France, in East Prussia and Holland, and elsewhere. Ponder this vast host, voiceless, suffering, dying, crouching beside their blackened ruins or fleeing from the devastated areas both east and west. Think of disease let loose, of the horrors of cold and famine!

"I know it is not easy to visualize details of conditions so foreign to average experience. It needs a mental effort few can make. It is because I was daily witness of such things in the South African War that I dare not be silent. Disease, devastation, starvation and death were words I then learned as war interprets them. I saw a country burnt and devastated as large parts of Europe are to-day; I saw old and sick, women and children turned out of house and home; I saw them, half clad, starving, lying sick to death upon the bare earth; I saw babies that were born in open, crowded trucks; I saw haggard, endless sick, gaunt skeletons, hourly deaths. There in the Boer States death swept away non-combatants in the proportion of five to one of those who fell in the field.

"It is because I know the brunt of this war, too, is falling and must fall, heaviest upon the weak and young, that I appeal now on their behalf, not merely to those who love peace, but to the great body of women who love children. Little children, more sensitive to exposure, to extremes of heat and cold, to tainted food, to starvation, and to the stench, the poisonous stench of war, quickly fade, quickly die.

"Will you not arise and work for peace?—For peace alone can save the children. It would be, I well know, a struggle against powers of darkness and will need the whole armor of God. Yet every sentiment of pity and of civilization, leave alone Christianity, demands the effort. The victims cannot help themselves; succor must come from without.

"Relief, we know, you pour most generously, but relief cannot meet a want so colossal, neither can it touch the worst ills. Cut at the root of the evil—the war itself. A strong lead is needed. Myriads want peace; they never wanted war. In each country this is true; constant proofs reach us from Germany and France, as well as various parts of England. The press of each nation asserts that the people are unanimous for war. It is not so, but those who have the means of speaking, and who swim with their governmental streams, can speak the loudest and alone are heard. Many dare not, many cannot speak. Others make a truce and save thousands of human lives and receive the blessings of thousands of wives and mothers.

"A union of neutral women could investigate the facts of the sufferings amongst non-combatants, and founded upon acquired personal knowledge they could in the name of Humanity formulate demands persistent, cogent, irresistible, not in favor of any one party or nation, but simply for Peace.

"It seems futile to turn to statesmen, governments or prelates for aid. They are tied and bound by position, custom and mutual fear. They await propitious movements. Famine, disease and death do not wait.

"Women have this advantage: they are still unfettered by custom and expediency; they need consult only the dictates of humanity. If ever the world needed their intervention on a vast scale, it needs it now!

"Failure in such a task would have no fears for them; failure in a noble effort is often a measure to success! The greatest have seemed to fail. Judged by human standards, Christ's life on earth was a failure. The effort in any case would leave its mark upon the thought and history of the world. Womanhood will have arisen in vindication of a higher humanity—to avenge desolated motherhood and protect martyred children; it will have asserted its right to shield the weak and young from the fatal results of the organized murder called war."

The appeal was not made in vain. The day after its receipt a number of prominent American women called a convention in Washington, D. C., on January 10th, 1915. Miss Jane Addams of Chicago acted as chairman. The result of this meeting was the organization of the "Woman's Peace Party," which adopted the following Preamble and Platform.

"We women of the United States, assembled in behalf of World Peace, grateful for the security of our own country, but sorrowing for the misery of all involved in the present struggle among warring nations, do hereby band ourselves together to demand that war be abolished.

"Equally with men pacifists, we understand that planned-for, legalized, wholesale, human slaughter is to-day the sum of all villainies.

"As women, we feel a peculiar moral passion of revolt against both the cruelty and the waste of war. As women, we are especially the custodians of the life of the ages. We will not longer consent to its reckless destruction.

"As women, we are particularly charged with the future of childhood and with the care of the helpless and the unfortunate. We will not longer endure without protest that added burden of maimed and invalid men and poverty-stricken widows and orphans which war places upon us.

"As women, we have builded by the patient drudgery of the past the basic foundation of the home and of peaceful industry. We will not longer accept without a protest, that must be heard and heeded by men, that hoary evil which in an hour destroys the social structure that centuries of toil have reared.

"As women, we are called upon to start each generation onward toward a better humanity. We will not longer tolerate without determined opposition that denial of the sovereignty of reason and justice by which war and all that makes war to-day render impotent the idealism of the race.

"Therefore, as human beings and the mother half of humanity, we demand that our right to be consulted in the settlement of questions concerning not alone the life of individuals but of nations be recognized and respected.

"We demand that women be given a share in deciding between war and peace in all the courts of high debate—within the home, the school, the church, the industrial order, and the state.

"So protesting, and so demanding, we hereby form ourselves into a national organization to be called the Woman's Peace Party.

"We hereby adopt the following as our platform of principles, some of the items of which have been accepted by a majority vote, and more of which have been the unanimous choice of those attending the conference that initiated the formation of this organization. We have sunk all differences of opinion on minor matters and given freedom of expression to a wide divergence of opinion in the details of our platform and in our statement of explanation and information, in a common desire to make our woman's protest against war and all that makes for war, vocal, commanding and effective. We welcome to our membership all who are in substantial sympathy with that fundamental purpose of our organization, whether or not they can accept in full our detailed statement of principles.

Platform.

"The Purpose of this Organization is to enlist all American women in arousing the nations to respect the sacredness of human life and to abolish war. The following is adopted as our platform:

The immediate calling of a convention of neutral nations in the interest of early peace.

Limitation of armaments and the nationalization of their manufacture.

Organized opposition to militarism in our own country.

Education of youth in the ideals of peace.

Democratic control of foreign policies.

The further humanizing of governments by the extension of the franchise to women.

"Concert of Nations" to supersede "Balance of Power."

Action toward the gradual organization of the world to substitute Law for War.

The substitution of an international police for rival armies and navies.

Removal of the economic causes of war.

The appointment by our Government of a commission of men and women, with an adequate appropriation, to promote international peace."

In the meantime women of other countries had not remained idle. Dr. Aletta H. Jacobs, President of the Dutch National Society for Woman Suffrage, directed a letter to the most prominent women societies of various nations, saying that it was of the greatest importance to bring those women, representing the women societies of the world, together in an international meeting in a neutral country, to show "that in these dreadful times, in which so much hate has been spread among the different nations, the women at least retained their solidarity and that they were able to maintain mutual friendship." At the same time she suggested to hold this International Congress in Holland, and offered to make the necessary arrangements.

While many women welcomed this first effort to renew international relations it was only natural that, especially in belligerent countries, a fierce criticism should be directed against this daring move. This criticism came even from some of the women's organizations. "It was to be impossible to hold the Congress! No one would attend! Even

if the Congress were held the nationalities would quarrel amongst themselves!" But those who had undertaken the work were not deterred by this criticism, but encouraged by many enthusiastic responses. The announcement that Miss Jane Addams had accepted the invitation to preside at the Congress gave courage to all who were working for it. And so the memorable "International Congress of Women for Permanent Peace" came to pass. It was held at the Hague from April 28 to May 1, 1915, and attended by 1136 delegates and a large number of visitors. The countries represented were Austria, Belgium, Canada, Denmark, Germany, Great Britain, Hungary, Italy, Netherlands, Norway, Sweden, and the United States of America.

Figure 63. Miss Jane Addams.

In her address of Welcome, Dr. Aletta H. Jacobs, the President of the Executive Committee, said:

"In arranging this International Congress we have naturally had to put aside all thoughts of a festive reception, we have simply endeavored to receive you in such a way that you may feel assured of our sympathy, our mutual sisterly feelings, our goodwill to link the nations together again in the bonds of fellowship and trustful co-operation.

"With mourning in our hearts we stand united here. We grieve for the many brave young men, who have lost their lives in barbaric fratricide before even attaining their full manhood; we mourn with the poor mothers bereft of their sons; with thousands and thousands of young widows and fatherless children; we will not endure in this Twentieth Century civilization, that governments shall longer tolerate brute force as the only method of solving their international disputes. The culture of centuries standing and the progress of science must no longer be recklessly employed to perfect the implements of modern warfare. The accumulated knowledge, handed down to us through the ages, must no longer be used to kill and to destroy and to annihilate the products of centuries of toil.

"Our cry of protest must be heard at last. Too long already has the mother-heart of woman suffered in silence. O, I know and feel most strongly, that it is impossible that a world-fire, such as has been blazing forth for the last nine months, can be extinguished, until the last bit of inflamable material has been reduced to ashes, but I also feel most strongly that we must raise our voices now, if the new era of civilization that will arise from these ashes is to rest upon a more substantial basis, a basis on which the women with their inherent conserving and pacific qualities shall have the opportunity to assist men in conducting the world's affairs.

"We women judge war differently from men. Men consider in the first place its economic results. What it costs in money, its loss or its gain to national commerce and industries, the extension of power and so forth. But what is material loss to us women, in comparison to the number of fathers, brothers, husbands and sons who march out to war never to return. We women consider above all the damage to the race resulting from war, and the grief, the pain and misery it entails. We know only too well that whatever may be gained by a war, it is not worth the bloodshed and the tears, the cruel sufferings, the wasted lives, the agony and despair it has caused.

"Important as are the economic interests of a country, the interests of the race are more vital. And, since by virtue of our womanhood, these interests are to us of greater sanctity and value, women must have a voice in the governments of all countries.

"Not until women can bring direct influence to bear upon Governments, not until in the parliaments the voice of the women is heard mingling with that of the men, shall we have the power to prevent recurrence of such catastrophes.

"The Governments of the world, based on the insight of the half of humanity, have failed to find a right solution of how to settle international disputes. We therefore feel it more and more strongly, that it is the duty, the sacred duty of every woman, to stand up now and claim her share with men in the government of the world. Only when women are in the parliaments of all nations, only when women have a political voice and vote, will they have the power effectively to demand that international disputes shall be solved

as they ought to be, by a court of arbitration or conciliation. Therefore on a programme of the conditions whereby wars in future may be avoided, the question of woman suffrage should not be lacking, on the contrary, it should have the foremost place.

"May this Congress be the dawn of a better world, a world in which each realizes that it is good to serve one's own country, but that above the interests of one's Country stand the interests of humanity, by serving which a still higher duty is fulfilled."—

The business sessions, presided over by Miss Jane Addams, led to the adoption of the following resolutions:

WOMEN AND WAR

Protest

We women, in International Congress assembled, protest against the madness and the horror of war, involving as it does a reckless sacrifice of human life and the destruction of so much that humanity has labored through centuries to build up.

Women's Sufferings in War

This International Congress of Women opposes the assumption that women can be protected under the conditions of modern warfare. It protests vehemently against the odious wrongs of which women are the victims in time of war, and especially against the horrible violation of women which attends all war.

ACTION TOWARDS PEACE

The Peace Settlement

This International Congress of Women of different nations, classes, creeds and parties is united in expressing sympathy with the suffering of all, whatever their nationality, who are fighting for their country or laboring under the burden of war.

Since the mass of the people in each of the countries now at war believe themselves to be fighting, not as aggressors but in self-defence and for their national existence, there can be no irreconcilable differences between them, and their common ideals afford a basis upon which a magnanimous and honorable peace might be established. The Congress therefore urges the Governments of the world to put an end to this bloodshed,

and to begin peace negotiations. It demands that the peace which follows shall be permanent and therefore based on principles of justice, including those laid down in the resolutions 5, 6, 7, 8 and 9 adopted by this Congress.

Continuous Mediation

This International Congress of Women resolves to ask the neutral countries to take immediate steps to create a conference of neutral nations which shall without delay offer continuous mediation. The Conference shall invite suggestions for settlement from each of the belligerent nations and in any case shall submit to all of them simultaneously, reasonable proposals as a basis of peace.

PRINCIPLES OF A PERMANENT PEACE

Respect for Nationality

This International Congress of Women, recognizing the right of the people to self-government, affirms that there should be no transference of territory without the consent of the men and women residing therein, and urges that autonomy and a democratic parliament should not be refused to any people.

Arbitration and Conciliation

This International Congress of Women, believing that war is the negation of progress and civilization, urges the governments of all nations to come to an agreement to refer future international disputes to arbitration and conciliation.

International Pressure

This International Congress of Women urges the governments of all nations to come to an agreement to unite in bringing social, moral and economic pressure to bear upon any country, which resorts to arms instead of referring its case to arbitration or conciliation.

Democratic Control of Foreign Policy

Since War is commonly brought about not by the mass of the people, who do not desire it, but by groups representing particular interests, this International Congress of Women urges that Foreign Politics shall be subject to Democratic Control; and declares that it can only recognize as democratic a system which includes the equal representation of men and women.

The Enfranchisement of Women

Since the combined influence of the women of all countries is one of the strongest forces for the prevention of war, and since women can only have full responsibility and effective influence when they have equal political rights with men, this International Congress of Women demands their political enfranchisement.

INTERNATIONAL CO-OPERATION

Third Hague Conference

This International Congress of Women urges that a third Hague Conference be convened immediately after the war.

International Organization

This International Congress of Women urges that the organization of the Society of Nations should be further developed on the basis of a constructive peace, and that it should include:

a As a development of the Hague Court of Arbitration, a permanent International Court of Justice to settle questions or differences of a justifyable character, such as arise on the interpretation of treaty rights or of the law of nations.

b As a development of the constructive work of the Hague Conference, a permanent International Conference holding regular meetings in which women should take part, to deal not with the rules of warfare but with practical proposals for further International Co-operation among the States. This Conference should be so constituted that it could formulate and enforce those principles of justice,

equity and goodwill in accordance with which the struggles of subject communities could be more fully recognized and the interests and rights not only of the great Powers and small Nations but also those of weaker countries and primitive peoples gradually adjusted under an enlightened international public opinion.

This International Conference shall appoint:

A permanent Council of Conciliation and Investigation for the settlement of international differences arising from economic competition, expanding commerce, increasing population and changes in social and political standards.

General Disarmament

The International Congress of Women, advocating universal disarmament and realizing that it can only be secured by international agreement, urges, as a step to this end, that all countries should, by such an international agreement, take over the manufacture of arms and munitions of war and should control all international traffic in the same. It sees in the private profits accruing from the great armament factories a powerful hindrance to the abolition of war.

Commerce and Investments

a. The International Congress of Women urges that in all countries there shall be liberty of commerce, that the seas shall be free and the trade routes open on equal terms to the shipping of all nations.

b. Inasmuch as the investment by capitalists of one country in the resources of another and the claims arising therefrom are a fertile source of international complications, this International Congress of Women urges the widest possible acceptance of the principle that such investments shall be made at the risk of the investor, without claim to the official protection of his government.

National Foreign Policy

a. This International Congress of Women demands that all secret treaties shall be void and that for the ratification of future treaties, the participation of at least the legislature of every government shall be necessary.

b. This International Congress of Women recommends that National Commissions be created, and International Conferences convened for the scientific study and elaboration of the principles and conditions of permanent peace, which might contribute to the development of an International Federation.

These Commissions and Conferences should be recognized by the Governments and should include women in their deliberations.

Women in National and International Politics

This International Congress of Women declares it to be essential, both nationally and internationally, to put into practice the principle that women should share all civil and political rights and responsibilities on the same terms as men.

THE EDUCATION OF CHILDREN

16. This International Congress of Women urges the necessity of so directing the education of children that their thoughts and desires may be directed towards the ideal of constructive peace

WOMEN AND THE PEACE SETTLEMENT CONFERENCE

17. This International Congress of Women urges, that in the interests of lasting peace and civilization the Conference which shall frame the Peace settlement after the war should pass a resolution affirming the need in all countries of extending the parliamentary franchise to women.
18. This International Congress of Women urges that representatives of the people should take part in the conference that shall frame the peace settlement after the war, and claims that amongst them women should be included.

ACTION TO BE TAKEN

Women's Voice in the Peace Settlement

This International Congress of Women resolves that an international meeting of women shall be held in the same place and at the same time as the Conference of the

Powers which shall frame the terms of the peace settlement after the war for the purpose of presenting practical proposals to that Conference.

Envoys to the Governments

In order to urge the Governments of the world to put an end to this bloodshed and to establish a just and lasting peace, this International Congress of Women delegates envoys to carry the message expressed in the Congress Resolutions to the rulers of the belligerent and neutral nations of Europe and to the President of the United States.

These Envoys shall be women of both neutral and belligerent nations, appointed by the International Committee of this Congress. They shall report the result of their missions to the International Women's Committee for Constructive Peace as a basis for further action.

The memorable Congress adjourned on May 1. In closing the sessions Miss Addams said:

> "This is the first International Congress of Women met in the cause of peace in the necessity brought about by the greatest war the world has ever seen. For three days we have met together, so conscious of the bloodshed and desolation surrounding us, that all irrelevant and temporary matters fell away and we spoke solemnly to each other of the great and eternal issues as to those who meet around the bedside of the dying. We have been able to preserve good will and good fellowship, we have considered in perfect harmony and straightforwardness the most difficult propositions, and we part better friends than we met. It seems to me most significant that women have been able to do this at this moment and that they have done it, in my opinion, extremely well.
>
> "We have formulated our message and given it to the world to heed when it will, confident that at last the great Court of International Opinion will pass righteous judgment upon all human affairs."—

In accordance with Paragraph 20 of the resolutions the members of the different delegations appointed to present the resolutions to the rulers of the belligerent and neutral nations of Europe and to the President of the United States of America began their work on May 7th. Various delegations with Miss Addams and Dr. Jacobs as speakers, were received on that day in the Hague by Prime Minister Cort van der Linden; on May 13th and 14th in London by Foreign Minister Sir Edward Grey and Prime Minister Asquith; on May 21st and 22d in Berlin by Foreign Minister von Jagow and Chancellor von Bethmann Hollweg; on May 26th in Vienna by Foreign Minister von Burian; on May 30th in Buda Pest by Prime Minister von Tisza; on June 2d in Berne by Foreign Minister Hoffmann and President Motta; on June 4th and 5th in Rome by Foreign Minister Sonnino, and Prime Minister Salandra; on June 8th by the Pope; on June 12th and 14th in

Paris by Foreign Minister Delcassé and Prime Minister Viviani; and on June 16th in Havre by the Foreign Minister of Belgium, M. d'Avignon. Other delegations submitted the resolutions to the Prime Ministers of Norway, Sweden, Denmark, and Russia. The resolutions were likewise sent to the Ministers of Foreign Affairs of all countries not visited by the delegates, and to President Woodrow Wilson.—

That all these efforts by noble-minded women, to secure the cessation of hostilities, failed, is a grave reproach to those men who directed the war. Blinded by hate and revenge they insisted that the murderous struggle be carried on to the bitter end. And to do this unhindered and unmolested, they decried all "pacifists" as despicable creatures to whom no attention should be paid. To speak of peace was made a crime, equal to illoyalty and sedition, and so the resolutions of the Woman's Peace Conference were drowned under waves of detraction and calumny.

One of the most glaring examples of this sort of warfare was that of *Miss Jeanette Rankin*, who in 1917 had been sent by the State of Montana as the first woman member to the House of Representatives. Her first act in this body was very dramatic. When on the memorable April 6th, 1917, the House voted on the question, if the United States should enter the World War, she answered the call with the words: "I love my country and I want to stand by it. But I cannot vote for war! No!" After these words she sank, tears in her eyes, into her chair. Although Miss Rankin had without doubt expressed the feeling of the overwhelming majority of American women, she nevertheless excited the wrath of the notorious "National Security League," who in 1918 defeated the re-election of Miss Rankin by sending broadcast to Montana tons of literature in which her vote against the declaration of war was stigmatized as an "infamous and damning act."

Undaunted by such persecutions the gallant women once more raised their voices when it became evident that the so-called Peace Congress of the allied delegates at Versailles, instead of giving quick relief to the starving millions, and instead of promoting good will and better understanding among the different nations, was degenerating into an orgy of autocracy, merciless extortion and land-grabbing, repudiating all the high-sounding phrases of humanity, democracy, self-government, political and economic liberty, with which the war had been carried on.

On May 12th, 1919, delegates of the "International Women's Party for Permanent Peace" assembled at Zurich, Switzerland, to discuss the work of the Peace Congress in Versailles and the movement for a League of Nations. Sixteen countries were represented, the neutral with thirty-five, the countries of the Entente with forty-nine, and the Central Powers with thirty-six delegates. Among the twenty-three delegates of the United States were Jane Addams, and Jeanette Rankin, ex-member of Congress for Montana. Again Miss Addams acted as president.

The noble spirit, that had brought these women together, found expression first in the following address of the French delegates to the German women:

"To-day for the first time our hands which have sought each other in the night can be joined. We are a single humanity, we women. Our work, our joys, our children, are the same. French and Germans! The soldiers which have been killed between are for both of us alike victims. It is our brothers and our sisters who have suffered. We do not want vengeance. We hate all war. We push from us both the pride of victory and the rancor of defeat. United by the same faith, by the same sense of service, we agree to consecrate ourselves to the fight against war and to the struggle for everlasting peace.

"All women against all wars!

"Come, to work! Publicly, in the face of those who have vowed eternal hate, let us unite, let us love each other!"

To this address the German women made the following reply:

"We German women have heard the greetings of our French sisters with the deepest joy, and we respond to them from the depths of our souls. We too protest against the perpetuation of a hate which was always foreign to women's hearts. Our French sisters! It is with joy that we grasp your extended hand. We will stand and march together, in common effort for the good of mankind. On the ruins of a materialist world, founded by force and violence, on misunderstanding and hate, we women will, through death and sorrow, clear the road to the new humanity. As mothers of the coming generations, we, women of all nations, want love and understanding and peace. Despite the dark gloom of the present we stumble, comforted, toward the sunshine of the future."

On May the 14th the delegates passed the following resolution, which was sent to the Congress at Versailles:

"This International Congress of Women expresses its deep regret that the terms of peace proposed at Versailles should so seriously violate the principles upon which alone a just and lasting peace can be secured, and which the Democracies of the world had come to accept. By guaranteeing the fruits of the secret treaties to the conquerors the terms tacitly sanction secret diplomacy. They deny the principle of self-determination, recognize the right of the victors to the spoils of war, and create all over Europe discords and animosities, which can lead only to future wars. By the demand for the disarmament of one set of belligerents only, the principle of justice is violated and the rule of force is continued. By the financial and economic proposals a hundred million people of this generation in the heart of Europe are condemned to poverty, disease and despair, which must result in the spread of hatred and anarchy within each nation. With a deep sense of responsibility this Congress strongly urges the Allied Governments to accept such amendments of the terms as may be proposed to bring the peace into harmony with those principles first enunciated by President Wilson upon the faithful carrying out of which the honor of the Allied peoples depends."

This communication was proposed by Mrs. Philip Snowden of England and seconded by Miss Jeanette Rankin of the United States.

Another resolution protested against the prolongation of the blockade as bringing starvation and death to innumerable innocent women and children of the Central Powers. It also urged that all resources of the world, food, raw materials, finance, transport should be organized immediately for the relief of the peoples, in order to serve humanity and bring about the reconciliation and union of the peoples. A third resolution demanded representation in the League of Nations for women, and that Miss Addams be the first woman representative. At its concluding session the Congress voted unanimously to call a world-wide strike of women in the event another war be declared, even if such a war should be sanctioned by the League of Nations.

WOMAN TRIUMPHANT

The wonderful spirit displayed by many millions of women during the World War gave foundation to the hope that universal suffrage would be an inevitable result of the war, and that the law-makers of all the belligerent countries would no longer deny this crowning privilege to those mothers, wives, and sisters, who had worked so nobly, suffered so keenly, and endured so patiently through the long years of this cruel catastrophe. In a large number of countries this expectation has been verified. To name them in chronological order, we begin with neutral Denmark, which in 1915 granted to her women full parliamentary suffrage and eligibility. Nine women were elected to Parliament. Iceland extended to her women the same rights, and one woman was sent to Parliament.

The next country was England, for many years the storm center of the suffrage movement. While in all other lands had been steps in evolution, England was the scene of a revolution. Not one with guns, and powder and bloodshed, but nevertheless with all other evidences of war. As Mrs. Carrie Chapman Catt, President of the International Woman Suffrage Alliance, graphically described,

> "there were brave generals and well trained armies, and many a well-fought battle; there have been tactics and strategies, sorties, sieges, and even prisoners of war, many of whom had to be released as they went on a hunger-strike. But in time, by the restless activity of the leaders, every class, including women of the nobility, working girls, housewives and professional women, became engaged in the campaign, and not a man, woman or child in England was permitted to plead ignorance concerning the meaning of woman suffrage. Together, men and women suffragists carried their appeal into the byways and most hidden corners of the kingdom. They employed more original methods, enlisted a larger number of women workers, and grasped the situation in a bolder fashion than had been done elsewhere. In other countries persuasion had been the chief, if not the only, weapon relied upon; in England it was persuasion plus political methods.

"First, the world expressed disgust at the alleged unfeminine conduct of English suffragists. Editorial writers in many lands scourged the suffrage workers of their respective countries over the shoulders of these lively English militants. But time passed; comment ceased; and the world, which had ridiculed, watched the contest in silence, but with never an eye closed. It assumed the attitude of the referee who realizes he is watching a cleverly played game, with the chances hanging in the balance. Then came a laugh. The dispatches flashed the news to the remotest corners of the globe that English Cabinet Ministers were "protected" in the street by bodyguards; the houses of Cabinet Ministers were "protected" by relays of police, and even the great Houses of Parliament were "protected" by a powerful cordon of police. Protected! and from what? The embarrassing attack of unarmed women! In other lands police have protected emperors, czars, kings and presidents from the assaults of hidden foes, whose aim has been to kill. That there has been such need is tragic; and when, in contrast, the vision was presented of the Premier of England hiding behind locked doors, skulking along side streets, and guarded everywhere by officers, lest an encounter with a feminine interrogation point should put him to rout, it proved too much for the ordinary sense of humor.

"Again, the dispatches presented another view. Behold, they said, the magnificent and world-renowned House of Parliament surrounded by police, and every woman approaching that sacred precinct, halted, examined, and perhaps arrested! Behold all this elaborate precaution to save members of Parliament from inopportune tidings that women would have votes; yet, despite it all, the forbidden message is delivered, for over the Houses floats conspicuously and defiantly a huge "Votes for Women" kite. Perhaps England did not know the big world laughed then; but the world did laugh, and more, from that moment it conceded the victory to the suffragists. The only question remaining unanswered, was: 'How will the Government surrender, and at the same time preserve its dignity and consistency?'"

Surrender came when in January, 1917, the Lower House of Commons adopted a resolution favoring a bill making women eligible as members of Parliament.

The bill was discussed again in October, 1918, and a vote of 274 to 25 on October 24th gave women the right to sit as members of Parliament.

Voting in the general elections on December 14th, 1918, for the first time, the British women enjoyed at last the victory for which they bravely fought. While they did not succeed to elect one of their women candidates for a seat in the Parliament, the election was nevertheless one of the most notable in years. Nearly in all districts the women voters made a satisfactory showing as compared to that of men. In Ireland one woman, Countess Georgina Markievicz, an Irish by birth and the leading female figure in the Sinn Fein movement, was elected to the House of Commons, the first woman ever sent to this body.

Canada likewise granted full suffrage to women. A bill passed the third reading on May 3d and received Royal Assent May 23d, 1918.

In Nova Scotia a bill was passed April 26th, 1919.

In South Africa Parliament accepted a Woman Suffrage Bill on April 1st, 1919, by 44 votes to 42.

When the revolution came in Russia, equal suffrage for women was accepted by the men of all parties without opposition. It has had, as Catherine Breshkovsky, the

> "Grandmother of the Russian Revolution," explained, "a profound effect upon the minds of the peasant women. They used to be often beaten by their husbands. Now the idea of freedom and equal rights has taken firmer root among them. Instead of submitting to beatings from her husband the sturdy peasant woman defends herself, and sometimes she even beats him, especially if he is drunk. The fact that during the war the women have had to do every kind of work has also contributed to this sense of independence."

When in November, 1918, the German Republic was declared, paragraph 31 of the Constitution provided that the representatives of the people be elected by all men as well as women over twenty years, and that women are eligible for all Federal and State Legislatures and municipal bodies. Under this regulation on January 19th, 1919, 36 women were elected to the Federal Parliament, and 22 to State Legislatures. Among the women elected to the Parliament were several of the most prominent leaders of the suffrage movement in Germany: Dr. Gertrud Bäumer, Dr. Käthe Schirmacher, and Dr. Alice Salomon.

In Austria the downfall of the monarchy nullified the law which forbade women to take part in political societies. The 12th of November, 1918, brought to the women universal, equal, direct, and secret suffrage and eligibility with the announcement of the republic. Seven women were elected, among them the well-known suffragist Adelheid Popp, who was also elected to the Vienna Municipal Council.

The Government of the Hungarian Republic likewise adopted a suffrage law which gives the vote to all men of 21 and to women of 24 if they can read and write. While this is not equality of the sexes yet, the government gave at the same time evidence of its profound respect for the abilities of women by taking one of the most important steps in the history of woman's progress. It appointed Miss Rose Bédy Schwimmer, highly respected for her activity and literary works on suffrage and peace, as ambassador extraordinary and minister plenipotentiary to Switzerland. But the conservative members of the Federal Council of that country refused to accept a woman ambassador, and so Miss Bédy Schwimmer found it advisable to tender her resignation, a month after having accepted her difficult task.

The new republic Czecho-Slovakia as well as the newly reconstituted state of Poland at once conceded full political citizenship to their women. In Czecho-Slovakia eight, and in Poland five women were elected to the Parliaments.

In Sweden full suffrage was accorded to women May 28th, 1919, when a bill was passed by large majorities in both houses of the National Parliament, according to which

every subject, man or woman, who has attained his or her twenty-third year, is qualified to vote.

In France the "Union Française pour le Suffrage des Femmes" sent on January 24th, 1919, a proclamation to the Parliament demanding that French women be given the franchise. The proclamation pointed to the fact that the right to vote had been recognized in enemy and allied countries and that therefore France should not be backward. But in spite of this on April 4th two women suffrage amendments to the Electoral Reform Bill were killed in the Chamber of Deputies. The provision making women eligible for election to the Chamber was defeated, 302 votes to 187. The vote against transmission of the right to vote to the next of kin of heads of families, without distinction of sex, was defeated 335 to 134. But on May 20th the Chamber of Deputies adopted a bill granting women the right to vote in all elections for members of the Communal and Departmental Assemblies. The vote was 377 to 97. The measure then went to the Senate.

Switzerland, with the European spread of woman suffrage all around, may be expected to soon respond to the wave of democratic sentiment. On January 22, 1919, the delegates of the Swiss Union of Women's Clubs adopted a resolution to request the Federal Council to order a radical revision of the Constitution, and grant to women equal political rights with men. On March 17th, the Grand Council of the Canton of Neuchâtel declared for the principle of Woman Suffrage, and likewise instructed the Government to prepare a suffrage bill. If passed this bill will probably be decided by referendum.

The Belgian Chamber of Deputies, by unanimous vote, adopted on April 11th, 1919, an Electoral Reform Bill, under the terms of which the right to vote is limited to widows who have not remarried, to the mothers of soldiers killed in battle and to the mothers of civilians shot by the enemy.

In Holland the first Chamber of the Dutch Parliament adopted on July 12th, 1919, a motion to introduce woman suffrage by a vote of 34 to 5.

In the United States of America the Western States have, as pointed out in a former chapter, never hesitated to acknowledge the rights of women to vote. But the Southern and Eastern States had remained reluctant in granting this privilege. And so the suffragists were compelled to conquer these regions step by step. The women of New York won full suffrage in 2961917, those of South Dakota, Michigan and Oklahoma in 1918. Presidential suffrage was secured in 1917 in North Dakota, Nebraska, and Rhode Island, and in 1919 in Indiana, Iowa, Minnesota, Wisconsin, Missouri and Maine.

For many years efforts had also been made by the friends of Woman Suffrage to induce Congress to act on the so-called "Susan Anthony Amendments to the Constitution," reading as follows:

"Section 1. The right of citizens of the United States to vote shall not be denied or abridged by the United States or by any State on account of sex.

"Section 2. The Congress shall have power by appropriate legislation to enforce the provisions of this article."

In 1914 the Senate again voted these amendments down by 11 votes. Again, in September, 1918, it was rejected by two votes, and again in February, 1919, by one vote. The House voted upon the resolution three times, rejecting it in 1915 by 78 votes, passing it in 1918 by a margin of one vote, and again, on May 21st, 1919, by a vote of 304 to 89. The fight ended on June 4, 1919, when the Senate adopted the resolution by a vote of 56 to 25.

"The credit of having won this victory," so the "New York American" said in an editorial, "belongs chiefly to the resourceful women of the land who have, for generations, been pushing this issue to the front in spite of stupid opposition and almost as stupid indifference.

"Liberal-minded men, a few in the early days, many more recently, have helped. But, primarily, it is a woman's victory, and no man will begrudge the acknowledgment. Equal partners in the economic and social life of the nation, American women will now be equal sharers in its political life and in the responsibilities which this will involve.

"The joy of triumph will be of brief duration. The period of responsibility will be long and trying. But the women of America will certainly meet it equally with the men, and if they do that the men will have no just basis of complaint. Political rule by men has been full of blunders. Women, too, will blunder, but they will not be likely to make the same kind of blunders that men make. The blunders that men make will tend to be corrected by the superior insight and intuition of women; and probably in time the blunders to which women will be prone will have counteraction by the men. So instead of the blundering being increased by the widened circle of electoral responsibility it is more likely to be lessened, for the cure for the ills of democracy is always more democracy.

"Anyhow, the change is here. It is world-wide. It comes as a resultant of increased freedom and it presages more freedom."

Chapter 35

WOMAN'S MISSION IN THE FUTURE

As woman now is man's equal partner, she must share in the difficult task of solving the many problems connected with the economic, social and political life of that nation to which she belongs. That she will assume this obligation, fully aware of its significance, cannot be doubted; we need only recall the noble spirit, enthusiasm, intelligence and perseverance which have distinguished all the leaders in the great movement for woman's emancipation.

Woman's mission in the future will be many-sided. Paramount among all questions, that demand her utmost consideration, is the prevention of future wars. And it may be said right here that mankind, through the efforts of women, will most probably find the final realization of hopes cherished for centuries by all right-minded people. We hardly need point to the glaring contrasts between the Peace Congresses called together by women at the Hague and in Zurich, and the conferences held by men at Versailles to secure a League of Nations. While the former meetings were distinguished by the perfect harmony and cordiality among the delegates of all belligerent and neutral nations, and while their resolutions expressed the good will and lofty disinterestedness of all members, the wearisome discussions at Versailles were characterized by suspicion, avarice and merciless extortion. The "Allies" no longer spoke for a common cause, but were rivals over the spoils of war. Each clamored for an individual gain. And instead of extending brotherly hands to the conquered enemy, instead of instilling hope in the hearts of the desperate, and instead of feeding the starving, they increased the bitterness and sufferings by an unwarranted and cruel blockade, through which more than a million innocent children and women were condemned to agony and death.

Many far-seeing men have expressed grave doubts that the "Covenant of Peace" and the "League of Nations" can prevent future wars. So we hope that women, who would again become the greatest sufferers through such a catastrophe, will continue in their efforts to re-establish international good will and solidarity. Deep abysses of antagonism

must be bridged; hate and the thirst for revenge must be quenched, and thousands of smarting wounds must be healed before humanity can hope for a better future. But women can perform these wonders. Since the organization of the "International Woman's Peace Party" the voice of women will be heard in the council of nations, and their influence will be mighty, for the women outnumber the men.

Most naturally the demands of women will also be directed to an international regulation of women's relations to men, which in most countries are far from satisfactory. The World War has emphasized the fact that in almost all countries women, on marrying foreigners, forfeit their own nationality and are compelled to adopt that of their husbands. Thus it happened in 1914 that many French and English women, having married Germans or Austrians, residents or citizens in France or England, were deported from their native countries, at the same time losing all personal property that they were unable to take with them.

Under the laws of the United States a loyal American woman, who marries an alien enemy, becomes herself an alien enemy, while a woman enemy alien who marries an American becomes herself a loyal American. By allowing the woman no choice of allegiance this law works injustice both to her and to the country.

An international agreement has been proposed that women shall not be deprived of their own nationality against their will, irrespective of marriage, and, when deported into enemy territory, shall be restored to their own country.—

Full equality between husband and wife, father and mother is also desired in regard to property and responsibilities, especially parental. In some countries, as for instance in Great Britain, under the existing laws only the father is recognized as the guardian of the children. He is the sole judge of what shall be their maintenance and education; and he has, prima facie, the sole right to their custody.

Another important question which demands regulation through international agreement, is the suppression of the White Slave Trade, that horrible evil, which under the imperfect conditions of civilization has assumed such amazing proportions. To abolish it, women have presented to the League of Nations Commission resolutions saying, that States who enter into the League shall undertake to suppress the sale of women and children and to punish severely the traffic in women, whether under or over age, and of children of both sexes, for the purposes of prostitution.—

The suppression of tuberculosis, of syphilis and other venereal diseases is likewise a serious problem calling for international regulation. The energetic co-operation of women is of utmost importance, as far too often innocent women become sufferers from these horrible diseases through infection from their unscrupulous husbands, who have concealed from their wives the fact that they were afflicted with such maladies.

The supervision of such diseases by health officers, and the provision of clinics for all infected persons will be demanded by woman legislators; likewise penalizing for infecting with venereal diseases.

While in most countries no questions are asked in regard to the health of the candidates for marriage, it has been through the activity of women, that the new marriage law that came into force in Norway on January 1st, 1919, demands that both candidates must declare in writing that they are not suffering from epilepsy, leprosy, syphilis, tuberculosis, or other diseases in an infectious form. Written declarations must also be given as to previous marriages and to children born to them out of wedlock. As this new marriage law contains not less than eighty-one sections, it is evident that henceforth in Norway it will be difficult to marry in haste.

Such laws for the protection of women are nowhere more needed than in the forty-eight States which together form the American Union. As everyone of these States makes its own laws, there exists a variety of laws in regard to the "age of consent," to marriage and divorce, far too intricate for any woman or lawyer to be thoroughly informed about them all. For instance the legislators of Florida have fixed the "age of consent" at 10 years (!), documenting herewith their utter ignorance in such a serious question. In other States it is 12 or 14 years, in Wyoming it is 18. How competent women think about this subject, may be judged by a resolution of the "Woman's Political Association of Australia," asking the Government to raise the age of consent to 21 years, and to extend this provision to cover girls as well as boys.

Very heterogeneous are also the marriage laws of the United States. In Tennessee girls may marry without their parents' consent when only twelve years old, while in other states they must not do so before eighteen, or even twenty-one. Missouri is one of the few states which still recognize common law marriages. As this state sets no minimum legal age for marriage, a boy or girl of twelve may without their parents' consent live together as man and wife.

Still more perplexing is the diversity in regard to the causes for absolute divorce. While South Carolina grants no divorce, other states are very liberal and acknowledge eight or ten different reasons as sufficient reasons for divorce. Marriages between Whites and Indians, or between Whites and Negroes or persons of negro descent, or between Whites and Chinese are prohibited and punishable in a number of states, while they are allowed in others.

Improvement in the status of the illegitimate child; child-labor and welfare; woman's status in industries; mothers' insurance during maternity; proper insurance for the invalid and aged; combating of alcoholism; the suppression of the traffic in opium and other injurious narcotics; the traffic in arms, especially with uncivilized or semi-civilized tribes and nations, and many other questions call for international regulation and the co-operation of women. To compare the laws of the various countries and to select the best and clearest laws to be used as a standard to which other states should be urged to raise their legislation, will be one of the great missions for the women lawyers connected with the various national leagues of women voters.

That women have the ability as well as the hearty desire to contribute in this way to the progress and welfare of the human race, needs no further explanation. It is for the men to accept and encourage their help and to utilize it to the fullest extent. The beneficial result of such co-operation can not be doubted. Women with their intuitive judgment, spiritual insight and knowledge of the needs of women, children, public education, sanitation, philanthropy, etc., will become a most important factor in the vast task of human betterment. And man, working with woman side by side in these noble endeavors, will not only profit, but learn that nature has given him nothing more sublime than woman.

INDEX

D

E

192, 195, 196, 203, 204, 205, 208, 214, 218, 224, 226, 227, 229, 231, 239, 244, 252, 253, 257, 258, 262, 267, 280, 281, 282, 288

equality, 145, 146, 147, 148, 177, 283, 288

Europe, 29, 37, 66, 75, 81, 82, 102, 117, 118, 120, 121, 126, 127, 134, 147, 155, 170, 178, 190, 205, 220, 224, 231, 232, 244, 252, 266, 267, 277, 279

evidence, 92, 187, 204, 249, 283

evil, 22, 39, 42, 51, 56, 61, 80, 95, 96, 98, 117, 123, 148, 157, 235, 253, 259, 267, 268, 288

evolution, viii, 4, 5, 16, 19, 23, 89, 163, 180, 187, 237, 244, 281

execution, 56, 102, 145, 196

exercise, 57, 68, 82, 147, 240, 247, 252

exertion, 156, 157, 165

expenditures, 167

exploitation, viii, 149, 163, 164, 253

F

factories, 149, 154, 155, 170, 172, 187, 253, 254, 255, 262, 275

faith, 37, 68, 69, 70, 81, 97, 174, 192, 232, 249, 279

families, 13, 52, 56, 73, 89, 98, 102, 135, 252, 255, 284

family life, 46, 50, 52, 56, 63, 68, 72

famine, 102, 118, 119, 267

farmers, 135, 155

fear, 87, 102, 153, 261, 267

feelings, 56, 68, 206, 209, 271

financial, 221, 279

flavor, 118, 126

flight, 102, 129

flowers, 23, 47, 84, 87, 88, 126, 133, 199, 200, 224

food, 6, 11, 20, 64, 111, 119, 136, 147, 167, 252, 264, 265, 266, 267, 280

formation, 159, 240, 251, 257, 269

France, 89, 92, 93, 97, 102, 103, 121, 125, 126, 127, 133, 143, 155, 180, 193, 196, 200, 201, 210, 215, 218, 226, 229, 232, 245, 262, 264, 267, 284, 288

franchise, 141, 240, 249, 260, 269, 276, 284

freedom, 58, 89, 117, 130, 133, 134, 139, 140, 144, 208, 247, 250, 269, 283, 285

French Revolution, vi, 128, 143, 144, 146, 149, 196

friendship, 105, 127, 147, 148, 269

fruits, 47, 147, 224, 279

funds, 131, 171, 235

G

general election, 282

general knowledge, 210

Germany, 89, 92, 93, 96, 116, 117, 125, 129, 155, 166, 170, 171, 192, 196, 200, 210, 212, 218, 220, 226, 229, 231, 232, 244, 245, 258, 262, 264, 266, 267, 270, 283

gifted, 165, 208, 213, 223, 227

God, 37, 68, 69, 80, 96, 102, 103, 110, 153, 157, 173, 174, 190, 203, 229, 241, 253, 258, 267

governments, 141, 172, 242, 265, 267, 269, 271, 273

Great Britain, 104, 155, 166, 168, 210, 218, 241, 244, 270, 288

Greece, 50, 58, 68, 189, 199, 247, 258

Greeks, v, 20, 49, 50, 51, 56, 57, 58, 183, 191, 223

guilty, 35, 57, 64, 102, 119, 120, 160, 242, 257

Guinea, 5, 6, 8, 110, 118

H

hair, 15, 47, 52, 56, 64, 66, 69, 98, 99, 250

happiness, 4, 16, 69, 125, 141, 174, 223, 240, 244, 259

hardships, vii, 4, 11, 16, 38, 135, 138, 139, 195, 244

harmony, 4, 50, 277, 279, 287

health, 11, 29, 64, 125, 148, 154, 160, 161, 165, 167, 171, 189, 213, 231, 232, 251, 252, 288, 289

Hebrews, v, 28, 33, 34, 95, 183

hemisphere, 171, 191, 204

higher education, 195, 235

Hindoo, v, 35, 37

history, vii, 20, 23, 28, 38, 61, 63, 101, 105, 109, 110, 114, 118, 121, 123, 129, 130, 139, 140, 143, 144, 169, 174, 180, 183, 189, 192, 193, 194, 206, 208, 212, 219, 220, 221, 237, 240, 265, 268, 283

homes, 12, 39, 52, 58, 72, 73, 88, 119, 135, 149, 171, 230, 233, 244, 251, 257, 258

horses, 19, 65, 151, 226

hostilities, 266, 278

hostility, 39, 69, 145, 177

House, 163, 207, 209, 234, 256, 278, 282, 285

human, vii, 4, 5, 6, 11, 12, 14, 16, 19, 20, 22, 23, 28, 34, 37, 38, 47, 81, 95, 96, 98, 101, 105, 110, 111, 113, 114, 116, 118, 133, 144, 151, 152, 159, 164, 167, 169, 173, 188, 202, 232, 233, 250, 255, 256, 258, 266, 267, 268, 269, 272, 277, 290

human activity, 173, 188

S

T

U

Related Nova Publications

THE FIFTY GREATEST WOMEN IN AMERICAN HISTORY

AUTHORS: Michael F. Shaughnessy and Donald C. Elder III

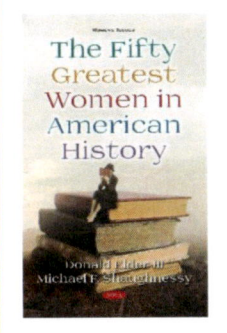

SERIES: Women's Issues

BOOK DESCRIPTION: Over the past several hundred years, many women have made major, significant contributions to society, to their countries and to their field of endeavor. Many of these women have not received the acknowledgement and recognition that they deserve. This book is an attempt to rectify that deficiency. In a warm, storytelling fashion, the authors lay out the scenarios and contributions of fifty of the most famous women of history.

HARDCOVER ISBN: 978-1-53616-130-4
RETAIL PRICE: $160

WOMEN'S ISSUES: BACKGROUND, LEGISLATIVE AND LEGAL DEVELOPMENTS

EDITOR: Luther Burke

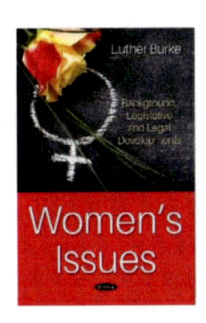

SERIES: Women's Issues

BOOK DESCRIPTION: This book is a compilation of CRS reports focused on women and women's issues, including women in Congress from 1917 to 2018; legislative and legal developments in pay equity; developments in the law on sex discrimination and the United States Supreme Court; issues for Congress on women in combat; and US efforts to address global violence against women.

SOFTCOVER ISBN: 978-1-53614-049-1
RETAIL PRICE: $95

To see a complete list of Nova publications, please visit our website at www.novapublishers.com

Related Nova Publications

FEMINISM: PAST, PRESENT AND FUTURE PERSPECTIVES

EDITOR: Josefa Ros Velasco

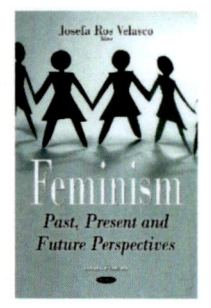

SERIES: Women's Issues

BOOK DESCRIPTION: The authors want to show the most current points of view on women's issues through researches that are taking place in different geographic places, thanks to a procedure based on the case studies and methods. Finally, they will attempt to clarify what the future holds for women and state their demands firsthand.

HARDCOVER ISBN: 978-1-53612-037-0
RETAIL PRICE: $230

CAUGHT UP IN THE SPIRIT! TEACHING FOR WOMANIST LIBERATION

AUTHOR: Gary L. Lemons

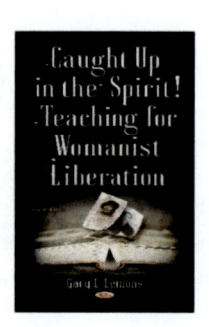

SERIES: Women's Issues

BOOK DESCRIPTION: *Caught in the Spirit! Teaching for Womanist Liberation* promotes the author's work in the college classroom as a black male professor of womanism. First and foremost, this book illustrates the self-transformative power of Alice Walker's concept of a "womanist." *Caught Up in the Spirit!* also foregrounds powerful writings by students who have studied African American literature with the author.

HARDCOVER ISBN: 978-1-53611-817-9
RETAIL PRICE: $230